A gift in honor of

My Mother and Father

From

Richard Cheung

BOWMAN LIBRARY

# The Legacy of
# Mark Rothko

# THE LEGACY
# OF Mark
# Rothko

## by Lee Seldes

HOLT, RINEHART AND WINSTON

NEW YORK

Published simultaneously in Canada by Holt, Rinehart and Winston of Canada, Limited.

LIBRARY OF CONGRESS CATALOGING IN PUBLICATION DATA

Seldes, Lee.
    The legacy of Mark Rothko.

    Bibliography: p.
    Includes index.
    1. Rothko, Mark, 1903–1970.  2. Painters—
United States—Biography.  I.  Title.
ND237.R725S44      759.13[B]      76-29921
ISBN: 0-03-014751-4

Portions of this book appeared in somewhat different form in the November 1974 issue of *Esquire* magazine.

First Edition
Designer: A. Christopher Simon

Printed in the United States of America
10 9 8 7 6 5 4 3 2 1

Grateful acknowledgment is made for the use of the following:

An excerpt from *Mark Rothko* by Peter Selz, published in 1961 by The Museum of Modern Art, New York. All rights reserved. Reprinted by permission of the publisher.

An excerpt from *New York Painting and Sculpture, 1940–1970* by Henry Geldzahler. Copyright © 1969 by The Metropolitan Museum of Art. Reprinted by permission of the publishers, E.P. Dutton.

An excerpt from *Conversations with Artists* by Selden Rodman. Copyright © 1957 by Selden Rodman. Reprinted by permission of the publishers, The Devin-Adair Co., Old Greenwich, Conn. 06870.

Excerpts from *The New Handbook of Prescription Drugs* by Richard Burack, F.A.C.P., with Fred J. Fox, M.D. Copyright © 1967, 1970, 1975 by Richard Burack, M.D. Reprinted by permission of the publishers, Ballantine Books.

# Contents

# CONTENTS

# Foreword

The central characters in this book are paintings. This is neither an attempt at a definitive life of Rothko nor a critical study of his art. It is rather the story of what happened to the paintings from their creation to their incredible travels after Rothko's death. In the now-famous lawsuit over their disposition, the paintings were to bear silent witness and, ultimately, convict the wrongdoers. This book is also an account of how an artist with a passionate commitment to his creations nevertheless failed to control their fate, and how he and his work fell into the hands of men interested only in the commerce of art. Through the history of Rothko's paintings, it is possible to examine the internecine world of art and how the predators within it operate, uninhibited by public scrutiny or regulation.

That profits from international trading in art have become immeasurable was demonstrated for the first time in the trial over the multi-million-dollar legacy left by Rothko. In 1974 dealers estimated that in New York City alone over a billion dollars' worth of art is bought and sold each year. But as the evidence and testimony relating to Marlborough sales made clear, that billion represents only the visible portion of a cache of invisible and undeclared profits channeled through

Liechtenstein into Switzerland—or any number of other foreign tax havens—where it is safely tucked away in top-secret bank accounts. There are few limits placed on the exploitation of art and artists, particularly after the artist's death. Perhaps this book will help alert painters and sculptors to some of the perils of commerce in art and, now that art is a commodity like stocks, gold, gems, and oil, help make the public aware that something must be done to control its trading.

This book resulted from reportorial coverage of the eight-month trial, the "Matter of Rothko," in a civil courtroom in downtown Manhattan. As the only member of the public present throughout the proceedings, I found myself in the role of unofficial jury, and naturally my impressions about the credibility of witnesses, lawyers, and documents are my own. Gradually, through the tedious pettifogging and profusion of paper, I was able to trace the actions of the principals involved and the surprising travels of some of Rothko's paintings. Two years of interviewing and examining documents clarified some of the questions surrounding Rothko's death and the subsequent "gift" of his work to Frank Lloyd by the artist's three trusted friends. One result of gathering these fragments was the construction of a timetable which revealed a surprising chain of circumstances—some accidental, others clearly plotted, and still more that remain hazy. So much time had elapsed that for some participants memories had dimmed; at least two important sources had died and, of course, recollections of a few had become suspiciously self-serving. But by doublechecking and corroborating facts from disinterested sources, I think I have given a fair picture—ugly as it is—of what went on and how, afterward, these events were covered up.

I would like to have seen Bernard Reis, but he made himself unavailable for interviewing, just as he had been unavailable for testimony. But from his sworn affidavits, one brief deposition, memoranda, letters, and other evidence, by interviewing his friends, former clients and partners, and by reviewing court records of other lawsuits in which he was involved, I believe I have accurately portrayed his part in these events.

Had it not been for the courage of a twenty-year-old girl, these facts would not have been known. As Kate Rothko, with reason, is publicity-shy, I hope that publication of this material will in no way harm her or her family. The art world and I are similarly indebted to New York State Assistant Attorney General Gustave Harrow, whose

*Foreword*

patient pursuit of truth must come through in the narrative. And to those good enough to be interviewed again and again, my gratitude. I hope I have done justice to them as well as to their parts in the story of the legacy of Mark Rothko.

I wish to thank my agent, Harriet Wasserman, and my editor, Jennifer Josephy, for their enthusiasm, encouragement, and tact, all of which helped make this massive endeavor a reality. And thanks, of course, to Timothy Seldes and Gilbert and Elisabeth for enabling me to devote my time (and theirs) to the unraveling of the tale, and for their forbearance at my temperamental distraction while writing.

# The Legacy of
# Mark Rothko

# 1

# Three Days That Rocked the Art World

(FEBRUARY 25–27, 1970)

Shall the companions make a banquet of him?
Shall they part him among the merchants?

Book of Job

A few minutes after 9 A.M. on Wednesday, February 25, 1970, Oliver Steindecker made his way through the office-bound crowds to a studio on East Sixty-ninth Street. He inserted his key into the lock of the ornate black door and let himself in. Another key, another black door slid back, and he was in a makeshift office, from where he could see racks of giant canvases stacked on one side of a long hallway. He shouted his usual morning hello toward the rear. There was no response. The living area was in the near corner of the forty-foot-square cavernous back studio, where somber black-on-gray paintings dominated the walls. The studio contained an assortment of sparse furnishings, including several bruised tables and chairs. The bed was empty, but rumpled sheets indicated that it had been slept in. Oliver approached the doorway of the small central bath-kitchen and peered in. There he saw his employer, Mark Rothko, the celebrated

1

American painter, stretched out on the floor near the sink. Oliver raced back through the foyer and banged on the front door of the adjoining studio, where Arthur Lidov, a commercial artist, and his assistant were already at work.

"Come quickly, I think Mr. Rothko is very sick," Oliver cried, and mumbled something about calling a doctor.

Rothko's body lay face up, his arms outstretched in a pool of congealed blood six by eight feet wide. His arms were slashed at the crooks inside the elbows. He was clothed in his undershirt, long johns with blue undershorts over them, and, on his feet, long black socks. More blood was spattered about, and on a nearby shelf lay a stained razor blade with Kleenex wrapped around one edge. Lidov, one of whose specialties is medical illustration, checked for vital signs. Rothko, he noticed, was unusually pallid—"jaundiced"—even for a recent corpse that had bled to death. Lidov persuaded Oliver that police, not doctors, were needed. A telephone call to the 19th Precinct, two blocks south, set in motion the legal and medical apparatus that attends violent death in the city of New York.

On the following day, the front page of the *New York Times* carried the news:

> Mark Rothko, a pioneer of Abstract Expressionist painting who was widely regarded as one of the greatest artists of his generation, was found yesterday, his wrists [sic] slashed, in his studio at 157 East 69th St. He was 66 years old. The Chief Medical Examiner's office listed the death as a suicide. Mr. Rothko had suffered a heart attack last year and friends said he had been despondent in recent months. . . .

Covering the obituary page were tributes to the artist and a list of his major exhibitions and honors. But from the sample of his work printed in the *Times*, the uninitiated must have found it impossible to discern why. How could such a painting have evoked poetic acclaim over the past twenty years from critics, collectors, and curators of contemporary art? Layout men had cropped Rothko's 1956 *The Black and the White*, and reduced it to the size of a postcard. Without color, and diminished 244 times from its true measurements, the *Times*'s image of the canvas was a travesty. It gave no suggestion of the power or the delicate nuances of the original—a dramatic study

in contrast wherein three disparate soft rectangles seem to float horizontally in tiers (the topmost a vivid red, the center white, the bottom black) on a gigantic rose-washed vertical canvas. The obituary listed Rothko's earlier dealers, but made no mention of the Marlborough Galleries, with which he had been affiliated in various ways for the past seven years. It was difficult for some in the art world to reconcile the artist's public image presented in the *Times* with the complexities of the man who but yesterday had been among them.

Rothko's success had been matched by few others. He had become one of the masters of fine art and, as the essayists repeatedly pointed out, had made an essential contribution to the framework of art history. Though his work was admired for its intense spirituality, Rothko, in a worldly way, was the embodiment of the American Dream.

His violent end continued the chain of tragic deaths among his generation of artists and poets. In 1948, surrealist painter Arshile Gorky had hanged himself in Connecticut. Eight years later, Jackson Pollock had died in an automobile crash on Long Island. In 1965, the international art world had lost the brilliant sculptor David Smith to another road accident. The poet Frank O'Hara had been killed the following year in a freak jeep accident on Fire Island. Others, including Franz Kline, Bradley Walker Tomlin, and Ad Reinhardt, had not died violently, but suddenly or prematurely.

For those who had survived and who had watched Rothko's life deteriorate during his last few years, the suicide did not come as a surprise: many thought he had been killing himself slowly through chain-smoking and heavy drinking. But the gory method was a shock. Those few who knew the actual details of the macabre mutilation found it unbelievably uncharacteristic. Two things seemed clear, however: that Rothko had hated himself, and that he had intended to stun the world by his exit. It was a ritual sacrifice, a final dramatic gesture. But he left no note of explanation.

"Why did he do it?" they asked each other. "Why?" Or as painter Hedda Sterne put it: "Who was this man, Mark Rothko, who killed my friend?"

Sharing the headlines with Rothko's suicide that February morning was an adjacent front-page story also of great interest to the art world. At a Sotheby Parke Bernet auction the previous evening, not only had a new record in art prices been set, but the event itself illustrated the commercial extravaganza the art marketplace had become

during the last decade. The media was present en masse. Dealers and collectors had come from all over the world, and more than 1,500 modishly attired people were present in the large amphitheater and its adjoining rooms in New York. Each sale was relayed simultaneously by closed-circuit TV to another glittering audience of wealthy patrons assembled at the Neiman-Marcus department store in Houston. A chorus of scattered "oohs" and "ahs" greeted each painting as it was displayed before the brown velvet curtain. A London *Times* correspondent compared the auction to a television quiz show when the studio audience is given its first look at the prizes, the fully equipped kitchen or the brand-name bedroom set.

While the elegant onlookers gasped, two of the paintings which went for all-time highs were masterpieces by van Gogh, painted while he was in the asylum at St. Rémy en Provence in 1889, the year before he shot himself. Heightening the drama, one of these, *Le Cyprès et l'arbre en fleurs* was purchased for $1,300,000 by a mystery bidder who, according to the auctioneers, had merely left instructions that he would top anyone else's bid by $50,000. The art fetched a total of $5,852,250. While the stock market was descending to new lows there was, declared the *New York Times*, "a bull market in art."

A few blocks north of Parke Bernet is the Frank E. Campbell funeral parlor. There, on the evening of the twenty-sixth, Rothko's body lay in state. Standing at the door, greeting those who came to pay their last respects, was Mell, Rothko's handsome dark-haired wife of twenty-five years, from who he had separated the year before. Family and friends filed in and out, embracing the widow and passing the peaceful-looking corpse. But novelist Bernard Malamud remembers a jarring detail to the semblance of repose: "Someone had put his glasses on—there was this rock wearing glasses."

The Rothkos' six-year-old son, Christopher, a pretty miniature of his father, was led forward by Mell and placed a recording of Schubert's "Trout Quintet" in the coffin. Kate, their nineteen-year-old daughter, added her father's favorite recording of Mozart's *The Abduction from the Seraglio*. Then painter Theodoros Stamos, looking dark and dramatic with a Fu Manchu mustache, placed a single flower on the chest of the dead man.

At 2:30 the next afternoon, the mourners crowded to Campbell's for the service. It was another of what the late artist Ad Reinhardt once ironically called "happenings in the art world." Side by side were

fashionable patrons, powerful museum trustees, dealers, critics, and poets—and, of course, artists young and old, famous and struggling. Wives and mistresses attended, as did former wives, boyfriends, and lovers. The artists included Willem de Kooning, warm and handsome at sixty-five, Adolph Gottlieb, who had recently suffered a debilitating stroke; Robert Motherwell with his wife, Helen Frankenthaler; James Brooks and Charlotte Park; Philip Guston and Jack Tworkov; Stamos, who sat in front; Hedda Sterne; and Barnett Newman. Among the widows was painter Lee Krasner Pollock, herself a formidable figure. These were the survivors of the first-generation of the New York School.

The modern Medicis were there in force—the art patrons and investors who can afford to commission, collect, and donate art. Many buy and sell as though they were dealers, and often serve as trustees of museums. The names and life-styles of some are better known than the works they have collected. The bearded taxi mogul Robert Scull found time to take in the funeral; he was still in the process of amassing the jazzy pop collection which would soon set new highs at Parke Bernet. Ben Heller, the art and textile merchant and collector, attended and seemed stricken; in three years, as a private dealer, he would make headlines with the two-million-dollar price tag he successfully attached to Pollock's *Blue Poles*. French-born John de Menil, the billionaire MOMA trustee from Houston, was there with one of his daughters; de Menil and his wife, Dominique, the Schlumberger heiress, besides possessing perhaps the finest collection of those present, had commissioned Rothko to create interior murals for a chapel in Houston.

Also attending were many other trustees (and collectors) representing the Museum of Modern Art and a large retinue from its prestigious staff: Alfred Barr, Jr., gaunt, distinguished, and idolized for his quiet aestheticism; the patriarch of modern art in America and Bernard Berenson to the Rockefellers, he was then in partial retirement from his forty-year-old founding stewardship of MOMA. He was flanked by Dorothy Miller, his handsome and tactful assistant. Not far from them was art historian–MOMA curator William Rubin, until recently an adviser to Rothko.

The Metropolitan, New York's dowager duchess of art, was represented by the bearded, trendy Henry Geldzahler, the curator of the newly created, hotly debated contemporary arts department; his recent exhibition "New York Painting and Sculpture: 1940–1970" had set a

record for swish ostentation but enraged serious artists and scholars, adding to Rothko's final depression. The Whitney, scene of many of Rothko's early battles, was represented by, among others, its present respected caretaker and director, John Baur; and there were also key representatives of the Solomon R. Guggenheim Museum.

Though art critics had been denounced by Rothko as "parasites," their adulatory critiques over the years had made his reputation worldwide and increased the demand for his work. As with collectors and dealers, the line between a critic, an historian, a curator, and a collector is thin—often nonexistent. Dore Ashton, Thomas B. Hess, Max Kozloff, Irving Sandler, Brian O'Doherty, Katharine Kuh (also a devoted friend of the Rothko family), and painter Elaine de Kooning, former wife of the artist, were among those present.

Even more numerous were the dealers—the merchants of art, the promoters and appraisers of potential values. Among them was Betty Parsons, now seventy, whose early encouragement had meant much to Rothko and whose gallery in the postwar dark ages had been one of the few showcases for living American artists. Representing the new merchandisers were two polished young salesmen–vice-presidents from the Marlborough Galleries, Donald McKinney and David McKee. Their presence made obvious the one notable but, under the circumstances, unnoticed, absence: their employer and Rothko's dealer, Francis K. Lloyd, a kingpin of the international art market for the previous decade. Lloyd had taken in the auction but had left that day for London, for reasons presumably connected with the supervision of his mighty art empire.

Unseen in the adjoining antechamber, Mell Rothko sat with Christopher, Kate, and a handful of relatives. Rothko's two elder brothers, Albert and Moise Roth, had flown in from the West Coast, and Rothko's nephew Kenneth Rabin had come with his wife from Washington.

Sobs and whispers subsided into silence as poet Stanley Kunitz rose and delivered the first eulogy. He conjured up a warm vision of his friend Rothko ten years earlier

> wearing his battered black fedora perched high on the glistening dome of his forehead . . . his nearsighted eyes behind the thick glasses are liquid with patriarchal affection and solicitude. His mouth is sensuous, quick to tremble with feeling. "Tovarich," he cries, with a huge embrace that locks me in, snug against his

baronial frame; safe from everything fretful, anxious, invidious; blessed at least for a moment in the religion of friendship, one of our better faiths. . . . Once I told him that he was the last rabbi of Western Art. And that made him smile, which was a relief, since one could never be quite certain when his face would darken. . . .

Kunitz finished with a poem of his about slain heroes, but first he paid tribute to Rothko as

one of the fathers of twentieth-century American painting, whose posterity is already visible on the walls of every museum of contemporary art. Others could and still do produce paintings that resemble his, but Mark's transcendental quality, his effect of a pulsing spiritual life, of an imminent epiphany, was a secret he did not share with others and maybe only partly understood himself. . . . So much of Rothko remains—in a multiplicity of glowing presences, in a glory of transformations. Not all the world's corruption washes his colors away.

Then artist Herbert Ferber rose to say a few words about his friendship with Rothko. The funeral ended with the Kaddish intoned by Rothko's brothers.

Before dispersing, the mourners milled about on the sidewalk. With the façade of the south wing of the Metropolitan Museum of Art in the background, they nodded and embraced, in muted tones exchanged greetings, chatted, or grimly discussed the tragedy. Except for the swollen eyelids and soggy handkerchiefs, it could have passed for an important opening at an art gallery. The scattered minks and sables, tailored dark suits, fur collars and muffs stood out against the waning February sunlight. Many of the mourners had participated in the gala spectacular at Parke Bernet. One onlooker even had the indelicacy to write to a friend that the Rothko funeral was "the best vernissage of the season."

Limousines pulled up and carried away the more affluent. Others drifted off singly or in groups, many to nearby coffee shops and bars, feeling the need for companionship after the anguish of the occasion. With a few close friends, the Rothko family went ten blocks uptown to the home of anthropologist Morton Levine, who, with his young wife, Anne Marie, had helped Mell with the funeral arrangements

7

and had scheduled at their home a quiet "wake" to ease the family's grief and loneliness. But Professor Levine himself would arrive somewhat late for the sad affair: he had work to do.

Under Rothko's will, Levine and two other trusted companions of the artist's last years, Stamos and Bernard J. Reis, a seventy-five-year-old accountant, were designated executors of his estate. It was Reis who had drawn up Rothko's will a year and a half earlier, and it was at his request that the other two remained at the funeral parlor to transact estate business.

With characteristic urbanity and affected English accent, Reis introduced Levine and Stamos to the lawyers he had hired to represent the estate, his longtime client Frank E. Karelsen, Sr., a dapper seventy-eight-year-old with a bristling white mustache, and Karelsen's bland young partner, Ernest Bial. The two lawyers had sat patiently through the funeral. Their mission was to obtain the signatures of the three executors so that the will could be probated. Such dispatch, Reis said, was essential to protect the large inventory of paintings Rothko had accumulated. Later Karelsen would remember that Reis said that he had chosen Karelsen as attorney because he was such a "tough negotiator." But no mention was made then as to why this attribute might come in handy.

The three executors signed the probate documents and thereby took the first small step toward what would become the art scandal of the century. Within three months the artistic remains of Mark Rothko would be secretly signed, sealed, and delivered to Francis K. Lloyd and the world of commerce. Much later, when the details of these dealings became known, the subsequent lawsuit would drag on in and out of the courts and press for years. Its hallmarks—legal legerdemain, camouflages and coverups, destruction of incriminating evidence, creative accountings, the laundering of records, funds, and paintings—would more than once cause the case to be dubbed in the press "the art world's own little Watergate." It would become a nightmare to those involved, including many present at Rothko's funeral, and would ruin lives and reputations, end longtime friendships, and realign business and social allegiances. In one case it would be cited as a factor in serious illness. Finally, measured in financial terms, the Rothko case would cost millions of dollars, a good portion in legal fees.

In the events of those three cold February days—the brutal death of the painter, the jackpot bonanza at Sotheby Parke Bernet, and the

funeral—were intimations of what was to follow. Moreover, they were revealing as scenes from the ongoing saga of what happens to art after business takes charge. The saga did not begin, nor did it end with the death of one of America's foremost artists.

Exactly what happened to Rothko's legacy of art after his funeral will be detailed later, but first Hedda Sterne's question demands an answer: "Who was this man Mark Rothko who killed my friend?" And left such havoc behind.

# 2 The Struggle

(1903–45)

Do immigrants beat us at the artistic game?

Maxwell Anderson

At the turn of the century, the world's largest ghetto was the Russian Pale of Settlement, the vast border area which extends south from the Baltic to the Black Sea, into which nearly five million Jews had been herded by edict of the czar. In the northeast part of the Pale, in that region which would become Latvia and later the Latvian S.S.R., was the province of Vitebsk, heavily forested flat land known for the severity of its long winters. Dvinsk, its largest city, had once been a desolate outpost of the Cossack army.

There Marcus Rothkovich was born on September 25, 1903, the youngest child of Jacob Rothkovich, a well-to-do pharmacist, and his wife, Anna Goldin Rothkovich. From the age difference between Marcus and his siblings, it is probable that his arrival was unplanned. His sister, Sonya, was fourteen years old, his brothers, Moise and Albert, eleven and eight respectively, and his parents were no longer young. The family was not religious, but after Marcus's birth, his

10

father for some reason returned to the synagogue. While the older children had been sent to public schools under the Jewish quota, Marcus received a strict religious upbringing. He attended *cheder*, the classroom attached to the synagogue, where he learned Hebrew and studied the Scriptures and commentaries as set forth in the Talmud. At home, the family spoke Russian and Yiddish, and there, as well as in school, emphasis was placed on the intellect; his sister recalls that the family library contained some 300 books.

Though Dvinsk was spared the pogroms, alarms and threats were frequent, as were rape and rampage by the soldiers. Between 1902 and 1906, thousands of Jews in other cities of the Pale were slaughtered in pogroms, violent mass attacks instigated by the czarist government. Photographs of the trenches which served as mass graves must have left an imprint on the memory of young Marcus.

Those who could fled westward; and the Rothkoviches were part of that influx of some two million Russian-Jewish refugees who managed to escape and emigrate to America between 1881 and 1914. In 1910, preparing for the emigration of his family, Jacob Rothkovich arrived on Ellis Island, where he took the Polish version of the family name, Rothkowitz; then traveled to Portland, Oregon, the home of his brother Samuel Weinstein, who had emigrated years before and was by this time well-established in the men's clothing business. (Samuel had for some reason taken his brother-in-law's family name when they went into business together.)

In 1911, through the underground, Jacob arranged the escape of his two older sons, who faced a general conscription in the czarist army. Two years later, he sent passage money for his wife, Sonya, and ten-year-old Marcus. They sailed from the port of Libau aboard the S.S. *Czar* in the relative luxury of second-class cabins, and after twelve days were greeted by New York's mid-August heat. They spent ten days with Weinstein cousins in New Haven, then boarded the transcontinental train that would take them part of the way to Portland; during the week-long journey, they wore tags indicating they spoke no English.

Portland in 1913 was a rough-and-ready lumber town flourishing at the junction of the Willamette and Columbia rivers. Springing out of the Gold Rush, it had only been incorporated as a city sixty years earlier, and its population had sprouted from 90,000 in 1900 to 207,000 in 1910. Except for the immense difficulties of language, the reunited Russian family was scarcely more rootless than much of the

rest of the population. Seven months later, however, the Rothkowitzes suddenly saw their hopes disintegrate. Jacob died unexpectedly, leaving his widow to hold the family together and the children to help in their support. Sonya, with a degree in dentistry, could find work only as a cashier, and Albert and Moise were employed by their wealthier Weinstein cousins until they could speak English well enough to pass the examinations in pharmacy. Marcus was enrolled in public school, but before and after classes worked as a delivery boy and also hawked papers in downtown Portland: in those days, boys bought the *Oregonian* and the *Telegram* from wholesalers for a penny a copy, and peddled them for three cents each. Later Marcus had a paper route in the predominantly Jewish neighborhood on the south side, where the family lived in a modest two-story frame house. The adult Rothko complained that he had never had time for childhood's carefree pastimes, that he had never learned how to play.

His brother Albert remembered that even as a boy Marcus was tense and sensitive. He was also perpetually ravenous, developing an appetite that continued throughout his life. Bitterly he would recall that during his childhood he had never had enough to eat. Nevertheless, he grew to a height of five feet eleven inches, the giant of the slight, diminutive family. Unlike the others, he was hefty, with a barrel chest, a large cranium, and big beautiful hands. He was not handsome by most standards, but as he matured, his physically powerful presence and resonant voice gave him an arresting attractiveness. His broad, high forehead and wide jawbones set off a smooth sensuous mouth, and behind his thick glasses, he had deep-set, penetrating, and intensely myopic brown eyes.

Marcus became fluent enough in his adopted language to complete Lincoln High School in three years, at the age of seventeen; as he told a local reporter after graduation, school had been "ridiculously easy." In addition, he had won a small reputation at the neighborhood Jewish settlement house as a debater and defender of labor and radical causes, and had hopes of becoming a labor organizer. His family had closely followed and applauded the Russian revolution, and Marcus admired the battles of Emma Goldman and the Industrial Workers of the World to unionize industry.

In the fall of 1921, he packed his few belongings and with two classmates, Harry Director and Max Naimark, went east to Yale (the alma mater of several of his more affluent New Haven Weinstein cousins), where all three had been promised scholarships.

There Rothkowitz shared a rented attic in a doctor's house in the Jewish section of the city. Though he was able to cadge many of his meals from his aunt, he later recalled that he had waited on tables to earn pocket money, an experience which must have included embittering humiliations. The clumsy, rawboned Jewish immigrant from Portland, with his exotic name, clothes, and accent, must have been an object of some derision for those bourgeois young gentlemen in white bucks and figured ties upon whom he waited. Later, with a rueful smile, he would only say that his spillage as a waiter was so ruinous that when he switched jobs, it was only natural that he should become a delivery boy for a cleaning establishment. The laundry belonged to the Weinsteins, who remember Rothko's first artistic endeavors as throwaway drawings on the packaging.

In the swinging postwar twenties, Yale and Princeton were the most elitist of the Ivy League colleges. Yale operated on a covert anti-Semitic quota system. Ninety percent of the student body were WASPs, and many had come from fashionable private or boarding schools in the East. While the smaller, more affluent influx of German Jews had been assimilated earlier with relative ease, the anti-Semitism of faculty and trustees became entrenched against the hordes of impoverished Eastern European Jews clamoring for a higher education. It was never openly acknowledged, of course, but recently uncovered memoranda from those days between the president and a faculty member discuss the "acute evil" of rising Jewish enrollment. There was no Jew on the regular faculty at Yale until 1943, no tenure granted a Jew until 1947, and not until 1965 was a Jew elected to the board of trustees.

For the undergraduate the same social stigmas prevailed. Jews were not elected to eating clubs, drinking clubs, fraternities, or secret societies. Nor were they asked to join the *Yale Daily News*: if they applied and were rejected as was columnist Max Lerner of the Class of 1924, they often believed that their writing was simply not good enough.

Whether the reasons were financial or social, after six months Rothkowitz and his two Jewish classmates from Portland were told that their scholarships had been withdrawn. The university would lend them tuition, but they must repay it when they could. The three men were dunned over the next decade, and when Yale caught up with Rothkowitz years later in New York, he offered them paintings in lieu of money. They were refused.

Rothkowitz's Yale friends remember him as a voracious reader, an

13

outspoken, "no-nonsense guy" who was deeply involved in contemporary political affairs. His cousins remember passionate discussions of music and Italian primitive art. Though he intended to become an engineer, he studied not only sciences, but European history and French, branching out in his sophomore year into economics, biology, philosophy, and psychology. Throughout his college career, he maintained a respectable academic record of B's and C's.

In his sophomore year, he was known as something of a rebel. For a few months, he and two friends published a weekly newspaper, *Saturday Night Pest,* in which they protested such old-line Yale rules as compulsory daily attendance at ecumenical chapel. After two years Rothkowitz decided rebellion was not worth the trouble—Yale's bulldog was so much bull—and in 1923 dropped out "to wander around, bum about, starve a bit." Though Yale's records do not confirm the story, Rothko later said he was so fed up with college that on his sophomore final examinations his written reply to every question was "I don't know and I don't give a shit." But whatever discomforts he experienced at Yale, forty-six years later the university would award him an honorary degree.

A clue to his difficulties then and afterward can be found in the yearbook of the Class of 1925. Unlike his classmates, who described Yale experiences, honors, and awards for athletic prowess, Marcus Rothkowitz listed members of his family who had graduated from college, whether in Vilna, Warsaw, or New Haven. More revealingly, he noted the date of his father's death. Reading it, one can almost experience the extent of the son's loss.

Rothkowitz went straight to New York, whose teeming street life he he would never tire of exploring. During this period he called himself an anarchist and lived in various tenements, finding work wherever he could, laboring for a while in the garment district, where he cut patterns for clothes.

The theater was his first love, but if he made attempts at finding a job on Broadway, they came to nothing. Back in Portland, he had painted sets for a stock company, but acting was what he had most enjoyed. As he often recalled, Clark Gable was once his understudy which, despite Rothkowitz's elephantine movements, is not entirely unbelievable, since the artist had a presence and a sardonic humor marked by a natural sense of timing. He could be immensely charming when he chose to be, generally for pretty women.

One night he went to meet a friend enrolled in a life drawing class

14

and was dazzled by the reclining figure of the nude model. (At least this is the way he told the story.) With unbounded enthusiasm, he joined the class. Anatomy, however, was not his forte; he gave up nudes for classes in painting and still life. Whether or not the story was told merely to amuse, by January 1924, eight months after quitting college, he had enrolled at the Art Students League, sampling classes on a monthly basis over the next two years. Then as now, the league offered intensive but freely structured classes taught by established artists, and for Rothkowitz, by nature anti-authoritarian, it proved a natural haven. He plunged into painting, and, before leaving the league, studied for four months under Max Weber. The odd hours amassed at the league were the extent of his formal training, and Rothko always referred to himself as self-taught.

During the late twenties, Rothkowitz illustrated maps for books by Lewis Browne, a retired rabbi from Portland who made a fortune writing popularized histories of the migrations and deprivations of the Jews. "Animated" maps were an important feature of these works, and Browne employed Rothkowitz to embellish them with drawings of fish, dolphins, and ships. For one title, *The Graphic Bible*, he promised Rothkowitz a share of the royalty above the $600 he had paid him for the work—or so Rothkowitz believed. But when the book came out, only Browne's initials were on the illustrations. Angered, Rothkowitz sued Browne and his publisher, Macmillan, asking for $20,000 in damages and a share in the royalties. Four "so-called artists," as one newspaper put it, testified that they had seen Rothkowitz making the engravings.

After three months, the case was finally decided for Browne and Macmillan, who had employed a team of prominent lawyers headed by Arthur Garfield Hays. In mid-February 1929, one reporter wrote a summary of its unusual complexity: ten hearings had consumed 700 pages of testimony and had involved the participation of two judges, a referee to render the final decision, and three lawyers. In the opinion of the referee, Rothkowitz had not proved the existence of a contract even though he had clearly done much of the work. After this experience, Rothkowitz retained little respect for either the law or lawyers.

In 1929, Marcus Rothkowitz became a part-time teacher of arts at Center Academy in Brooklyn, a parochial school attached to a synagogue. He disliked teaching, but was forced to pursue it for another thirty years, even after he became famous. Though he had abandoned

formal religion when he immigrated, at Center Academy Rothkowitz performed the familiar rites.

During this time, on a holiday in the Catskills, Rothkowitz and artist friend Louis Harris met two attractive girls from Brooklyn. Like ingenues and juveniles in a musical comedy, both sets leaped into matrimony. Rothkowitz's wife, the former Edith Sacher, daughter of a Brooklyn upholsterer, was bright, pretty, and Jewish, but the marriage was a mismatch in terms of temperament. He was a melancholy romantic Russian consumed by the desire to be taken seriously as a painter. Mozart, Aeschylus, Shakespeare—what they were to music and drama, he believed he would be to painting. As friends recall, Edith was essentially pragmatic. She began to design silver jewelry, then went into business and made a financial success of it. She persuaded a reluctant Rothkowitz to do menial odd jobs, from designing jewelry to making deliveries. He could not forgive her for insisting that he so demean himself. Friends agree that she did not love him.

Disagreements between the Rothkowitzes centered on art. During the late twenties, Rothkowitz had become close to Milton Avery, who would have an important influence on his work, and Avery's wife, Sally. Once, after Rothkowitz had found a buyer for one of Avery's canvases, his friends, as a token of their thanks, wanted to give him a small painting. As Avery brought out his work, one by one, Edith made no secret of her contempt. As for the one which Marcus finally selected, she said, "I wouldn't hang it in my bathroom." Sally Avery remembers that Rothkowitz was suffused with embarrassment and anger.

For the artist, used to hard times, the Depression, though it meant leaner pickings, brought opportunities with both immediate and long-lasting rewards. In 1935, under the WPA, Roosevelt set up the Federal Art Project—the first acknowledgment by the government that artists and writers play important roles in American society. In 1933, Rothkowitz had had two solo exhibits in the Contemporary Arts Gallery in New York and in the Portland Art Museum, automatically qualifying him for employment by the Project. In 1935, he was hired in the easel-painting division of the Project and for two years earned $23.52 a week. What happened to the largely representational, misty interiors, and studies of brooding, attenuated figures he produced during this time is not known; presumably, like those by other artists, they

disappeared into schools, hospitals, and institutions throughout the federal bureaucracy.

While the Project existed, more than 100,000 paintings and murals and some 18,000 sculptures were created under its auspices. For New York artists, and there were about 2,000, the Project produced more than a paycheck and a reason for painting: it also fostered a new unity—an informal collective life. When, for one reason or another, individuals were given the "pink slip" that signified dismissals, the artists picketed and, once during a wholesale arrest, went to jail together. They formed organizations and exchanged ideas, philosophies, and skills.

During this time Rothkowitz met Willem de Kooning, Jackson Pollock, and Arshile Gorky and became close to Adolph Gottlieb. Nobody sold anything, but the Project had its own gallery which regularly exhibited artists' work, and large exhibitions were held by the Federation of Modern Painters and Sculptors. A free-wheeling group of dissident artists formed, calling itself the Ten. Determined to initiate searches for space and exhibit together, the group, which included Rothkowitz, Gottlieb, Joseph Solman, and Ilya Bolotowsky, spoke as revolutionary outcasts who despised the art establishment and the popular literal American painting. As the Whitney Dissenters, they published a broadside attacking that museum and the "symbol of the silo" in the nation's art. They were exhibited in the Gallery Secession (an informal artists' cooperative); the Montross Gallery; at Galerie Bonaparte in Paris; then, back in New York, at J. B. Neumann's New Art Circle, the Georgette Passedoit Gallery; and at the Mercury Gallery. While the exhibits of the Ten brought attention to and respect for the artists' courage, they brought no money.

Dorothy Miller and Alfred Barr of the fledgling Museum of Modern Art visited the Federation of Modern Painters and Sculptors exhibits together, looking for promising artists. At the front door they would separate, so as not to influence each other, and later compare notes; invariably Marcus Rothkowitz was among the artists on both lists.

In 1939, streams of refugees poured into New York, and, with the fall of Paris in 1940, Manhattan became the adopted cultural capital of the world, a temporary refuge for many celebrated artists, writers, and musicians. Among the exiles were Mondrian, Matta, Duchamp,

# THE LEGACY OF MARK ROTHKO

Léger, Masson, Tanguy, Chagall, and Breton, and for New York artists there was still much to be learned firsthand from these seasoned European originals. Expatriate Peggy Guggenheim returned with her husband, Max Ernst, to re-form her brilliant salon, opening a witty and innovative gallery named Art of This Century.

Having obtained his citizenship papers in 1938, in the early 1940s Marcus Rothkowitz dropped the last syllable of his surname. He also abandoned the dreamlike urban landscapes, the subway interiors, and plunged into a new genre, using idealized Greek gods and goddesses and archaic symbols as themes for calligraphic abstractions. It was as if by shortening his name, he were free to simplify and move further away from realism. The quality of the work of this period is uneven, but already he demonstrated a mastery of strong brushwork and a subtle sense of contrasting light and color.

In 1943, enraged by a review of their paintings exhibited in the annual Federation of Modern Painters and Sculptors Show, Marcus Rothko and Adolph Gottlieb jointly signed a letter to Edward Alden Jewell, art critic of the *New York Times*. First, they took a few jabs at Jewell who had expressed "befuddlement" over their work; then, though they refused to explain their paintings, they maintained that their expressionistic interpretations of the Syrian Bull and the Rape of Persephone had as much significance today as in art of 3,000 years ago. "Their explanation must come out of a consummated experience between the picture and the onlooker." A five-point aesthetic manifesto followed:

1. To us art is an adventure into an unknown world, which can be explored only by those willing to take the risks.
2. This world of the imagination is fancy-free and violently opposed to common sense.
3. It is our function as artists to make the spectator see the world our way—not his way.
4. We favor the simple expression of the complex thought. We are for the large shape because it has the impact of the unequivocal. We wish to reassert the picture plane. We are for flat forms because they destroy illusion and reveal truth.
5. It is a widely accepted notion among painters that it does not matter what one paints as long as it is well painted. This is the essence of academicism. There is no such thing as good painting about nothing. We assert the subject is crucial and

only that subject is valid which is tragic and timeless. That is why we profess spiritual kinship with primitive and archaic art.

In those days, Rothko lived in a tiny walk-up in the West Fifties near the Museum of Modern Art. One day Alfred Barr and Dorothy Miller dropped by and asked to see the representational paintings of city scenes they had liked. He refused, saying he no longer had them. Again he had changed his artistic identity, dropping a syllable of his first name to sign his new surrealist canvases "Mark Rothko." The shapes in his paintings were reduced to clearly meaningful symbols that seem to dissolve into a fluid background.

During the war, the Rothkos' unhappy marriage ended, and as a settlement, Edith took a number of Rothko's paintings. "Marriage is an impossible situation for an artist to engage in," he declared. But in late 1944, he was introduced by a friend, photographer Aaron Siskind, to Mary Alice Beistle, a pretty, vivacious twenty-three-year-old illustrator of children's books. Small and thin, with dark eyes and dark braids wound around her head, "Mell" was a recent Skidmore graduate and a WASP descended from Abraham Lincoln. For her, this starving middle-aged Russian-Jewish painter was anything but suitable. But when she first came to New York from Cleveland, Mell had told friends that she "always wanted to marry an artist." Despite their disparate ages and backgrounds, they fell in love and were married within six months—on March 31, 1945, in Linden, New Jersey.

Nineteen forty-five was a year filled with promise for Rothko. In January, Peggy Guggenheim had mounted his first important one-man show at Art of This Century; few of the paintings sold, but it was a succès d'estime. Prices for the "seascapes" ranged from $150 to $750. In the spring, a second show, of Rothko's beautiful watercolors, priced from $150 to $250, was held by Betty Parsons in Mortimer Brandt's gallery. (Rothko loved painting watercolors; toward the end of his life he would say wistfully, "I could have been a great watercolorist, you know.")

The Art of This Century exposure, his first real break, had not been without disappointments. Though later reviewed in *Art News*, the art columns in the Saturday newspapers did not cover it. Swallowing and no doubt choking on his pride, he typed a letter to Emily Genauer of the *New York World-Telegram*. He was, he wrote, "keenly dis-

appointed" not to read her opinion of his work. He added that if Miss Genauer would review it some subsequent Saturday, it would make him very happy. Still no review appeared.

But undaunted by such minor reverses, he was readying himself for explorations into new realms of art. He would impress Emily Genauer—with more than his nerve.

# 3 The Triumph

(1945–55)

> For me the great achievements of the centuries in which
> the artist accepted the probable and familiar as his sub-
> jects were the pictures of the single human figure—alone
> in a moment of utter immobility. . . . I do not believe
> that there was ever a question of being abstract or repre-
> sentational. It is merely a matter of ending this silence
> and solitude, of breathing and stretching one's arms
> again.
>
> Mark Rothko
> "The Romantics Were Prompted"

In postwar New York, the art scene was uncomplicated, intimate,
and localized. The camaraderie among artists, seeded in the WPA, had
been nourished through the war (few of them actually fought) and
flourished into an even more generous communality. Most of the
European grand masters, the wartime exiles, had returned to their
homelands. The New Yorkers had steeped themselves in the work
of these artists and had been awed by their presence, but few were sorry

21

to see them depart. At last it was possible to see clearly their own accomplishments and goals.

From their cockroach-ridden lofts and coldwater studios, they would rally together in the evenings to drink, talk, and party. The solitude of the act of creation made vital the shared sociability of nights. At their studios, the Cedar Street Bar, or the Waldorf Cafeteria in Greenwich Village, they would swap ideas, techniques, jokes, and gossip. Though money and art were dominant themes, no one dreamed that his art might bring money. In those days they talked of where to find inexpensive cotton duck for canvases, rent-controlled space, or where they could feed two for a buck. They discussed Blake's transcendentalism, Matisse and *The Red Studio*, and Albert Pinkham Ryder. Or philosophy—the writings of Nietzsche, Kierkegaard, Sartre, and Camus. Their healthy anger continued to knit the circle tightly together. They reminded each other that—unlike Europe, where art was traditionally a highly respected discipline—in America the artist was not part of society but of the great unwashed. They chose to be uncouth.

As some saw it, these New York artists could be lumped into two groups: "uptown" and "downtown." The downtowners were not only identifiable by location, but by their conviviality and enthusiasm. Often they could be found at various jazz joints, boozing heavily, illustrating points with napkins, glasses, salt and pepper shakers, whatever was at hand. In the forefront of this group was Jackson Pollock, already experimenting with action-painting; whether for his work or his alternating roles as drunken paranoid lion and tender sober lamb, he was already becoming a myth. Another, Franz Kline, genial and unassuming, would draw on placemats or a telephone book, and took endless delight in benches, billboards, and other furniture of the city. The group also included Ad Reinhardt, the mocking, embittered newspaper cartoonist, and the learned, tempestuous, and amorous Dutchman Willem de Kooning, then a sign painter.

The uptown crowd lived more conventionally; their friendships and gesticulations were more restrained. Their talk tended to be wordier, their allusions more high-flown, philosophic, and theoretical. They seemed more absorbed with the whys of art, while the downtowners were preoccupied with the more immediate hows. Among them was Robert Motherwell, a decade younger than most of the others, and a shade too literate and Ivy League for some of them.

Another, bushy-mustached Barnett Newman, was an authoritative writer and at that time the group's unofficial interpreter; he even bestowed poetic titles on his friends' paintings. Of Adolph Gottlieb, who looked more like a cloak-and-suiter than a hungry artist, it was said that he had family money behind him. Finally, in the uptown crowd, was Mark Rothko, already balding, sporting a small mustache, the intense expression behind his glasses the only outward clue to the passion he described as "an insatiable appetite for ubiquitous experience."

On the Street, which was then contained in a mere two blocks along Fifty-seventh Street near Fifth Avenue, only a handful of galleries exhibited contemporary art. In 1946, when Betty Parsons opened her gallery, she signed three painters whom her friend Peggy Guggenheim had exhibited at Art of This Century: Jackson Pollock, Mark Rothko, and Clyfford Still, an innovative and temperamental loner then teaching in San Francisco. Her gallery was friendly and informal almost to the point of unprofessionalism. An affectionate, high-strung former socialite, Betty Parsons was herself a painter and by no means a hardheaded businesswoman. Contracts were based on one's word; it was goodwill that counted. "We were skating on thin ice," remembers Miss Parsons, "and every time we were about to fall through, we would hope to sell another painting." Records of sales were hit-or-miss, often scribbled on backs of envelopes. Poorly typed simple contracts guaranteed the gallery a one-third commission and fifteen percent of what was sold from the studio, in return for which the artist was exhibited yearly. But the prices were only in three figures, and the holes in the ice were visible much of the time.

In the summer of 1946, both the San Francisco Museum of Art and the Santa Barbara Museum of Art mounted exhibits of Rothko's surrealistic seascapes, and the Rothkos went west for a visit. From San Francisco, he wrote ecstatic boyish letters to Miss Parsons. The museum was considering the purchase of a watercolor, *Tentacles of Memory*, for $150. His large oil (*Slow Swirl by the Edge of the Sea*, a 6'3" by 7'1/2" canvas painted in 1944 during the Rothko courtship and thus of great sentimental significance to the Rothkos) had a "beautiful hanging in the rotunda of the museum. . . . I cannot describe the adulation I have received from the artists in San Francisco." That summer and the next, when he taught at the California School of Fine Arts, he became fascinated with the work of Clyfford Still, who was venturing into "new

23

and beautiful" abstractions, as Rothko wrote. "Still's show has left breathless both my students and everyone else I have met."

Back in New York, in the fall of 1947, he embarked on the great adventure of his life. His surrealistic abstractions gave way to explorations of new realms of space and color. The forms in the foreground disappeared as if flattened into misty patches of color suspended in space. Other artists in the group were also experimenting, and the excitement of one fired the imagination of another. A new language evolved, an American revolution in art: total abstraction. Recognizable shapes, frames, perspective, lines—all the old vocabulary—exploded into flat chromatic schemes of color and light. House and car paints and brushes and sponges, joined traditional media and tools. Gigantic canvases were used to create a new "intimacy," as Rothko saw it, bringing the viewer (audience) into an immediate relationship with canvas (drama). The first important movement to emanate from America, it would be known as the New York School of Abstract Expressionism.

Each of the two dozen artists who charted the course was committed totally to abstraction, but their approaches varied. With Pollock and de Kooning as navigators, some glorified the spontaneity of the act of art, the "gesture" itself. Drips, splotches, dramatic swirls seemed to regenerate their canvases. Critic Harold Rosenberg later would coin the term *action-painting* to describe the excitement of these works. Those who sought more controlled emotional effects from color and light emulated Matisse, simplifying, discarding unnecessary line and detail for dramatic emphasis. Clyfford Still, Mark Rothko, and, later, more in the hard-edged geometric genre of Mondrian, Barnett Newman would become known as innovators of color field painting. For Rothko, these experiments in space and color were a natural outgrowth of his misty backgrounds of his surrealistic scenes. Gradually the several varied shapes would be reduced to the well-known floating rectangles, a theme that would allow him endless experimentation in contrasts and balancing of relationships between color and scale. From this time he stopped titling his paintings. With one exception they would be identified only by number and year.

A forum to air their ideas, arguments, and discoveries was established. With Motherwell, Still, sculptor David Hare, and William Baziotes, Rothko gave $200 to start *Subjects of the Artists*, an art school on Eighth Street. Friday evenings were devoted to guest lec-

24

tures or feisty debates calculated to attract attention. The school closed after one term but led to the formation of Studio 35, which became the Club, where meetings were more social and loosely knit. Friday nights were still devoted to avant-garde debate, and such poets as Barbara Guest, Kenneth Koch, and Frank O'Hara became integral parts of these evenings. To further their vision, two periodicals were started: in 1947, Motherwell and Harold Rosenberg began publishing *Tiger's Eye*, followed by *Possibilities*, under Newman's editorship.

A fledgling member of the group in those days was Theodoros Stamos, who also joined Betty Parsons's gallery. Seventeen years younger than Rothko, considerably less articulate than any of the others, and entirely self-taught, Stamos was considered a prodigy. He became close to the Rothkos, who treated him affectionately, "like a kind of mascot," Miss Parsons remembers.

Though Rothko had sold paintings to the Whitney, as well as to the San Francisco and Brooklyn museums, he refused to exhibit in the Whitney Annual of 1947 because he did not want to be shown next to "mediocrity." His yearly exhibits at the Parsons gallery became increasingly dramatic, though few paintings sold. At Rothko's 1949 exhibit there, Thomas Hess was struck by the "abstractions of flat thin colored areas that float like clouds over large canvases. At first the paintings seem to work by color alone—wild contrasts of green, orange, yellow, and scarlet create a savage rhetorical impact. But under this extremely emotional level is a strength of composition which is almost Oriental in its reticence." Others were aghast at the absence of content: "The famous 'pot of paint flung at the canvas' would apply here with a nicety," wrote one reviewer, alluding to Ruskin on Whistler.

No matter that his new paintings attracted notice; that year Rothko sold only a few small earlier paintings for a total income of $3,935, including his teaching salary. After deducting costs of materials, his net income was only $1,386.65. The Rothkos were able to survive through Mell's resourcefulness in cadging and stretching small quantities of food, secondhand clothes and furnishings. At that time, however, Rothko was proud of poverty to the point of martyrdom: "The unfriendliness of society to his activity is difficult for the artist to accept. Yet this very hostility can act as a lever for true liberation. Freed from a false sense of security and community, the artist can abandon his plastic bankbook, just as he had abandoned other forms of security. . . . Free of them, transcendental experiences become possible."

# THE LEGACY OF MARK ROTHKO

After their marriage the Rothkos had moved to an apartment where bedroom, kitchen, and studio were so compactly arranged that to show a painting Rothko had to back out with it into the hallway. Other artists, particularly Gottlieb, mocked his continued proximity to the Museum of Modern Art and accused him of seeking favors by rubbing shoulders with the director, Alfred Barr. In fact, when they could afford it, the Rothkos did lunch at the Valmor, a neighborhood bistro where Barr and Dorothy Miller also ate. It was not uncommon to see the two couples join forces on occasion and share a table.

The 1950 Rothko exhibit at Parsons was a smash. "This talented New Yorker's most brilliant show to date," wrote Hess, "and proves him to be one of the most gifted manipulators of color today." Other enthusiastic reviews appeared. Mrs. John D. Rockefeller III chose a $1,000 Rothko for the small but spectacular guest house that Philip Johnson was designing for her; Jeanne Reynal bought another for $1,250; and four others sold at prices ranging from $500 to $800.

Alfred Barr wanted a Rothko for the Museum of Modern Art but knew that the acquisitions committee was too hidebound to acquiesce in such a revolutionary purchase. He chose a $1,250 canvas and asked architect and trustee Philip Johnson to buy the painting and donate it to the museum. "Alfred Barr did not believe the trustees would dare reject it if I gave it," Johnson recalls. Nevertheless, the painting caused a flap when it came before the committee. "The trustees hid it in the closet for two years," says Betty Parsons. When in 1952 they finally voted to accept it, A. Conger Goodyear, one of the museum's founders, resigned in disgust.

In the spring of 1950, the Rothkos left New York for their first tour of Europe. Both of their mothers had died within the year, and the trip promised an antidote to grief. A small inheritance Mell had received helped pay their way. Though England, France, and Italy were still suffering from war shortages and their bombed cities had not yet been rebuilt, the Rothkos were dazzled by the pleasures of travel and the glories of the art and architecture of the Old World. The trip had another lasting benefit: on it they conceived a child. "We went to Europe two and came back three," Rothko was fond of saying.

That year Betty Parsons generously gave Rothko an advance; his income had not amounted to enough to pay taxes. Two days before the new year, an additional deduction arrived: a baby girl, Kathy Lynn.

Later the child was called Kate, the American name taken by Rothko's mother. On occasion, Rothko could be seen promenading about the streets pushing a carriage, surprising acquaintances who knew him as a night prowler of the neighborhood, one who seldom left the studio during the day.

In those years the marriage was happy. In contrast to her practical midwestern background, Mell adored Rothko's Russian moodiness and Yiddish cynicism. Rothko enjoyed morbidity, and on bleak fall and winter days would announce that he was nourishing his "slavic predilections." His genius also preoccupied Mell. In the presence of others she referred to him as Rothko and, among a few intimates, Mark, but only in the most private of circumstances he became her pet "Bunchy."

To support his enlarged family, Rothko gave up his part-time job at Center Academy and took a higher salaried ($5,190) professorial position at Brooklyn College. But he was neither accomplished nor interested in faculty politics, and was violently opposed to the "Bauhaus philosophy," which, as he saw it, was espoused by other members of the faculty. "It has filled our cultural vernacular," he wrote, "with false and facile chatter."

As an artist he was determined to maintain his opposition to materialism, and the fate of his paintings preoccupied him. He once told a friend, "They are like my children, I cannot send them away." In 1949, he wrote what would become a kind of epitaph. Reprinted over the next thirty years, the statement would haunt him for the rest of his life and certain owners of his paintings long after he died.

A picture lives by companionship, expanding and quickening in the eyes of the observer. It dies by the same token. It is therefore a risky act to send it out into the world. How often it must be permanently impaired by the eyes of the unfeeling and the cruelty of the impotent who would extend their affliction universally.

For many years, he attempted to live by these lofty principles in the face of obvious problems of day-to-day survival. With Clyfford Still he remained adamant against the Whitney annuals and in 1952 refused to sell two paintings to the museum, which he privately referred to as a "junkshop." Paraphrasing his earlier statement, he wrote to Whitney director Lloyd Goodrich:

Since I have a deep sense of responsibility for the life my pictures will lead out in the world, I will accept with gratitude any form of their exposition where their life and meaning can be maintained and avoid all occasions where I feel that this cannot be done. . . . At least in my life I must maintain a congruity between my actions and my convictions if I am to continue to function and do my work.

Five years later, he would again stress this position to Goodrich, adding, "I must act accordingly in the interest of the paintings which I still hope to paint."

Nevertheless, both Rothko and Still agreed to let Dorothy Miller show their works as part of the "15 Americans" exhibit at MOMA in 1952, in which each would have his own room. Rothko's new studio was in the West Forties, in a stained-glass factory, and when Miss Miller went over to make a selection, the artist was charming and acquiescent. But when the paintings arrived at the museum, she found "a different bunch of pictures." Of the fifteen egoists, it had not been Rothko whom she had expected to cause trouble. Still and Pollock, perhaps, but they, surprisingly, behaved "like angels."

Still was given first choice of space and naturally chose the largest room at the end of the gallery. Rothko's preceded his and was adjacent. Faced with the large wall at the end, Still told Dorothy Miller the painting he wanted for that space. He had created a huge textured black painting with streaks of red and white, which he later introduced to her as his "great big black bastard." Miss Miller agreed that it was a marvelous finale to the exhibit, and they arranged the Still room around it, working late into the night. When she arrived at the museum the next day, the room had been rehung. Still explained that Rothko had not liked the arrangement and he and Still had spent the morning rehanging everything; clearly it was the power of the "big black bastard" that Rothko had wanted to diffuse. She persuaded Still to help her rehang the paintings in their original positions.

Rothko insisted on hanging his own room. He also demanded (contrary to his later attitude toward lighting) that his room be given a bright spotlight. That, Miss Miller told him, would harm not only his work, but everyone else's as well. He gave in, but hung the paintings too close together. René d'Harnoncourt, who had replaced Barr as MOMA's director, and whom Rothko also respected, was dispatched

to the studio to reason with him. Rothko agreed to the spacing but the several paintings slipped in without Dorothy Miller's approval remained on the walls.

The critics, for the most part, were enthralled by the exhibit, but the public was not yet ready for Rothko and Still, having only just grown accustomed to Pollock's originality.

The museum had planned to send "15 Americans" on a tour of Europe, but since Rothko and Still refused to allow their works to travel abroad where placement could not be supervised by them, the plans were cancelled.

Despite Rothko's contrariness, the exhibit meant much to him, and after it closed he was elated. As he wrote artist friend Herbert Ferber that August, having visited MOMA: "My room is now occupied by Marin and O'Keefe [sic]. I must admit that the afterglow remaining from my own stuff made these quite invisible to me at least. . . . The weather here is heavenly and one walks about in the sun and breeze really feeling like a million bucks."

But the glow was soon eclipsed by dissension among the artists. Jealousies, rumors—some fanned by favoritism among critics and new-found acolytes—caused factionalism. "They began contesting each other's prerogatives," says Sam Hunter, the art historian and professor who became director of the Jewish Museum. "Thoughts of enshrinement had entered their heads. It was a question of who would be bishop, who would be Pope."

Barnett Newman had become both pugnacious and defensive after his first show at Parsons in 1950. He thought that his fellow artists, including Rothko, did not take his relatively late-blooming artistic talents seriously. When Ad Reinhardt listed him with Motherwell and others as "a traveling design salesman" and an "avant-garde huckster," Newman sued him and later threatened to sue the Jewish Museum, which was planning a Reinhardt retrospective. Praise for Newman's work by critics Harold Rosenberg and Clement Greenberg only aggravated the situation, and Rothko and Newman fought, perhaps partially because Rothko boasted that he had "taught Barney how to paint." They stopped speaking, a break which caused Rothko some anguish: "How I miss Barney," he would say a decade later.

A succession of minor incidents contributed to the fragmentation of the group. One such incident occurred in Pollock's studio in 1952, when he was painting the enormous *Blue Poles*. Filled with enthusiasm, he

invited Rothko and Newman to his studio to see it. "Isn't it the greatest?" he asked. There was a moment's silence. "Don't forget we are all painters," replied Rothko.

In 1954, Rothko was given two important one-man shows, the first at the Rhode Island School of Design and the second, arranged by curator Katharine Kuh, at the Art Institute in Chicago. One of the paintings looked so radiant on the Institute's walls that the museum purchased it for $4,000 for their permanent collection. That same year, when art dealer Sidney Janis, formerly a businessman, added Rothko, Pollock, and Kline to his stable, it meant that they had arrived. Yet even with his take-home pay from Brooklyn College supplementing his sales, Rothko's income amounted to only $2,433, approximately the amount Janis was asking for one Rothko. Betty Parsons remembers he had to borrow $500 from her that year.

Rothko's reliance on Brooklyn College for a meager income came to a stormy conclusion that spring, when the "Bauhaus" faculty committee denied him tenure because they found him "too inflexible." He had been asked to add vocational courses such as advertising, textile design, and applied arts to the fine arts courses he was already teaching. He appealed the committee's decision, and at the faculty meeting to reconsider his tenure, expounded his iconoclasm. Certain excerpts from his notes reconstructing the meeting read like a Socratic dialogue on art and morality:

Q: You are not flexible enough. Could you teach advertising?
ROTHKO: In an extreme emergency, I may use advertising as a lever for my point of view, but there is no reason for the necessity to arise.
Q: Why are you willing to work in a department devoted to an antagonistic philosophy?
ROTHKO: That is the history of every artist's life. If we awaited for [sic] sympathetic environments, our visions which are new would never have to be invented and our convictions never spoken. . . . Harmony based on substantial agreement with the Bauhaus philosophy would be a perversion. . . .
Q: A department is like a team. One assigns bases and duties must be carried out for it to run smoothly.
ROTHKO: What kind of a team? My idea of a school is Plato's

academy, where a man learns by conversing with men of consequence.

Q: Have you been able to continue your professional activities, paint and have exhibitions since you have taught here?

ROTHKO: Yes, it is a matter of public record.

Q: If you obtain tenure, would you remain teaching?

ROTHKO: But I have been able to teach and work all of my life. One cannot make prophecies forever. However should I find that I cannot do both I would have to stop teaching. . . . I insist that precisely that knowledge is what makes me valuable to the school. Of what value would I be . . . if I were willing to sacrifice my work for teaching? It is the opposite which guarantees my unremitting concern and involves me in the subject which I teach. I was not brought into this department because I am primarily a teacher or an advertising man or a textile man. I was asked to join the department because I am Mark Rothko and the life-long integrity and intensity which my work represents.

But the "Bauhaus" won. A brief, official letter from the president of Brooklyn College, Harvey Gideonse, denied Rothko tenure and clearly infuriated the artist: superimposed on the cold prose is the hot, heavy imprint of the sole of Rothko's right shoe.

# 4 Recognitions

(1955–63)

> In the Dionysiac dithyramb man is incited to strain his
> symbolic faculties to the utmost; something quite un-
> heard of is now clamoring to be heard: the desire to tear
> asunder the veil of Maya, to sink back into the original
> oneness of nature; the desire to express the very essence
> of nature symbolically.
>
> Friedrich Nietzsche
> *The Birth of Tragedy*

During the winter of 1955–56, the noted American art scholar Meyer
Schapiro was in London lecturing for the BBC. One day he went to
the Tate Gallery to see "Modern Art in the U.S.," a new exhibit sent
over by the Museum of Modern Art. There on the floor before enor-
mous works by Rothko and Pollock rolled a young artist in a delirious
fit of rapture. Schapiro was delighted; it was a repetition of the young
artists' excitement he had witnessed six years earlier in New York.
"When work is genuinely new and strong," as he put it, "only a few
sensitive people recognize it." Usually, true enthusiasm is ignited by

32

fellow artists. Later, word spreads to ever-enlarging circles of critics, scholars, and museum people, and lastly to the public.

True to Schapiro's theory, most of the British critics ridiculed the large abstractions. The London Sunday *Times* referred to them as "Yankee Doodles." Writing in the *New Statesman,* John Berger found them wicked and compared them unfavorably to a show of French Realists mounted at Marlborough Fine Arts on Bond Street. "These [American] works in their creation and appeal are a full expression of the suicidal despair of those who are completely trapped within their own dead subjectivity."

Rothko had refused to lend his own works to the London exhibit, and Dorothy Miller had been forced to supplement the museum's Rothkos by borrowing from early collectors. Rothko and Still remained adamant about sending their works off untended in group exhibitions.

Yet the Rothkos could ill afford such pride; despite growing recognition, money continued to be scarce. Having obtained a full scholarship for her, they could afford to send Kate to Dalton, an expensive private school. When in late 1954 the family moved to a much larger rent-controlled space on West Fifty-fourth Street, Rothko tore up the black linoleum from the floor of the apartment on Sixth Avenue, and carried it to the new place, where he relaid it. He would take the family and friends for occasional outings in an old Studebaker whose doors had to be tied shut with rope.

Except for what he was working on at a given time, most of Rothko's canvases had to be rolled up and stored. He could not afford professionally built stretchers, and those he himself knocked together from two-by-two boards were, according to Sidney Janis, too weak. For exhibitions, Janis persuaded him to hire expert James Lebron to build his stretchers.

Assembling ingredients for painting was often time-consuming. For canvas, once or twice a year he combed wholesale fabric houses downtown for remnants of fine cotton duck, and, with the aid of one of his students, he would try to prepare enough canvases to last six months.

He found secondhand brushes on sale at large paint stores; once housepainters had finished with them, their pig bristles were worn and softer. The studio was filled with bags of powdered color pigments, cans of linseed oil, turpentine and buckets for mixing which held one to three gallons. Other containers held dried granules of rabbit-skin

glue for sizing and priming. Much later drums of polymer liquid would be added for working in the acrylic medium. When he used tempera, he would follow a procedure that has existed since the Renaissance, separating dozens of eggs and beating the whites into a consistency close to that of a soufflé. Those few friends who saw Rothko perform this rite were delighted by the bulky Balzacian figure with large hands, delicately transferring yolk after yolk from half-shell to half-shell.

When in 1955 Janis showed twelve of Rothko's paintings, one took up an entire wall. The exhibit, wrote Hess, reemphasized the "international importance of Rothko as a leader of postwar modern art." At the Janis gallery, Rothko now wanted the lighting dim. Visitors remember that Rothko and Janis behaved like the rain-shine figures on a Swiss barometer; whenever Janis would turn up the spotlights, Rothko would turn them down. He was a "strange creature" about lighting, Janis remembers. "No matter how low it was, he would reduce it. It made the gallery so dismal, but he wanted some kind of mystery attached to his painting." The show was not a commercial success, but Rothko's prices went up. Rumors circulated among other artists that one Rothko had sold for $10,000, which intensified jealousies. While Rothko still refused to show in groups at museums, he did not object when Janis's exhibits included his paintings with major works by Motherwell, Kline, and Pollock, At Janis the artist's work was acquired by important American collectors, and shows there received extensive critical coverage.

After the fiasco at Brooklyn College, Rothko accepted positions as a visiting lecturer, first in the summer of 1955 at the University of Colorado at Boulder, and in the winter of 1956–57 at Tulane. During these academic forays his letters to the Motherwells and Herbert and Ilse Ferber were humorous, anecdotal, and warm. Boulder was "this physical and human desert" which drew from him

rhapsodies for that island of Paradise which is New York City. . . . There are three pressures which are being exerted against me here, to none of which, I promise, will I submit.

1. All our local acquaintances want us to climb mountains.
2. Mell wants to get me on a horse.
3. My students want me to teach them how to paint abstract expressionism.

My boss here is Boston, Harvard, and alas a poor cousin of the Fricks. To him I am Yale, Oregon, and a cousin of the rabbi of Lodz.

. . . . Two of my paintings hang here for the last three weeks. The silence is thick. Not a word or look from the faculty, students or the Fricks. One of them on my first visit, I found was hung horizontally. I phoned the hanger about his error. "Oh, it was no error," he said. "I thought it filled the space better." I swear by the bones of Titian this is true.

Writing from New Orleans, he again longed for "blessed" life in New York. He despised his neighbors "whose wives have the restless itch and have glued their souls to the U. Art Dept. . . . If [you have] any doubts, we can say firmly now that these represent the lowest point of civilization anywhere and anytime and here lie the poisons by which empires must destroy themselves."

By this time Rothko's works had appeared in Venezuela, most of Europe, and would be seen the following year in India. But worldwide recognition failed to line the artist's pockets, and when the couple returned to New York from Tulane, they were still pinching pennies.

Then came the unexpected—a fantastic financial burgeoning of the art world. A decade after the Second World War, trading in art was becoming the elaborate, commercial enterprise it is today. Before that time, the turnover in the market had depended on the patronage of a few wealthy collectors, whose interests were mostly limited to old masters. With postwar prosperity came new millionaires—the shipping tycoons of Greece and Norway, the oil barons of Texas and the Middle East, new uranium, electronics, and computer kings. In terms of capital gains, art "appreciation" took on new significance.

As prices soared, dealers proliferated. The supply was limited and the demand intensified. Auction houses in London, Paris, Stuttgart, Basel, and New York staged elaborate sales jammed with competing purchasers. In 1954, an estimated $33 million worth of canvas was sold at auction. The boom also produced millions of popular reproductions, expensive books and magazines, and films—devoted to art. In December 1955, the first of a two-part series of articles in *Fortune* proclaimed art another of the most desirable international currencies. Both investments and investors were divided into three categories:

"gilt-edged," "blue chip," and "venture capital." The gilt-edged bonded security, of course, was the old master—European, and preferably dead at least 150 years—and his purchaser was powerful old money or important museums. The blue-chip stock consisted of impressionists, the School of Paris, postimpressionists, and perhaps Picasso, and buyers had to be able to pay twenty thousand to one million dollars. To play the market, *Fortune* advised, one should buy the speculative or growth issues, living artists worth about $500 to $3,500 in their own country but with a much greater potential value on an international level. Listed as the "good buy" in American art were pioneers of the New York School, and topping the list of possibly bullish artists were de Kooning, Rothko, and Pollock.

The following month *Time* featured the group as the "Wild Ones" and depicted them as suffering from a gigantic persecution complex, with "rumpled testy" Rothko the outstanding martyr to his subjective artistic visions.

Perhaps the two publications were partly responsible for yet another falling-out among the artists. After *Fortune*'s stock quotations, Clyfford Still wrote Rothko a prickly letter demanding the return of the pictures that they had exchanged over the years, citing as his reason the increasing attempts by others to capitalize on their paintings. He bitterly lamented his earlier naïveté about what he had believed were honest aspirations of the fellowship of artists, implying that Rothko, like others, had sold out. Still warned Rothko of the presence of a new kind of crass young collector-on-the-make bent on exploiting their creations. He had come to the point, he wrote, where he felt like arming himself with brass knuckles each time he came across any art world type.

The canvases were returned, and another association ended.

In the early fifties, there was a constant round of parties given by artists and their circle. There were no frills but many drinks, and, as often as not, dancing. When Rothko danced, it was an arresting sight: he had the grace of a goggle-eyed Babar, with a special circular hugging step. Mell enthusiastically embraced any occasion for a celebration, particularly religious holidays—both Christian and Jewish—but "only the cheerful ones," Kate points out. On Chanukah, she lit the candles and Rothko said the prayers, and the family celebrated Passover, alternating the annual seder with friends.

Wearing an old overcoat he inherited from Motherwell, Rothko,

the perpetual insomniac, continued to prowl the streets late at night. Often he would drop in at Jerry's Bar and Grill where he would meet Sally Jessup, a young actress and her friends. She remembers fondly his clumsy entrances: "When Mark came in wearing his big long overcoat—with a cigarette dangling from his lips—he moved like a ferryboat bumping side to side into port." Later, when she married artist William Scharf, who occasionally helped Rothko in the studio, the Rothkos held the reception.

In the mid-fifties Rothko's melancholy moods deepened into depressions and, along with his intense appetite for life and work, caused extremes in his behavior. Motherwell remembers:

"He could be a volcano, a primitive Ivan the Terrible. But then he loved life, and could have great love and compassion for others. Yet there was always something love-hate about his friendship. He zigzagged, becoming close, sympathetic, helpful when a friend had real problems," and would "weep at injustices to others, at an unfair situation, say, in a movie.

"Handling money was always a problem. He paid cash for everything. When a thief broke into his mailbox and stole his bank statement and he had to go to the bank to straighten it out, he went into a depression as intense and prolonged as Kafka writing *The Castle*."

Neither Rothko's increasingly heavy alcoholic intake, nor his well-developed hypochondriacal tendencies helped his growing bouts of melancholia. Though he would bundle up in scarves and hats when the weather became the least bit cool and would worry long and loud about the slightest symptom of illness, he deeply distrusted doctors and other figures of authority, which prevented him from obtaining professional help.

When, in the summer of 1956, he developed a high fever and swollen, painful joints, he went to bed for three months. Finally he was persuaded by Herbert Ferber (who, under his full name, Herbert Ferber Silvers, was also a dentist), and another friend, to permit the visit of a physician. Grumpily, Rothko allowed Dr. Albert Grokest, Ferber's internist, to examine him, but was too terrified to let him take a blood sample. Discovering uric acid crystals in Rothko's right ear, Grokest decided the artist had gout. Since there was to be no blood test, Grokest checked his diagnosis therapeutically with medicine. Rothko downed a dose of colchicine, and his symptoms almost immediately began to disappear. It was, indeed, gout. Since Rothko admired "skillful thinking and orderly solutions," as Grokest put it,

he began to trust him and finally allowed the doctor to take a blood sample and prescribe the proper dosage of Benemid pills; as a result, the uric acid level in his system dropped threefold. Grokest also discovered that Rothko suffered from hypertension. Though the drug controlled his gout, Rothko stubbornly refused to undergo regular medical checkups or seek further professional help. He did not really care about his body.

During this period, Rothko grew increasingly irritated by much of his publicity and constant identification with the New York School. As he wrote in 1957: "To classify is to embalm. Real identity is incompatible with schools and categories, except by mutilation." Ready labels bothered him—he even hated being called a brilliant colorist. He told writer Selden Rodman:

> You might as well get one thing straight. I'm not an abstractionist. . . . I'm not interested in the relationship of color or form or anything else. I'm interested only in expressing basic human emotions—tragedy, ecstasy, doom and so on. And the fact that a lot of people break down and cry when confronted with my pictures shows that I can communicate those basic human emotions. . . . The people who weep before my pictures are having the same religious experience I had when I painted them. And if you, as you say, are moved only by their color relationships then you miss the point.

But by 1958 rapturous reviews and monographs had proliferated. His paintings, evoking subjective outpourings from critics and poets, were likened to the "fatalism, stately cadences, and desperately controlled shrieks" of Greek drama; "walls of light," being enveloped in a "vast smothering embrace . . . ominous pervasive light—that of the sky before a hurricane . . . doorways to Hell . . . glowing caverns . . ." So many metaphors and similes made him feel even more trapped.

Financially, things began to look up. In 1958, Rothko's exhibit at Janis was a tremendous success, and his paintings were fetching as much as five figures. Collector Armand P. Bartos began seeking out his paintings, the Burton G. Tremaines, who had followed him from Betty Parsons, added to their fine collection of Rothkos, and Frank Stanton, then president of CBS, acquired *The Black and the White* (1956). For little money (and a good-sized mortgage), the Rothkos bought a cottage in Provincetown. Though not particularly handy,

Rothko himself made the necessary repairs and improvements, building his studio on the top floor.

That same year Rothko was chosen along with Mark Tobey, one of his great admirers, to represent the United States in painting at the twenty-ninth Venice Biennale. "Rothko's glowing patches of color were a point of interest to critics, dealers, and artists from every country," wrote Yvonne Hagen of his "room full of towering and powerful red canvases." She likened the spellbinding effects to that of Picasso's *Guernica.*

Though he received numerous honors, he still resisted those which he found corrupting. In the summer of 1958, the Guggenheim announced that Rothko was among the contestants in their biennial International Awards (with a first prize of $10,000 and a top national prize of $1,000). But Rothko viewed contests among artists as meaningless and demeaning, and had submitted no entry. But perhaps Janis had.

In late August, Guggenheim director James Johnson Sweeney sent Rothko a check for $1,000 as the U.S. winner. Rothko returned it with a proud confidential note:

> . . . . If my surmisal is correct, I must return the check which is enclosed and inform you that the picture involved [*White and Greens in Blue* (1957), later bought by Nelson Rockefeller] cannot be available for either exhibition or the contest.
>
> I am writing this in privacy. I have no desire to embarrass anyone should you wish to substitute anyone else's painting.
>
> I am very sorry to take this step and do so only after searching thought. I look forward to the time when honors can be bestowed simply for the meaning of a man's work—without enticing paintings into the competitive arena. . . .

Hastily the prize was awarded to another artist, and Rothko's principles remained untarnished.

But during the fall, news that he had rejected the prize jumped out at him from an art column. He had been betrayed, and was furious. One Saturday afternoon as he was visiting the Whitney Museum, then on Fifty-fourth Street, he became visibly distraught. Friends said later that it was the sight of critic Emily Genauer across the gallery, and that somehow in his bitterness he connected her with the news story and the betrayal of his confidence. In any case, he angrily bolted for the museum's front door. With blind fury, he misjudged the entrance

and put his hands through the floor-to-ceiling plate-glass window adjoining the doorway.

Blood and bits of broken glass were spattered about the floor. But when the museum employees rushed up to see whether Rothko was all right, he brushed them aside, saying: "Forget about it. Just let me out of here." He was directed to a doctor next door, who sewed up the wounds. Rothko would not let him use anesthesia. After several quick Scotches with his companions in a nearby bar, he went home. "Don't forget," he told them, "I'm a moujik" (Russian peasant). By the time Whitney director Lloyd Goodrich reached him by phone, Rothko reassured him that he was well enough to play the piano (even though this was not among his skills). To other friends he later admitted that he had been traumatized by the sight of his blood.

Paintings by the leaders of the New York School were now selling for more money than the artists had ever imagined. But little cash funneled back. Sidney Janis had a system of withholding a reserve of artists' earnings against taxes and other expenses. According to lawyer Lee Eastman, Franz Kline had been living on a paltry $5,000 a year before his death in 1962, at which time Janis relinquished to the estate some $200,000 he had withheld.

"Artists are babes in the woods," explains Eastman, who has nurtured among others, Josef Albers, de Kooning, and Naum Gabo. "Especially the first generation abstract expressionists—who were dumb and easy pickings. They never had any money, were fearful of having any and of being exploited. And when it finally came rolling in, there was great disbelief. Taxes became the big bogeyman."

Bernard J. Reis, a soft-spoken elderly accountant with a law degree, worshipped art and artists. Openly priding himself on his sensitivity and refinement, Reis was no ordinary facts-and-figures CPA. He specialized in the care and feeding of the great, the near-great, and the promising in the world of the arts, as well as handling their financial problems. He advised them how to stagger their incomes over the years to avoid too big a tax bite at one time, and he drew up wills for some of them. For the most successful he helped set up private tax-exempt foundations. As a friend and confidant he relished his clients' personal problems, interesting himself in their love lives (including marital or extramarital affairs and discords), their clothes, diets, and especially any medical or psychiatric difficulties. He also played artistic cupid, mixing and matching poor artist clients with rich collector

clients, to the benefit of both. No detail of an artist's life was too picayune for Reis's attentions. He also seemed to adore assisting helpless widows, kindly insisting on assuming the burdens of the most minute details of their late husbands' estates. As one artist describes Reis's talent, "Bernard has a knack for showing great concern, as if *your* life and fortunes were *his* greatest assets."

The fashionable Reis town house and garden in the East Sixties was the scene of a memorable series of salons in the fifties. Here Reis's tiny fluttery wife, Becky, presided over vintage French wines, gourmet delicacies, and an ample bar. The walls were adorned with the creations of many of the guests. As Reis's clients became famous, their works were transported from upstairs to places of honor downstairs, joining Picasso, Braque, Matisse, Soutine, and others, with the important Lipchitz visible through the glass doors to the garden. Often, such visiting celebrities as Sir Herbert Read, Vincent Price, Chagall, Max Ernst, and Peggy Guggenheim were royally wined and dined by Reis and his wife amid their extensive collection of art and artists.

By the late fifties many of the New York School were among the Reis coterie, which included Mark Rothko, Franz Kline, Adolph Gottlieb, Robert Motherwell, Helen Frankenthaler, Willem de Kooning, Philip Guston, Naum Gabo, Esteban Vicente, Larry Rivers, William Baziotes, Herbert Ferber, Theodoros Stamos, Raymond Parker, Adja Yunkers, portraitist René Bouché, Jacques Lipchitz, and, later, Kenneth Noland. Over the years Reis's list of clients also included playwrights and authors Edward Albee, Gore Vidal, Dore Schary, and Lillian Hellman; collectors Peggy Guggenheim and Albert and Mary Lasker; artists Max Ernst, Duchamp, Chagall, and George Grosz; producers Joshua Logan, Herman Shumlin, and Clinton Wilder; and several important art dealers

In their avid collecting, Bernard and Becky Reis proved masters at the game of inexpensive acquisition. For financial services rendered by his firm, Reis would "accept" a gift of art. At first this seemed a considerate and even happy solution for the artist, since barter was the only payment he could afford. But for some there was a hitch. Good-natured Franz Kline, for example, found that Reis would appear at his studio to choose a large and important oil rather than a lesser work such services actually warranted. At the same time, few artists were keen enough to notice that the gifts exacted were not reported on their income tax forms prepared by Reis's office.

For the artists and their wives, lovers, friends, and connections, the

Reis house, with its beautiful appointments and famous people, seemed a haven. As one of the group remembers: "All of us had been fearfully poor and treated like bums. Some couldn't afford sheets. To be accepted in a civilized house meant a great deal. The Reises were kind and thoughtful and generous and went out of their way to be so. Becky cooked marvelous meals and stinted on nothing. We talked art and European travel, literature, and theater. And, of course, Bernard was always so helpful, taking care of nasty business details no one understood."

But when clients left his aegis, they often went away angry, having found his financial advice faulty or his interest in their personal lives meddlesome. By this time Lillian Hellman, Joshua Logan, Herman Shumlin, French dealer Louis Carré, and documentary filmmaker Louis de Rochemont had already left for these reasons. They would be followed by Willem de Kooning, Naum Gabo, Esteban Vicente, Herbert Ferber, and Robert Motherwell. And some of Reis's former accounting partners, on discovering his private arrangements with artists, sued him to obtain their fair share of the profits.

In the autumn of 1958 Rothko had a windfall. The culturally enlightened whiskey heiress Phyllis Bronfman Lambert persuaded her father to commission Rothko to paint a series of murals for the new House of Seagram Building designed by Mies van der Rohe on Park Avenue. Within his studio, then a converted YMCA gymnasium on the Bowery, Rothko built interior walls to the exact dimensions of the space designed by Philip Johnson in which the paintings would hang. Rothko was to execute murals covering some 550 square feet for $35,000, with $7,000 down and the rest to follow in equal installments over four years. The invoice sent to him from Seagram read "for decorations." It was his first major commission, but his attitude toward it was ambiguous. The huge hall, he became aware, was intended to be an expensive restaurant, "a place where the richest bastards in New York will come to feed and show off." Nevertheless, he worked on the murals for eight months, creating three sets of huge, progressively darker wine-colored murals. Many of the canvases were square, containing outlines of floating vertical rectangles, some of which gave the impression of doorways.

In the late spring of 1959, Rothko decided he needed a rest. Having received $14,000 of the commission, he planned a tour of Europe for the family. Before sailing aboard the U.S.S. *Constitution*, Rothko was

persuaded by Bernard Reis to have wills drawn up for himself and Mell. If both died, Herbert and Isle Ferber were to be Kate's guardians and would also serve as executors, with Reis himself as alternate executor. If a catastrophe occurred whereby Kate, the legatee, also died, the estate was to be divided seven ways among Rothko's brothers and sister, Mell's two sisters, Ferber, and Stanley Kunitz. To clarify the intent, the Rothkos sent letters to Reis and the Ferbers:

June 11, 1959

Dear Friends,

We have just made wills which provide that in case of our death and Kate's, you are to be the Executors. The principal item in the estates, of course, is the inventory of paintings and it is our wish that the pictures be sold as follows:

a. The museum or individual who will acquire the largest number to be held in a single place should be given preference.
b. To museums outside of New York City and in Europe which will acquire at least six paintings.
c. To museums or individuals who will acquire at least three pictures.
d. These conditions for distribution should be adhered to for a period of five years.

With thanks, I am
Sincerely,
Mark Rothko
Mary Alice Rothko

It is significant that specifications for the future disposition of Rothko's paintings did not appear in the will but only in the accompanying letter. Though this is the only letter of intent found, Rothko's later wills—drawn up by Bernard Reis and witnessed by Reis's employees—followed the same pattern. This is the earliest indication that when drawing up artists' wills, Reis advised his clients not to specify the disposition of their work, so that the estate need not be bound by the legal instrument.

On the voyage—in the tourist-class bar aboard the *Constitution*—Rothko met John Fischer, then the editor of *Harper's*, who was also

traveling with his family. After satisfying himself that Fischer was in no way involved with the art world, Rothko began to talk freely. Fischer, who had never known anyone quite like Rothko, liked him immensely and took detailed notes on their conversations. In an article published after Rothko's death, he provided rare insights into the core of ferocity under Rothko's outwardly benign, affectionate, and intellectual manner.

Rothko told Fischer that he had taken the Seagram job with "strictly malicious intentions. I hope to paint something that will ruin the appetite of every son-of-a-bitch who ever eats in that room. If the restaurant would refuse to put up my murals, that would be the ultimate compliment. But they won't. People can stand anything these days."

Rothko continued: "After I had been at work for some time, I realized that I was much influenced by Michelangelo's walls in the staircase room of the Medicean Library [in the Laurentian Palace] in Florence. He achieved just the kind of feeling I'm after—he makes the viewers feel that they are trapped in a room where all the doors and windows are bricked up so that all they can do is butt their heads forever against the wall."

Over many Scotch-and-sodas, they discussed art and the sorry lot of the artist both in the world in general and the art world in particular. "I hate and distrust all art historians, experts, and critics," Rothko railed. "They are a bunch of parasites, feeding on the body of art. Their work not only is useless, it is misleading. They can say nothing worth listening to about art or the artist. Aside from personal gossip—which I grant you can sometimes be interesting."

For special abuse he singled out Emily Genauer, who lately had described his work as "primarily decorations," and Harold Rosenberg, whom he deemed "pompous." Rosenberg, he said, "keeps trying to interpret things he can't understand and which can't be interpreted. A painting doesn't need anybody to explain what it is about. If it is good, it speaks for itself, and a critic who tries to add to that statement is presumptuous." He did not add that perhaps part of his resentment toward Rosenberg was defensive: the critic had analyzed and praised the works of Gorky, Pollock, and de Kooning, while devoting little space to Rothko.

He flayed the "whole machinery" for popularizing art—"universities, advertising, museums, and the Fifty-seventh Street salesmen." He did

not exclude the Museum of Modern Art from his list of bêtes noires, even though it was then offering him an important one-man exhibit. MOMA "has no convictions and no courage," he said. "It cannot decide which paintings are good and which are bad. So it hedges by buying a little of everything." Yet he would permit them to give him a show. "I want to be very explicit about this. They need me. I don't need them. This show will lend dignity to the museum. It does not lend dignity to me."

After both families had landed in Naples, Fischer believes that on two occasions he detected in Rothko's inspiration "some deeply hidden religious impulse." After visiting Pompeii, Rothko described the "deep affinity" he felt for the murals in the House of Mysteries there—"the same feeling, the same broad expanses of somber color" as his own recent work. And when the families spent an idyllic day seeing Paestum together, an Italian boy asked whether the artist was there to paint the temples. His reply was: "Tell him that I have been painting Greek temples all my life without knowing it."

When they returned to New York, and Rothko could resume work on the murals, he fulfilled his vow to Fischer to "keep my malice constantly in mind. It is a very strong motivating force." When he visited the restaurant (which had become the Four Seasons) he saw that it was as opulent as he had predicted. But spoiling the appetites of the richest bastards in New York by surrounding them with his dark visions of man's mortality no longer seemed worth the pleasure of his malicious irony; and it had become clear that the people would taint his paintings. In 1960, Rothko raised enough money to repay the commissions and withdraw the murals. They demanded a sanctuary of their own, and a decade later the Tate Gallery would establish a room devoted to them.

Naturally, the incident received a great deal of coverage. While critics and the public admired Rothko's idealism, his detractors spread the word that he had deliberately capitalized on the publicity; and it is true that he had not discouraged the impression that he had originally thought the site was to house an employees' commissary. Philip Johnson says that "Rothko knew from the start what it was to be."

During this period his reputation as an artist grew. Patrons, museum directors and curators, and collectors were converging on his Bowery studio. Those who picked their way past the bodies of derelicts included

aristocratic Duncan and Marjorie Phillips, of the Phillips Gallery in Washington, who in 1960 gave him a one-man show, and that December installed a room devoted to his work. Having heard of the beauty of his Seagram murals, collectors John and Dominique de Menil made an appointment with Rothko to see them, and were so overwhelmed that they found themselves talking in whispers. About the same time, Mrs. Eliza Bliss Parkinson, a MOMA trustee, wanted a Rothko and persuaded Dorothy Miller to accompany her to choose a painting. They selected three possibilities, one of which Mrs. Parkinson bought for about $7,000. Rothko had asked that the other two be sent to Janis, but Miss Miller, also art consultant to the Rockefellers, called David Rockefeller and asked whether the newly established Chase Manhattan Bank's Art Program might be interested in purchasing one. Instead, Rockefeller bought one of the paintings himself and hung it in his outer office, where it remains.

Though collectors were avid for his paintings, some of which were fetching $20,000 at Janis, not until 1960, when Rothko was fifty-seven, did his earnings begin to rise. With his first real money, he bought an expensive stereo for the studio. Mell began house-hunting near Dalton, so that Kate could walk to school, and found a spacious brownstone with a backyard on East Ninety-fifth Street, across the street from the Motherwells. Mell had always longed for a house with a garden, but for Rothko the neighborhood had no charm—no friendly bars, no interesting jaunts or joints.

The house cost $75,000, and Bernard Reis helped him obtain a $20,000 mortgage through lawyer and client Frank E. Karelsen, Sr.; a second mortgage was acquired in Kate's name for $16,000. The fourth floor of the brownstone was converted into a studio, where Rothko seldom worked but stored paintings; in this way, Reis advised, some of the upkeep of the house could be deducted for taxes. After this major investment, Rothko told friends he hoped to keep his expenses down to $15,000 a year.

In January 1961, the Rothkos were the recipients of a two-page telegram from the forty-three-year-old President-elect, John F. Kennedy, inviting them to participate in his inaugural festivities. Rothko rented a dinner jacket and Mell borrowed an ice-blue satin evening dress, and with Franz Kline and his close friend Elizabeth Zogbaum they took the train to Washington. At the Inaugural Ball, they had a box near Joseph Kennedy, and as Mrs. Zogbaum remembers, they were dazzled by the young President "who looked like a golden statue."

But after recognition came fame, and with it, like too much light on a negative, instant overexposure.

By the early sixties, newness, catchiness, and youth—always in the ascendancy in America—had been formally declared "in." Fittingly enough, both ends of Madison Avenue—the advertising and art worlds—joined to propagate their products. The phrase *Pop Art* was coined in England to describe America's Kleenex culture, and art factories in New York set about filling the new bill, spewing forth expensive products. New art entrepreneurs jumped on the bandwagon; clever dealers like Leo Castelli gambled on the publicity and personality of the young superstars, their public happenings and trademarks—Jasper Johns and the American flag, Andy Warhol's movies and Campbell's Soup cans, Roy Lichtenstein's comic strips, Robert Rauschenberg's media collages, James Rosenquist's advertisements. To some it seemed a denigration of artistic principles as well as the many years of hard work that had gone into the mastery of their medium. As Rothko and other artists told one another, it was "anti-art" practiced by what Rothko called "charlatans—young opportunists." Public art replaced private vision, and overnight, heavily promoted in the mass media, became a national fad.

By 1961, the nabobs of the art establishment had declared the New York School passé. An art world symposium was held on the Death of Abstract Expressionism. No matter that sainted relics of that bygone era—Rothko, Kline, de Kooning, Still—were hard at work, painting on an even grander scale.

Rothko's forthcoming retrospective at the Museum of Modern Art was a capstone—or, as others were ready to declare, a tombstone—to his career. He became ill with worry and anticipation; unable to eat, he consumed quantities of alcohol.

For hours he studied the enormous areas the museum would devote to his retrospective. There was to be a room for some of the Seagram murals, and he determined that four of the preliminary set and four of the final set should be represented. With Mell's help he arranged the show. All together there were fifty-seven paintings, overwhelming some of the rooms. MOMA curator Peter Selz wrote a monograph for the catalogue, comparing the murals to both the Egyptian tombs and the legend of Orpheus:

> celebrating the death of a civilization. . . . The open rectangles suggest the rims of flame in containing fires, or the entrances to

tombs, like the doors to the dwellings of the dead in Egyptian pyramids, behind which the sculptors kept the kings "alive" for eternity in the *ka*. But unlike the doors of the dead which were meant to shut out the living from the place of absolute might, even of patrician death, these paintings—open sarcophagi— moodily dare, and thus invite the spectator to enter their orifices. Indeed the whole series of these murals brings to mind an Orphic cycle; their subject might be death and resurrection in classical not Christian mythology: the artist descending to Hades to find the Eurydice of his vision. The door to the tomb opens for the artist in search of his muse.

Selz went so far in that fanciful vein that his monograph was considered a parody and was itself parodied by others.

Although there were many rave reviews, only one critique, by Robert Goldwater, seems to have satisfied Rothko. In his essay, Goldwater stressed the subtle paradox, the demanding provocation, and the "utter seriousness" in all, even the most colorful, of Rothko's work. Goldwater also was insightful about the few hints the artist's work gave of his psychological makeup.

> There has been a single-mindedness in the pursuit of a vision, an insistence upon one direction, an exploration of the possibilities of one means that is admirable, often overwhelming, and (why not say so?) at times exasperating in its refusal to relax. This has much to do with the size of the pictures and with Rothko's insistence upon controlling the conditions of public exhibitions. (One suspects that in the world of the contemporary artist, only such braced and tense self-confidence can achieve such concentration. [. . .]) It is related as well to the violence which the artist attributes to his own work and which to the observer, faced with the horizontal harmonies of these tremendous canvases, seems more closely akin to violent self-control.

Goldwater referred to an earlier statement of Rothko's that his work was "violent, more so than any living artist's." The violence in his art resulted from a controlled "tension," which Rothko described as "conflict or desire which in art is curbed at the very moment it occurs." To create the subtly balanced tension of his colors and flat forms on the giant canvas demanded a psychic stress, an intensity, that perhaps

only the canvas could contain. The man could not. "My paintings are my not-me," he would later tell a friend.

Rothko visited the museum every day during the exhibit, studying the paintings and their placement. Having his works grouped in families in a friendly environment had become an obsession. And, more and more, as his palette darkened his work demanded such treatment.

Feeling triumphant after the MOMA show, Rothko agreed to lend the museum enough paintings for a second exhibit, which traveled to six European countries and later to major cities in the United States. An Italian collector, Dr. Giuseppe Panza di Biumo of Milan offered to pay $100,000 for five of the Seagram murals from that exhibit. Reis advised Rothko to stagger the $100,000 over four years and put half in the name of his daughter. Rothko wrote a letter to Panza di Biumo, explaining: ". . . since I must lean upon [Mr. Reis's] advice in these matters, having so little knowledge myself, I would like to abide by them." But the boom in Pop Art interfered with this transaction. Panza di Biumo noted the new trend and after payment of $40,000 changed his mind. He no longer wanted the tragic dark murals, but chose two others from the exhibit. Rothko explained that that was not possible "because all of the pictures that were in the travelling show have been consigned to a foundation now being formed where they will remain intact as a group." Instead, he sent Panza di Biumo transparencies of six "very important" paintings from which the collector might select two. And since the deal "was contemplated several years ago," he discounted the price by $8,000, asking Panza di Biumo to "keep the price [$20,000 apiece] confidential."

In 1962, Sidney Janis's stable also became Pop-ularized, and the artists of the New York School—Rothko, Kline, Motherwell, de Kooning—left angrily. "Their reaction was just as violent then as it was when they were less secure," says Janis.

Janis also recalls that at this time a large Rothko was sold for $30,000. Money was pouring in, and, as Janis explains it, Rothko's tax bracket had become too high to make gallery representation practical. From his studio, in one year, he could sell five paintings to a gallery's ten and make almost the same amount of money without paying the gallery's one-third commission.

That spring, Rothko was acutely depressed. His brother Albert was ill with what doctors in Washington, D.C., diagnosed as terminal

cancer. "Over all hangs the shadow of my brother and other things," Rothko wrote Ferber. Rothko persuaded Albert to go into New York's Memorial Hospital, where specialists performed an operation that saved his life.

Adding to Rothko's misery was the faddism of the art world. When he ran into critic and museum administrator Sam Hunter on the street, he launched into a diatribe against pop stars and instanct success: "Those young artists are out to murder us."

In May 1962, during the short-lived glamorous days of Camelot, the Kennedys gave a magnificent state White House dinner celebrating the arts. To honor French cultural minister André Malraux, who was launching the *Mona Lisa* on a national goodwill tour, 168 prominent guests were seated at 17 banquet tables. In the brilliant assemblage were playwrights Arthur Miller and Tennessee Williams, actresses Julie Harris and Susan Strasberg, and novelists Robert Penn Warren, Saul Bellow, and John Hersey. George Balanchine and Agnes de Mille, Leonard Bernstein, Isaac Stern, Eugene Istomin, and Leonard Rose represented dance and music. The artists dining on lobster en bellevue, stuffed bass polignac, and pheasant in aspic included Andrew Wyeth and Mark Rothko.

The Rothkos, seated with Lyndon and Lady Bird Johnson, were impressed by the illustrious company, but Rothko feigned aloofness. Saul Bellow remembers the artist saying that he didn't give a damn about such festivities, but added quickly that his sister was excited for him. Yet, says Bellow, Rothko was clearly in a high state of exhilaration.

Sporting an Upmann cigar, President Kennedy made a smiling toast: "This is becoming a sort of eating place for artists," he joked. "But they never ask us out."

Kennedy was the only politician for whom anyone can remember Rothko having expressed a good word. Certainly, dining in the White House in formal evening attire was a far cry from his radical youth. He had had no interest in politics since a Communist flirtation in the thirties, when for a brief period he reportedly had been a member of a fellow-traveling cell in Greenwich Village.

Two days later, the old Missourian painter Thomas Hart Benton decried the hypocrisy of the occasion. Art, he said, "has nothing to do with high society," nor does "a bunch of artists playing the social game." The Kennedys' inconsistency was clear. They "lionize artists,"

putting *"them,* not their work on show." A few years earlier Rothko would have been the first to agree.

In the early sixties, architect John Luis Cert designed an administrative and health center at Harvard, known as Holyoke Center. Cert admired Rothko's murals and asked him if he would donate some to Harvard for the building. In 1962, Bernard Reis drew up a codicil to Rothko's will deeding a gift to Harvard University, so that Rothko could deduct twenty percent of the fair market value ($200,000) of a triptych and two other large murals over four years. The paintings were to be placed under the supervision of the donor, hung in the lounge, never sold or loaned, and moved only with the permission of the donor or the Mark Rothko Foundation, a nonprofit organization still to be formed. But the Harvard Corporation, a relatively conservative group, was uncertain whether they would accept the gift. It was left to Harvard's president, Nathan Pusey, a methodical midwesterner, to evaluate the art.

When the murals were completed and ready for delivery, Pusey, knowing little about art, and less about abstract art, made an appointment with Rothko at his studio, then on First Avenue in the Seventies. When Pusey arrived, having traveled down from Cambridge, he found himself in front of a ramshackle building in a disreputable neighborhood near the river. He rang the doorbell, but there was no response. He turned around in the entranceway and noticed a burly fellow dressed like a workman, scuffling across the street carrying a paint bucket. Rothko greeted him cheerfully and led him up a flight of stairs to the studio, where "miles of eggplant-colored paintings stood in a long line" awaiting Pusey's perusal. Rothko found two unhygienic paint-stained glasses and poured Pusey and himself a morning slug of whiskey, adding ice cubes from the cardboard container.

As Pusey and the painter sat, Rothko asked, "Well, what do you think of them?" Pusey remembers that he was at a loss but finally said that he thought they were "rather sad." From Rothko's expression Pusey understood that he had been "right on the beam."

After that hurdle Rothko and Pusey embarked on what Pusey remembers as a "wonderful talk." Rothko explained that the dark mood of the monumental triptych was meant to convey Christ's suffering on Good Friday, and the brighter hues of the last mural, Easter and the Resurrection.

Pusey was intrigued by Rothko's metaphysical mood and by the

profundity of feeling in the painting, which became apparent to him as they talked. He saw Rothko as a philosopher-painter whose inspiration was based on a vision of universal religion.

Pusey returned to the board of overseers and wholeheartedly recommended acceptance of the gift.

In his sixties, Rothko would confide to friends that he had become more attractive to women, a fantasy he persisted in believing. Actually, while he greatly enjoyed indiscriminate flirting, only three serious affairs evolved during his twenty-five-year marriage to Mell. In these relationships, as in other special friendships, he was discreet, courtly, thoughtful, and affectionately romantic. But one of the women told Mell about their liaison, which did nothing to narrow what had become a growing schism in the marriage.

But in late 1962, when Rothko was fifty-nine and Mel forty-one, she was pregnant again, and on August 31, 1963, he became the father of a son, Christopher Hall.

In *The New York School,* Dore Ashton marks 1961 as the finale to the group's reign. The end of an era was marked that spring when three famous painters gave a party for more than 800 people in an enormous loft with colonnades and parquet floor. It was not the comfortable old group, she noted, but filled with unfamiliar faces representing the new art business community. The final touch was the guards, Pinkerton men stationed at the door, a far cry from the days of penniless bohemianism, when the lean, hungry artists themselves had resembled thieves.

With the death of Franz Kline in 1962, after a serious illness not helped by excessive drinking, many felt the heart had gone out of the art world. Gentle, imaginative, funny, Kline had had no enemies. The morning after his death, on her way to work, an old friend decided to drop in at his Fourteenth Street studio for a last visit. She climbed the stairs and pushed open the door. In the studio, going through the racks of rolled canvases and small papers was a familiar hovering figure, the accountant-connoisseur Bernard Reis. Simultaneously, in the bedroom, Kline's family was sorting his personal effects. The scene was painful and she left quietly, the picture forever etched on her mind. It was a private cameo that presaged what would transpire on a grand scale eight years later.

# 5 Dollar Signs and Question Marks

(1963–68)

The people who make art their business are mostly impostors.

Pablo Picasso

Frank Lloyd was born Franz Kurt Levai (the Polish version of Levy, pronounced lev-EYE) near Vienna on July 13, 1911. The son of antique dealers, he did not join the family trade. Instead, in the early 1930s, he bought a chain of gas stations around Austria. ("I was in oil," as he later described it grandly.) According to his official biography, after the anschluss, when Nazi troops moved into Austria, Levai escaped by trading "all his possessions" with an S.S. officer for a passport and visa.

All he had in his pockets was the equivalent of ten dollars in currency and a gold cigarette case—but he did manage to smuggle some paintings to Paris, where he retrieved them after the war. In Paris, he was joined by his non-Jewish wife, Herta, and his parents. By June 22, 1940, when France surrendered after only six weeks of actual fighting, the Levais had moved on to Biarritz, where their son Gilbert

53

was born. Three days after the "armistice," while Jewish refugees were being rounded up by the French, Franz Levai managed to escape to England aboard a Polish vessel. His wife and son returned to Vienna safely, but his parents would die at Auschwitz.

In England, he was interned in a refugee camp, which later became part of the Pioneer Corps. Foreigners were conscripted to trim trees, mend roads and fences, and provide backup labor services in the war effort. Levai trained as a mechanic and volunteered for a repair unit with the Royal Army Service Corps, which later ran supplies and equipment for the Normandy invasion.

Refugees with relations in countries under Nazi control were advised to take new identities, and at this time Franz Kurt Levai became Francis Kenneth Lloyd, associating himself with the financial power represented by his Lloyds of London bankbook. Reportedly, his gambling exploits with fellow corpsmen augmented the small holdings in his account.

In the Pioneer Corps, Lloyd met Harry Fischer, a fellow refugee with promotional flair and some knowledge of art, who had been a rare-book dealer in Vienna. After the war, Lloyd and Fischer opened an art gallery and bookstore on two floors of 17 Old Bond Street in London. The gallery was named Marlborough, after the Duke.

Money was scarce in postwar England. London was pocked with bomb sites; sugar and gas and other necessities were still rationed. To meet heavy tax burdens and refurbish estates, the landed gentry were forced to dispose of their collections of old masters—some accumulated only two generations earlier under the tutelage of the Duveens. Naturally, the upper classes preferred to raise cash discreetly, and this became the essence of Marlborough's style. Noble provenances were whispered in the back-room office of Marlborough Fine Art, while in the showroom "Cézanne and Rouault" or "Paintings of Importance" were exhibited.

In 1950, Lloyd and Fischer employed nobility itself as a director of Marlborough Fine Art in the languid twenty-two-year-old person of David Somerset, lately a lieutenant in the Coldstream Guards. In Britain, where the caliber and schooling of one's thoroughbreds and hounds are a measure of rank, power, and wealth, Somerset's father, the Duke of Beaufort, was top-drawer. For many years he had been Master of the Horse, first to George VI and then to her Royal Highness Queen Elizabeth. There are few castles or county seats in England

where a Somerset is not an honored guest, and, as heir to the Duke of Beaufort, David Somerset would inherit vast estates—some 52,000 acres encompassing a goodly portion of western England.

Adding to his impeccable inherited social and financial credentials was Somerset's marriage to Lady Caroline June Tynes, daughter of the Sixth Marquess of Bath, thereby increasing the length of his entry in Debrett's.

"We needed some class, some atmosphere," Lloyd said. "And David gave it to us." Somerset knew which dark-paneled rooms in what castles contained old masters that might be purchased. Marlborough's openings became grander, flashier, studded with royalty and gossip columnists; the Queen herself attended a benefit night staged by the gallery. Friends of Somerset in the international jet set, such as Gianni Agnelli of the Fiat fortune, provided the venture capital Lloyd needed to make important purchases; and, as special situations arose, industrial and banking giants were persuaded to provide investment backing. Lloyd's customers and backers included Ragnan Moltzau, a Norwegian shipping magnate; Brazilian publisher Assis Chateaubriand; Bruno Haftel, a European industrialist said to be residing in Argentina; Greek shipping billionaires Onassis and Goulandris; the Rothschilds; and such Americans as Paul Mellon, Joseph Hirshhorn, and Norton Simon.

By 1960, with Fischer running the gallery and Lloyd pursuing Somerset's contacts, business was flourishing, and profits were salted away through Lloyd's Liechtenstein companies into Swiss banks. Marlborough expanded into a new gallery at 39 Old Bond Street, where the ground floor was occupied by a branch of Lloyds bank.

Lloyd had already realized that, as prices skyrocketed, the supply of old masters would soon be gone, many winding up in museums in America, where tax laws make such donations advantageous for millionaires. Shrewdly, Lloyd foresaw that there was another fortune to be made in contemporary art. Using modern marketing techniques, he could create a fierce demand for an artist's output—especially if the art was carefully doled out over a period of years and throughout the art capitals of the world. While the artist was alive, it was important that only a few works be put on the market to create the impression among collectors that each work was especially desirable and rare. When the artist died, the supply would become finite and, if totally controlled, even more valuable or "important," as Lloyd termed it.

Esthetics had little to do with the formula ("If it sells, it's art," Lloyd told his salesmen), but in order for the game to finally succeed at the highest stakes, the artist must have already achieved prominence.

As inducements to sign exclusive long-term contracts with Marlborough, Lloyd offered artists advances, staggered payouts from Swiss banks, expensive color catalogues, promotional tie-ins, and international exhibits. He promised handsome full-color catalogues, monographs by well-known curators, prominent art critics, and historians. For their trouble, he offered the writers generous fees or perquisites. This practice benefited him, in turn, by putting these influential voices of the art world somewhat in his debt. Lloyd's methods and business acumen were in distinct contrast to the clubby Victorian ways of other English dealers.

But his brilliant gambit worked. In 1960 Marlborough took on the estate of Paul Signac and such living greats as Henry Moore, Francis Bacon, Barbara Hepworth, Oskar Kokoschka, Ben Nicholson, and Graham Sutherland. Like most artists, they were grateful to be shielded from the facts of business life and guaranteed a steady income. The rejected English dealers were outraged. "It's a bit like stealing a patent," said Peter Gimpel of Gimpel Fils, after having groomed and lost Hepworth, Nicholson, Lynn Chadwick, and Kenneth Armitage to Marlborough. From America, Lee Pollock transferred the lucrative estate of Jackson Pollock to Old Bond Street.

Another inducement for the artists was the promise of worldwide exposure. As a step toward accomplishing this, Lloyd formed an equal partnership with another backer, Bruno Herlitzka (said to be Agnelli's agent), and opened Marlborough Galleria d'Arte near the Spanish Steps in Rome; it was run by an attractive and charming Italian, Carla Panicalli, an intimate friend of Lloyd's, who was extremely well connected in international art circles.

By the sixties, New York had emerged as the center of the booming art market. In 1963, Sotheby's, the oldest London auction house, was negotiating to buy Parke Bernet. Art prices continued to soar, while auctions took on the high-pitched nervousness and adopted the instant intercontinental relay systems of the stock market. New investors burgeoned, and talk was of the "down-side risk" of a Corot or a Bruegel, of Monet as a "hedge." A new breed of art-collecting superstars, often with the aid of press agents, captivated the media. The time was ripe for Frank Lloyd to storm New York. With typical panache,

he set about acquiring all the ingredients necessary to dominate the marketplace. The right connections had always proved as invaluable to Lloyd as his own quick wits, and he would prove even more adept at forging and cementing new relationships in the new world than he had in the old.

Lloyd's initial contact in New York was lawyer and art collector Ralph Colin, who wore so many hats in the art world that he had wide leverage as a power broker. He was then attorney for and confidant of CBS chairman William Paley, who put him on the board of the Museum of Modern Art, where he became a vice-president of the museum and MOMA's international council. He was also a director of Parke Bernet and the lawyer for Knoedler's gallery. In 1962, Colin founded a protectionist lobby, the Art Dealers Association of America, the purpose of which was "to promote the interests of persons and firms dealing in works of fine art and to improve the stature and status of the fine arts business and to enchance the confidence of the public in responsible fine arts dealers." The organization also assisted dealers and collectors in encounters with the IRS by unifying standards of appraisals for tax purposes. It also had aspirations to self-regulation in a business with virtually no outside controls. Later the ADAA became so established that, by 1968, the Internal Revenue Service would invite members of the association to join an official Art Panel to check suspect appraisals—many signed by fellow ADAA members! Colin became the vice-president and general counsel, spokesman and moving force behind the ADAA, a position that would prove extremely helpful to Frank Lloyd.

In addition to his public offices, Colin had been named the executor of the estates of several important art world figures. After Curt Valentin died in 1954, Colin, as executor, sold part of the venerated dealer's stock to another client, Otto Gerson, who with his wife, Ilse, and Valentin's assistant, Jane Wade, opened the Sculpture Center in 1956. The gallery had a wonderful collection of sculpture and a stable of prolific sculptors that included David Smith and Jacques Lipchitz. By 1960, when Gerson died, he too had named Colin as his executor. When it became apparent that Ilse Gerson and Jane Wade could not carry on the business, Colin served as the matchmaker between the Gerson gallery and, as he described Lloyd and Fischer, "the men who built Marlborough Fine Art," creating the Marlborough-Gerson Gallery. For a reportedly bargain price, Lloyd took title to the stock from the estate, signed Smith and Lipchitz to exclusive five-year con-

57

tracts, and cased the city for further talent. Colin became Marl-borough-Gerson's general counsel and, as an officer of the gallery, was empowered to co-sign checks. Mrs. Gerson and Jane Wade were given the titles of president and director respectively, but had no share in decisions or profits. Stephen Weil, a young lawyer from Colin's firm, went on the payroll as administrator.

As befitting this vast new enterprise, Lloyd chose a prime site at the center of the art world, high in an office building on the corner where the old mainstream of Fifty-seventh Street met the new hordes of Madison Avenue dealers. Unlike the walk-in, window-shop loca-tions of other galleries, the sixth floor of the Fuller Building was an appropriate setting in which to do "business."

To create the proper ambiance, Lloyd hired Wilder Green, a well-known designer, later president of the American Federation of Arts. The interior would cost $250,000—no paltry sum in those days. To its 12,000 square feet, Green added subdued gray slate floors, movable white plastic partitions, and simple but elegant appointments, all of which lent the gallery the tastefully austere atmosphere of a modern museum. The young salesmen, each handling his own batch of artists and customers, deported themselves like dedicated curators of im-portant collections, helpful guardians of the flame. Most of them had been trained in London and knew how to "soft sell" art, cater to the whims of difficult dowagers, and massage the egos of high-powered businessmen and temperamental artists.

Backing for the venture came from the Texas oil fields. Through the offices of her friend, dealer Spencer Samuels, who became the new gallery's treasurer, Mrs. Cecil "T.T." Blaffer Hudson was persuaded to put up $5 million.

As in England, Lloyd was not interested in those promising artists who as yet had no reputation; rather, he wanted the well-known and aging artists of the New York School and their valuable estates. And what better entrée could he find to these newly rich artists or their widows than the financial adviser who was entrusted with their accounts: Bernard Reis.

This time the matchmaker was Lee Eastman, the lawyer for de Kooning and for Franz Kline's estate. His fellow lawyer Ralph Colin asked him to arrange a dinner at the St. Regis where Frank Lloyd could meet with Bernard Reis and three of Reis's clients: Philip Guston, Willem de Kooning, and Mark Rothko. Guston recalls the conversation:

LLOYD: We will do anything—just tell me what we can do for you.

DE KOONING: Okay, stop people from copying me.

LLOYD *(nodding, all smiles)*: Oh yes, we will do that.

ROTHKO: Will you give me a one-man show in Minsk?

LLOYD *(bigger smile)*: Oh yes, we will do that.

Lloyd pulled out elaborate folders and pamphlets showing the layouts of his posh galleries and plans for another in Cologne. But, says Guston, all this was wasted on Rothko, who for the first time in fifteen years he had known him, was drunk to the point of incoherence. When Guston and Eastman departed with Rothko and de Kooning, Lloyd and Bernard Reis remained at the table sipping brandy, deep in conversation.

After this meeting, Bernard J. Reis, Inc., became the accountants for Marlborough-Gerson. Reis himself set up the new gallery's accounting systems with elaborate international tie-ins to Lloyd's Liechtenstein companies. Like Ralph Colin, Reis was empowered to co-sign gallery checks.

One by one Reis's collection of artists joined Marlborough—not that many needed much persuading. "Most of us would have given our eyeteeth to join Marlborough then," says an artist who was not asked. "The glamor was catching." Among Reis's clients who signed were Larry Rivers, Adolph Gottlieb, Naum Gabo, Guston, Motherwell, the estates of Franz Kline and William Baziotes, and, initially to a limited extent, Mark Rothko.

Lloyd's blandishments varied according to the traits and vulnerabilities of each artist. He plied Motherwell with champagne, caviar, and lunches at Le Pavillon. David Smith, Lloyd claims, was offered fine tools and materials and a tie-in with the Spoleto Festival in Italy. Once, a Marlborough employee was sent out to buy him a pair of size 15-EE shoes.

But while his promises were honeyed, Lloyd lived up to his reputation for driving a hard bargain. The terms of each contract that suited him best were those that maximized his profits through Liechtenstein purchases and sales and minimized his down-side costs, such as U.S. taxes, on any given transaction. As further insurance against the possibility of losses, Lloyd went heavily into what he called "the wholesale business," making outright bulk purchases of an artist's work—often twenty or more works per lot—at discounts of forty to

fifty percent or more. He insisted if he could on combining this prac-
tice with a long-term exclusivity clause, consigning the artist's produc-
tion to him for a specified number of years. When possible, Lloyd
also insisted on a "survival clause," so that if the artist died before the
term of the contract ran out, Lloyd could maintain control. Since these
methods totally controlled an artist's output, it is not too difficult to
see where one source of a dealer's conflict of interest might lie: obvi-
ously, it is more profitable for a dealer to sell the art he owns outright
than to offer the artist-owned work in competition; moreover, the
fewer paintings sold, the greater the demand—still another reason
to let the consigned paintings remain unsold.

The secrecy with which transactions in the art world are conducted
makes art an especially attractive investment. Another attraction for
big investors is the lack of laws or regulations governing art dealings.
No U.S. agency except the IRS has any power over these tradings, and
it is not difficult to find a way around the tax laws—as many multi-
national entrepreneurs from Bernard Cornfeld to Gulf Oil have found.
Money can easily be funneled through a foreign shelter into a num-
bered Swiss account.

Lloyd purchased his artists' works through Marlborough A.G. then
operating from a post office box number in Chur, Switzerland, on the
border of Liechtenstein. Not surprisingly, many of his wealthy cus-
tomers and backers preferred to pay out large sums to Lloyd through
Liechtenstein. Marlborough bank guarantees and payments were
made through Swiss banks.

Though Rothko included dealers among other "parasites" of the
art world, he sold fifteen paintings in 1963 to Lloyd's London gallery
for $148,000, with the provision that the retail markup be at least forty
percent. And he agreed to let Marlborough A. G. represent him abroad
exclusively for a period of five years at a commission of one-third. In
1964, Marlborough would mount a Rothko exhibit in London. In
New York he would continue to sell from the studio. So that Marl-
borough would have little competition for Rothkos in Europe, the
artist also agreed that his New York purchasers would thenceforth sign
contracts guaranteeing that they would not attempt resale outside the
United States for five years.

The exhibit chosen for Marlborough-Gerson's gala vernissage was
another brilliant stroke: "Art and Maecenas: a Tribute to Curt

Valentin." If any two characters could appeal to the art world's conceits, they were the patron of Virgil and Horace, and the beloved dealer and benefactor. Lloyd tried to strike a Valentin pose when the the gallery was young. "I never try to sell art," he told a reporter. "It either sells itself or it doesn't." A few years afterward, he would frankly reject that role: "I don't gave a damn what anyone says. There is only one measure of success in running a gallery: making money. Any dealer who says it's not is a hypocrite or will soon be closing his doors." And finally came his most famous statement, "I collect money not art."

But if the gallery seemed dynamic from the outside, inside it was a "little dictatorship," as Jane Wade soon discovered. She charges that "They opened my mail and monitored my telephone calls." She quit after a year and opened a private gallery. "Lloyd is overbearing and despotic," she told *New York Times* reporter David Shirey afterward. "But when he wants to be charming, he's all Viennese with cream on top—on top of a Prussian general's spiked helmet."

In 1964, Bernard Reis helped Rothko select his last studio, half of a converted carriage house in the chic East Sixties. The rent was $600 a month. The studio's vast space was ideal for Rothko's work and was conveniently situated near the wealthy and fashionable—and only two blocks from the Reis town house. The northern half of the handsome red brick structure contained a three-story, forty-foot-square arena where a century ago members of the Stillman railroad barony performed equestrian feats. Lit by a huge central skylight cupola the cavernous room held a balcony on one wall which had enabled the proud parents and their guests to chaperone or applaud the riders astride their prancing mounts twenty feet below. It was "big enough to hold a hundred race horses," was his friend Stamos's description. The balcony floor served as the living quarters of the family of Arthur Lidov, a commercial artist and inventor, who rented the studio adjoining Rothko's.

In the studio, he immediately began experimenting with lighting effects. An enormous parachute-like device which he called his "diaper" was rigged to the skylight. With pulleys and ropes he could alter the daylight at will. A small electric heater which he had carried from studio to studio was installed in the gigantic space, and the place became another sanctuary away from home.

That summer, racks for storing canvases were built along most of a

long wall in the large front room, carving the space into a small reception room with a hallway opening into the enormous back studio. While the carpentry was in process, the Rothkos stayed in a rented house in the Springs, an artists' colony in the fashionable East Hampton on Long Island.

For several years philanthropists John and Dominique de Menil had contemplated commissioning an artist to create the interior murals for a chapel to be built in Houston. In Europe they had visited and studied Rennaissance chapels, the recently built Matisse Chapel of the Dominican Sisters at Vence, and the Audincourt chapel containing Léger's stained-glass windows.

In 1964, the de Menils, still awed by the powerful Seagram murals, asked Rothko if he would take the commission. At last, he could paint his temple. Philip Johnson, who had designed the de Menil house in Houston, was to draw up plans for an octagonal structure with alternating recessed walls in the interior, based on the baptistery on the island of Torcello, near Venice. Rothko was to have right of approval of architectural details. For tax reasons, Bernard Reis recommended that Rothko's $250,000 commission be staggered over four years.

Within the studio, Rothko had walls built to the exact measurements of six of the walls of the octagonal interior of the chapel. With almost religious fervor he began his work. A series of assistants prepared the enormous canvases by laying white duck against huge stretchers—many twelve by fifteen feet—and cutting and stapling the fabric to fit. Then they brushed on a sizing glue made from heating rabbit skin in a double boiler until it dissolved. This primer, used by masters for centuries, took a day or so to harden, tightening and strengthening the canvas as it did.

When it came time to apply the background color, Rothko became tense and relentless. Under his directions, the paints, usually Indian red with black pigment, were mixed by the bucketful and thinned with turpentine to the consistency of consommé. Propping the giant canvas against the wall, Rothko mounted the ladder to paint the upper part, while an assistant was assigned the bottom. They had to work fast before the temperature and consistency of the wash became too firm for an even texture. The paint from above would splatter about, dripping on the man below. Rothko would cry out instructions, and if the canvas was not tinted perfectly, he would fly into a rage and dis-

card it. Once the canvas had dried, he would often study the surface for hours, contemplating the possibilities for its final form. Later he would employ two assistants, working from opposite ends of the canvas, to do the background tinting while he barked at them from a short distance. With the tinting completed, he would send the assistants out of the studio, climb the scaffold, and begin to block the opaque black forms on the surface of the foreground. He usually insisted on solitude. Only Mozart blaring on the stereo was welcome company.

Rothko wanted to control the entire environment of the chapel. His murals had to dominate and enhance an ambience of reverence. With the values so close, the colors so dark, the lighting was crucially important. The look of the paintings in the New York studio, lit by a twist and a pull of the ropes controlling his parachute, convinced him that the cupola should be reproduced atop the chapel. He broached the idea to the de Menils, who felt obligated to acquiesce. Johnson, however, had planned an eighty-foot-high pantheon-like dome, which he said would cut the Houston glare and filter it into the recesses of the chapel. "Rothko wanted to be his own architect, and it was a mistake," says Johnson, who resigned from the project.

After Johnson's resignation, when Rothko was asked about the chapel, he would murmur, "It has come to an impasse." Houston architects Howard Barnstone and Eugene Aubry were commissioned to work with Rothko, keeping Johnson's floor plan. Barnstone flew to New York regularly, carrying a four-foot model of the chapel, which Rothko would inspect by putting his head up through the hole in the bottom. He made scaled miniatures of the paintings calculated to the fraction of an inch and worked out detailed schemes for the interior juxtapositions. Each detail of the architecture was gone over in minute detail, from the special asphalt-tile flooring to the fifteen-inch-high rails placed in front of the murals to discourage vandalism.

For three years Rothko concentrated on how the chapel would work. When he finished the paintings in 1966, there were fourteen to be hung in the chapel and another eight experimental studies. There were still experiments, decisions, and selections to be made concerning the paintings' relationships to each other and the chapel as a whole. Finally he would decide on a central triptych representing Salvation, with more motion and more soft browns than in the flanking murals. The triptychs to the left and right were opaque black trinities, each central panel slightly raised for drama, with internal hard-edged

borders (made by using masking tape on the edges). Four single panels would alternate between the three triptychs, with a fifth single panel, Damnation, facing the central triptych.

The vast endeavor drained the artist emotionally and physically. As Rothko wrote the de Menils on New Year's Day, 1966; "The magnitude on every level of experience and meaning of the task in which you have involved me, exceeds all my preconceptions, And it is teaching me to extend myself beyond what I thought was possible for me. For this, I thank you."

The project dominated his life. He summoned friends to contemplate the murals. "Do you see it?" "What do you see?" he demanded. Typically, whatever words the visitor chose were rarely satisfactory. Nevertheless, those he invited felt honored, even when they later discovered that their invitations were far from unique. As critic Brian O'Doherty pointed out, "Rothko's chapel pictures were, during the years of their creation, one of the art world's great sights" but they had become so public that it was "a little like discovering that Queen Victoria, after unexpectedly granting one her favors, was also sharing them with the other courtiers."

And courtiers there were in abundance. Rothko by now was a public figure, an idol, a legend, his studio a landmark for celebrated visitors—poets, professors, scientists, movie stars, novelists, and politicians. Describing these encounters, Rothko could be sardonic. He would tell about the time Michelangelo Antonioni wanted to meet him. When they finally shook hands Rothko asked him why. "Because we have much in common," replied the director. "I film nothing and you paint nothing."

While some found Rothko modest and unassuming, others thought him the opposite: one common criticism was that his pomposity increased with his success. He continued to protect himself from the bitchery of the art world long after he became idolized. The younger generation threatened him. With a demoniacal gleam in his eye, he would set traps for the young admirers. "It was like walking through a minefield," remembers Max Kozloff, who had desperately wanted to write a book on Rothko. "I can remember exactly when I made my mistakes." He and Rothko had been lunching at Martell's, a bar near Rothko's First Avenue studio, "and I told him I would like to know more about his development as an artist." Rothko was offended. "What development? I did not develop. You talk like a critic." Kozloff was banished from his company and barred from the studio,

allowed back only once to see the chapel murals, which everyone else in town had already seen—a dispensation Kozloff attributes to having acquired a beautiful young wife. It was then that he fell into another trap. When Rothko sat down, Kozloff did too and they talked briefly. Suddenly, with a smile, Rothko charged. "You did not come to see the paintings." He gestured. "They are over there."

Although the studio was a sanctuary, Rothko had a compulsion to connect, and the telephone became the symbol of his contact with the world. No matter what he was doing, he would stop to answer the phone. One day, artist Bill Scharf, who refuses to answer the telephone while working, was helping him prepare the enormous canvases for the chapel murals, while Rothko was painting high on a ladder. The telephone rang, and when Rothko saw that Scharf absolutely would not answer, he dropped hastily down the ladder's rungs, lodging one foot in a bucket of paint. Cursing, he thumped across the floor with the bucket attached to his shoe and picked up the phone. Too late, it was dead. He dubbed Scharf "that impossible Swede," and though they remained friends, he thereafter refused to keep him on in the studio.

In the summer of 1966, the family went abroad. They stayed with Carla Panicalli, the manager of Marlborough's Rome gallery, who, to Mell's annoyance, treated "Marco" like her prince, Gay, chic, handsome, Carla was emphatic to his every whim.

After visiting Italy, France, Holland, and Belgium, the Rothkos went to London. They spent a leisurely day with Frank Lloyd's ex-wife, Herta, and her son Gilbert and Lloyd's nephew, Pierre Levai, at Herta's country house. Lloyd, now fifty-five, after several years of swinging bachelorhood had recently remarried a pretty thirty-year-old schoolteacher named Suzanne Skilken from Dayton, Ohio, whom he had met at a New York party. Lloyd and his bride, whom he called Susan, spent much of their time traveling between the galleries and sun-drenched resorts, settling during the winter in a large house on Paradise Island beach in the Bahamas, where they kept his yacht and spent their days swimming and snorkeling. He was in constant touch by telephone with his rapidly expanding art empire.

The following summer the Rothkos were invited to Berkeley at the behest of Peter Selz who had left MOMA to become director of the Berkeley museum. Rothko actually enjoyed teaching there and, uncharacteristically enough, his relations with the students. As he wrote

Ferber, they were "gentle, cordial, intelligent and willing to listen. But above all I think they want to explain themselves to you and are grateful that you listen. . . . This is an episode that I value, for in New York I have not found a way of contact with the young that is as illuminating."

Rothko continued to limit his sales, despite pressure from eager collectors, and refused to sell to those he considered unsympathetic. "My father was always careful where his paintings went," remembers Kate Rothko. "Before he agreed to sell he would invite the people to his studio to meet them." One such couple was Paul and Hope Makler, who wanted a Rothko not for their gallery in Philadelphia but for their living room. Through Sally Avery, they had received an invitation to the studio. They would have bought a painting then, but Rothko told them he could not sell more than a few a year and those were already promised. For several years they telephoned periodically, but his answer was always the same. Finally in 1967, he said, "Yes, I think it's your turn." They chose a bright orange and red painting, which they found they could not live with. "It was like sitting in a furnace," says Hope Makler. So they chose a large (105″ × 93″) 1961 maroon and black, which in March 1968 they purchased through Marlborough for $28,000, an $8,000 discount from the $36,000 minimum price agreed upon when Rothko consigned it to the gallery. David McKee, former Marlborough vice-president, who sold the painting, remembers that Rothko was furious when he learned of the discount. He raised a stir with Frank Lloyd and for a long time would not be placated. Wanting both to know more about the Maklers and see where they had hung his painting, he went with Mell to Philadelphia. Apparently the Maklers passed the test.

To those who annoyed him he would not sell. Once he told Jane Wade, "Don't ever let me see that man again." To a lady who wanted to exchange a dark painting that "depressed" her, he said, "By all means bring it back." But when she wished to replace it with a brighter one, he refused and returned her money. Medium-sized oils on canvas were selling for from $25,000 to $40,000 and small paintings on paper from $7,000 to $10,000. He often asked for payment in cash. Along with lawyers, dealers and taxes were high on his list of bêtes noires. To a young artist, he explained: "The dealer gets a third, taxes take another third, and there's only a third left for my family. Why pay a dealer?

I can sell four or five paintings a year from the studio and have plenty to live on."

By the late sixties, more than a few artists had become disenchanted with Marlborough. After signing with Lloyd, too often they found themselves in limbo, and that the glorious promises continued a certain amount of empty air. In 1968, septuagenarian sculptor Naum Gabo, whose retrospective was being shown at the Albright-Knox Gallery in Buffalo, was appalled to learn that armed with a court order Marlborough had attempted to seize and attach his twenty-eight sculptures. Marlborough claimed breach of contract and $375,000 in damages for lost profits. In his countersuit against Marlborough, Lloyd, and Bernard Reis, Gabo charged coercion. He had not known when he was persuaded to sign the contract that his accountant Bernard J. Reis was also Marlborough's accountant. Motherwell, too, had difficulties: "The degree of sadism at the gallery was unbelievable even for a big corporation. They were catty, bitchy, humiliating, and treated you like a schoolboy standing in a corner." After the champagne and caviar days were over, Motherwell remembers, Lloyd made no effort to disguise his dislike of Motherwell, calling him his "gentleman artist." "If you are in his power, he is ruthless," Motherwell notes. "He knows everyone has his price; Lloyd's potency is money." Despite a guarantee of exhibitions, Motherwell was given only two in nine years, one in New York and another at Marlborough Rome. When he decided to leave the gallery and let his contract expire, he found that he had been caught in an automatic two-year renewal of the contract—which contained a clause that said the artist had to give two weeks' notice of his decision to terminate the contract. If he left, Marlborough could sue him for breach of contract. He says little effort was made to sell his paintings. "Someone there—I believe it was Lloyd—said to me, 'Artists are only rich when they are dead.'" In 1972, when Motherwell was finally free to leave Marlborough, he went to Knoedler's, where, after two years, he said, "I made twice what I had in nine years at Marlborough, and was given fifteen exhibitions," there and with affiliated galleries abroad.

By 1968, Rothko, too, had found that Marlborough was not living up to his expectations. After a 1964 exhibit in London, there had been no further one-man shows, much less the promised world-wide exposure. Of the fifteen paintings Lloyd had purchased five years earlier

through Marlborough A. G., only two had been sold in Europe, and nine in New York. Rothko was not sure what Lloyd's markups actually had been, and he had not sold Marlborough any more paintings, though from time to time he had consigned a painting to them. In any case, he allowed his European exclusivity clause to expire in June of 1968. He had no further need of Frank Lloyd.

# 6 The Price

(APRIL 1968–FEBRUARY 1969)

One pays dearly for immortality: one has to die several
times while still alive.

<div align="right">

Friedrich Nietzsche
*Ecce Homo*

</div>

In the spring of 1968, Rothko was hard at work on new canvases,
and his mood was mellow. More than twenty giant canvases for the
chapel murals had been finished for a year. After intensive reflection,
he had selected the final fourteen. The stretchers had been deepened
five inches to add ballast and more depth to the canvases. Plans for
the lighting and the installation had been discussed with architect
Barnstone in detail, but would not be final until the chapel was built.
He was using the walls and pulley system from the chapel construction
in the studio as enormous easels for other works.

The Tate room for the Seagram murals was also close to becoming
a reality. The trustees had formally requested the paintings in writing
and assured him of ideal space, a gallery where other paintings

would not interfere with the impact of his work. He planned a trip to London so that he could see the room and choose which paintings were most appropriate—as he wrote to Tate director Sir Norman Reid, to give the space "the greatest eloquence and poignancy of which my paintings are capable."

On a balmy April day, Rothko's friend Ulfert Wilke, a painter and collector, brought a lady from Cleveland to the studio. After complaining about the price, she bought a small oil on paper for $4,500. Afterward Wilke and Rothko headed east for lunch. Rothko was feeling fine, Wilke remembers, and was even careful to wait until ordering food before allowing himself a Bloody Mary. After lunch Wilke put the top of his small convertible down and they drove uptown. On the way they passed a florist's, where spring flowers already bloomed, and Rothko hopped out to buy Mell some geraniums for the garden. At one corner Wilke spied a Volkswagen plastered with Day-Glo flowers. "Well, Mark, what do you think of that?" asked Wilke. "All cars should look that way," was Rothko's unlikely pronouncement.

When the men arrived, Mell and four-year-old Christopher were in the garden planting flowers. The Rothkos and Wilke had an easy small-town conversation over the fence with neighbors. Rothko told about a time he had been sitting in the front room of his brownstone on a hot summer night. All the windows were open and he overheard a passerby inquire of a companion, "I wonder who lives there with all these Rothkos?"

That night, after Wilke left, the Rothkos went out to dinner. On the walk home, Rothko suddenly felt a fierce pain in the middle of his back. His legs were numb. They took a taxi home, where Mell called Dr. Grokest, who, hearing the symptoms, strongly suspected his ailment to be an aneurysm. Under no circumstances would Rothko allow Grokest to send him uptown to Columbia Medical Center, the hospital with which Grokest was affiliated. It was too inconvenient. So Grokest arranged to place him in New York Hospital under the care of the prominent cardiologist Dr. Irving Wright, and his associate, Dr. Allen Mead. Mell also telephoned Bernard Reis.

By the time the ambulance arrived at the hospital both Mell and Grokest saw that they had been displaced. At the desk was the kindly, thoughtful, and ever-helpful Bernard Reis. Much to the annoyance of Grokest and Mell, he shunted them aside, insisting on signing

Rothko in and giving all the personal data to the registrar. Because of Reis's advanced age and his help in the past, Mell and Grokest were reluctant to protest his interference.

An X ray tended to confirm that he suffered a dissecting aneurysm of the aorta, a severe vascular problem. An arteriogram indicated arteriosclerosis and that the probable cause of the dissection was hypertension. To lower Rothko's blood pressure, reserpine, a tranquilizer, and a diuretic were prescribed. Later, Elavil, a mood elevator, was added.

Every day during the three weeks Rothko was hospitalized, seventy-four-year-old Bernard Reis would walk three blocks from his town house to visit. Bearing cartons of Becky's homemade broth, Reis would read aloud items of interest from the newspapers. Rothko was touched by his extreme kindness.

By the time he was discharged, Rothko had physically recovered to a large extent. The doctors told him that if he continued to take his medicine regularly, was careful about his diet, and cut down on alcohol, smoking, and other inducements to hypertension, he might avoid the usually fatal recurrence of the aneurysm.

But mentally and emotionally he never quite healed. The fears and anxieties that had lain submerged over the years surfaced and overwhelmed him. All his life he had been subject to bouts of depression; now it was a pervasive melancholia. Death, which had preoccupied him before, seemed imminent. His health and reputation, always constant concerns, became obsessions. The egoism which had nourished his genius deteriorated into tearful bouts of self-pity, guilt, and doubt. The mistrust he had felt for the art world, a necessary and instinctual form of self-preservation, deepened into paranoia.

The Rothkos left for Provincetown early that year. The summer was a fog of drunkenness and agony. Since his illness, Rothko had not had the energy to really paint, but he rented a small garage near his house and experimented with watercolors and acrylics on rag paper. He had hoped to develop a Socratic dialogue with local young painters. But, remembers artist Jack Tworkov, when confronted by a group of youthful artists, Rothko would find even the straightest questions impertinent. He had never encouraged informality and did not like to be called "Mark" by these puppies. He also leaned too hard on close friends, fighting with Motherwell; Stanley and Elise Kunitz could not take the intensity of his drunken self-pity. To them his loneliness

seemed almost metaphysical; but out of his fear and immobilization he rejected help, finding solace only in drink.

Helen Frankenthaler, at that time still married to Motherwell, wrote the Ferbers of "the tragic air around the Rothkos" that summer, "dreadful to watch, sad, angry-making—powerful and hopeless all at once and even contaminating for some of us."

By the time he left the Cape for New York, much of his anger was directed at Mell, and their relationship had deteriorated into drunken brawling. Chemically, Mell could not tolerate alcohol—one drink brought out the worst in her. At forty-six, tired of living in his shadow, she demanded attention. Rothko could only focus on his own pitiable condition. He began to think of separation.

On September 13, Bernard Reis drew up a new will for Rothko, in which the Mark Rothko Foundation was declared the chief beneficiary of Rothko's estate. Mell's share was reduced to $250,000 in cash, plus the brownstone and all the contents thereof. The children were written out, though they would inherit equal shares of Mell's legacy in the event of her death. Nor would Mell continue as co-executor with Theodoros Stamos—Stamos remained, but she was replaced by anthropology professor Morton Levine and seventy-four-year-old Bernard Reis himself. Morton Levine and his wife, Anne Marie, Christopher's piano teacher, would become the children's guardians in the event of the simultaneous death of both parents.

No specification was made in the will as to the foundation's purposes. Under the previous will, drawn a year earlier, as an educational charity the foundation was left all but forty-eight of Rothko's paintings, which had gone to Mell and the children. In this will, the foundation's directors were specified as the three executors—Reis, Stamos, and Levine—and two art experts—Robert Goldwater, the scholar Rothko had chosen to write the official book about his work, and MOMA curator William Rubin. It was prophetic that Reis's longtime secretary, Ruth Miller, typed all the names except Rubin's in upper case. Rubin would be dropped from the board of the projected foundation within the year.

The foundation's primary inheritance, Rothko's hoard of paintings, was stored in four or five warehouses about town but had never been catalogued. When Levine, an amateur photographer, offered to do a slide inventory, Rothko accepted. The chapel murals had been put

in storage awaiting completion of the structure that would house them. The paintings were brought in lots from the warehouses to the studio, where Rothko's assistants set them up, Levine photographed them, and the artist's friend Dan Rice catalogued them by year, size, and medium—a procedure which took several months. Meanwhile, Rothko was painting papers in various sizes and mediums—they piled up by the dozens in a large stack in a corner of the studio.

Rothko's new young helper, Jonathan Ahearn, thought the inventory "very sad" because Rothko "clearly was preparing for his own death." Jonathan asked him what he intended to do with the paintings, particularly with a large oil which he hoped Rothko might donate to the Rhode Island School of Design. Rothko replied that they were his "monuments" and that the foundation would keep them together and see that they were exhibited in groups in the proper ambience.

Rothko had taken no steps to renew his Marlborough contract, but Ahearn remembers that occasionally a smooth young man in a Cardin suit would drop by, for whom Rothko made no attempt to disguise his dislike. This was Donald McKinney of Marlborough. Despite Rothko's official dissociation from them, Marlborough still listed him as one of their artists in all their many catalogues and would continue to do so throughout the eight months he was unrepresented.

That fall, Arnold Glimcher, the young and ambitious owner of the Pace Gallery, approached Rothko to see if he would sell some paintings. Rothko responded by saying that he needed to raise $500,000 in cash. Glimcher then telephoned Ernest Beyeler, perhaps the most prominent and successful art dealer, who operates on an international scale from a modest gallery in Basel, Switzerland. Beyeler agreed to put up half the cash, flew to New York and, with Glimcher, made an appointment to see Rothko. When the two dealers arrived at the studio, Rothko received them with reserve and dignity. They quickly arrived at the terms. Beyeler would exhibit him abroad, but Rothko insisted there would be no exhibits in the United States, where he thought he was overexposed. The batch of paintings selected would be mixed in size, medium, and period, but based on a maroon-black, $5' \times 6'$ oil on canvas hanging on the wall of the receiving office, for which they would pay $30,000. Because the quality of Rothko's paintings was so consistently high, general price levels could be established

by the size of the painting. With this as a yardstick, they would buy approximately eighteen paintings for their $500,000 in cash on the line.

The selection was to take place the following day. "But first," said Rothko, "I must check with Bernard Reis, my accountant."

When the three men met again, Rothko was obviously in distress. With tears in his eyes, he said: "The situation has changed—I'm terribly sorry, I can't do it. I like you very much but it just isn't possible."

Rothko invited Beyeler back to the studio, where he told the dealer how much he admired him, his reputation, and his fine catalogues, and apologized for reneging. He went into the kitchen to make drinks, and after several minutes Beyeler found him there weeping. Tactfully, the Swiss dealer attempted to reassure him: "I don't want to embarrass you, Mr. Rothko. If you can't, you can't." Beyeler left wondering what sort of a powerful hold Rothko's accountant had over him.

As was his custom when in New York, Beyeler dropped in at the Marlborough Gallery. There Frank Lloyd took him aside and asked if he would like to share in a Rothko purchase with him. Beyeler was astonished and quickly told Lloyd that he was involved "elsewhere" and could not. It cannot be determined whether Lloyd really intended to offer Beyeler part of some deal or was testing his intentions, having heard from Reis about the Beyeler-Glimcher offer. Both Lloyd and Reis later denied that they knew of this overture, and Lloyd further claimed that Beyeler attempted to double-cross Glimcher and initiate a Rothko deal with him.

Perhaps the Beyeler offer was what led Rothko to intimate to neighbor Arthur Lidov that he no longer had any need of Frank Lloyd. According to Lidov, Rothko said another big European dealer was going to pay him $1,250,000. Like others, Lidov believes Rothko was not interested in money as such, only in the monetary status his paintings achieved in the art marketplace, where steadily rising prices were the only certain measure of success. Another time, Rothko confided to Lidov that he had $750,000 in a numbered Swiss bank account. While Lidov was skeptical about the amount, the account itself did not seem to him unlikely. But for Lidov, who despises abstract painting as well as the pretentious verbiage of its critical acclaim, not much that Rothko said was to be trusted.

The repeated admonitions of doctors against alcohol had worried Rothko enough to abstain for a while. But before long he resumed drinking and chain-smoking. He began to find devious ways around the restriction. He would start at 5 A.M. with a slug of vodka straight from the bottle, reasoning that it was a glass or mixing that made a drink. He stowed a bottle at Lidov's and made a habit of visiting him in the late afternoons to chat—and get a little help from the bottle. He had been putting away about a fifth a day since the fifties, according to his friend and former apprentice Dan Rice, and had become addicted to both nicotine and alcohol. The former was obvious to others, but, perhaps partially because of Rothko's huge frame, until the last twenty months of his life only a handful of people were aware of his dependence on drink.

But as is common knowledge, alcohol acts as a depressant, and Rothko's moods had already descended to the lowest depths. Bernard Reis took Rothko to Dr. Nathan Kline, a well-known psychoanalyst who specialized in tranquilizers and antidepressant drugs. Kline, whose reputation began with experiments in which he used imipramine and doxepin while he was research director of Rockland State Hospital, was the recipient of awards from the Albert and Mary Lasker Foundation for Medical Research—the charity Reis had set up for Mary Lasker for which he served as director and treasurer and through which he had cultivated a number of important medical connections. Kline's enormous private practice was established in a luxurious suite in an elegant town house off Madison Avenue, only two blocks west of the Rothko studio. Bernard Reis had also been Dr. Kline's accountant and had negotiated the lease and improvements made in Kline's offices. The waiting room at Dr. Kline's was always crowded with individuals in various stages of depression, forlornly waiting to see him and receive the magic pills which would ease, energize, or elevate their psyches. In cold weather, a log-burning fire enhanced the artificial cheer.

For Rothko's mental state, Kline prescribed Valium and an experimental antidepressant, which, with the pills Rothko was already taking for hypertension, gout, and insomnia, added to the pharmacopoeia which overflowed from his medicine cabinet and often covered his bedside table.

For a while Rothko believed he had discovered if not a panacea, at least a useful crutch. Later, he described to novelist Bernard

Malamud the debilitating depression after his heart attack and the impossible summer when he had found himself unable to paint. Luckily, he said, he had seen a psychiatrist and had been able to break out of the downward pattern. A wonderful new drug, he did not say what it was, better than Valium, had enabled him to control his depression. Though his other doctor (Grokest) disapproved of this drug, his life had been restored by it. Not only could he paint again, he had been able to create many—some 300, he said—small paintings. Even better, to Malamud it seemed that Rothko felt secure and had a sense of his own worth. Without sadness and with no premonitions, he spoke of the future.

The demand for his paintings was escalating, and while he continued to raise his prices, he would offer special discounts to purchasers with whom he felt a rapport. One distinguished customer, who bought a large painting, was Dr. Franz Meyer, director of the Basel Museum and a friend of Bernard Reis's. Rothko said that the price of that painting was actually $45,000 but he would sell it to Meyer for $35,000. Other Reis clients—producer Clinton Wilder, Mary Lasker, and Edward Albee—also bought paintings directly from Rothko at reduced rates.

When a collector agreed to pay cash, Rothko, if drunk, might stash the money away casually in a drawer or somewhere else in the studio. If he was sober, important things like money went into a "well," a hollow space at the center of rolled-up canvases hidden behind the partitions made by the full-scale walls of the chapel structure.

One day during that fall of 1968, Rothko became frantic. Money was missing, along with a contract or bill of sale. It was not in the well, where he thought he had put it, and he suspected young Ahearn. Cagily, he asked leading questions, until finally, Jonathan blew up. "I quit. I could have ripped you off blind many times, Rothko," he shouted. "I know those little paintings are worth ten thousand dollars each. But I haven't taken anything. Call the police. I demand a lie detector test." At that, Rothko wept, full of gentle apology, and their relationship was transformed. Before Ahearn left in February 1969, he "became fatherly toward me," Ahearn remembers affectionately. Where the money went is unknown. After that incident Rothko at least once was known by purchasers to have rushed off to the bank to secure cash packets in his safe-deposit box.

Rothko's paternity, late by any standards and too much responsibility for a man in his physical and mental condition, filled him with guilt. At seventeen Kate was rebellious, eager to leave home and escape her parents' drunken squabbles. She had skipped her senior year at Dalton, where she had not been happy, to attend the University of Chicago, but the adventure had not worked out. Kate and her roommate were mismatched—the other girl was four years older, engaged, already a woman of the world, and Kate felt lost. After three months she fled home.

A brilliant student, she had been indulged by her mother, but her emotional needs had been neglected, since the family was always subordinated to Rothko's artistic drive. His own uncertainties had made him overprotective toward Kate, yet he was blindly ambitious for her both socially and academically. She had to be wildly popular and go to the "best" college, Radcliffe; in both respects she had disappointed him. With the unseeing passion of a Lear, he ranted about his daughter, whom when small he had "lusted after." "She hates me, she hates my paintings." he told others. Kate had reacted to the social pressure by biting her fingernails, twisting strands of her hair, and overeating. As described by friends, Rothko himself could be gluttonous, would eat as though "filling a void." Even after a full-course lunch in a restaurant, he sometimes was not satiated, and, passing a sidewalk vendor, he would hastily buy and wolf down a frankfurter. Yet Rothko could not tolerate this tendency in his daughter; perhaps he saw himself in Kate's appetite, and that was unforgivable.

Christopher, then five, caused him even more anguish. The gap between an infirm sixty-five-year-old and a spoiled, active, noisy, bright young boy became unbridgeable. Yet Rothko plied Topher with expensive toys until the boy's room resembled Santa's workshop. While perhaps fearful of Rothko's stormy outbursts, Christopher sometimes reacted with similar tantrums against his father; so Rothko arranged that his young assistant, Oliver Steindecker, and other assistants occupy Topher. The youths taught him to ride a bicycle and also put up swings in the brownstone and a basketball net in the studio. Oliver taught him to skate and often took him on jaunts to Central Park.

However, not even for his children's sake could Rothko tolerate Mell's increasing alcoholism. He reported that she was drinking "around the clock." At art world gatherings, though she always looked

perfectly groomed and well-dressed, it became noticeable that she had been imbibing.

Rothko's melancholia and anger were also clear. In 1968, during the Rothkos' annual Christmas cocktail party, Mell, as usual, wore a bright red dress and had decorated the house with evergreens and holly. Rothko had given her some expensive pre-Columbian jewelry like Becky Reis's, which she had refused to wear. She and Rothko were barely civil to each other. Somehow they managed to get through Kate's eighteenth birthday, December 30.

On New Year's Day, two days later, Rothko left home and moved into the studio. He didn't pack, he just walked out. He would return on visits as his shirt supply diminished and surreptitiously tuck clean shirts under his coat when he left.

Although he continually worried about the family, telephoning and perpetually checking on them, he could not handle any real responsibility other than their financial well-being. He had Bernard Reis set up a financial arrangement for Mell, which, she told friends, was more than she needed. He asked his friend Sally Scharf, whose son was Topher's schoolmate and best friend, to look after Mell, Topher, and Katie for him.

Carla Panicalli flew over from Marlborough's Rome gallery to console him. She told friends that she had done little during her two-week visit to New York but "sit and hold Rothko's hand."

Despite his earlier protestations, in late February 1969, Rothko sold another batch of paintings to Lloyd. For $1,050,000, twenty-six oils on canvas and sixty-one smaller paintings in assorted media on paper were sold to Lloyd's Liechtenstein headquarters. Theoretically the million dollars seemed to be a good deal. In addition, Marlborough was to mount canvases which had been rolled in storage for more than a decade, and the gallery was to pay Rothko's restorer, Daniel Goldreyer, to mount all the papers on canvas. But actually the terms were not favorable to Rothko. The payment, without interest, at first to be ten years, was extended to fourteen years at the insistence of Reis, in order, he said, to obtain Lloyd's guarantee from the Rothschild bank in Zürich. To avoid income taxes it was important to stagger payments, but fourteen years was excessive, especially considering Rothko's age and physical condition. Only $100,000 was paid down, and the total payment without interest discounted would only amount to about $615,000. Marlborough's terms for twenty-six paint-

ings and sixty-one papers were far less favorable than the Beyeler–Glimcher offer of $500,000 outright for only eighteen or twenty paintings four months earlier. The transaction was a direct contradiction of Rothko's pattern of withholding paintings from sale. Perhaps there were hidden incentives. Later, insiders would say that part of the deal was a substantial additional sum deposited in numbered Swiss accounts.

But by far the oddest element in the sale was a supplemental agreement under which Marlborough became Rothko's exclusive agents for the next eight years, until he reached seventy-three. In return for exclusivity, Rothko could borrow up to $75,000 at any time and he obtained a "put" clause, whereby Marlborough, if Rothko chose to sell, had to buy four paintings a year from him at ninety percent of retail market value. This would have enabled him to share in the rising market for his paintings. Significantly, unlike his 1963 contract, the new one contained no "survival clause," which would have made it binding on his heirs and estate.

These terms were revealed by Marlborough long after Rothko's death. What is most puzzling is why he agreed to the exclusivity terms at all. As he explained his arrangement to one friend, Vita Deming, he could sell as many paintings as he wished from the studio (as long as he did not undersell Marlborough's prices) and the gallery was compelled to purchase four paintings a year from him if he chose to consign them, with a very small dealer's commission.

In any case, Reis and Stamos contend that Rothko felt somewhat guilty about having "put one over on" or "gotten the better of" Frank Lloyd on the deal. Reis reassured him by explaining that Lloyd was "an entrepreneur who calculated his own risks." In her discussions with Rothko, Vita Deming found him, the old-fashioned socialist, as acutely embarrassed discussing his dealer as "a child caught being driven to school by a chauffeur in a limousine."

Before he signed the contract, Rothko had been doing some cash-and-carry business with the small papers, of which he offered Bernard Malamud a choice. As Rothko pulled out the paintings, the novelist became mesmerized by a black painting with a jagged blue line running through it, and thought he saw in it the drug-aided breakthrough in Rothko's depression. "It was an autobiographical painting," he says. But Rothko, noticing his absorption, quickly qualified the selection: "Except that one."

Finally Rothko showed him two maroon and black paintings.

"Here," he said. "You can have these. I'll give both of them to you for six thousand in cash. But don't tell anyone, they are worth much more now."

Though Malamud said he would not pay cash, Rothko rolled the paintings up and fitted them into a cardboard cylinder. "If you or your wife don't like them when you get back home, just mail them back to me. But," he stressed, "if you do, be sure to insure the packet for twenty-four thousand."

Neither of the Malamuds liked maroon and Bernard sent the paintings back with a polite note asking whether he could buy some of Rothko's more colorful work. No response to that question. When the Malamuds later invited him to a party, he did not go.

That February, before the Marlborough contract was signed, a Brooklyn doctor and his wife arrived at the studio to pick up a small painting they had chosen from the group Rothko had completed after the unbearable Provincetown summer. "I'm giving it to you for half price," he said, "seven thousand. Don't tell anyone." Again he wanted cash. For an hour Rothko sat with them in the little front room, pouring himself straight Scotches, puffing on endless Chesterfields while offering the doctor a detailed account of his aneurysm. On the table beside him lay two books: a large art biography of Arshile Gorky and William Gibson's *A Mass for the Dead*. On the sidewalk afterward, the doctor said to his wife: "What a tragedy, the poor man. That kind of coronary problem is fatal within two years. He knows he is going to die."

# 7 The Last Year

> Simply by being compelled to keep constantly on his
> guard, a man may grow so weak as to be unable any
> longer to defend himself.
>
> Friedrich Nietzsche
> *Ecce Homo*

After he moved into the studio that winter, Rothko began seeing
Rita Reinhardt, the widow of his late colleague Ad. A beautiful
German-born woman in her late thirties, Mrs. Reinhardt was yet
another artist's widow sheltered under the magnanimous wing of
Bernard Reis. Whenever she needed help with business affairs and
papers, she would call on Reis, who would obligingly handle the
matter for her. At the outset, Reis, who disliked Mell, encouraged the
romance with Rothko.

That year, Rita Reinhardt was badly in need of funds. Unlike
Rothko, Reinhardt had never caught on during his lifetime, and
people were just beginning to "understand" his work. (He is known
for his later monochromatic black canvases with stark geometric

81

crosses hidden in them.) To help her select which works to offer for sale, Rothko accompanied Mrs. Reinhardt to the warehouse where her husband's paintings were stored.

Two years after his death, several dealers, including Arnold Glimcher and Frank Lloyd, now saw possibilities in his work. Glimcher, who made Rita an offer, believes he was thwarted by the influence of Bernard Reis. On paper, Reis was still merely Marlborough's accountant, but more important, as a finder, he was bringing many of his stellar clients, both artists and collectors like Mary Lasker, into Lloyd's fold. (Through Reis, Mary Lasker would sell eight Matisses to Lloyd for two million dollars.)

In March, when the time came for Rita's negotiations with Lloyd, it became apparent to those present where Bernard Reis's allegiance lay. During a key session at Marlborough, Reis was pushing so hard that another of Mrs. Reinhardt's advisers demanded sharply of Reis, "Bernard, just whose side are you on?" When the deal was concluded, Mrs. Reinhardt, for a payout of $655,000 over six years, sold 180 works of art—paintings, collages, and gouaches. She thought the price fair, considering that at Betty Parsons, Reinhardt had proved relatively unsalable, and knew that her bargaining position was therefore far inferior to Rothko's. In a second contract signed at that time, she agreed not to sell any paintings on her own for the next six years, unless she gave the gallery a commission of one-third.

That spring, Rothko's relationship with Mrs. Reinhardt became close. For Rita, her friends agree, Rothko fulfilled a perverse need to care for brilliant, difficult artists. At the time, she talked quite openly of marrying Rothko. For a few months he was more cheerful, but by the summer, he confessed, he knew he must remain unentangled.

Wildly ambivalent in many respects before his illness, Rothko was even more so afterward. Whereas once he had been discreet, particularly about those he was close to, now, often due to a combination of drugs and drink, he was quite the opposite. About Mell, especially. Though he still depended on her in many respects, worried about her, and was in constant touch with her by telephone, on occasion he would tell unflattering tales, some of which, about her drinking, almost certainly were true. Others, it appears, were distorted or concocted apparently because of his need to justify his own behavior toward her.

His insecurities often led him to emotionally inconsistent attitudes toward others. "He would give you the moon and the stars one day, full of affection. The next morning he would curse you and wonder

out loud why he had been such an ass," says a close friend. "More than that, his basic dislike for himself made him wary; if he confided in you—and he was always swearing you to secrecy about the simplest things—later he might distrust you for holding such a confidence, however small."

The fact that since his illness he remained sexually impotent plagued him enough to complain to friends and doctors. Some felt that underneath these spoken worries lay the unspeakable fear that he had become impotent not as a man but as an artist—that he had lost his passion and capacity to create great art.

In his utter dedication to the promulgation of his works, he had lost his objectivity. More confusing, he had retained his canny brilliance as well as his theatrical talents. With some people, he was still the loving friend, although his conversation was generally about himself. With others, he became the misunderstood intellectual. According to one companion, at a party filled with well-known actors and actresses, Rothko seemed jealous of the flattery and attention they received. "He wanted to be treated like a movie star." Then columnist Max Lerner came over, patted him on the back, and said, "Why are you so worried? After all, Mark, you're the only genius here." He was mollified, but such moments never lasted long.

Though on paper Rothko was a millionaire, he lived like a pauper. The accoutrements at the studio were frugal, the few items of furniture were junk-shop Victorian and Sears, Roebuck modern. When, at great expense, he had a shower installed illegally, he agonized over the purchase of a $1.99 Woolworth shower curtain. When he first wore the expensive tailored suits which Reis influenced him to buy, "he looked like a real mensch," as Becky Reis put it to friends; but at night, he was apt to drop the suit in a heap on the floor.

He often talked about sharing his wealth, helping a few elderly artist friends who had not succeeded in the marketplace. At the same time, he would fly into a rage if he thought someone was "trying to get something for nothing," and often declared that he could not trust anyone "who did not have one foot in the Depression."

Having only painted innumerable papers on a small scale for the past year, by the spring of 1969 Rothko regained enough of his physical and emotional powers to bring out large stretchers again and, using fast-drying acrylic paints, embark on a series of stark, opaque black-on-gray paintings. It was a kind of breakthrough at last. The

soft, misty interior rectangles disappeared, and the darkness became inpenetrable, sharply delineated from the gray and edged with abrupt white margins. Three of his assistants say that the idea had come to him from the small acrylics which he had attached to the walls with masking tape; when the tape was removed, Rothko was struck by the contrast created accidentally by hard white edges. Others, including Herbert Ferber, believe the idea had come to him from the margins surrounding photographs of his paintings.

Four hours he would sit brooding before the new works, and when visitors came to the studio, he would ask, "What do you think? What do they say to you?"

When Maurice Sievan, one of the elderly painters for whom Rothko had great affection, stood staring at the paintings, Rothko shrugged and said to him, "Meshugge, eh?"

Oliver Steindecker told him they were like "night on the moon." Restorer Daniel Goldreyer said at the time, "Quite frankly, they are the ugliest paintings I ever saw—get off that kick." Rothko replied, "Do you really think so?"

To Stamos, they were beautiful "Goya-esque landscapes." Betty Parsons calls them "sort of a farewell," a finale in style. Without realizing what he was saying, one collector was surprised to find "Reinhardts" in Rothko's studio.

When Jonathan Ahearn and his new wife came back to the studio for a visit, Rothko showed them these blacks on grays with great pride. Like many others, Ahearn found them "ominous," and "filled with impending doom."

But there is little question, no matter what reactions they inspired, that for Rothko these new works represented a kind of renewal. As Philip Guston points out: "Of course he was ecstatic about those pictures. Like me. When I finish the most horribly depressing painting, I can barely contain myself. I lie down on the floor and rollick with laughter."

He painted some twenty different blacks on grays. Like the chapel murals, these paintings would affect viewers with their awesome finality and would also fulfill one of Rothko's aspirations: "What I want," he told Ahearn, among others, "is for people to cry when they experience my paintings. The way I do when I hear Beethoven's Fifth Symphony." Rothko's great paintings can still evoke such pure feeling. The blacks on grays have been compared in emotional and intellectual depth, in fact, to Beethoven's last quartets. But for tech-

nique, it was Mozart's virtuosity that Rothko most admired, his orderly mind and delicate balance.

After this phase, as Jack Tworkov points out, Rothko had nowhere to go. If he had been able to complicate his image rather than simplify it to the extreme, his art could have soared in new directions, but the image which had become his trademark was inescapable. As Sally Avery speculated, what if it had been possible for him to start again under an assumed name, as Japanese artists do when they have reached a plateau in their careers. But, after all, he had changed his name and his style twenty-five years before—it was too late to begin again.

That same spring, over lunch, Rothko asked William Rubin of MOMA to become a director of the about-to-be-formed Rothko Foundation. Rothko told him that the foundation would hold the bulk of his paintings. He was, Rubin says, concerned about the protection, promulgation, and ultimate disposition of his work. Rothko again stated his long-standing objective: "a deep desire to keep many or various groups of his paintings together permanently." Earlier Ben Heller had explored the possibility of a Rothko wing at Princeton's new museum, but nothing had come of it because Rothko had not offered to provide financial upkeep.

But, Rothko said, Bernard Reis had decreed that the purposes of the foundation, because of an IRS decision, must contain clear charitable benefit. As a secondary function, therefore, it would distribute moneys to certain impoverished elderly artists.

Rothko's "virtual obsession" with the placement and the destiny of his paintings was emphasized to Rubin in yet another way. A Rothko room at MOMA like that scheduled to be installed at the Tate had always been one of his dreams. However, the trustees had vetoed any such permanent sanctuary. Rubin did persuade him to make a gift to the museum of five paintings. An exhibit scheduled to open in June, "The New American Painting and Sculpture: The First Generation," would feature a roomful of these Rothkos and the others in MOMA's collection.

To choose the paintings for the exhibition and the gift, Rothko took Rubin and art scholar Robert Goldwater to the warehouses, the studio, and the brownstone. Rubin and Goldwater inspected all the large oil paintings—more than 250 altogether. Both experts were impressed and remarked on the extraordinarily consistent high quality

85

of his paintings. It was amazing to them that an artist could have maintained such high standards over a period of twenty years.

Rubin finally narrowed his selection. Of seven he wanted, Rothko gave him three; two other, formative works he said belonged to Mell, since they were hanging in the brownstone. Mell agreed in writing to donate these two, even though one was *Slow Swirl by the Edge of the Sea*, which Rothko had traded back from the San Francisco Museum, because of its importance as a transitional work and its personal significance.

Rubin also chose two later, larger works (*Homage to Matisse* and *Number 20,* 1950, the only paintings from his mature period that Rothko titled), which he asked Rothko to sell to a collector who would donate them to the museum. Rothko refused. They were part of important groups which must always be kept and shown together, never singly. There were, he said, five or six such groups. Had he known what the future held for these paintings, without doubt Rothko would have accepted Rubin's proposal.

In 1969 there was very real pressure on artists to donate works to museums. This was the last year an artist was allowed to deduct the fair market value of his gift from his income taxes. In December 1969, Congress would pass the so-called Tax Reform Act aimed at curbing some of the questionable activities of charitable foundations. Retroactive to July 25, 1969, the law decreed that the only deduction the creator could take for giving his oeuvre to a museum or a charity was the cost of his raw materials. (Nixon fell afoul of this law when, in order to deduct the gift of his vice-presidential papers and claim a highly inflated $570,000 value, the transference was backdated to the spring of 1969.)

For the artist, the new law was devastating. Like an old pair of shoes given to a thrift shop, his creation was no longer considered by the U.S. government to have meaning in terms of the skill, training, genius, and emotion that went into its making. Officially, art became chattel, to be used as such by everyone but those whose dreams it represents. The law did make speculation in art less attractive to private foundations by limiting the terms of their deductions for gifts of art. But the individual wealthy noncreator who purchased the work might capitalize on it in many ways. In fact, the Rockefellers, the Mellons, and other millionaires, continued to use donations of art as a means of reducing taxes—sometimes to zero. After the Tax Reform

Act, the only way in which artists could see their earlier works assured of the protection afforded by museums, without total financial loss, was for the artist to prostrate himself before a benefactor. Find a rich friend, Bernard Reis and other accountants advised their clients. Ask him to buy your painting, let it appreciate at least six months, and donate it to a museum. If the patron donated money or stocks equivalent to the declared value of the painting and the museum purchased it directly, everybody won. The donor got a better deduction than if he had given the painting outright, and it looked as if the museum had sought the artist's work. But, no matter, the law was grossly unfair and genuinely demeaning to artists.

Yet another highly questionable IRS procedure had been instituted a year earlier, when the official Art Panel was established to guide the IRS about tax deductions taken for works of art. Revolving appointments to the panel were made by the commissioner from the art clique itself—dealer members of the ADAA and curators and directors of museums. Six days a year, these far-from-disinterested professionals would meet to evaluate the claimed deductions for art in artists' and collectors' estates and works of art donated to charities. In the microcosm of the art world, it was next to impossible for these outsiders not to know exactly whose works of art they were considering, and though sworn to secrecy, whispers of the deliberations could be easily passed on to interested parties. Artists' estates were particularly vulnerable to reassessment; despite the fact that their creations might not have sold during their lifetimes—as was the case with David Smith's sculpture, for example—the IRS could and would, using post-mortem sales figures as a yardstick, claim mammoth increases in taxes due. Nor could the estate deduct dealers' commissions as necessary expenses. Thus the formation of the panel led to even more fudging of inventories, appraisals, charitable deductions, and to increasingly huge fees paid to lawyers and accountants.

After Rothko's lunch with Rubin, a preliminary meeting of the fledgling foundation was held at the studio. Rubin and Goldwater, Levine, Stamos, Reis, and Rothko attended. Or rather as Rubin remembers it, Rothko could not be described as totally there—he was "soused," and when he tried to cross the floor, he fell on his face.

Nevertheless, the discussion proceeded. Rubin presented the alternatives he and Rothko had discussed at lunch. Perhaps like the Léger Museum in France, the foundation might buy a brownstone to house

and exhibit the collection. But Rubin remembers that Reis interjected that was not "viable," because it would cost too much. Rubin then proposed long-term revolving loans to museums which could not afford Rothko purchases but would agree to exhibit the works in their own space with natural or low lighting. This way, he said, costs would be kept to a minimum, since museums generally pick up the tab for insurance, transportation, and even restoration. There was some talk of giving grants for some impoverished elderly artists, but Rubin remembers this as scarcely more than an aside. Rothko appeared so "dazed" that he might not have heard a word.

That June, when Bernard Reis had his lawyers, Karelsen Karelsen and Nathan, incorporate the Mark Rothko Foundation, Rubin was dropped as a director, as a year earlier in Rothko's will Mell, Stanley Kunitz, Ben Heller and Herbert Ferber had been. Clinton Wilder, an intimate friend and client of Bernard Reis's, and composer Morton Feldman, whom Rothko liked, replaced Rubin. Privately, Rothko asked critic Katharine Kuh to serve on an advisory board of the foundation, but such a board was never established.

According to its official papers, the foundation could hold "real or personal property" and was vaguely defined as "exclusively for charitable, scientific and/or educational purposes." There was no mention of aiding indigent artists. Like Rothko's will, the document was deliberately vague—to avoid any bind, as Reis later told Goldwater.

Rubin and Rothko lunched together several times after that meeting, but there was no further discussion of the foundation. Rubin thought Rothko was "embarrassed" that he had been dropped, and, not known for his excessive humility, Rubin was perhaps too proud to bring it up (or perhaps he thought it might compromise his position at MOMA). Rothko may have been angry because he had heard that Rubin had sold one of his Rothkos to Ben Heller. Besides, each time Rubin saw him, Rothko was drunk. Later, Mell told Rubin that Bernard Reis had influenced Rothko against him. But the other directors agree that Rothko was angry because Rubin had suggested he be paid a fee as consultant to the foundation.

To present his life's work properly, Rothko had asked Robert Goldwater to help him write a book. They would meet for two-hour sessions in the afternoon, and Goldwater would make extensive notes. During these periods, Goldwater found Rothko lucid and articulate, though bitter, particularly about the youth of the day, who he said did not know or understand his work. Through the book, he hoped to

correct that breach and to silence the outpourings of admiring but ill-informed critics about the meaning of his paintings.

If at the end of his life Rothko was naïve in his friendships and business dealings, and susceptible to flatterers—though paranoid at the same time—about his art, his instincts were sound. In choosing Robert Goldwater, professor at New York University's Institute of Fine Arts and head of Nelson Rockefeller's Museum of Primitive Art, to be his official biographer and the executor of his artistic testament, he put his trust in a man of integrity and ability. A dry but original historian, Goldwater comprehended Rothko's unconventional religious turn of mind.

During his last year, Rothko relied on others for even the most pragmatic decisions. Perhaps it was for reinforcement, or was his only way to keep in touch with people. "He had a terrible fear of abandonment," suggests Albert Grokest. He would often call friends for lunch at the last minute or would try to make contact at odd hours; Stamos, for example, would be greeted in the early hours of the morning with "Hosannah to you." Those with regular habits had to turn off the telephone. He usually called with some silly problem. Stanley Kunitz recalls endless late-night conversations about an overcoat. "He wanted to buy an overcoat like mine and could talk about it indefinitely." The overcoat was a constant topic with others, too. When he finally found someone who helped him buy one at a discount, he returned it. The "Rothko overcoat" became an art world byword, like Rembrandt's hat.

Stamos and other artists would make an effort to have lunch with Rothko. Rita Reinhardt would devote many evenings to going out with him alone for dinner or to art world parties. Morton Levine would drop by after teaching for stiff drinks and soothing classical music.

When Rothko went to Ninety-fifth Street, there was usually a fight. Having heard gossip about Rita, whom she thought had been *her* friend, Mell was hurt and jealous. Or Rothko might begin the argument with "Are you trying to poison me putting oil in this salad?" "She gave me rice when she knows I hate rice," he would complain to Lidov after a meal at home, ignoring the fact that rice was recommended on his low-fat diet.

On weekends, Topher would come down to the studio, where Oliver Steindecker would play with him. Or Sally Scharf and Rothko would

take their sons on an outing. When Kate saw her father he was generally in a deep uncommunicative depression. Only once did he seem close to his old self, when in the fall he took a taxi to Brooklyn to visit her new first-floor apartment where she had moved to attend Brooklyn College. He advised her about courses and reminisced about his teaching days in Brooklyn.

The proximity of the studio to the Reises' town house made daily visits convenient. "I would see him for breakfast, lunch, or dinner, sometimes two and three times a day," said Reis. Levine remembers that Reis "hovered over" Rothko. Frank Lloyd described Reis and Rothko as "Siamese twins." Stamos was more specific, noting that Reis served as Rothko's marital adviser, had clothes tailored for him, outlined itineraries of trips to Europe, including the finest restaurants, and introduced him to many collectors. Later, describing the relationship in court, Stamos would add pointedly, "They were closer than most married people in *every* respect." From this allusion, many people among the press and public thought Stamos was implying that Reis and Rothko had been lovers, but according to Rothko's doctors and intimates, there was never any evidence that he had homosexual tendencies at all—quite the opposite, he adored women.

It is far more likely that for Rothko Reis became something of a father figure. Embittered by the loss of his own father (both when Jacob left Dvinsk for Portland and when he died three years later), Rothko, as his insecurities mounted, needed constant reassurance. The role of substitute father suited Reis who could bask in Rothko's glory, which in turn gratified the artist. Moreover, this septuagenarian daddy would watch over Rothko's affairs, count his money, in effect mete out an allowance, choose his clothes, give charming parties, compliment him on or reject his friends, worry about his health, and find him doctors. Whether the paternal aspects of their relationship ever occurred to either of them is not known.

As in most dependencies, there is some evidence of both love and hatred from Rothko and, from Reis, what might be called jealousy. To at least two friends, Rothko said that he could not stand Reis or "that type of man." There was no doubt of his financial dependency, but to these two he repeatedly talked of his dislike during that last year. He was annoyed that Reis made a habit of coming for breakfast—instant coffee and RyKrisps. Once when Rothko had a woman guest in the studio, the doorbell rang. He went to the front door and

came back minutes later. "Oh God," he said in his most disparaging voice, "it was just good old Bernie. I got rid of him." (Few called Reis anything but Bernard to his face.)

Over the preceding years, Rothko had broken with or dropped close friends, often encouraged to do so by Reis, who would point out their defects or alleged disloyalty: Herbert Ferber, William Rubin, and Ben Heller—all of whom had once been close advisers of Rothko's, —fell out with him, and say Reis was a divisive force. Both Reis and Levine encouraged Rothko to leave Mell; the Reises told Kate what a good thing it was for her father that he had left her mother. A lawyer friend of Levine's advised Rothko about divorce proceedings, but Rothko did not actually go through with it. And after the match with Rita Reinhardt began to look serious, Reis and Stamos discouraged that, too. Stamos would make fun of Rita's melancholy outward calm and perpetual black dresses and would suggest to Rothko that she was only after his money and paintings.

Despite anxiety about his artistic stature, Rothko continued to receive honors—among them, in June 1969, the Rothko room at the MOMA exhibition. At the opening, he was noticeably pleased when a group of young artists approached him worshipfully and one said, "Thank you, Rothko, you permitted us." From Yale, his rejected alma mater, he received an honorary degree, which read:

> As one of the few artists who can be counted among the founders of a new school of American painting, you have made an enduring place for yourself in the art of this century. . . . Your paintings are marked by a simplicity of form and a magnificence of color. In them you have attained a visual and a spiritual grandeur whose foundation is the tragic vein in all human existence. In admiration of your influence which has nourished young artists throughout the world, Yale confers upon you the decree of Doctor of Fine Arts.

And whether he knew it or not, his prices were at new highs: On June 9, at Marlborough Gallery, a 94″ × 70″ Rothko titled by the gallery *Orange, Purple, Orange* painted in 1960 and sold to Lloyd three months earlier for $22,200 (forty percent discount on a minimum retail price of $37,000), was purchased for $50,000 by Mrs. George Staempfli, the wife of an art dealer. A month later, another, slightly

larger painting, sold to Lloyd for $22,800 the preceding February, was resold by Marlborough for $53,500 to Mrs. Louise Ferrari.

Nothing could raise Rothko's spirits for long. That August, while almost everyone was on vacation—including the Reises and doctors Grokest and Kline—Rothko hit a new low. He made an appointment with the doctor to whom the absent Grokest had referred him, who increased the dosage of Tofranil, one of his antidepressants.

But his mood continued to decline. A few days after his visit to Grokest's replacement, in a state of grogginess he staggered into the office of Dr. Allen Mead. It was Mead who had treated Rothko during his hospitalization for the aneurysm, but the internist, who shared an office with Dr. Wright, Rothko's cardiologist, had not seen Rothko for more than a year. Mead noted that on this visit Rothko was totally disoriented, disturbed, and dazed, though his blood pressure was good. Mead cut in half Rothko's dosage of Tofranil and Dr. Kline's prescriptions for Mellaril and Valium, which the artist was taking four or five times a day, and sent a report of this to Dr. Kline.

In September, Grokest persuaded Rothko to see a more traditional psychiatrist, who reported that Rothko's depression was of such magnitude that he should begin therapy immediately. But, says Grokest, "Rothko had no tolerance for introspection. He did not want to change."

For a number of years, Grokest had seen Rothko alone socially in order to reassure him that he would not be abandoned and convince him he was "lovable—and capable." When Rothko was low, Grokest would ask whether he was "doing any suicidal thinking." Rothko would either say no or remain painfully silent. When Grokest asked him that fall how his relationship with Topher was going, Rothko muttered unintelligibly, then said clearly, "Oh, don't worry about Topher. Steindecker and Topher are crazy about each other." Grokest told him that having found a surrogate father for his son was nothing to feel guilty about, and Rothko, he thought, seemed greatly relieved.

In different ways, both Grokest and Arthur Lidov tried to warn Rothko about Reis. Lidov asked Rothko how Reis could possibly advise him and the Marlborough Gallery at the same time. Grokest became angry about Reis taking him to Kline without consulting Grokest. But Rothko would hear nothing against Reis from them. "He is the best in that business," he would reply. "I leave everything to him." Almost everything, the world would learn in time.

# 8

# The Last Months—
# the Final Pressures

## (OCTOBER 1969–FEBRUARY 24, 1970)

> Out of the very love one bears for life, one should wish
> death to be free, deliberate and a matter of neither
> chance nor surprise.
>
> Friedrich Nietzsche
> *The Twilight of the Gods*

The stately, black-tie world of the Metropolitan trustees found itself mingling with tribal swingers dressed as American Indians, frontiersmen, Cossacks, Restoration rakes, gypsies, houris, and creatures of purest fantasy. The see-through blouse achieved its apotheosis that night, and spectators lined up three deep to observe the action on the dance floor—there was a rock band in one gallery and a dance orchestra in another, to say nothing of six strategically placed bars. Works of sculpture acquired festoons of empty plastic glasses, the reek of marijuana hung heavy in the air, and at one point late in the evening, while the rock group blasted away in a room full of Frank Stella's paintings and David Smith's sculptures, a tall woman and a lame sculptor wrestled for

93

fifteen minutes on the parquet floor, untroubled by guards, spectators or a century of Metropolitan decorum.

This is Calvin Tomkins's by now classic description of the party held on the evening of October 18, 1969, at the Metropolitan Museum in celebration of its entry into contemporary arts with the mammoth exhibition "New York Painting and Sculpture: 1940–1970." The occasion also served as the opening of the museum's three-year centennial celebration staged by Thomas P. F. Hoving, the Metropolitan's flamboyant forty-year-old director. The art had been selected and assembled by Henry Geldzahler, curator of the two-year-old department of contemporary art. Four hundred eight works by forty-three painters and sculptors filled thirty-five galleries on the museum's second floor.

For many artists the exhibit was a fiasco. Geldzahler had dealt with the acknowledged giants of the era in an eclectic hit-or-miss fashion. Works by his friends predominated. So did those owned by his collector friends or handled by his favorite dealers. The critics roasted the show and him. "A boo-boo on a grand scale," was what John Canaday called it. "An inadequately masked declaration of the museum's sponsorship of an esthetic-political-commercial power combine promoted by the Museum's Achilles heel"—that is, Geldzahler. Favoritism was charged. Others charged that critic Clement Greenberg, who was known as kingmaker of the art world and Geldzahler's guiding light, was behind the selection and had omitted representative works by such important artists as Louise Nevelson and Larry Rivers.

Geldzahler himself wrote a revealing monograph for the exhibit. He described the history of the era and the changing power structure of the art world. Praises were heaped on everyone—art magazines, critics, other museums, curators, collectors—even certain artists—but special plaudits were reserved for the dealers. Defensive about his position and the criticism engendered by the museum's crash program in modern art, he likened his department to a larger and better dealer's gallery. Contemporary art needs space, he said, and the Metropolitan was more "generously" equipped to show these works than were other museums or galleries.

The skyrocketing prices and the materialism of the star-studded art marketplace Geldzahler judged good for art and good for the museum:

While the total self-interest of New York's real estate industry, for example, is contributing to the destruction of the city, this same self-interest in the economics of the art world may finally benefit the public. A work of art often makes its way from the privacy of the artist's studio, through the gallery to the collector, and finally to the museum. The general public is excluded from purchasing and living with much of the best art being produced in our society, for it is in short supply in relation to the number of potential owners, and because it is expensive. Ironically enough, these very factors, scarcity and price, inevitably help speed paintings and sculptures into museums and other public institutions where they become available to the widest possible audience. Our tax laws make it sensible for the wealthy to give works of art to museums, and our social structure makes it attractive to be associated with a museum. . . . While works of art are sometimes bought cheap and sold dear, or are accumulated in the drive toward upward social mobility, there are also many collectors who love art and are willing to share it with others.

Share it with a tax write-off. In other words, the higher the prices, the better for everyone—except perhaps the artist, from whom art was "bought cheap."

What Canaday had implied and what Geldzahler neglected to mention in his essay was that many of the 408 art works he had chosen were actually merchandise for sale from some of what he called "important" collectors and "far-sighted, blue-chip dealers." From his close friends, taxi magnate Robert Scull and his brassy wife, Ethel, Geldzahler had borrowed seventeen of their newly and cheaply assembled collection. The Sculls would offer much of their splashy collection for sale at Parke Bernet, establishing new highs in contemporary American art prices and auction showmanship. The sales were in two lots, the first within a year, the second three years later. Naturally, the Metropolitan's imprimatur greatly enhanced the prices.

And while Hoving's preface had claimed that the entire exhibit was "loaned from museums and private collections around the world," actually this was far from true. In any contemporary exhibit, reliance on dealers' stock is necessary, but Geldzahler had overindulged his New York dealer friends. When the attribution read "courtesy of

Marlborough-Gerson Gallery" or Castelli or Knoedler, the works, of course, were for sale. "Private collection New York" on thirty-two of the forty-two Ellsworth Kellys in the show might have stood for Sidney Janis, then his dealer. There were forty works by Geldzahler's friend Jasper Johns in the show, fifteen of them obtainable from Leo Castelli. And ten of the twenty-two sculptures by David Smith, for whose estate Clement Greenberg served as executor and Marlborough as exclusive dealer, had invisible price tags.

Geldzahler was serving new status, both social and financial, to his friends. It was the beginning of the dowager museum's transformation into a "bordello," as one important collector termed it. And in two years' time, she was destined to turn into a very high-class stripper, de-accessioning some of her prize possessions to the pushier peddlers in the art crowd.

The show angered Rothko and gave rise to further uncertainties. It exacerbated his self-doubts, his hatred of the marketplace, and his fears for his stature in that fickle, artificial world. Even though ten of his paintings were given a large room of their own, the relative preponderance of Pop and Op bothered him. Of the roomful of Rothkos, one, *Reds Number 16,* 1960, had been acquired by Scull and loaned to the show; the rest were loans from other collectors and a museum. Rothko confided to a friend that the Reinhardt space was more prominent than his work deserved. Five of the nine Reinhardts were owned by Frank Lloyd, part of the March purchase from Rita Reinhardt. Was that the reason Reinhardt was accorded new stature? And Marlborough had scheduled an elaborate Reinhardt retrospective to commence in March right after the Met exhibit ended.

The room at the Tate was scheduled to open in 1970. Rothko had cancelled his trip to London for a firsthand study of the space, but that fall, using a scale model of the space, he determined which of the Seagram murals would suit it best. One had been sent to London, seven more would follow. By the time Tate director Sir Norman Reid arrived on his annual New York visit, the decision had been made. During Reid's visit Rothko became falling-down drunk and, according to Arthur Lidov, was totally unaware of his bodily functions.

Rothko and Rita Reinhardt gave a cocktail party in the studio that fall, his last, which was not a success. Rothko was uncomfortable.

Black-on-gray paintings hanging on the walls of the chapel struc-
ture may have added to the stiffness of the occasion.

Twice, in November and December, Rothko, desperate, telephoned
Dr. Grokest. "What shall I do?" he asked. Each time he said that
Bernard Reis had taken him to see Dr. Nathan Kline at night, after
office hours. He had been given new pills and one, Sinequan, had
frightened him. Should he take it? "Under no circumstances," advised
Grokest, again appalled that no one had consulted him for his diag-
nosis and Rothko's history or to discuss which drugs he was already
taking. Sinequan's side effects tend to intensify such symptoms of
alcoholism as blurred vision, staggering, and forgetfulness. When
Rothko dropped in during December, he was "pie-eyed, having con-
sumed astronomical amounts of alcohol." Grokest reiterated his warn-
ings against Sinequan. A week later, Dr. Kline sent Grokest a registered
letter, saying that Rothko was acutely depressed and "suicidal." Kline
requested a consultation with Grokest. Grokest did not reply. Later
when Kline telephoned Grokest to discuss Rothko, still incensed by
Kline's methods of prescribing drugs without medical consultation,
Grokest refused to have further contact with him.

On a December afternoon at the studio, Morton Levine showed his
slides of Rothko's inventory. Reis and Stamos sat with Rothko and
watched, as much of his life's work flashed on the screen. Persuaded by
Reis to set his affairs in order, Rothko prepared to make a further sale
to Lloyd. Most of the proceeds would be used to establish trust funds
for the children and supply some seed money for the Mark Rothko
Foundation.

As the gallery's accountant, Reis knew Lloyd's profits on Rothko's
February sale had already been more than substantial. Having sold
only ten of the oils on canvas and eight papers by December 31, 1969,
the gallery would gross $525,770. Since Lloyd had paid Rothko only
$100,000 down on the eighty-seven works, whose total price was
$1,050,000, the balance to be paid over the next thirteen years with
no interest, his gross profit over just ten months was already $425,770
—well over four times what he had paid. And there were sixteen
immensely salable canvases and fifty-three assorted papers in the
Marlborough warehouses waiting to be doled out slowly to eager
purchasers.

The pressures on Rothko mounted. When Lloyd and Donald Mc-
Kinney arrived at the studio to make the selection, Rothko was dis-

dainful. His friend Dan Rice, who was helping him out at the time, remembers that he said in an aside, "Watch these slanty-headed people, they don't know which end is up." And indeed Rothko and Rice watched wryly as Lloyd and McKinney passed up the new blacks on grays for more colorful works.

Lloyd chose some of the paintings that Rothko had been carefully re-creating in his earlier style, some greens over blues and reds over greens. "Subconsciously Mark was lining his coffers, to sock it away for Mell and the kids," says Rice, and adds that these paintings were of superior quality, despite their resemblance to paintings past. "With anything Mark painted, quality was all-important." The brighter colors were bound to be more salable than the more somber work, so Lloyd, as usual, got his money's worth.

Lloyd bought eighteen oils on canvas for $396,000—based on "anticipated resale values" totaling $498,000—This produced an outflow of $63,000 in cash, with another $114,000 to be paid Rothko in ten yearly installments. One hundred forty-four thousand dollars would go to the children in trust and the foundation would receive an initial $18,750 that year and for four years thereafter.

Several times during the last year of his life, Rothko stormed into Marlborough on Fifty-seventh Street and demanded to see their price lists. Somehow he had heard that their markup was much higher than they had led him to believe. One Marlborough employee has reported that she was told to switch the prices while Rothko cooled his heels. His suspicions were justified, but it is not known whether they were confirmed.

Rothko refused to go to Mell's Christmas party. In fact, very few people from the art world did show up. They had always treated her like "some little middle-class yahoo from Ohio," as Dan Rice's wife, Jackie, puts it. Now that the star performer had left the stage, why bother with that boring show? Her wounds deepened as she felt her rejection. And she had heard about the party Rothko had given with Rita, which many of their old friends had attended.

Rothko's one known, though oblique, reference to suicide was made at a party given by Katharine Kuh during the holidays. He looked very thin, drawn, and tense but he had not had a drink, at least not there. After expounding on his personal problems to Katharine in the kitchen, he said, "I just don't know what to do about it all. The best

thing would be to do away with myself. They would all be better off if I was dead."

Miss Kuh suggested he see a doctor, but he bridled. When she saw him several weeks later, he told her he was unwell, depressed. He couldn't work. What he had accomplished was unappreciated. He couldn't move beyond his one image, which, she believes, bored him and had imprisoned him. "He was stymied, benumbed by worries and apprehensions," she says. "A man of professional mind caught in a web."

Sometime during that last year of his life, Rothko reportedly had Reis execute another will. It was said to be witnessed by Rita Reinhardt, among others. Allegedly, when she later asked Reis about this will, he is said to have told her that he had destroyed it because it was unfair to the children. How it could have been more disadvantageous to the children than Rothko's previous will does not bear scrutiny.

During that same period, while Rothko was turning increasingly paranoid, he took a lady friend to the movies. They saw, as she remembers it, John Huston's *The Kremlin Letter,* in which someone was murdered for money. When they emerged from the theater, Rothko said to her dramatically "Well, you see, don't you, what *they* will do for only *one* million dollars?"

On January 27, 1970, Rothko again stumbled into the office of Dr. Allen Mead without an appointment. He said that he had been seeing Grokest weekly, but Grokest had gone to Mexico, specifying Mead as his replacement. Rothko had continued to take large amounts of Valium. He said he had been unable to work. Everyone was pressuring him—his family, his girl friend. He was impotent. He could sleep with the help of chloral hydrate, but would wake in the middle of the night. He weighed 154 pounds; he had a hernia, gout, and emphysema from chain-smoking. He was confused about what he should be eating to ward off hypertension. But his blood pressure, which Mead took on both arms as is usual with cases of hypertension, was good. He had continued to receive medication from Dr. Kline.

Mead explained the diet carefully, repeating his warnings about alcohol. Again he cut back Rothko's Valium dosage and reported this to Kline. He was somewhat surprised to receive a form letter from Kline's office two weeks later, asking him to detail the drugs Mark Rothko was taking, and to find an undated telephone message from Kline that Dr. Wright had jotted down saying that Kline had put

Rothko on Sinequan. "Attention," it read. "Some other physician has scared him to death, told him Sinequan is bad for coronary cases." Kline asked that Mead reassure him. "Rothko is scared to death, expects to die at any moment."

In February, Rothko said that he was able to work again. With Rita, he appeared at the usual round of parties, still low but no longer outwardly so desperate. He worried about his eyesight, which had never been good. Extremely myopic, he could not move without his spectacles. But when he read or studied details, he would remove the glasses and hold the book or menu within inches of his eyes. It is unlikely that he suspected the new medication might affect his eyesight.

Perpetual company kept him going. Often he would summon to the studio people he had not seen for years. He continued to worry about his aging friends who had not achieved a success comparable to his own: George Constant, Maurice Sievan, and Gwen Davies. Out of the blue, he asked artist Jim Brooks and his wife, painter Charlotte Park, to the studio. But Jim went alone, and when he arrived Rothko seemed slighted that Charlotte had not come. For this rare occasion, he had invited Mell to the studio. Brooks thought her role was almost that of Rothko's translator. Rothko was edgy and withdrawn. *War and Peace* was lying on a table, so they talked about Tolstoy. Then Rothko asked Brooks what he thought of the black-on-gray paintings. Warily, Brooks said he found them melancholy; but he was not wary enough. The response was "Not melancholy—they are forceful."

Then, Brooks realized, Rothko got to the point. "How are you doing?" he asked. "Fine," Brooks replied quickly to forestall Rothko. "I think he was going to give me a handout."

Rothko went to a dinner party Betty Parsons gave. She had invited a group of young people, hoping they would be able to establish a rapport with him and allay his distrust of youth. But he could not relate; more than that, she found, his memory had gone. Others had also noticed this. Sometimes in midsentence he would break off as though he could not remember what he was saying.

At a big party given by the dealer Grace Borgenicht, celebrating the opening of a Milton Avery show at the Brooklyn Museum, Rothko sat down with Maurice Sievan and, full of affection, talked of philosophy, music, and art for half an hour. The discussion began like old times, touching on Mozart, Kierkegaard's *Either/Or*, and Nietzsche's views on death in *The Birth of Tragedy*. Rothko, after asking about

Sievan, started talking about himself. But he was not really communicative. "Nobody," he said, "understands my work anymore."

As Jim Brooks sees it, "When his work became a commodity he could no longer evaluate it; he did not know whether people were buying his paintings because they were good or because they were Rothkos."

Some days before Rothko died, author and psychologist Gerald Sykes visited him at the studio. They discussed gout, which still plagued him. Occasionally his finger joints were swollen. Sykes told him that he had been able to rid himself permanently of gout by taking Benemid and going on the wagon. Rothko seemed to be paying attention and then spoke "with exceptional clarity and vigor" of "public art" and his disgust with the Met show. Sykes thought he was in command of his faculties but noticed that from time to time he was secretly swigging from a bottle in the kitchen.

Ten days before he died, his friend Sally Scharf went to Central Park with her son, Andy. There she saw Rothko sitting alone near the skating rink, where they had so often taken their boys together. But he looked so contemplative, so low and alone, that she decided not to disturb him.

That week, Thomas Messer, director of the Guggenheim, brought a curator to look at the blacks on grays, hoping to exhibit them. "I was moved by them," he said. "They are very beautiful, dark, autumnal paintings."

A former assistant, Ray Kelly, and his wife came to see Rothko at the studio. Rothko mentioned how much the Metropolitan show had depressed him. Kelly asked whether he could borrow $5,000 to buy a house on the Bowery. Rothko said that if they could come back next week, he would have the money for them.

On Thursday, February 19, Rothko had breakfast with Bernard Reis. The Reises were leaving New York that day for California, to visit their daughter and two grandchildren. Reis said he discussed the Guggenheim exhibit with Rothko and a further sale to Marlborough —the third within a year. Donald McKinney had an appointment with Rothko at the studio the following Wednesday, February 25. From the studio, they were to go to the warehouses, where McKinney would make his selection. Rothko was deeply disturbed by this invasion of his works' privacy. Before this, he had selected those paintings he wanted to sell; no purchasers had ever been to his warehouse. This

dreaded appointment was to plague and preoccupy Rothko throughout his final days.

A family get-together had been planned for that Thursday evening before Mell and Topher were to leave for Washington, D.C., to visit Rothko's nephew, Kenneth Rabin, and his wife over the long Washington's Birthday holiday. The Ninety-fifth Street dinner was another flop, both parents filled with venom and recrimination.

But after the departure of his wife and son, Rothko worried. On Saturday he called Kate at Bellevue Hospital, where she was working weekends, and asked if she had heard from Mell and Topher, did she think they were all right? Somewhat impatiently Kate replied that of course they were fine. It was Kate's last conversation with her father. Rothko later telephoned Mell anyway, sounding so low that Mell called Morton Levine and asked him to look in on him. Levine called back to say it was nothing more than another deep depression.

On Saturday evening, with Rita Reinhardt, he went to a party at furrier Jacques Kaplan's. His eyes were glazed and he seemed withdrawn, in noticeable distress.

On Sunday, again he was seen sitting alone all bundled up near the Central Park skating rink.

On Monday, restorer Daniel Goldreyer had an appointment with Rothko at the studio. Goldreyer thought Rothko seemed especially unsure of himself and withdrawn. He was not drinking.

The following day, Goldreyer spoke to him on the telephone about work in progress. Rothko had a lunch date with Sally Scharf, which she was forced to cancel. She telephoned to tell him that her son was ill, and she reminded Rothko that the following day was an occasion, the boy's sixth birthday. Rothko telephoned his distant cousin, nightclub impresario Max Gordon, and they reminisced about selling newspapers fifty years ago as boys in Portland. Gordon remembers that Rothko talked quite bitterly about his deprived childhood and wealthier Weinstein relations.

That afternoon he kept his scheduled appointment for a checkup with Dr. Mead. In many ways, his condition had improved in the past four weeks, but still he was agitated and depressed. He had been working, he said, and denied that he had been drinking. He was now seeing Dr. Kline regularly, had an appointment for the following Friday. He was still taking Sinequan for his depression and insomnia. His blood pressure was "superb," and Dr. Mead told him that there was no reason why he couldn't have a normal life expectancy for a

man of sixty-six years. After this good news, he walked home. On the way, he met Jack Tworkov, who had been to his doctor for a checkup. They greeted each other, but Rothko seemed so "glum" that Tworkov thought his health report had been bad.

That night Rothko dined at a local deli with Rita. Ever since Dr. Mead had cautioned him against fatty foods, he had adhered strictly to his diet—even skinning chicken before eating it. Emotionally, he was fraught with rage and frustration. It was the appointment with McKinney the next day that deeply distressed him. How dare Lloyd force his way into the warehouses to pick and choose from the long-treasured hoard of paintings? He had previously confided this anxiety to his assistant, Oliver Steindecker. Why had Bernard pressed him to do this? Whose side was Bernard on? And yet he was mortally afraid of offending Reis, fearful of a confrontation. Rita became annoyed with his indecision. She told him that there was no reason he had to do anything he did not want to, that after all he was a man of free will, was he not? He could tell them to go to hell. Or if he really did not have the courage to offend Bernard or Lloyd, he could feign illness, pretend he had a cold, and send Donald McKinney away.

They walked back to the studio. He downed his usual combination, blue chloral hydrate pills with Scotch. Rita Reinhardt took a taxi home.

About 9 P.M. New York time, his brother Albert Roth telephoned him from Santa Monica. They had a lengthy fraternal conversation. Mark, Albert said, seemed mellower than usual. He was not at all prickly. He inquired after the rest of the family and sounded genuinely concerned.

What happened after Albert hung up remains unclear. Not surprisingly, the stories told afterward would change with time.

# 9    **February 25, 1970**

And three firm friends, more sure than day and night—
Himself, his Maker, and the angel Death.

> Samuel Taylor Coleridge
> *Complaint*

On Tuesday, February 24, Arthur Lidov worked through the night in his downstairs studio preparing some sketches he was to take to Chicago the next day. His wife and children lay sleeping upstairs in their apartment. Lidov had not seen Rothko for several days, though habitually the middle doors between their studios—which gave onto an alcove containing their mutual thermostat and the cellar stairs—had been left unlocked in recent years.

Lidov's long work table was positioned against the wall of Rothko's kitchen. This common wall, made of homosote only about a quarter of an inch thick, was anything but soundproof, and had led to some friction between the two artists over the years. On certain other wall areas, one or the other had installed cork panels and baffles of various sorts, but still, at Lidov's, Rothko's telephone could be heard when

it rang, along with flushings of the toilet, ordinary conversations from the kitchen, and often music blaring on Rothko's stereo. Out of necessity, Lidov had learned to ignore most sounds, but from time to time would become exasperated by them—as he could be about many other qualities of his illustrious neighbor: his drunkenness, his role-playing, "his highly organized self-pity" and depression, his stupidity about the process of living (how thermostats operate, burnt food on the stove), his self-centered conversation, his high-flown phrases about his art (which Lidov calls "very expensive wallpaper"), his putdowns of Mell (whom Lidov considered "the more gifted artist"; she could draw). Yet Lidov retained a fondness for the man.

That night, though he scarcely left his desk except for a few quick snacks, Lidov heard no sounds from Rothko's studio. He was still at work when his assistant, Frank Ventgen, arrived about 9 A.M. Wednesday. Twenty minutes later, when Oliver Steindecker came running for help and they saw Rothko's body, Lidov realized that he must have been within six feet of Rothko when the artist slashed his arms.

The suicide, he says, came as a shock, but not a total surprise. He speculated occasionally over the years that Rothko might kill himself (though Rothko had never made even veiled references to him about it). But Lidov thought he lacked the courage. If Rothko were to take his life, he would be sure to take some relatively painless way out. Violent slashing was "the last thing he would do to himself," says Lidov, agreeing with those who knew him best, adding that "he couldn't even cut his own hangnail." When he cut himself shaving or was given a new prescription by a doctor, it upset him abnormally. Either pills or hanging might have been the expected method for him. Pills were easier, but with all the ropes and pulleys in the studio, hanging might be the first thing to enter his mind. Later, Lidov concluded that Rothko had locked his middle door that night as part of a carefully orchestrated suicide.

But Oliver Steindecker told Rothko's friends that he was certain that the suicide had not been planned, but must have been done impulsively. Rothko had made important engagements that he had seemed anxious to keep. And certainly he wanted to see the Seagram murals installed at the Tate and the de Menil chapel murals installed in Houston.

From the moment that Oliver and Lidov called the police at 9:35, there was a great amount of confusion at the studio. As Lidov remembers, Stamos arrived some minutes before the police. When he saw

Lidov's fancy camera equipment, he asked Lidov to photograph Rothko's body as it lay in its immense dark pool of blood. Stunned by the suggestion, Lidov refused, reminding Stamos this was against the law. Then the police cars drew up, with sirens blaring and lights flashing. A sergeant Keneally and a Patrolman Grice set about searching the body and the premises. A young intern from Lenox Hill Hospital officially pronounced Rothko dead. The police had no idea who the artist was or of the value of his paintings; the squalor of the studio and its paltry furnishings (the appraiser would put a total valuation on them of forty dollars) belied its fancy address.

Lidov brewed pots of coffee in his studio while Oliver and Stamos telephoned. Oliver tried to reach Morton Levine, but he had left home; Anne Marie Levine said she would come over. Then, around ten, Lidov thinks, the front doorbell rang and Stamos answered it. On the doorstep were Rita Reinhardt and Donald McKinney, ready to visit the warehouses. On hearing the news, Rita became hysterical, refusing to believe Rothko dead and demanding to see the body. Since nobody was quite sure when Mell would arrive, and Stamos declared it important to avoid a meeting between the two women, Lidov forcibly restrained her from entering the studio. She wept and said that she had spoken to Rothko on the telephone about midnight and that he had not sounded suicidal then—just upset about the Marlborough sale. She told Lidov that she had come that morning to make the warehouse business less painful for Rothko.

Oliver, with Anne Marie Levine, took a taxi to Ninety-fifth Street and rang Mell's doorbell at about 11 A.M. They brought her back with them to the studio. Her demeanor was calm, but she was bewildered: for months Mell would puzzle over why no one had called her right away. She confided to friends her suspicion that Rita was at the studio when Rothko died. She called Kate in Brooklyn and told her only that her father had died, waiting until she arrived to tell her how. She telephoned another friend, with whom she had a lunch date. "My world has collapsed," she said. "Rothko is dead."

The detectives arrived and began questioning everyone, including Morton Levine, who had been at a funeral in Brooklyn. When Levine had returned to his office near Washington Square, he had found a message to call the studio. His wife answered the phone and said, "Mark's dead." He had taken a cab to the studio immediately.

At 12:30, the investigator from the medical examiner's office, Dr.

Helen Strega, examined the body, poked about, interviewed Mell, and wrote her report. Dr. Strega suspected that Rothko had taken an overdose of barbiturates, but was unable to find any drugs in the studio except some phenobarbital in the medicine chest.

With memorable composure, Mell told Dr. Strega that she had talked to Rothko on the telephone the day before and that "he was his usual depressed self," that he had been going to a psychiatrist for some time and had been taking many pills for his condition. Dr. Strega put in a call to Dr. Nathan Kline, but was unable to reach him. In her quick tour of the studio, she noted that there were "no other signs of violence or disturbance" and "no note of explanation."

Earlier someone had telephoned Dr. Allen Mead's switchboard, requesting his presence. When he got the message, he left for the studio, reflecting on the way how strange his relationship with the artists of the New York School had been. Through an odd combination of circumstances, he had been the doctor who had already pronounced two dead: Franz Kline in 1962, then Ad Reinhardt in 1967. And now Mark Rothko was dead, whom he had seen only yesterday afternoon, who had seemed in somewhat improved spirits, to whom he had given good news about his heart condition. Why had Rothko killed himself now and not last month, when he was at his nadir? Or two summers ago, after the frightening aneurysm?

Dr. Mead passed the police cars drawn up in front of the studio and as he entered, a group of bearded, long-haired men and boys who looked like a "bunch of hippies" were talking in the anteroom. No one paid any attention to him. He bent down and examined the body, measured the pool of blood, and then noticed something on the floor. There were two empty medicine bottles which Mead believed he recognized as having contained chloral hydrate. He estimated that Rothko had been dead at least six to eight hours. He jotted down the information and left. Though Mead expected inquiries, for more than five years no one ever asked him about Mark Rothko. Not the police, the medical examiner, Mell, or anyone else.

It was close to one o'clock when Dr. Strega ordered the body taken to the morgue. The following morning Morton Levine officially identified the corpse as Rothko, completing the procedure before autopsy. He signed the document, stating that he had last seen Rothko one week before and adding that the artist was "depressed over ill health." Later, Dr. Judith Lehotay, a pathologist in the medical examiner's

107

office, would, with four other doctors present, perform the autopsy. The cause of death forwarded to the police and health departments for the death certificate read:

SELF-INFLICTED INCISED WOUNDS OF THE ANTECUBITAL
FOSSAE WITH EXSANGUINATION
ACUTE BARBITURATE POISONING
SUICIDAL

For the medical examiner's office, the procedures as well as the type of suicide seemed fairly routine. "This type of wound is not the sort we see in homicide," said Dr. Milton Helpern, then the city's chief medical examiner. The doctors, like the police had no idea who Rothko was. From their point of view, he was another elderly white male, the category of persons who most often commit suicide.

And Rothko's choice of instruments, though not the most common, were not unusual by coroners' standards. Often suicides attempt to ensure death by using several methods at once. In Rothko's case, the overdose might have been intended to anesthetize himself against the pain of cutting the artery. The crook of the arm is less often chosen as the object of mutilation than the wrist or throat, but, according to the late Dr. Helpern, this is not so rare. In fact, it is an "extremely efficient" method of killing oneself; death comes quickly from loss of blood if a brachial artery is slashed. Most sedatives, on the other hand, take a long time to act.

So the medical examiners saw nothing unusual about the death of the Mark Rothko or "Rothknow," as it was spelled on the autopsy record. The fact that the autopsy revealed acute gastritis and a large cake of green gelatinous matter in the stomach confirmed Dr. Strega's suspicions about poisoning. The manner of death was not further explored. The coroner's office was overworked, understaffed, and had a flood of cases to investigate. All "violent, suspicious, sudden, and unexpected deaths" in the city are their responsibility, and there are some 35,000 cases a year.

What exactly—the overdose or the razor—had killed Mark Rothko was left unresolved. His death was classified a suicide. Dr. Lehotay's report, though inconclusive, was forwarded to the police department and the health department, where, as is customary, the first finding, "self-inflicted wounds," became the official cause of death listed on the death certificate. Since no one questioned the suicide or suspected

homicide, the tape of the autopsy—marked Rothknow #1867—was not even transcribed. It was filed away under 1970.

The conclusions drawn by the police in their investigations were revealed several months later when an article on a day in the lives of a pair of New York City detectives was published in the *New York Times Magazine*. The day happened to be February 25, 1970. (The time was set at about 4:30 P.M.—one of several errors.)

A call comes in (detectives call them "squeals"): a man found dead in an East Side studio. The young patrolman on the scene says it looks like suicide, but he doesn't want to commit himself. [Detectives] Lappin and Mulligan arrive 10 minutes later at the East 69th Street studio of Mark Rothko, the abstract expressionist painter. The body is lying in a pool of blood in the kitchen and the water in the sink is still running. Lappin glances quickly around the room and sees that the double-edged razor blade that apparently inflicted the deep gashes has a piece of Kleenex on one side. "Suicides are amazingly careful not to cut their fingers as they slash their forearms," says Lappin. The artist's trousers are folded neatly over the back of a nearby chair. "Didn't want to get blood on them. And the water in the faucet was on because he didn't want to leave a mess for somebody. He did himself in at the sink and fell to the floor when his blood level got too low. And he has hesitation marks on the forearms—little cuts to test out the blade while he thought about it." Rothko's wallet is intact and there is no sign of rifling in the studio, which contains scores of the artist's works, worth hundreds of thousands of dollars.

A call to the artist's doctor [Kline] reveals that Rothko had been despondent after a recent operation and that his health generally had not been good. "An open-and-shut suicide," says Lappin. Although he has never heard of Rothko and has no idea of what the artist's works are worth, he takes no chances; he arranges for the police to guard the studio 24 hours a day. . . .

"We were surprised to learn that his suicide was so ritualistic," says Robert Motherwell. "We had been mourning him and then we happened to see that article a few months later and the pain was revived." What had he attempted to tell the world by the ritual?

And why had he left no note? His family and friends agreed that

Mark always wanted to have the last word. It would have been far more like him to have taken an overdose and then to have tried to call one of them. He must have telephoned someone. There must have been a final attempt to reach out.

One of those most undone and baffled by Rothko's suicide was Robert Goldwater. He had thought that Rothko was totally committed to the book they were writing, and they had scheduled further appointments.

What did seem clear was that deep-rooted self-hate and rage against his world drove him to this violence against himself. But what of his hypochondria and inherent fear of blood and violence? Psychiatrists maintain that individuals with paranoid psychotic tendencies are often compelled to act out their fears and morbid fascinations.

For one family, his timing was unforgivable and unbelievable. "But he did it on my son's birthday; Mark loved the boy, he wouldn't have done that to him," says Sally Scharf. But there is a psychological theory (though incredibly pat) that covers his timing. Dr. Grokest, to whom Rothko had confided more bits and pieces of biographical information than he had to most people, notes that Rothko's father, Jacob Rothkovich, had abandoned him when he was seven years old, leaving the family in Dvinsk to go to America. He had died three years later, soon after the family was reunited in Portland. These events, as Grokest sees it, led to Rothko's terrible fear of abandonment. Somehow Topher's imminent seventh birthday, in August, had become a crisis for Rothko of which he was extremely apprehensive. Here Grokest's theory stops; he did not know about the Scharfs. But since their son and Topher were best buddies, perhaps Rothko had confused them and their birthdates. He had known the Scharf boy since his birth, and had been the first person other than the Scharfs to hold the baby in his arms. In rage at his own abandonment, could Rothko have become his own father and abandoned himself (Christopher), who was approaching seven, the age of the loss? The confusion of identities and the acting out of a previous traumatic event were part of a psychological pattern; psychiatrists call it the transference introjection. However improbably neat and simplistic an explanation, it also fits.

Another hypothesis is that Rothko was not ready or willing to accept Dr. Mead's good news about his health. Rothko had been preparing himself for death for a year and a half. Even with a temporary medical reprieve, emotionally he was ready to die and wanted to be in control.

He had often said to his assistants that he, unlike many others, did not believe Pollock and David Smith meant to commit suicide in those road accidents. "If I choose to commit suicide," he told Jon Ahearn, "everyone will be sure of it. There will be no doubts about that." It is true that controlling his destiny was always important to Rothko; it was clear from his techniques in painting, the constant reasoning, the worry and care that went into his work. To one assistant, he was like an "Austrian clockmaker." This need to control might even explain the uncharacteristic but efficient method of self-mutilation with the razor. Then there is the cynic's view—that the bloody suicide was the only way left to get the attention Rothko felt he deserved.

Perhaps more significant in terms of Rothko's philosophy is the poetic symbolism of the tragedy. The enormous patch of congealed blood was the ultimate work of art, the final dramatic gesture, the true, most poignant action painting. Motherwell remembered that Rothko had explained that "the main criterion for his work was ecstasy —that was the only subject he was concerned about." As his mentor, Nietzsche, emphatically described Dionysian rites in *The Birth of Tragedy*: "No longer the *artist*, he has himself become a *work of art*."

In the studio, his last canvas was a large, unfinished study in reds. Perhaps, as he had said earlier when painting in a more colorful style, he was "going home." Or as he had once told Dore Ashton, people often misinterpreted one of his bright yellow and red paintings as being optimistic. Rather, Rothko said then, it represented tragedy.

But there were many reasons, many pressures on him, argue the realists. Some he stated, others were left unspoken; some were real, others imagined. He thought he ought to move back home, to be a better father to Topher, yet he owed Rita Reinhardt something as well. At the same time he wanted to be unencumbered. His memory was noticeably failing him, due to arteriosclerosis, drink, and pills. His eyesight seemed to be going as well. And the fickleness of fame troubled him. He thought his art was not getting the recognition it deserved, his stature threatened by the manipulated trendiness of the art marketplace. And he longed to achieve a new plateau in his work, a new image, more complex in form. It eluded him. His old pride in himself as a have-not isolated by his empty wallet from bourgeois society, had vanished long ago. There was no way to return to his old values. In dealings with Lloyd, he had sold his soul for a piece of Liechtenstein.

The final turn of the screw that night in February almost certainly

was the new deal Lloyd had proposed and the scheduled warehouse selection with McKinney the next day. Pressured into yet another sale to Lloyd? That their hold on him might have been related to the mysterious Swiss bank accounts could explain the extremity of his distress. How else could they have attempted to force Rothko to give them access to his precious oeuvre carefully stored away for posterity? And one can only speculate on the dual position of Bernard Reis. Rothko had angrily discussed with Rita the pressure Reis had been applying. Had he finally come to believe Reis's fealty was first and foremost to Frank Lloyd?

That Rothko had real motivations to kill himself seems clear; how he actually died remains mysterious. Whatever his thought at the time, through his death he became a martyr to the art marketplace. To have attempted so sensational an exit he must have had some hope that his martyrdom would not be in vain. That the world would not get his message for some time was not his fault.

# 10

# Odds Out...
## "And to the family of the deceased..."

(FEBRUARY–OCTOBER 1970)

Nature teaches beasts to know their friends.

—Shakespeare
*Coriolanus*

On February 25, after the police and medical officials had left the premises and the corpse had been taken to the morgue, Mell Rothko searched the studio. In the well behind the walls of the Houston chapel structure, in cubbyholes, and between the pages of books she found assorted old envelopes containing $1,800 in cash. That afternoon Oliver Steindecker did an inventory of the paintings in the studio. The kitchen was cleaned up by Roy Edwards, a young protégé of Stamos's who had assisted Rothko with the chapel paintings and now worked for the Marlborough Gallery.

From the time of Rothko's death Stamos behaved differently toward Mell and the children. They had always considered "Stemmie" an affectionate, close friend. Both children had been dandled on his knee, and Mell and he had spent long hours in telephone confidences. But he began to act as though Rothko's dead body and effects were per-

113

sonal possessions, that the family were outsiders, even enemies of some sort.

As a memento, Stamos took Rothko's paint-stained fedora. After Mell had picked up Christopher at school and taken him home to tell him his father had died, Stamos appeared at the brownstone. He persuaded her to let Rothko's body be buried in the Stamos plot in East Marion, on the north fork of Long Island. She later told friends that he had also had an affidavit with him which he asked her to sign, waiving her rights to contest the will. She did not sign, and Stamos absolutely denied the incident.

It was Donald McKinney, Mrs. Reis remembers, who telephoned them in California with the news. When she and Bernard flew back to New York the next day, Morton Levine drove out to Kennedy airport to meet them. Reis was distraught and kept blaming himself for having left town. He went straight to his lawyer's office and spent most of an hour discussing the estate with Frank E. Karelsen, who had been a client of his for forty years. Had he been in New York, he said, Rothko would not have done this. By Friday, Reis had arranged the meeting which was to take place between Karelsen and his fellow executors at Campbell's after the funeral. Before the services, Reis lunched with Donald McKinney and David McKee of Marlborough. Their boss, Frank Lloyd, had just left for London after the Parke Bernet auction and a whirlwind four-day stay in New York.

For those connected with the New York School, symbols of celebrity status seem to extend even to the grave. "There is this obscene jockeying about the placement of the bodies," says one art-funeral goer. The Green River cemetery in the Springs on the south fork of Long Island is a small, serene rural graveyard where for more than two centuries the few local farmers (called "bonackers") buried their dead. In 1956, however, the modest character of the spot changed—much in the way the neighboring farmland had. Over the past decade the seaside woods and pastures of the Springs had turned into a rural refuge for many artists and others fleeing the city. Old barns and farmhouses became the studios of well-known painters and sculptors and home to their circle of friends and connections.

As he had led the revolution in abstract painting, so, too, Jackson Pollock led the postwar migration to the country. When he died in the summer of 1956, to mark his grave, his widow, Lee Krasner, chose a huge boulder under a tree in the Green River cemetery. At its

center is a large bronze plaque with the dates of his birth and death, and his signature, many times enlarged, emblazoned on it. Later, poet Frank O'Hara would have a small stone marker there. In 1967, Ad Reinhardt, though he had never spent time in the area, was buried there by his widow and friends in a strange silent funeral that had no ceremony. Many years after painter Stuart Davis died, his widow chose to bury his ashes near Pollock. She had his signature chiseled on an imported black polished granite stone. "The Davis looks more like a Reinhardt" is the local artists' jest. Among the others buried at Green River is the first wife of dealer Ben Heller. The surprising influx of art world notables led sculptor Ibram Lassaw to pun, "They are dying to get into our cemetery."

But Mark Rothko would not be buried in the shadow of Jackson Pollock's monument. Perhaps one reason that Stamos was so possessive about the corpse was that he thought the north fork of Long Island, where Stamos then owned a summer house, merited some of the New York School's posthumous glory. Even in death, the old rivalries seem to exist.

So that Saturday, February 28, the family cortege drove for two hours to the Stamos plot in a graveyard overlooking Shelter Island Sound. Having left Topher with friends, Mell and Kate watched as the coffin was lowered into the grave.

Sometime during the week after Rothko's death, Steindecker realized that three paintings were missing from the studio. The affable policeman on guard, unaware of the value of the paintings, had noticed nothing. Oliver reported the theft of the paintings to Mell, who mentioned it at the will-reading on March 6. Also assembled that day in the living room of the brownstone were Kate, Levine, Stamos, and Reis. Mell was there with her new lawyer, Gerald Dickler, whom she had hired the day before at the recommendation of Lee Krasner Pollock. Dickler who knew Reis well, was introduced to Levine and Stamos. Frank E. Karelsen, Sr., read the brief will handed him by his associate, Ernest Bial. Reis estimated the value of the estate at $5 million. When Rothko died, he left $141,441 in cash, treasury bills worth $191,000, and was owed more than $1,425,800, primarily by Marlborough A.G. in Liechtenstein. But by far the most valuable asset was the reservoir of approximately 800 paintings Rothko had kept. Asked their worth by Dickler, Reis replied over $2 million. There would, said Reis, be heavy taxes, maybe $500,000 or more.

Reis recommended that Mell file the necessary papers to obtain her statutory widow's benefit of one-third of the estate tax-free—estimating in this way her inheritance to be around $1,600,000—and also file "elections" for the children against the foundation. By exercising this option, the family would be entitled to one-half of the estate. Under New York State law, when a legacy is left to charity, papers can be filed for children, who "elect" to exercise their rights to one-half of the estate. This provision was set up by the state's founding patroons in the belief that philanthropic largesse should not enable anyone to buy his way into heaven.

Mell, stung that Rothko had not provided for his children directly, said she would consider this, and also agreed reluctantly when Reis suggested she not take her $250,000 bequest outright, but stretch it out in an allowance of $250 a week. Mell realized that this plan made her dependent on Reis, but, according to Dickler, she was afraid of antagonizing him.

After Mell mentioned the missing paintings, Reis said it might prove fruitless to report it to the police, since they had been guarding the studio when the paintings disappeared. He would, however, alert the Art Dealers Association. That way, circulars would be sent to dealers who might recognize the paintings if an attempt were made to sell them. Curiously, the theft was not reported to insurance company investigators.

After the will-reading, Levine walked downtown with Reis for a while. During the stroll, Reis informed him—and Levine said it was a surprise to him—that for their troubles, under New York law each executor would be paid two percent of the estate. Fees might amount to $95,000 for each of the three men.

Several days later, Stamos went to dinner at the Levines', where Levine showed forty or fifty slides of the paintings. In the middle, Stamos began to feel ill. He said, "You know, like I thought I was dying." In anguish, he went home before the viewing was concluded.

To resolve whether or not she should file elections on the children's behalf against the estate (largely the reservoir of paintings), as Reis had suggested, Mell telephoned William Rubin at the Museum of Modern Art. She told him of Reis's advice and of her deep respect for Rothko's wish that the foundation hold his life's work. She did not want the paintings for herself, but should she "elect" against the foundation for the children's sake? Rubin, who had inspected the oils the previous spring, told her there were more than enough paint-

ings to go around. The important oils, of course, should be kept together by the foundation, but he saw no reason why the children should not get their share of the lesser paintings and papers under the election procedure.

Everyone in the art world knew that Rothko's paintings had commanded high prices for at least the last ten years of his life, during which time they had soared from some $15,000 to $60,000; but few were aware that he was a millionaire. Mell confided to a friend that in addition to the outward assets of his estate—the cash, the debts owed him, and the reservoir of paintings worth millions—there were two secret numbered accounts in Swiss banks. The first, she said, was in both their names, and the second was countersignable by Bernard Reis. Rothko had also mentioned Swiss accounts to Lidov and Daniel Goldreyer. To Goldreyer he had specified that one was intended for Kate and the other for Topher. No trace of this money has yet surfaced.

Mell's adult life had been devoted to her husband and children. For the sake of his genius, during the first fifteen years of their marriage, she had endured many deprivations, made sacrifices, and helped him escape the burdens of ordinary living. And, as she said, "No matter how bad I've been in other ways, no one can say that I have not been a good mother." But in middle age, she hoped to make a life for herself, to work at a job, even if it were in the art world, which had treated her shabbily. With another Dalton mother who had worked with her as a volunteer in the school library, she made plans to find work in the fall.

Her alcoholism was not lessened by the pressures of widowhood. But she was still careful to keep up her appearance, and seemed healthy, looked attractive, and was lively when sober. There had been periods of several weeks when she had gone on the wagon and, under a doctor's supervision, taken antabuse. She regularly took medication for high blood pressure.

That spring she had other problems as well. No one would tell her what was going on. She telephoned Levine and asked to see his slides of the paintings. Though he had retained an inferior set for himself, which he had shown to Stamos, he told her to call Donald McKinney at Marlborough. The best set, which was in the studio after Rothko died, had been turned over to the gallery. When she telephoned Levine again to ask about the estate, he referred her to Bernard Reis. Thirteen of the smaller paintings on paper had been

taken from the studio by Marlborough for "safekeeping" and registered in the stockbook. Perhaps because Mell had discovered the loss through Oliver and his inventory, on April 6 they were returned to the estate. No wonder then that one night that spring when she and Katharine Kuh were walking to a dinner party together, Mell said to her, "Katharine, I don't know what to do. I'm not sure, but I think there is some real hanky-panky going on with Mark's estate. It's all so tangled up I don't know how to handle it." Among the guests that evening were Morton and Anne Marie Levine. In an aside, Katharine Kuh raised an eyebrow and nudged Mell. "Him, too?" she whispered. "Maybe, but I'm not sure," replied Mell.

Mell discussed rewriting her will with friends and Gerald Dickler. Who would be the best guardians for the children? Perhaps the Scharfs, if they would take on the responsibility. She explored it with them and Sally's sister, her close friend attorney Phyllis Kravitch, in Savannah. Mell's last will had been drawn up in 1959, four years before Christopher was born. Under the will, Kate's guardians were the Rothkos' closest friends in those days, Herbert and Ilse Falk Ferber. Since then, the Ferbers had divorced, Ferber had remarried, and the friendship had dissipated. He was, she said, "a man she had not talked to in years." When Ferber asked to deliver one of the eulogies at Rothko's funeral, Mell had acquiesced because Kate seemed favorably disposed toward him. Ferber was also the executor of Mell's old will; his alternate was Bernard J. Reis.

Mell had decided to elect against the estate for the children. She did not want the widow's exemption. She had more than enough money, she said, thinking, no doubt, of the Swiss accounts. But it is puzzling that she was not persuaded to elect for herself, since her one-third would have come tax-free, thereby increasing the family inheritance by more than a million dollars.

She also considered attempting to break Rothko's will. The basis of the suit would have been that Rothko was of unsound mind and unduly under the influence of Bernard Reis at the time he signed it. But when she asked Dickler about it, he advised against it, or so she told Phyllis Kravitch. Besides, she did not want to damage Rothko's reputation with any notoriety about his irrational behavior over the last two years. But she was not entirely happy with Dickler's advice and confided to several friends that she was considering finding a new lawyer. In fact, Dickler was in rather an awkward position. On Lee Pollock's behalf he had successfully negotiated a strong contract

with Frank Lloyd for the estate of Jackson Pollock nine years earlier in London. Then in 1963, when Marlborough-Gerson opened in New York, he had represented her in her own right as an artist when she signed with Lloyd. Lloyd had admired Dickler's skills in these deals enough to ask him to become Marlborough's New York counsel. Dickler declined, citing conflict of interest, at which time Lloyd chose Ralph Colin for the job. But Dickler felt complimented by Lloyd's offer, and Lee Krasner Pollock, who had a good head for business, was more than content with the perquisites of the Marlborough stable. Much later it would be revealed that Dickler, for many years, had engaged in business dealings with Bernard Reis.

In late March 1970, Dickler had become more deeply involved with the Rothko estate. At a lunch with Dickler, Reis asked him to help rewrite the foundation's hitherto ambiguous charter to conform with the requirements imposed by the 1969 Tax Reform Act, and to limit its purposes to distributing grants to needy mature artists. Saying that he had consulted Mell first, to diminish this apparent further conflict of interest, Dickler later took on the job.

Socially, life remained disconcerting for Mell. Becky Reis paid a visit, and, as Mell sat chain-smoking, Becky gave her a long lecture about smoking near Rothko's valuable paintings. What would happen if there was a fire? Mell later mimicked the conversation privately for Dan and Jackie Rice. "It didn't occur to Becky," she pointed out, "that there used to be two chain-smokers, and now there was only one."

The Reises gave their annual gala spring garden party, which was an awkward affair for Mell. Rita was also a guest and Marlborough Gallery echelons attended in full force. Kate remembers noticing that one of her father's late black-on-gray paintings hung on a wall and wondering whether it had been a last gift.

On May 29, 1970, the international art world gathered in London for the grand opening of the Rothko room at the Tate Gallery. Mell flew over for the opening, but nobody paid much attention to her, and, at the party, she was seated at the far end of the table. Morton Levine and Bernard Reis and his wife Becky were there, along with other Marlborough representatives from their galleries, in London, Rome, and New York. The Seagram murals at last had a home, and abundant praise from the English press.

In June, Reis requested that all the thirty-two paintings stored in

119

the brownstone's fourth-floor studio be turned over to Marlborough Gallery for "storage and insurance purposes." Mell signed a letter agreeing to this, provided that the paintings were kept separate from Marlborough's own. Donald McKinney and Roy Edwards then removed the paintings to Marlborough's warehouse.

In July, Mell took Topher to California, then to Portland to visit Rothko's elder brothers, Albert and Moise Roth, and his eighty-year-old sister, Sonya Allen. While in Oregon, with seventy-seven-year-old Moise at the wheel, there was an automobile accident in which their car was suspended over a cliff. No one was seriously injured, but Mell was considerably shaken. However, when Albert and his wife saw her again, she seemed to suffer no aftereffects. The Roths, however, thought that she acted tense, as though she were trying to compensate for some guilt feelings about Rothko.

On August 24, Mell and Topher arrived in New York to prepare him for the second grade at Dalton and to celebrate his seventh birthday on August 31. On August 26, with no warning, Mell died. Topher was watching cartoons on television in the living room, which was adjacent to her bedroom when Mell awoke, put on her bathrobe, had a cup of coffee from the electric pot near her bed, and crossed the floor to the bathroom. From the living room, Christopher heard her gasps as she collapsed; he ran in and tried to rouse her.

Bewildered, Topher ran downstairs to the dining room, where Mell's English beau, Tony Arnell, was sleeping on a daybed. Tony called an ambulance, but it was too late. Gerald Dickler was called and identified the body. Kate was in Vancouver, British Columbia, vacationing with friends. A cousin was able to track her down, but by the time Kate flew back to New York, Morton Levine had arranged everything. Topher was installed in a maid's bedroom on the Levines' third floor.

Mell's death shocked her friends; she was only forty-eight and, except for heavy drinking, was in apparent good health. Despite her sudden and premature demise, the medical examiner performed no autopsy. Someone telephoned her doctor, who confirmed that she had high blood pressure, and that satisfied the authorities. "Hypertension due to cardiovascular disease" was the cause of death listed on the certificate.

Mell's funeral was held in the same large room at Campbell's as Rothko's had been, but only a handful of mourners were present. Most people were away on holidays; few knew Mell had died.

Under the supervision of Gerald Dickler and Morton Levine, the paintings and sculptures in the living quarters of the house were put in storage.

When Mell died, Bernard Reis was again visiting his daughter in California. On his return he made a thorough search of the brownstone, looking for a later will, but finding none telephoned Ferber in Vermont to inform him that Ferber possibly was Mell's executor and Kate's guardian. A few weeks after the funeral, Kate made arrangements to meet friends at the brownstone where she planned to pack up some things to take back to Brooklyn. To her horror the house had been turned upside down. As her friend Jackie Rice describes it, "they had rifled through the house like vultures, pulling out all the drawers, going through the cupboards and closets, and scattering their contents."

A law student and an art historian—the former representing Ferber and Mell's estate, the latter Rothko's—were busy making an inventory of all the papers. Since some of them were Rothko's and therefore valuable, both estates sought control of them. Ferber assumed control since they were part of the brownstone's contents but was sued by the Rothko estate until lawyers negotiated a settlement two years later. When, at the time of the inventory, Kate asked to look through the papers she was advised by her guardian's lawyer, Stanley Geller, that this would not be legal. (She later learned that this was not true.) However, she did manage to hide a few of her parents' intimate love letters, and thorough as the search had appeared to be, they had overlooked one important set of papers stored in an ancient portable metal filing box. The little tin box was to be found in the brownstone long afterward.

For Topher, life at the Levines' was totally structured, quite the opposite from the freedom he had enjoyed. They told him he was spoiled. Nevertheless, Levine instituted adoption proceedings. Friction developed between the Levines and Kate, as well as some of the family friends who rallied round and took Topher off to play. Levine had kept Mell's address book, which Kate wanted, among other reasons, to answer sympathy notes and thank friends for flowers. He said he would have it Xeroxed and give her the copy. After an argument, she finally retrieved it. But her father's honorary Yale degree was lost, and it would take six years for Bernard Reis to relinquish Kate's own birth certificate and social security card. She did manage to recover her father's hat from Stamos.

# THE LEGACY OF MARK ROTHKO

None of Rothko's three executors expressed sympathy over Mell's death. Once, when Kate went over to the Reises' to sign some papers, the accountant said, brusquely, that he was sorry to have missed the funeral, then turned abruptly back to the papers.

Early in October, Kate had a tearful meeting with the three executors at the Reis house. She asked if she could have her share of the inheritance in paintings, which would entail a little less than one-fourth of the estate (the children's share was subject to inheritance taxes, while the foundation, a charity, was tax-free)—or possibly about 150 paintings. All three executors, Kate says, assured her that she could have *some* paintings. Levine remembers saying that she ought to discuss just how many with her guardian, Ferber, and that he believed a "judicious admixture" of paintings and money would be more prudent.

At that same discussion, Kate brought up the subject of Christopher's guardianship. She wanted to take her brother away from the Levines, whom she felt were "too strict, their life too rigid" for the boy. Because his table manners were not acceptable to the Levines, he generally ate his meals on a tray upstairs in his little bedroom. Levine, whose wife was expecting their first baby in a few weeks, said he would consent to relinquish guardianship if a responsible alternative was suggested. Kate called Mell's sister, Barbara Northrup, in Columbus, Ohio, who agreed to take Christopher as her legal ward. When Barbara Northrup asked the boy to come to Columbus, he guessed that it was not just for a visit and accepted willingly. The day before the Levines' son was born, Christopher departed for Ohio to live with the Northrup family.

For a time Kate believed that the emotional meeting with the executors had resulted in a solution to her problems. But despite the assurances of the three men that day, her hopes of inheriting her father's paintings—or seeing any one of them on the walls of her ninety-dollar-a-month Brooklyn apartment—were frustrated. Mell's suspicions were to be confirmed. There was indeed some "hanky-panky" afoot concerning the legacy of Mark Rothko.

# 11 Dealer's Choice

(FEBRUARY–JUNE 1970)

Many forms of conduct permissible in a workaday world for those acting at arms length are forbidden to those bound by fiduciary ties. A trustee is held to something stricter than the morals of the market place. Not honesty alone, but the punctilio of an honor the most sensitive, is then the standard of behavior.

Judge Benjamin Cardozo
*Meinhard* v. *Salmon*

After Rothko's death that chill February day, Donald McKinney returned to Marlborough Gallery, where a medium-sized 1961 Rothko oil was sold for $50,000 to collector Joseph Bernstein. That afternoon in Palm Springs, California, at the tennis court of billionaire collector Joseph Hirshhorn, the telephone rang. It was Frank Lloyd in New York with the news of Rothko's suicide—and, reportedly, an offer of a special deal on Rothko's paintings before the prices went up.

Three months later, Lloyd, the master dealer, would win total con-

123

trol of the almost 800 paintings Rothko left behind. How he managed that so swiftly, so secretly, is a study in greed.

Within five weeks of Rothko's death, the executors had turned the Rothko studio over to Marlborough, lock, stock, and lease. This was done, Reis told the others, to cut down expenses of the estate. The lease was signed on behalf of Marlborough by Bernard Reis, as was the check for the rent. The place was renamed the Marlborough Studio. When Reis, Lloyd, and McKinney visited the studio and decided to appropriate it for the gallery, as McKinney would later remember, Frank Lloyd "declined to enter the room where Rothko died." Other than that, "Rothko was not in our minds at all."

There, Lloyd and McKinney began to assemble their choice of the valuable large oils, culled and winnowed from Rothko's warehouses. To ensure easy access, the executors signed a letter which Reis had drawn up, authorizing McKinney to withdraw paintings. He was, the letter stated without regard to truth, "under bond to" and the "official appraiser of" the estate. The letterhead read "Studio of Mark Rothko," but the address was Bernard Reis's town house.

At the outset, said Reis, the reason for this selection of the best of Rothko was to prepare for an important Rothko retrospective to be mounted by Marlborough for the Venice Biennale that June. It soon became plain to all that Lloyd's intentions were along more acquisitive lines. Late on an April evening at the gallery, there was a slide show of the Levine photographs of the paintings. Levine noticed that Lloyd would comment, "Yes, I will take that," or "No, pass," as the paintings appeared on the screen. He commented to Pierre Levai, Lloyd's nephew, as they left the room, that it was clearly purchases Lloyd had in mind.

On April 1, five weeks after Rothko's death, Reis quietly went on Marlborough's payroll at a nominal salary of $20,000 a year as director and secretary-treasurer of Marlborough New York. It was never announced publicly, and although many art world insiders were aware that Reis was connected with Marlborough, no one knew, or would learn for some time, exactly how close or formal the affiliation was. For the retired CPA, it was a dream come true. Now the only facts and figures he would have to deal with were those connected with his first love, art. As for the petty details of accounting, he had risen above them. For that, Marlborough hired an accountant, Louis Bernstein, a former partner of Reis's. Bernstein had fallen out with Reis after discovering Reis was privately taking art in return for Bernstein's

accounting services to artists. Now, Lloyd told Bernstein, he had "other things," not accounting, for Bernard to handle. Reis did continue, as he had for years, to countersign Marlborough's checks.

The following day, at a meeting of the Mark Rothko Foundation at the Reis town house, all three nonexecutor directors were present: Robert Goldwater, Morton Feldman, and Clinton Wilder. Reis formally introduced Wilder, his longtime friend and client to the other two. Nothing was said about Reis's new job or about pending estate negotiations with Marlborough—even though at that time, before the children's elections to half the estate, the foundation was the sole beneficiary of Rothko's hoard of paintings. There was a motion to elect officers, and Wilder was elected president. Morton Levine became vice-president, Stamos, secretary, and Reis, treasurer. Later Stamos would remember that Wilder then announced that it had been Rothko's last wish to reincorporate the charity so that its purpose would be to aid elderly artists. But the minutes of the meeting merely state that Bernard Reis "reported on the incorporation, discussed the wishes of Mark Rothko, and read the bylaws."

On April 13, according to Levine, the three executors met again at the Reis town house, at which time Reis said the estate needed cash and that they must "hurry forward" a deal with Marlborough. At that, Levine claims he challenged the positions of the other two vis-à-vis Marlborough. He said Rothko had told him that Stamos was negotiating his own contract with McKinney, and the art world knew that Reis was connected with Marlborough. Levine said that he demanded court approval of any deal with Marlborough, because they could be accused of conflict of interest. Both Reis and Stamos lost their tempers at this implication and told Levine it was not relevant. The talk became vituperative. Stamos screamed "Fuck you" at Levine, and Levine called Stamos a son of a bitch. More restrained with seventy-five-year-old Reis, Levine told him he was being "arbitrary, high-handed, and intolerable." Reis and Stamos contend that this episode never occurred.

Whatever happened, Levine did not hold this outraged stance for long. But he claims to have rejected "out of hand" several sweeteners Lloyd offered him. Lloyd took him to lunch at Shepheard's, a posh dining room in the Drake Hotel, where he offered to underwrite a biography of Rothko if Levine would write it. Levine said in view of the pending negotiations, such a suggestion was improper, and besides, historian Robert Goldwater had been selected by Rothko to do

his official art biography. Lloyd then said he would like to print a eulogy Levine had written and use it as a preface to a Rothko catalogue. Flattered, Levine specified that he could accept no money for it. Later, when he delivered the script to the gallery, McKinney tried to give him an envelope containing a check, which Levine refused. Lloyd denies both stories. It was Levine who "proposed to write a book for us," he later claimed.

In fact, Levine was hard-pressed for money; or, as he put it, "in need of funds." He told the other two executors that Rothko still owed him $2,500 for the photographic inventory he had taken the previous year. Though Rothko had paid him $5,000 and had given him a painting at the time, presumably in gratitude for this endeavor, the estate paid him the $2,500. In the fall, after he lost his teaching job at Brooklyn College, the estate would pay Levine another $2,500 to board Christopher Rothko for the two months following Mell's death.

The cards were further stacked on April 30, when Reis wrote a three-page memorandum to Stamos and Levine—which he would live to regret. In it he first listed Rothko's previous contracts with Marlborough A.G., but omitted key provisions favorable to Rothko. According to this memo, under the 1963 contract Rothko had agreed to let Marlborough represent him "throughout the world," omitting the crucial statement that it could not represent him in the United States. As for the 1969 contract, Reis quoted the eight-year exclusivity clause but neglected to mention two important facts: first, the "put" under which Rothko had the right to compel Marlborough to buy four paintings a year at current market prices; second, that Rothko had the right to draw an advance of $75,000 a year from Marlborough. He also implied that Rothko had required Marlborough's "consent" in order to make his gift to the Tate Gallery. From the Reis memo, Rothko appeared to have been just another indentured workhorse in the Marlborough stable.

Reis pressed for a quick sale to Lloyd so that, he said, important exhibits, which Marlborough would arrange in London, Rome, and Venice, would not be canceled. He added:

> So as not to lose valuable time, I have permitted, with your consent, the photography of paintings for the show. I have also arranged with the Saidenberg Gallery, New York, for a proper appraisal of the pictures. Marlborough is anxious and so am I

to consummate a proper deal for the sale of the paintings. I on my part do not want the Estate to pay for any expenses of cataloging, photography, shipping, and publicity or the large amount needed for restoration and mounting.

It is, therefore, imperative that a contract be negotiated as soon as possible, otherwise the show [Venice] will have to be cancelled to the great detriment of the Estate. It is most important with our large stock of paintings to publicize Rothko at this time in the European market.

Because of my professional connection with Marlborough New York, I do not want to participate in the negotiations, but do want to approve any contract relating to the disposition of the paintings. I shall assist with all my background, knowledge, and experience.

Meanwhile, there was much activity at the new Marlborough Studio. At night, a pair of moonlighting *Life* magazine photographers were making transparencies of the 100 paintings Lloyd and McKinney had selected. Cabinetmaker James Lebron was working by day at the studio, making stretchers for the paintings that had not been mounted. Reis dropped by almost every day, and Stamos joined Reis at least one afternoon.

The Reis memo was read aloud at what Stamos called a "philosophy meeting" on May 4. The upkeep of the paintings would cost "hundreds of thousands of dollars," said Reis, and Karelsen estimated the estate had $1 million in liabilities such as taxes and legal fees. Unless there was a bulk sale, the lawyer said, the IRS might consider the estate an art dealer and tax sales as ordinary income, rather than at the more favorable capital gains rate. It was their duty as executors to liquidate the estate.

It was decided that seventy-eight-year-old Karelsen—though he had no knowledge of art—would handle the actual negotiations with Lloyd. Two days later, after a preliminary discussion in Karelsen's office, Stamos and Levine accompanied him to Marlborough for their first session with Lloyd. Levine had asked Karelsen to prepare an alternate proposal that the 100 paintings would be consigned to Marlborough rather than sold. If that were not possible, they determined, the asking price for the 100 oils would be $3 million. How they arrived at this figure is not known, but Levine said they based it on what Rothko had confided to them about his sales. But not one

of the three had bothered to check out these sales or the latest auction sales of Rothkos, or any authority on prices. The number 100 arrived out of thin air—none of the principals can pinpoint its origins. Nor, incredibly, were they aware of exactly which 100 paintings they were negotiating to sell.

Lloyd stressed that his lawyers had told him that the 1969 exclusivity clause was legally binding on the estate. When Karelsen set the price at $3 million, Lloyd laughed. "Three million dollars isn't even in the ballpark," he said. The stock market was hitting new lows, he reminded them. He would have another look at the slides before making his offer.

After that meeting, at Reis's request, Karelsen's firm prepared several legal advisements. Rothko's 1969 exclusivity agreement prevented the executors from entertaining any bid other than Marlborough's until 1977, a memorandum concluded—even though there was no specific clause written into that contract that made it deliberately binding on his estate (as there had been in his 1963 contract with Marlborough). The "put," which could have brought in an estimated $300,000 annually until 1977, obligating Marlborough to buy four paintings a year at ninety percent of market value, was not discussed. The law firm also maintained that despite Reis's "conflict of interest" as an officer and director of Marlborough, which would ordinarily make court approval of a deal with Marlborough mandatory, such approval was not necessary. Surrogate's Court, in Karelsen's opinion, did not like to be asked for advice about projected business dealings. This was a peculiar position, since, with a similar contract between the estate of Franz Kline and Marlborough, Reis himself, several years earlier, had appeared in court to seek the Surrogate's approval. Levine professed that his anxieties about this were mollified by the firm's legal-looking document.

On May 12, at Parke Bernet, Marlborough bought *The Cleft*, its first and only Stamos painting, at auction for $1,200. The bidding had previously halted at $500 before Marlborough hiked it upward.

On May 13, Donald McKinney prepared a list of the paintings Lloyd had selected. Bernard Reis wrote a letter to Daniel Saidenberg formally requesting an appraisal. In this letter, he specified that there were 885 Rothkos in the estate (a figure which was later reduced to 798). Daniel Saidenberg, who lists himself in *Who's Who* as a cellist and an orchestra conductor, had never handled any Rothkos. But the gallery, which he owns with his wife, Eleanor, had engaged in a

number of joint deals with Marlborough over the years, buying and selling works of art. Surely, Reis was aware of this new conflict of interest, since he had co-signed the checks in payment from Marlborough to Saidenberg on many of these deals. And Daniel and Eleanor Saidenberg had visited Frank and Susan Lloyd at their Nassau retreat on Paradise Island four months earlier while the Reises were also houseguests.

The next meeting with Lloyd was set for May 19. On that afternoon, Levine and Stamos met at the Karelsen offices and were shown the Saidenberg appraisal. The 100 paintings, estimated Saidenberg, were worth only $750,000. Stamos declared this estimate to be "dumb," and Levine called it "ridiculous." It would later be revealed that this appraisal had been typed on Bernard Reis's typewriter.

So with Karelsen as their spokesman, the two executors went to the gallery to negotiate with Frank Lloyd. They were aware that "Mr. Marlborough," as Stamos sometimes called Lloyd, was no pushover. Karelsen restated the asking price of $3 million. When he heard this, Lloyd took them over to the window and showed them a nearby Dow Jones sign that indicated a new low in the already depressed stock market. Then, pointing to a paper which both Levine and Stamos later stated was a copy of the Saidenberg appraisal—which they themselves had only seen for the first time some minutes earlier—Lloyd offered them $800,000.

There followed a jack-in-the-box routine by Lloyd. As he made his "final offer," he would pop out of the room, leaving Stamos and Levine to discuss each figure. They would "huddle," as Stamos put it, and Lloyd would pop back with a series of final offers. When his final "final" figure came up to $1,800,000, the others agreed. After that, because this sum was so "extravagant," Lloyd stated his terms: the deal was with Marlborough A.G. in Liechtenstein, $200,000 would be paid upon signing, the rest paid out in installments over the next twelve years without interest. As a first installment the estate was to receive an average of $2,000 in cash per painting. The fact that the total paying of $18,000 per painting extended over twelve years without interest meant that the paintings' average value was only $12,000 each.

Afterward, Reis came into the room and congratulated them. Stamos and Levine were "jubilant," Reis said later. Reis declared it "an excellent deal," they had done a "marvelous job," and they patted each other on the back in agreement. Reis told Karelsen that he was a

great negotiator. Karelsen told Reis that he felt he had "completely out-negotiated Mr. Lloyd on everything." "Everyone was elated," Reis would remember.

Lloyd's view was simple: "They tried to set it as expensive as possible and I tried to buy it as cheap."

Later, Louis Bernstein, Marlborough's temporary accountant, asked Bernard Reis if $1,800,000 was not awfully little for 100 Rothkos. According to Bernstein, Reis replied: "What the hell do I care? The kids each get half a million, and who gives a damn about the charity?"

On May 21, the contract was signed by each of the three executors. It was then dispatched to Marlborough A.G. in Liechtenstein, where it was signed by a trustee for Francis K. Lloyd. Lloyd makes it a rule never to sign anything.

Three weeks later, with attendant fanfare and catalogues, a Rothko retrospective opened at the Ca' Pesaro palazzo in Venice, coinciding with the Biennale. The catalogue did not say that Frank Lloyd owned all of Rothko's paintings on exhibit. The reviews were rapturous, and when the show moved to Marlborough New York that fall, it proved both a critical success and financially rewarding to Frank Lloyd.

The deal remained their secret. But rumors that something had happened began to spread across Fifty-seventh Street and up Madison Avenue.

# 12 Much Fanfare and Some Suspicions

(OCTOBER 1970–MAY 1971)

What artists call posterity is the posterity of the work of art.

Marcel Proust
*Within a Budding Grove*

*MARLBOROUGH*
*Marlborough Gallery, Inc.*
*41 East 57th Street, New York*

*Marlborough Fine Art, Ltd.*          *Marlborough Galleria d'Arte*
*39 Old Bond Street, London*              *Via Gregoriana 5, Rome*

October, 1970
PRESS RELEASE

### MARK ROTHKO

An exhibition of paintings by Mark Rothko will open at the Marlborough Gallery, 41 East 57th Street, New York City on Friday 13th November.

131

# THE LEGACY OF MARK ROTHKO

> This is the first major exhibition in America of paintings by Mark Rothko since the comprehensive show at the Museum of Modern Art, New York in 1961.
>
> The twenty-one works to be shown are among the finest ever executed by Rothko. They fully reveal his sublime use of color, ranging from the torrid, liquid hues so familiar in his earlier works, to the more sombre richness of his later paintings.
>
> This group of paintings dating from 1947–1970 was shown for the first time this past summer at the Ca' Pesaro Museum of Modern Art in Venice during the Biennale. This exhibition was widely acknowledged to be one of the most important in Europe in 1970.
>
> Mark Rothko is one of the leading figures in 20th-century painting and his work is represented in major museums and collections throughout the world. . . .

So ran Marlborough's press release announcing its own Rothko exhibit in the fall of 1970 in New York. It is particularly relevant in contrast to the low opinion of Rothko's stature that Lloyd would later adopt.

To further spotlight the show, Lloyd bought full-page advertisements in art magazines. In addition to the back-cover ad in *Art International*, a Swiss-based glossy publication, there appeared in the same issue two esoteric editorial treatises on Rothko by leading critics. Lloyd later claimed credit for the publication of these articles as well as another by editor Thomas B. Hess in the November *Art News*, which also contained a full-page Rothko advertisement; but it has never been made clear exactly how he arranged for the critiques.

The art world turned out en masse for the Marlborough opening. A few of its good customers had been given previews. One, Katharine Ordway, bought *Yellow, Pink, Yellow on Light Pink*, created by Rothko in 1955. Or rather, she thought she had bought it. According to Miss Ordway, when she came back several times to see it, Donald McKinney assured her that as soon as it was restretched it would be hers. He had, he added archly, written her name on the back of the canvas. The price of that painting was $68,000, quite a jump from her last purchase from Rothko directly, in his studio in 1968, when she paid $26,000 for a painting of approximately the same size. "Prices became very expensive after his death," she attests, "but it was a beautiful picture, and I had my heart set on it." Miss Ordway, how-

ever, was never to see that painting again. She kept reminding Mc-
Kinney, who sold her another two years later for the same price; but
"her" Rothko disappeared into the Marlborough maze and did not
reappear for six years.

Kate Rothko was also present at the Marlborough opening, but no
one paid any attention to her. Gilbert Lloyd, Frank's son, with whom
the Rothko family had spent such a pleasant day in London four years
earlier, appeared not to recognize her. Neither did Lloyd or his nephew
Pierre Levai, who had pressed his attentions on her during the Lon-
don visit. She did, however, come away with an armful of catalogues
and posters—the closest she would come to owning a Rothko for seven
years.

The three executors and their lawyers remained mute about the
secret deal six months earlier. They kept it from the other directors
of the Mark Rothko Foundation—Robert Goldwater, Morton Feld-
man, and Clinton Wilder—even though the foundation was the chief
beneficiary of the estate. Goldwater began to be suspicious when
Reis told him that Rothko had changed his mind just before he
died and wanted the foundation only to aid elderly indigent artists,
and that lawyers were rewriting the charter to reflect this wish. Based
on his own conversations with Rothko, Goldwater did not believe this
could be so. Besides, Rothko had asked him to be a director because
the artist had trusted his judgment as an art scholar about the ex-
hibition of his paintings. So on October 14, Goldwater wrote Reis a
letter asking that the foundation formally discuss the change in
purposes.

He confided his fears to William Rubin, who asked Bernard Reis
directly whether there was a change in the foundation's purposes.
Rothko had changed his mind about the foundation in the months
before he died, Reis repeated. Rubin later sent a stinging letter to
Bernard Reis with carbons to Stamos, Levine, and Goldwater:

> To be sure, the news you imparted to me Thursday, namely
> that the Foundation is now exclusively concerned with the con-
> version of Rothko's paintings into cash to be distributed as
> grants to artists, is profoundly surprising . . .

Rubin went on to cite the public loss:

> That Mark should have reversed himself in those last sick and

133

distraught months is a tragedy for the public that would have gotten access to his work, as it is also a disservice to his reputation. The major works will now presumably be sold, many of them disappearing into private hands for the foreseeable future, and certainly never again to be made visible in the groupings in which Mark invested so much feeling. The many museums all over the world which would have been able to make Mark's work visible in this ideal way will be lucky if they can ever purchase a single picture. With important Rothkos now selling for over $80,000 each, and the price promising to go steadily upwards, small museums, university museums, and, above all major national museums such as the museums of Modern Art in Paris and in Rome will not (despite your assumptions to the contrary) be able to get important Rothkos. . . .

Rubin suggested pointedly that had Mell Rothko known about the change, she might have contested the will before her death. And he added:

What I do find surprising is that Robert Goldwater, who in his professional capacity presumably would have had the major role in the decisions regarding the disposition of the paintings and who was in dialogue with Mark right up to his death, should have, as you indicated to me, just now found out about this reversal in purposes. I have since telephoned Robert and gather that Mark never said a word about it to him but, to the contrary, gave the impression that his concern about the future of his paintings remained unchanged. . . .

Finally, he asked Reis to reconsider the position of the foundation in the light of Rothko's illness.

If Mark, in the disturbed last year of his life, could have dismissed his abiding concern about his work, it can only be explained as a function of his pervasive depression and despair. As you yourself observed, he harbored frequently changing, frequently contradictory feelings about everything and everybody, especially toward the end. Even if Mark at one point did dismiss his concern for the future of the work, he did it as a sick man, not

134

far from suicide. Since he also expressed views to the contrary, you are faced with an ethical problem: which of his views to make operative. Certainly, these original purposes are what Mark had wanted throughout his life and indeed during at least part of his terminal sickness. There are, after all, so many paintings in the estate that if you were to remove only the most important and make them publicly visible in the manner Mark wanted, you would still have a great deal left to sell.

Goldwater also had told Rubin that Reis and the others kept suggesting that Dore Ashton or Max Kozloff write the definitive book on Rothko. Rubin therefore added in a postscript that if such were the case it would be "nothing less than an unwarranted thwarting of a dead artist's wishes."

The response to this letter elicited from Bernard Reis was, according to Rubin, "one of anger coupled with an attempt to intimidate me." Reis said he was going to take it up with the trustees of MOMA. Rubin coolly sent him a list of the names and addresses of the board members: "I never heard from him about it again."

Nevertheless, the foundation's charter was officially amended a few weeks later "to limit and change the corporate purposes in order to more accurately reflect the objectives and functions of the Corporation." It would now award grants-in-aid "to mature creative artists, musicians, composers, and writers." No longer would it "perform any educational purpose."

According to the incorporation papers signed only by Wilder and Stamos, two days after Rubin sent his letter to Reis a special foundation meeting was called at which all the directors voted unanimously to endorse the amendment. Yet there is no evidence of such a vote in the minutes kept of this meeting. But with the promise of exclusive access to Rothko's papers still dangled before him and no way to prove he was right about Rothko's wishes, perhaps Robert Goldwater was persuaded to go along with the others; and in February 1971, Bernard Reis granted Goldwater a limited two-year access to the papers.

And Reis had ambitious plans for the foundation. In Cambridge, Massachusetts, the immense Rothko murals adorning the glassed-in dining room atop Harvard's Holyoke Center were deteriorating from intense exposure to the sun. As described later in a campus newspaper, since 1963 they had been damaged and their predominant color had gone from dark purplish-brown to "faded blue-jean." Ac-

135

cording to Rothko's contract with Harvard, the murals could not be touched or moved even for restoration without the express permission of the Mark Rothko Foundation. If they were moved, the foundation had the right to reclaim them. By 1971, naturally, the paintings were worth a sizable fortune on the commercial market. In the spring of that year, Frank Lloyd, at Marlborough's expense, sent Bernard Reis with Marlborough restorer Allen Thielker to Cambridge on a reconnaissance mission. Ostensibly, they were to determine the murals' restoration requirements. But, according to a spokesman for the Harvard Development office, several letters from the foundation implied that they intended to reclaim the murals. Paralyzed by the terms of the contract, Harvard installed solar-controlled blinds, but dared go no further with the restoration. The Harvard Corporation feared the foundation might sue for their return if the murals were touched.

Even with a new charter, the directors of the Mark Rothko Foundation, except for Vice-President Levine, Secretary Stamos, and Treasurer Reis, would not learn of the Marlborough sale for another year. The foundation, even though it had inherited the paintings, should not be apprised of "estate business," Reis cautioned the others. And his accountings of the foundation's assets did not reflect any of the $200,000 Lloyd had paid for the 100 paintings or the rest of the moneys due under the contract.

Herbert Ferber, as Kate's guardian, also tried to discover what had taken place. But, in the fall of 1970, his lawyer, Stanley Geller, could only learn from Frank E. Karelsen that 100 paintings had been sold for $1,800,000. Karelsen said he would send Geller copies of the contract and Rothko's 1969 agreement with Marlborough, but he never did. Lawyer Gerald Dickler, acting in behalf of Barbara Northrup, Christopher's guardian, also wrote Karelsen but could uncover no further details of the sale.

Meanwhile, Lloyd's promotion and publicity proved privately rewarding. "It beared fruit," as Lloyd put it. For $475,000, Paul Mellon bought five of the 100 Rothkos Lloyd had purchased from the estate in May. The price of one of these, $180,000, was close to Lloyd's downpayment for the entire lot. And these five Rothkos were just hors d'oeuvres; Mrs. Mellon's taste for Rothkos would grow by lavish leaps. By the end of 1970, Lloyd had sold another seven from this lot, bringing the kitty to almost $1 million for only twelve paintings.

Naturally, these sales—like most in the art world—were shrouded in secrecy and would have remained so had not the veil been forcibly lifted two years later.

But Lloyd was not satisfied. There were many plums to be picked from the other 700 or so paintings in the estate.

By November, Lloyd had quietly organized another brilliant feat of legerdemain. In collaboration with a pool of museums in Zürich, Düsseldorf, Berlin, Rotterdam (and later London and Paris), Marlborough would mount a large Rothko show that would travel throughout Europe. The museums would exhibit the paintings and pay costs of insurance and transportation. Lloyd would collect the profits from their sales. With a handful of ringers actually from a private collection, it would look like a legitimate museum exhibit—but actually the bulk of the paintings in the show, like all those at the Ca' Pesaro palace in Venice, would have Marlborough price tags. Marlborough would produce a beautiful catalogue with color plates to encourage sales, as well as to highlight the exhibition. (Since Marlborough listed itself as "agent for the estate of Mark Rothko," presumably the museum directors believed that the paintings belonged to the estate.)

In December, on their arrival in New York, three of the pool's representatives, the directors of museums in Zürich, Düsseldorf, and Berlin—were taken by Donald McKinney to the Marlborough Studio. There they selected fifty-seven Rothkos for the show, which would open in Zürich in March. Donald McKinney appraised the paintings for the insurance that the museums paid.

On January 12, 1971, Daniel Saidenberg produced for tax purposes a curious appraisal of the 795 paintings Rothko had left behind (not including the three stolen from the studio after the artist's death). Since the IRS had required minute, item-by-item appraisals of the furnishings in the brownstone and studio, it is difficult to understand why Saidenberg expected them to accept the following appraisals grouped by medium and period: All figurative and surrealistic canvases before 1947 were valued at $100 each, except for thirty-two surrealistic works which were valued at $800 apiece. Ninety "multiform" canvases created in those lean, exciting years between 1946 and 1951 were appraised at $3,000 each. One hundred and seventy-seven assorted papers from the mature years until Rothko's death, at $3,000 each. Twenty-eight undated works, in various media, were lumped together at $2,000 each. One hundred and forty-five large

"sectional" oils on canvas, painted between 1952 and 1970 (92 of which Lloyd had purchased as part of the 100), were valued at $12,000 each.

There is a clear inconsistency between the two Saidenberg appraisals of the lot of 100 purchased by Lloyd; In May 1970, while the executors negotiated with Lloyd, the paintings had been valued at only $750,000; but eight months later, for the IRS, the group was said to be worth $1,200,000—approximately the value agreed upon by Lloyd. It was a surprising reversal of the usual practice of maximizing the appraisal for the purpose of sales and minimizing it for the IRS.

Together, said Saidenberg, all 795 paintings were worth only $2,654,-900. He produced this extraordinary "global" or "fungible" appraisal (in which similar items are lumped together) instead of the standard item-by-item appraisal. Nor did his appraisal conform to procedures as recommended by the Art Dealers Association of America, of which Saidenberg is a member.

Saidenberg qualified his opinion within an elaborate framework. Guided by three legal opinions shown him (one from Karelsen and two from Lloyd's legal teams), he concluded that the February 1969 exclusivity agreement signed by Rothko was binding on the estate. Therefore, "the market for the paintings is narrowly limited and the usual test of value is not applicable, i.e., what a willing buyer (other than Marlborough) would pay for the paintings." He also justified his low estimate by stating that a "great majority" were in poor condition, rolled and unstretched, and would "require expert restoration in order to make them salable." Saidenberg also cited the difficulty of disposing of such a large number of paintings; the purchase by Marlborough of the best Rothkos in 1969; the limited market for the early works, which meant that many paintings would be disposed of only over a long period of time and their upkeep would require enormous expense; and earlier, higher prices Marlborough had paid Rothko, which were also spread over a long period of time (so that only their discounted rates without interest could be used as a comparison). Finally, Saidenberg cited "the present depressed condition of the economy."

And something else was wrong. When the art world finally learned that the number of paintings in the estate was only 798 (and that only 177 of these were late paintings on paper), several people believed that large numbers of papers were missing and unaccounted for. In his last year and a half, Rothko had painted an enormous number

of papers, estimated at between 800 and 1,000. In the studio, a pile of paper grew to three feet in height and was later moved to Santini Brothers warehouse. Rothko sold some of these papers (about six a year) directly from his studio. Even allowing for the sixty-one papers Marlborough had purchased in 1969 and deducting several gifts Rothko may have made to such friends as the three executors and Rita Reinhardt, there should have been hundreds of papers left. The papers believed to be missing have not yet been found.

Exactly one year to the day after the funeral, the Rothko Chapel was dedicated. It was an historic occasion, an instant renaissance in the New World—art and religion again on common ground, in the garish industrial city of Houston, Texas. Both worlds were color-fully represented. A cardinal was sent from Rome as the papal emissary. Bishops representing several Protestant and Greek Orthodox churches, an imam of Islam, and important rabbis had flown to Houston to spend the weekend in ceremonial dedication, as guests of John and Dominique de Menil and their Institute of Religion and Human Development. Art critics, historians, editors, poets, curators, museum directors, collectors, painters, and sculptors from far and near had all been invited. Almost everybody came except Matisse who wrote from France that he was too ill to attend.

From the outside, the octagonal brick building in the lower-middle-class neighborhood near Rice University was unprepossessing and up-staged by *Broken Obelisk*, Barnett Newman's simple rusted steel sculpture, which stood in the reflecting pool. (The day after the Rothko dedication, the de Menils would infuriate Houston politicians by formally dedicating the Newman to the memory of Martin Luther King.)

At Marlborough's expense, Bernard and Becky Reis flew down with Clinton Wilder. Levine and Stamos, with the latter's young friend Roy Edwards were also there. Dominique de Menil addressed the participants: "This is an exceptional assembly of men of God repre-senting a great multitude, an assembly also of artists and poets, of writers and art lovers, of men and women of good will. . . ." Poetically, she described Rothko's greatness, his dedication, and his "timeless" message. "It was a vision of simplicity, a message of silence. An in-viting silence, a regenerating silence. There is warmth in these paint-ings. They embrace us without enclosing us. The eye and the mind go through into the infinite. . . ."

Kate Rothko had also flown down for the dedication with Katharine Kuh, the Tworkovs, and the Scharfs. After spending several months dismantling the brownstone's clutter of family possessions in order to sell it, she had recently shaken off a depression as deep as one of her father's. A job checking beneficiaries in a life insurance company did nothing to raise her spirits. She had holed up in her little Brooklyn apartment, filled with doubts and guilts, and the weight of bereavement and orphanhood. The responsibility she felt for her brother's happiness and for her dead parents preoccupied her. She began seeing a clinical psychologist, and by removing herself physically and mentally from the art scene and the fashionable East Side of Manhattan she was able to begin to lead her own life. She enrolled for the summer session at Brooklyn College and joined Weight Watchers, losing some thirty pounds to reveal a tiny waist. By the time of the chapel opening she had emerged as a handsome twenty-year-old girl, resembling her mother. She wore a long, loose-fitting white dress with a high neck. Her mane of thick, straight, long black hair and dark eyes were a striking contrast to an ivory complexion. But, as family friends put it: "If Mark and Mell had not died, Katie would have had little chance of pulling herself together. It was her parents' death that was responsible for the making of their daughter."

The chapel received rave reviews from the art press. Barbara Rose likened it to the Sistine and the Matisse chapels. The paintings, she said, "seemed to glow mysteriously from within." One critic, however, Emily Genauer (Rothko's nemesis), assailed it: "Instant gloom," she wrote, "filled with black unbearable nothingness." She could not wait to escape. The crowded ceremony, however, was no way to experience the impact of the chapel itself, which demands solitude. Visitors are still awed by it; some sit for hours in silent contemplation. Sometimes, as Rothko hoped, people cry. It is, as persons of all ages and persuasions seem to agree, an oasis of peace and quiet amid the commercial bustle of Houston.

How it works as an artistic environment is another matter. As Brian O'Doherty pointed out, the paintings had evoked far more response in the controlled light of Rothko's studio than they did in the harsh glare of Houston. Rothko had never visited Houston; the skylight cupola that replaced Philip Johnson's truncated steeple design did not act as a subtle filter, as the one in the studio had. Bright as Houston's sun is, it does not illuminate the recessed paintings. Only

the benches on the central floor are daylit, spotlighting the viewer and diluting his view of the mammoth canvases. The spotlights in recesses of the octagon are not at all what Rothko intended for these works. The movement, however slight, in the brush strokes of several of the nocturnal paintings is lost. And there is little contrast. The cement walls are dull gray.

By another stroke of bad luck, the artist's plans appear to have been misrepresented after his death by those who stepped forward claiming to the de Menils to have inside knowledge of Rothko's final thoughts about the chapel. How this happened was revealed in a 1970 interview with Rothko's former assistant, Roy Edwards:

> When the chapel is finished, Stamos and I are going to go over the details with Mrs. de Menil. There's going to be a kind of stucco wall with a slight grayed-off color. It's not going to be bone-white—Rothko didn't want that. It'll look a lot like pale gray, with a little bit of brown in it maybe. But we're going to look over the final colors for the interior.

He further stated, erroneously:

> It's very strange, but no one knows how the paintings should be placed—except me. Rothko didn't leave any notes at all. And if I hadn't taken measurements from the studio, all this would have been lost. The paintings would have been placed haphazardly, without any notion of what Rothko had in mind.

Edwards claimed that he had taken these notes on his own initiative, and that once "the paintings were done, it was a dead issue, [Rothko] didn't care any more."

Later, it became difficult to find Roy Edwards. After working for Marlborough, again assisting with restoration in the studio, he declared, "The entire art world is corrupt." Edwards shaved his head, donned peach pajamas, and joined the Hare Krishna movement. Three years later he became a member of their South African mission and was thus out of reach of the courts or further interviews.

However, at that opening in February 1971, at least one participant sat aghast: the architect who had conferred with Rothko about the minute details of the structure and hanging. The talks had broken

off abruptly. In the fall of 1968, Howard Barnstone suffered a nervous breakdown. In a sanitarium for many months, he had been treated with electroshock therapy. When he emerged, he discovered that the shock treatment had caused memory lapses. While he was ill, his partner, Eugene Aubrey, had supervised the building. It was not until the chapel was about to be dedicated that Barnstone remembered a crucial conversation he had had with Rothko about the color of the walls. It was too late to redo it: photographs had been taken and the critics had already seen the interior. The de Menils had painstakingly attended to every detail of what they had been led to believe were the artist's wishes. Dominique de Menil commented on the wall's grayish hue (was she in fact quoting Stamos and Edwards?): "The mere suggestion of white walls threw him [Rothko] into a panic. He had an abhorrence for pure white, which he equated to hospital sterilization." Barnstone remained silent; only he knew that an important element of the chapel was not right.

What had come back to him before the ceremonies began was a discussion he had with Rothko just before his breakdown. When asked about the color of the walls, Rothko was silent for a few minutes. Then he unbuttoned the sleeve of his shirt, rolled it up, and pointed to the flesh on the inside of his forearm. "It must be this color," he said. That is, pale ivory with a slight yellowish cast—"the color of cellutex" Barnstone calls it. Another quirk of fate—combined with human frailty—had intervened between the wishes of the dead master and the exhibition of his final and most important commission.

A month later, on the first day of spring, the Rothko traveling exhibition opened at the Kunsthaus in Zürich, attended by Lloyd's most prominent European customers. It was a beautiful show, containing many of Rothko's masterpieces, some of which had never been exhibited publicly. Of the sixty-two Rothkos exhibited, only five had no connection to Lloyd. These were paintings that Rothko had sold to Dr. Giuseppe Panza di Biumo of Milan in the early sixties, and they lent an air of respectability to the show. The others were for sale (though a handful had already been sold by Marlborough just before the show left New York). Of the fifty-seven, Lloyd had purchased five in 1969, and fifty-two had been left in the estate when Rothko died. Twenty-five of these Lloyd had bought outright as part of the 1970 lot of 100 paintings. The other twenty-seven still should have belonged nominally to the estate. But such was not the case. It was Frank

Lloyd's fast shuffle with twelve of these masterpieces that would contribute to his downfall.

In early summer, while the Rothko exhibit was being hailed at the National Gallery in Berlin, the executors' dealings with Marlborough were finally revealed.

# 13 An Unveiling:
## The Dummy Uncovered

(JUNE–NOVEMBER 1971)

> However, in my fifty years of practice, I have learned
> that appearances can sometimes be more important than
> realities. . . .
>
> from an affidavit of
> Frank E. Karelsen, Sr.

On June 17, 1971, an unassuming dentist ambled into Marlborough
Gallery on the sixth floor of the Fuller Building. Rolled up under his
arm were some paintings he had discovered in a closet in his office. At
the gallery, the suave receptionist summoned Bernard Reis, who, after
a quick study realized that the numbers scrawled on the back of the
paintings matched those of the three "missing" Rothkos which had
disappeared from the studio shortly after the artist's death. The dentist
had been directed to Marlborough by the owners of the Rosenberg
Gallery, situated near his office (and next door to the Saidenberg
Gallery) on East Seventy-ninth Street. He explained to Reis that the
pictures had probably been left there by a patient several months

earlier. Reis gave the dentist a receipt for the paintings, but neglected to ask his name or that of his erstwhile patient. There was no reward.

The recovery, apparently out of the blue, returned to 798 the official number of paintings left as Rothko's inheritance. The timing was fortuitous. For eight months Karelsen had postponed inquiries made by the lawyers representing the interests of the Rothko children regarding the 1970 sale to Marlborough. Karelsen finally scheduled a briefing for June 25. The parties gathered in a conference room in his offices, where a handsome poster advertising one of Marlborough's recent Rothko exhibits dominated the walls. Executors Morton Levine and Stamos, with Karelsen and his associate Ernest Bial, represented the estate. Reis did not appear. There, for the children's sake, seeking to learn the details of what had happened, were Herbert Ferber, with his lawyer, Stanley Geller, and Gerald Dickler.

At seventy-nine, Karelsen looked as well preserved as ever, but though he seemed observant, he had been declared legally blind a few months earlier. He was fond of fumbling in his pocket and pulling out his doctor's affidavit of blindness to pass around. (For one thing, this allowed special parking privileges for his chauffeur-driven Cadillac.) His office walls were adorned with signed pictures from well-known Democrats—from presidents (FDR, HST, JFK, LBJ) to judges —as evidence of his longtime political fund-raising abilities.

If Stamos bristled defensively, perhaps it was because a public announcement had been made that he had joined the Marlborough stable. Of course, Stamos's terms were a closely guarded secret. When, that spring, Marlborough had sent out its effusive press release announcing its representation of Stamos, the final paragraph stated: "A major monograph on Stamos by Ralph Pomeroy will be published by Harry N. Abrams in 1971 and Marlborough intends to have an important exhibition of his recent work in 1972." Both events would occur, but the book would not appear until after the Rothko trial was adjourned.

Levine, too, had reason to be uncomfortable. He was in the midst of financial as well as marital difficulties. With the approval of Reis and Karelsen he had already borrowed $5,000 from the estate and was about to ask for and receive a second $5,000 loan. And though he had taken nothing from Lloyd, his conscience evidently was not quite at ease. A few weeks before this meeting, Dr. Albert Grokest was shocked by a telephone call from Levine, who had also been a patient

of his. Levine asked him if he "had any dirt on" fellow patient Herbert Ferber. After lecturing Levine on the topic of medical ethics, Grokest hung up. In a few minutes the telephone rang again; this time it was Anne Marie Levine apologizing for Morton and then reiterating her husband's question. Doubly appalled, Grokest again slammed down the receiver.

When the meeting got down to the business at hand, Karelsen reaffirmed the sale of 100 Rothkos to Lloyd's Liechtenstein headquarters for $1,800,000. The cavalier terms of the payments—$200,-000 down and $133,333 a year for twelve years with no interest—were discussed, and two copies of the contract were passed from hand to hand. When the children's lawyers requested copies of their own, Bial stated that he would have to have more Xeroxes made. He would, he said, prepare a packet of relevant documents and send them to their offices. But much of the meeting was spent trying to resolve the suit by Rothko's estate against Mell's estate, seeking title to the documents found in the brownstone.

When the fat parcels arrived several days later, Herbert Ferber had left New York to spend the summer in Vermont. Geller and Dickler were astonished to discover a second Rothko estate contract with Marlborough included with the other papers. This extraordinary document was unlike any that the lawyers had seen. Under its terms, the rest of Rothko's oeuvre, "approximately 700 paintings," were consigned to Marlborough's New York gallery for twelve years. It was signed by all three executors and by Lloyd's nephew, Pierre Levai, for the gallery, and like the sales contract dated May 21, 1970. Besides the extended period of time (two to six years is usual), other provisions of consignment were incredibly unfavorable to an artist of Rothko's stature. Marlborough's commission was fifty percent of the sale price— or forty, if the sale was discounted to another dealer. Other basic protections for the estate did not exist. Minimum sale price was left to the gallery's discretion—"at the best price obtainable but not less than the appraised value of the estate." Ostensibly, the floor was dependent on the low Saidenberg appraisal of January 1971 (seven months after the apparent date of the contract's execution). Moreover, the second contract seemed to have been signed blindfolded, since, at the time, no inventory existed of the 700 paintings that were being turned over to Marlborough. A "schedule to be prepared" was mentioned in the contract, but until Donald McKinney prepared such a list on June 24, 1971, the day before the meeting in Karelsen's office,

there was none. Under the contract, there was no way of checking prices obtained. Though an accounting to the estate was mandatory every six months, none had been made (nor would it be for another year). There was no drawing account for the estate, as there had been under Rothko's 1969 contract, which had provided for $75,000 on demand. Insurance coverage was limited to $1 million for all 700 paintings.

Neither Dickler nor Geller could understand why they, as Dickler later put it, had been "kept in the dark" about the consignment contract. This "further concealment" made them suspicious, but they concluded that the contract was so unconscionably unfavorable to the estate that the executors were ashamed to discuss it.

Another unexpected document was included in the packet: Rita Reinhardt's 1969 contract with Marlborough. The lawyers could only assume that it had been given to the Karelsen firm by Bernard Reis so that its relatively unfavorable terms as to price and payout could be compared to the Rothko estate contracts. Since Stanley Geller had become Rita's lawyer after its execution, he was chagrined to discover that his client's contract was so publicly flaunted in an unrelated matter.

On Yom Kippur, Kate Rothko drove 100 miles on the flat Long Island highways out to East Marion to visit her father's grave. She wondered whether she should attempt to have his body disinterred and buried elsewhere, far from Stamos. The site, after the tiring two-hour drive, looked peaceful, with the calm waters of Long Island Sound visible in the distance. The slab of graystone chiseled MARK ROTHKO, 1903–1970 now displayed an added effect—a symbolic splash of dark paint.

Late in September, when Herbert Ferber told Kate that *all* the paintings had been turned over to Marlborough, she was thunderstruck. Not that she had completely trusted the three executors, but they had assured her a year ago that she would inherit at least some of her father's paintings. By that time—and apparently since May— there were no paintings left for them to give her. With the backing of some friends, Kate pressed Ferber to initiate a lawsuit against the executors and Marlborough.

Ferber hesitated. For him it was an "odious and difficult" decision. As an artist, he was not unconscious of Lloyd's power—most of the art world knew Lloyd to be ruthless when obstacles interfered with

his business interests. Moreover, when Marlborough opened its New York gallery in 1963, Ferber had hoped to become part of the stable. On his behalf, several friends, both in New York and in Rome, had discussed his talents and work with Lloyd.

As for the executors, there, too, Ferber had reason to hesitate. He did not know exactly what position Reis held at Marlborough, what had happened to Rothko's paintings since the contract, or how the art world would react. He had once been one of Reis's clients, and for a time, with his former wife, Ilse, had been on the guest list for the Reis parties. But after Ilse became mentally ill and was hospitalized, Bernard and Becky Reis, with Rothko, had claimed to have taken steps to have her released. The subsequent break in their friendship was widely known in the art world. After the Ferbers' divorce and his remarriage to his attractive young dental assistant, though he and Rothko remained cordial if distant, the rift with the Reises continued. Ferber had no wish to tangle with Bernard Reis. As for Morton Levine, at the time of Rothko's death, the Ferbers and the Levines had been friends, though the couples since had fallen out. Since both Ferber and Levine were close to Robert Motherwell, that crucial friendship might be impaired. Stamos had been a friend for many years, and the fact that he was an artist made many in the art world long to excuse his weaknesses. But Stamos had signed with Marlborough, after turning over the Rothko estate. Where his allegiance lay seemed clear. Would the art world think Ferber insane to institute a suit against these people and the mighty Marlborough?

In her logical way Kate reviewed the events: her father's serious illness, his alcoholism, and how both had affected his personality; the influence Reis had exerted over him; the suicide; the hasty deals with Marlborough; the rude behavior of all three executors to her mother and herself; her mother's death. What would her father have wanted her to do? Not the finally uncommunicative, broken, hostile man, but the man who had wept at injustice to others, who revered art, and knew he was destined to be great. Who, above all, loved his paintings and wanted them kept together for posterity in groups in empathetic environments. Since his death, Kate had quietly visited museums, searching out his paintings, seeking to understand more about what he meant to convey. She knew that, for her father, money in itself had meant little, though he had confused his values somewhere in the sixties when art and dollars became interchangeable, the former being measured only by the latter. Nor had Rothko intended his children to

be wealthy; inherited money went against the old socialistic morality. He had merely intended that they be comfortably well off, with enough money to educate themselves in their professions.

Kate would fight. For two reasons: for the paintings, to give them the "life" that her father had hoped for them; and against the blatant injustice and betrayal. She hoped the world would not conclude that she wanted money, because she did not.

These things had been turning over and over in her mind for months. She realized that Reis, Stamos, Levine, and Francis K. Lloyd must have believed they had nothing to fear from anyone—least of all her mother. And they must have dismissed Kate as a fat, spoiled brat too upset by her parents' death to understand what was going on. Or they believed that they could somehow deal with her. But she would sue. She would be twenty-one on December 30, and if her guardian did not agree, she could hire her own lawyers. Ferber did agree.

# 14 Maneuvers

> Furthermore, in this kind of serious litigation the respondents should keep the petitioner on the defensive, and the passage of time . . . is in favor of the respondents. Also, it gives the respondents one more crack at getting Surrogate DiFalco on the case.
>
> > from a March 2, 1972, strategy letter stamped "Confidential" from Arthur Richenthal to Frank E. Karelsen, Sr., concerning the "Matter of Rothko"

Located in New York's downtown civic district, the Hall of Records, which houses Surrogate's Court, is a grimy granite relic of the pomp of a bygone age. Its Corinthian columns lead the eye upward to a row of life-sized statues of some of New York's more exalted politicians, its early mayors. Atop the attic roof stands an odd assembly depicted in heroic human form: Childhood, Maternity, Industry, Philosophy, and Poetry. In its way a grandiose mausoleum to the propertied dead, the building took seven years to construct and, by the

150

time it was completed in 1911, cost New York taxpayers $10 million. Once it represented the acme of civic grandeur, its style borrowed from the eclectic baroque favored by the Academy of Beaux Arts of the Second Empire in France. The enchanting clay-colored marble staircase beneath the arched colonnades of the main hallway was copied directly from the great Paris Opera.

The lavish embellishments serve as a fitting backdrop for much of the work of the two judges elected to serve fourteen years on the bench at Surrogate's Court for New York County. The disposition of billions of dollars in inheritance depends on their judgments. Another million dollars is dispensed yearly in fees or patronage to lawyers and bankers appointed as guardians, executors, and trustees, and especially in the court's allotment of attorneys' fees. Overseeing wills, the adoptions and guardianships of wards and orphans; supervising estate management; settling potential conflicts of interest and disparate claims, the two Surrogates are responsible for adjudicating whatever problems arise concerning the personal effects and tangled human relationships the dead leave behind to plague the living.

The lofty two-story courtrooms on the fifth floor are also sumptuously decorated in antique rococo style. Elaborate curving marble fireplaces, balustraded balconies, and hand-carved gold leaf and mahogany reliefs of cupids, the Graces, the Seven Deadly Sins, skulls, and eagles silently watch over the judicial hearings. Surrounding the courts, above and below, are rooms of dusty files jammed with wills and case histories. These are the records of millions of estates, both rich and poor, which repose here as a caution for those to come. It is against the faded elegance of this setting that the final acts of the tragedy of Mark Rothko took place.

On November 8, 1971, a petition was presented by lawyer Stanley Geller to the clerk of Surrogate's Court. In the centuries-old parlance of English chancellery, it stated that Herbert Ferber, acting for his ward, Kate Rothko, prayed the court would grant a decree removing the three executors, enjoining Marlborough from further sales of the estate paintings, directing Marlborough to pay back "illicit profits" already made on the paintings, voiding the two contracts, and directing Marlborough to return the unsold paintings to the estate.

The petition charged that the three executors had "entered into a conspiracy with Marlborough Gallery and Marlborough A.G. and other corporations affiliated with them, to defraud the Estate of Mark Rothko, Deceased, to waste the assets of that estate and to dispose of

the paintings . . . for the sole benefit and profit of the respondents. . . ." At the time the contracts were signed, executor Reis "was and still is an executive employee and/or the chief accounting officer of [Marlborough]," and had "substantial interest in those corporations, both financially and as a matter of personal prestige." Levine and Stamos were both aware of Reis's dual position, the petition charged; further, Stamos had entered into a contract with Marlborough "arranged by Reis" or through his "influence." Both Levine and Stamos were "under the domination and control of Reis."

By giving Marlborough "virtually absolute control of the market" for Rothko's paintings, the executors "drastically limited the supply of money available" to the estate, "prevented" the children from inheriting paintings or giving them to "the great museums of this country and this world for the benefit and enjoyment of all mankind," committed themselves to paying "unconscionably excessive" commissions, and "compounded the fraud" upon the estate. Moreover, the petition continued, for thirteen months, the executors and Marlborough "willfully and deliberately concealed from all other persons interested in the Estate" the details of these agreements.

That same November, Millard Lesser Midonick, a reform Democrat, was elected to Surrogate's Court. An active, athletic fifty-seven, Midonick had served as a judge in Family Court for nine years and had written a book on juvenile justice, but in legal circles he was relatively unknown. His outstanding qualities appeared to be friendliness, kindness, and integrity. When Midonick was sworn in on New Year's Day, the Rothko petition would automatically become part of his caseload due to the alternating monthly court calendar.

When, two weeks after Midonick's election, the news of the Rothko lawsuit was published in the *New York Times,* the art world exploded with rumor, insinuation, and expectation. While many knew that there was some sort of deal between the gallery and the Rothko estate, that Bernard Reis had some vague connection with the gallery, and that Stamos had joined it recently, few were cognizant of the specific details—not even the three non-executor directors of the Mark Rothko Foundation. And Reis had never told them he was actually an officer and director of Marlborough. At a cocktail party in London that fall, director Morton Feldman, who had been abroad for more than a year, was surprised to hear: "Guess what, Bernard Reis and Stamos were in cahoots with Marlborough and that's probably why Stamos got into Marlborough." Clinton Wilder evidently did not object when Reis

told him that the estate's business was not the business of the foundation. Under Reis's benevolent supervision, since its rechartering a year earlier, the foundation had continued to dispense small grants to artists, composers, writers, and poets, unaware of what had happened to its legacy or where the money was coming from.

For a long time the subject of Kate's suit was discussed in whispers; few in the art world were unaware of the potential vindictiveness of the art combine. It was typical of those who knew damaging facts that might have helped Kate's case to retreat into cocoons, murmuring, "But I don't want to get involved." For some, though, Herbert Ferber emerged as a sort of St. George fighting the dragon dealer in pursuit of justice for his wronged ward. But most of those who had glimpsed the tiny dragon's sharp teeth believed that Frank Lloyd would bite back spitting fire—or at least settle the affair for a sum of money before the case went to trial.

Perhaps one reason the suit was not settled out of court was because at the time it posed no real threat to Lloyd. The "Matter of Rothko," as the case was known in legal jargon, was flawed from the beginning. In his pleading, Geller had failed to name Frank Lloyd personally as a defendant—only Marlborough New York and Marlborough A.G. in Liechtenstein. Nor at the time had Geller filed a separate motion requesting a court order to restrain Lloyd from any further sales of Rothko's work. Such a restraining order is almost always sought in proceedings where unique properties are involved. But Stanley Geller says three things prevented him from bringing this motion: he had enough difficulties serving suit on a Liechtenstein corporation; he did not believe this judge, or any judge for that matter, would look favorably on two separate motions brought simultaneously (in his experience it only served to confuse and complicate the main issues); and the fact that he knew so little about Marlborough and Reis's actual relationship with it. Also his client, Ferber, reported to him that the art world thought he (Ferber) was "crazy," and the suit had no chance of succeeding.

Assistant Attorney General Gustave Harrow had never heard of Mark Rothko when he first read the news of Kate Rothko's suit. In fact, he had spent half of his forty-one years buried in law books and knew nothing about the art world. He looked the part of an absent-minded professor of poetry or fine arts—a small, balding, friendly-faced fellow with a fringe of brown hair encircling his pate, and a

Rossetti mustache—far more than he resembled his colleagues in the Trusts and Estates Bureau of the New York State Attorney General's Office. After some quick preliminary investigation, Harrow and his boss, Louis Lefkowitz, decided that this was a case they ought to at least keep an eye on, and Harrow filed notice of the appearance of the attorney general in the suit, thus enabling him to receive and study papers of all the parties involved.

For his defense, Frank Lloyd had marshaled a phalanx of lawyers from two firms. Arnold Roth, from Ralph Colin's firm, Rosenman Colin Kaye Petschek Freund and Emil, represented the New York gallery. Marlborough A.G., the Liechtenstein parent company, was represented by three lawyers—Irving Moskovitz, his partner Emmanuel Dannett and an associate, Norman Shaw of Graubard Moskovitz McGoldrick Dannett and Horowitz.

To represent the three executors, Reis had hired Arthur Richenthal, a feisty verbal brawler, whose defense would be offense with no holds barred. From the start, the defense team employed a strategy of delay to impede the antiquated machinery of Surrogate's Court. This would cause proliferation of motions and actions, countermotions and counteractions in both Surrogate's Court and the Appellate Division of the Supreme Court. The strategy worked to slow down the proceedings by creating enormous amounts of paperwork and confusion.

In May 1972, six months after the case began, the executors responded by initiating two suits against the Rothko children. In one, they challenged the legality of Mell's election proceeding entitling the children to inherit one-half the estate. Two weeks later, contesting the wording of Rothko's will, they sued to attach the forty-four paintings which had been left to Mell (and, on her death, to the children) as "all the contents" of the Ninety-fifth Street brownstone. They would try to prove that "all the contents" of the house was not meant to include paintings. Kate decided that these suits were just attempts to scare her into dropping the case.

Since these two suits were filed in May, a court calendar month when Surrogate Samuel di Falco happened to sit on the bench, they fell under his jurisdiction. The election suit was eventually thrown out of court, but the brownstone-paintings or will-construction suit dragged on, finally coming to trial more than a year later.

Assistant Attorney General Harrow, meanwhile, had been boning up on the stature of Mark Rothko and the value of his paintings. With a notebook and stenographer, he had optimistically set about inter-

viewing important personages in the art world. What they told him and his associate lawyer, Laura Werner, was about to lead him into decisive action. One aspect that particularly interested him was the duplicitous role of the foundation that emerged from his discussion with Robert Goldwater. Goldwater said he had thought Rothko intended the foundation to serve two purposes: primarily, the protection and exhibition of his paintings in museums, and secondarily the dispensing of grants to aging artists in need. He described his efforts to query the other directors as to why the foundation had changed its purposes and the letter he had written Reis, demanding to know more. Reis, Stamos, and Levine had each assured him that Rothko had changed his mind shortly before he died. Goldwater also related that the executors had never revealed any information about the Marlborough contracts to him or the fact that Reis was officially an officer and director of Marlborough Gallery.

On June 8, 1972, Harrow had uncovered enough for the attorney general to enter the suit on behalf of the public as "the ultimate beneficiaries of the Mark Rothko Foundation." Echoing Kate Rothko's suit charging self-dealing, fraud, and conspiracy to "waste the assets of the estate," Harrow's suit added that the respondents had acted in "total disregard of the beneficiaries of the Foundation and of the public interest in the preservation and proper exhibition of the paintings of one of the foremost artists of the period in the U.S." On that same day, Gerald Dickler joined the petitioners on behalf of Christopher's guardian and aunt, Barbara Northrup. Within ten days, Harrow persuaded Stanley Geller to join him in seeking a temporary order from Midonick restraining Marlborough from further sales of estate paintings. Had this action taken place seven months earlier, it would have protected the estate from the loss of scores of paintings.

While legal fretworks were being concocted downtown, all sorts of frenetic activities were taking place at the Marlborough galleries. Marlborough had opened an elegant gallery in Zürich; in late 1971 Lloyd had established a fifty-fifty partnership with Canadian dealer Mira Godard, and Marlborough-Godard galleries were opened in Toronto and Montreal. Pierre Levai would serve as liaison between New York and Toronto and unofficially would handle other activities. Not much profit was to be made directly from sales in these Canadian galleries, but Lloyd's reasons for such expansion would prove sound from his viewpoint. It impressively enlarged his network and at the same time camouflaged other operations in which he was engaged.

Publicly, too, the New York gallery was bustling with events. The promised Stamos exhibit took place, but, despite the fanfare, his paintings were not selling well during their fifteen-month consignment at Marlborough. At McKinney's insistence, Stamos allowed the gallery to lower the prices. Even so, during 1972 and the next year, the gallery would sell only five Stamos paintings, the highest going for $8,000. Stamos's share of the sales—fifty percent—was less than the amount he had borrowed from Marlborough in anticipation of sales. And his Greek pride must have suffered another blow when collector Gilbert Kinney returned a Stamos, *Aegean Sunbox #3*, and credited the $3,000 he had paid for it against a damaged 1953 Rothko—only a foot longer—which he purchased for $63,000. It was one of the 100 paintings Lloyd had bought from the executors.

Bernard Reis was at the gallery daily. "Bernard reveled in the glory of being in the gallery" remembers a former salesman. Lloyd traveled much of the time (since, to avoid paying U.S. resident taxes, he timed his stays to accrue to less than six months a year), and while he was away Reis used his conference room office and telephones. Reis's fascination with sales was clear; roaming around the gallery, he would query the salesmen, "Did you get a bite today?" "Did you sell anything?"

He also made use of Marlborough's international setup in Liechtenstein to sell several of his own paintings and would sell more, grossing over a million dollars in these divestitures. In a special exhibit Marlborough mounted in the spring of 1972, "Masterpieces of 19th and 20th Century Art," eight of the thirty-five works belonged to Reis or to his family; unsurprisingly, considering his influential position, his art received preferential treatment in the show. His Tanguy priced at $90,000 was reproduced on the Marlborough catalogue cover and used as the ad in art magazines. Also well-displayed were his Chagall, Ernst, Franz Kline—all of whom were at one time former clients—and his two Mirós and a Brauner.

The Rothko traveling show reached the Musée National d'Art Moderne in Paris on March 23, 1972. An impressive luncheon was held for Lloyd, his family, and his important customers at the ministry of culture. The exhibit continued to receive fine notices, and more paintings were sold. In fact, Lloyd was dealing out Rothko canvases at an accelerated pace; later, with these 1972 transactions, he would again demonstrate that the hand is indeed quicker than the eye.

Part of his genius was the quick-witted way he could keep innumerable balls aloft as he jetted around the globe. That spring he was negotiating for twenty percent of a Japanese syndicate which would open a Tokyo gallery, Marlborough Torii Fine Art Ltd.—another grand expansion, or so it seemed, of Lloyd's worldwide empire.

At the same time Lloyd's efforts to cement close relationships with important museums were paying off. As with the artists he had won over, the manner of cultivation varied according to the needs of the curator. At the Metropolitan Museum, during the three years of Thomas Hoving's lavish centennial celebrations, Lloyd's relatives and salesmen moved closer and closer to the sources of power.

The Met really became part of the extended Marlborough family in 1970, when Rosemary Hare, a girl friend of Pierre Levai, became the administrative assistant to the late Theodore Rousseau, then vice-director for curatorial affairs and after Hoving the most important power in the administrative hierarchy of the museum. Promptly after Rosemary's elevation, Pierre Levai married her.

For several years, above Rosemary Levai's desk outside Rousseau's office, there hung a painting much admired by surrounding staff members. It was Henri Rousseau's *The Tropics* (or *"Monkeys in the Jungle,"* as it was popularly known). The painting had recently returned from the Boston Museum where it had been featured as one of the "One Hundred Masterpieces from the Metropolitan Museum of Art."

Then abruptly, on May 2, 1972, the painting disappeared. The museum would never see it again. Theodore Rousseau, with Hoving and Met president Douglas Dillon assenting, had secretly sold the painting to Lloyd's Liechtenstein headquarters for $600,000. Everett Fahy, the curator of European painting, had objected to the sale, but was unable to stop it. The rules were simply revised so that the curator had no say about disposals from his collection. Along with *The Tropics* went *The Olive Pickers* by van Gogh, priced by the Met at $850,000. Curiously the purchases were divided and the latter went to Marlborough New York. Backing for Lloyd's $1,450,000 purchases reportedly came from David Somerset's friend, Fiat magnate Gianni Agnelli, who at the time wanted the Rousseau for his private collection. But several months later, when the news of the scandalous sales of paintings from the Met's collection hit the news media, Agnelli quickly returned *The Tropics* to Lloyd. The speculations in the press had added to Fiat's already difficult labor problems. Lloyd later resold

that painting for $2 million through his new Japanese connection, and the van Gogh for another $1,500,000 to the Paris branch of the Goulandris family of the Greek shipping fortune.

Seven weeks later, through Henry Geldzahler and Theodore Rousseau, Lloyd was able to make a most advantageous private swap with the Met. Two years earlier, at the time of the "New York Painting and Sculpture" show, Geldzahler had wanted to purchase David Smith's *Becca* from Marlborough. The asking price then had been $100,000, and the trustees had turned him down. Two years afterward—because of the Met show, as Hoving admitted to *New York Times* reporter John Hess—Lloyd jacked up the price to $250,000. Then in June 1972, with the museum's frantic de-accessioning of the collection bequeathed them by Adelaide Milton de Groot (which included Rousseau's "Monkeys"), initiated supposedly to pay for their 1971 $5,560,000 purchase of Velázquez's *Juan de Pareja*, Henry Geldzahler saw a way to get *Becca*. Lloyd would exchange it for six paintings by modern European masters from the de Groot collection. He would even throw in a $15,000 abstraction by California artist Richard Diebenkorn. In return, the Met would give Lloyd a Bonnard nude, Modigliani's *Redhead*, a still life by Picasso, a Renoir sketch, *Roses*, and two paintings by Juan Gris—even though this would entirely eliminate Gris from the museum's collection.

But by early June, after negotiations with Frank Lloyd had been satisfactorily completed, there still remained some major formalities to be handled at the Met. Only one of the paintings, the Renoir sketch, had even been approved for de-accessioning by the Met board of trustees. The other five, in fact, had not been included on the master list. So, at a June 12, 1972, meeting of the acquisitions committee, Rousseau and Geldzahler obtained approval for the exchange "subject to the de-accessioning of five paintings of equivalent value." It was another of the Met's unaccountably hurried procedural by-passes: eleven days later, on June 23, the exchange was reported to the executive committee, standing in for the full board. Then and there— and after the fact—the five paintings were officially de-accessioned. The five paintings according to Geldzahler and Rousseau were not of museum quality; and Rousseau cast doubt upon the authenticity of the Modigliani. It was all very unorthodox to say the least. If the Met had needed money—its official reason for disposing of art from the collections—why had the paintings not been put up for auction or competitive bidding among a group of dealers? Knoedler had ap-

praised five of the paintings for $330,000 to $335,000; if the museum had sold them to Knoedler, the acquisitions committee could have bought the Smith and Diebenkorn—and still had money to spare.

This type of group exchange between the Met and Marlborough is not an uncommon practice in art dealings. By lumping a number of art objects together and making a trade, it is next to impossible to sort out actual values assigned to each work, and individual resale prices, therefore, can easily become arbitrary choices of the dealer. The more works of art involved, the more difficult it is to unravel the exchange, thereby serving to confuse and confound IRS investigations or public inquiry. Later evidence in the Rothko case illustrates how adept Lloyd had become in the technique of exchanges.

Typically, Lloyd played the part of the loser with the Met; Marlborough claimed to have appraised the paintings at a total of $230,-000—$30,000 less than the new price he had been asking for the Smith and Diebenkorn together. Shedding crocodile tears, Lloyd must have asked, And what if Mrs. de Groot's Modigliani turns out to be phony? Whereupon Theodore Rousseau promised Lloyd a refund of $60,000 or the equivalent in art if such were the case. Both Lloyd and Rousseau were masters at this sort of Alphonse-Gaston posturing.

During that spring, Hoving, Rousseau, and Geldzahler made plans with Frank Lloyd to exhibit the works of the English painter Francis Bacon, another distinguished Marlborough artist, in 1973. However, the Bacon show had to be postponed when in late 1972 and early 1973 the *New York Times* uncovered the notorious de-accessioning deals with Lloyd. It was shelved until the public furor had died down, long after the Met's trustees issued a white paper detailing the dealings with Marlborough, and the New York State Attorney General's investigation of the museum's policies over the de Groot resales had wiped the slate clean—even though the museum was henceforth required to report its sales of art valued at over $25,000 to the attorney general and the public. But in 1975, the Bacon retrospective, another carefully camouflaged Marlborough selling show, was mounted at the Met.

In June 1972, Rothkos from the Paris show, which had closed in mid-May, were unloaded on a dock in New York harbor. There was such a demand for the paintings in Marlborough showrooms that a secretary, Alison Burnham, wrote a note to the customs agent attempting to speed delivery. "Please hurry out this shipment," she wrote. "Salesmen already champing at the bit." But the salesmen's

eagerness to sell the paintings was frustrated. These traveling Rothkos were to pause only briefly at Marlborough Gallery in New York.

The same day that Lloyd concluded his secret swap with the Met uptown, the public proceedings downtown in Surrogate's Court moved toward surprisingly stringent action. Judge Midonick decided in favor of Harrow's motion to enjoin Lloyd from further "sales or other disposition" of estate Rothkos without special permission from the court. Because of Reis's uncontested intimate business connection with the gallery at the time of the contracts, the judge concluded: "It is clear that the issue of self-dealing pervades the proceedings." The law firms were immediately notified of the decision, and three days later Midonick signed the temporary restraining order, scheduling a hearing on the subject for mid-July.

But in the past the courts had proved no match for the wiles and bluster of Francis K. Lloyd; why should this case be different? Despite the court order, by air, sea, and land, batches of Rothkos were spirited out of the United States. The judge would not learn of these forbidden excursions for almost two years.

# 15 Misalliances

(MAY 1972–MARCH 1973)

Two may keep counsel when the third's away.

Shakespeare
*Titus Andronicus*

In June 1972 Morton Levine was scheduled to leave town for a trip to the West Coast. For at least several weeks he had been insisting to the other directors of the Mark Rothko Foundation that the charity needed separate legal representation and that its lawyer must be "without connections either in the art world or with the lawyers in the case." He had suggested a friend, Thomas Woodbury, a White Plains lawyer who fulfilled both these requirements. At a foundation meeting on May 8 at the Reis town house, Robert Goldwater proposed that he and Clinton Wilder, as the only non-executor directors present, meet with Woodbury to discuss the foundation's position. Though the others agreed, three days later Bernard Reis arranged a meeting of the full board and invited Woodbury to join them. Thus the non-executor directors were prevented from acting on their own; and what-

161

ever advice was given at this meeting was not recorded—no minutes were kept.

Some days later Levine was invited to lunch with Frank Karelsen and his associate, Ernest Bial, and the estate's litigator, Arthur Richenthal, at Karelsen's club. They urged Levine to accept Richenthal's nominee, Samuel Greenspoon, a pugnacious and cavillous Southern orator, as counsel for the foundation. Levine says he "categorically refused." And after a long ride in Karelsen's limousine after lunch, as Levine remembers, he became even more adamant. According to Levine, he told them that if Richenthal's nominee was hired, it would be "over my dead body." But while Levine was in California, the relatively simple complexion of Kate's lawsuit changed. The attorney general formally entered the case and Harrow and Geller argued persuasively for the temporary injunction against Marlborough. Surprisingly, the Mark Rothko Foundation entered the suit supporting Marlborough's position by seeking to delay the injunction, and its spokesman was none other than Greenspoon. When Levine discovered this, he became furious, seeing the danger of his position. As he wrote a friend two months later, he had insisted that the foundation be able to "express its self-interests as an heir letting the chips fall where they might." Otherwise, his "dual-loyalty" was a burden whereunder "it was impossible to show that, de facto," he "was schizophrenic enough to be a foundation man acting for the foundation when that was called for and an executor acting for the estate when wearing that crazy hat."

He deeply regretted the foundation's stands in court, "which are both against its interests as an heir and for the interests of Marlborough and the executors."

Levine decided to take two major steps: to resign from the foundation and, as an executor, to divorce his position in the lawsuit from that of Reis and Stamos. After all, unlike the others, he had not been charged with self-dealing and might salvage his reputation and continue as an executor. He went back to Paul Weiss Rifkind Wharton and Garrison, the law firm he had hired two years earlier to help him adopt Christopher Rothko. They agreed to take the case and prepared an affidavit that supported Harrow's injunction against Marlborough. Levine now charged that Reis, in his capacities as officer and director of Marlborough, was guilty of self-dealing in pushing the others for a contract with the gallery, and that Stamos had a "potential conflict of interest," since in May 1970, he had been "considering

entering into an agreement of his own with Marlborough," which he had later consummated.

Despite his split from Reis and Stamos, Levine maintained that everybody had acted in good faith and that there had been no concerted effort or conspiracy to defraud the estate. As his affidavit read: "I wish to emphasize that I have never doubted or suspected the integrity of Reis or Stamos and I do not believe that they consciously despoiled the Estate for the benefit of Marlborough or themselves." He maintained this difficult stance—for the injunction, but against the removal of the executors—throughout the case. This would lead Richenthal to characterize him as "the man on the flying trapeze."

Surprised that the foundation had moved to delay the temporary restraining order in spite of its potential gain as chief beneficiary of Rothko's estate, Harrow decided to challenge its position in writing. He sent a letter to Greenspoon's firm expressing astonishment that the charity now appeared in court with papers "diametrically opposed to that of the Attorney General" that would "result in irreparable damage to the charitable interests." He urged that the foundation "reverse its position" and join him in seeking the temporary restraining order against further Marlborough sales of Rothko estate paintings.

At last, with the temporary restraining order granted and Levine's sudden about-face made, there were two chinks in the solid wall of secrecy surrounding the fate of Rothko's paintings. As ammunition for the injunction, Harrow had obtained affidavits from other dealers, and art historians H. Harvard Arnason and Sam Hunter, attesting to the great demand for Rothko's paintings and his preeminence as an artist. Dealer Richard Feigen revealed that soon after Rothko's death he had twice approached Bernard Reis offering to buy an unlimited number of Rothkos. He was prepared to offer in cash, he swore, "four to six times" the $1,800,000 that Marlborough would pay over twelve years for the 100 paintings. Dealer Lawrence Rubin, younger brother of MOMA curator William Rubin, essentially agreed with Feigen's estimate. Private dealer Ben Heller confirmed Feigen's estimates and added that by then, the summer of 1972, the values of the 100 paintings sold had increased to between $70,000 and $125,000 per painting. Arnold Glimcher of the Pace Gallery revealed the $500,000 cash offer that he and Swiss dealer Ernst Beyeler had made to Rothko in the fall of 1968. They still wanted to purchase Rothkos, he stated. Private dealer Harold Diamond also said he estimated the 100 paintings to be worth, wholesale, two to three times Marlborough's purchase price.

All agreed the consignment contract was unconscionable. As Feigen put it, "The fifty percent commission on consigned paintings for a twelve-year period seems grossly unfair to me and unprecedented in the art world for an artist of Rothko's standing and marketability." Ten to twenty percent commission would have been appropriate (twenty-five was the maximum figure given), and two to four years a fair term.

Heller, who had been a "very close friend" of Rothko, said that since 1954 he had bought eleven Rothkos, of which he still owned six. These, he said, he "would not sell because they are too personally important," but he nevertheless estimated their values at $75,000 to $250,000 apiece. He stressed that he "had often discussed Rothko's goals with him," and listed them:

> To protect and insure the financial solidarity of his wife and children, to arrange and locate in at least one place or in several, a significant body of his work so that viewers could understand who he was, what he sought to do and what he did achieve; and to seek to provide support to those older artists whom the art world . . . had either not recognized or temporarily recognized and then had forgotten.

Heller added,

> Those of us who were close to Rothko were well aware of his personal disturbance in the last months of his life. I cannot believe that could fairly be considered to have changed the total commitment he held toward keeping a body of his work nor can I feel that the execution of these contracts satisfied his goals either spiritually or financially.

The fight over the injunction was bitter. Lengthy affidavits were put in evidence by Lloyd and Reis with briefer support from Stamos. The foundation as represented by Greenspoon now publicly and wholeheartedly supported the contracts.

In Reis's affidavit, he lashed out at a list of "enemies." Clearly he suspected that William Rubin—who had been dropped by the foundation and who had written him the letter which challenged its sudden change in purposes—was the fomenter of a plot to victimize him. Rubin's name had not been mentioned in the lawsuit, but Reis

claimed that the "clique of experts," who had come forward with affidavits, and Herbert Ferber were part of the "powerful" William Rubin "faction of the art world." He said they were "not disinterested men but hostile to me out of personal spite and Marlborough because of business rivalry and envy." Rubin's "deep-seated hostility to me is a matter of common knowledge in art circles." He said Rubin held him responsible for being dropped from the foundation, when really it was Rothko who had made that decision. Among other charges, Reis said that at the preliminary 1969 foundation meeting Rubin "demanded that he be paid a fee for his services as director of the foundation." He also said that Rubin's "enmity" arose from being forced to sign a contract when he bought a Rothko in 1967, by which he guaranteed that he would not sell, give away, or loan the painting without Rothko's approval. As for the others, he went on, "Herbert Ferber's animosity towards me is also well known in our art circles— because he identifies me as the cause for the alienation between him and Mark Rothko during the last few years of Rothko's life." Reis related the story about getting Ferber's wife, Ilse Falk Ferber, released from the mental institution to which Ferber had committed her. Reis attempted to demolish Feigen's business reputation by denying that Feigen had made inquiries about purchasing the paintings after Rothko's death. He had had lawyer Bial investigate Feigen's financial condition in 1970 and claimed that the dealer was "deeply in debt," having "mortgaged his building and pledged many paintings as security for a loan."

Ben Heller "pretends," Reis asserted, that he was a close friend of Rothko's but "not in his later years. Mark Rothko heard that Ben Heller sold one of Mark's paintings to the Whitney at a substantial profit and about the same time is supposed to have purchased another of Mark's paintings from William Rubin."

Reis attached a copy of the extraordinary memo he had written to the other two executors on April 30, 1970, in which he had pressed for a quick sale to Marlborough. Evidently he wanted to show proof that he had absented himself from the negotiations. Apparently he and his lawyers did not foresee how damaging that memo was to his case.

Those art world figures whom Reis had attacked replied with more detailed information. Ferber stated that his wife had left the institution on her own with no help from Reis and Rothko, and that he and Rothko had remained friends until the artist's suicide. Outraged,

Feigen replied that he had indeed put up as collateral some paintings and property a few years earlier until mortgage rates were lowered, but that he was quite solvent. When he had approached Reis about a sale of Rothkos, he had been representing Artemis, the powerful international art investment fund backed by wealthy Brussels banker Leon Lambert. In addition, after he made his first offer, Reis put him off, refusing to take calls or answer letters. Late in the spring of 1970, Reis told him he had *just discovered* that Rothko had a binding commitment to Marlborough.

But the most enlightening information came from William Rubin, who dictated a memorandum from the south of France, where he was vacationing with his brother, and confirmed the memorandum by cable. He asked Harrow to submit with it a copy of the fiery letter he had written Reis in the fall of 1970 challenging him on the foundation's change of purposes. This important document therefore became part of the record. Rubin declared that to say that the other experts and dealers were part of any faction was "laughable" and that, except for his brother, of course, he barely knew the dealers in question. He also pointed out that in view of his important position at MOMA, it was absurd to think that he would have promoted himself as the salaried curator of any small Rothko museum. He detailed his version of the 1969 meeting at the Rothko studio during which Rothko had (in a stupor) remained silent.

Reis's defense of the decision to turn over all 798 paintings to Lloyd was essentially to blame his longtime friend and lawyer, eighty-year-old Karelsen. "I and my fellow Executors were advised by our counsel Frank E. Karelsen that our primary duty as Executors was to expeditiously liquidate the assets of the estate, and that this principle was particularly applicable in the case of non-productive assets such as paintings. Based on this advice, we discussed various ideas, consignment of all or some of the paintings. We agreed the best method would be to sell a significant quantity outright and consign the rest, providing the estate with a business 'hedge' against both up or down fluctuations in the market." Karelsen had said that the 1969 exclusivity clause was binding, so they could bargain only with Marlborough for the best financial terms. The reasons for the haste were, first, there was no reason to delay and, second, Marlborough was using the upcoming Venice Biennale as a lever. The retrospective was an important memorial that would enhance the monetary value of Rothko's paintings.

Lloyd, Reis, and Stamos claimed that there was no way of predicting that values of Rothko's paintings would increase after his death. The reason for their subsequent appreciation had nothing to do with Rothko's stature, which was not *that* great (they implied he was one of a group of minor artists), but was due to Marlborough's excellent promotion and international organization. Their defense even claimed that Rothko had been virtually unknown in Europe until after his death, when Lloyd's exhibits and promotion began to circulate and create a demand.

As for conflict of interest or "self-dealing," the defense maintained that the deals were "arms-length" because Reis had not negotiated. Further, they claimed that Reis had joined the gallery in January 1970 at Rothko's insistence, and that Rothko had suggested and approved of Reis's dual role. Stamos stated that Rothko had often urged him to switch to Marlborough. It was altogether the dead artist's fault that they found themselves in this awkward situation.

Lloyd's affidavit, naturally, supported the contracts. As the "founder" of all the Marlborough entities, he alone was in full charge of their "operations and activities." (He and his founding partner, Harry Fischer, had recently fought over Marlborough, and Fischer had left to open his own London gallery.) Since his was largely a "wholesale business" which involved the acquisition or rights to "all or a substantial part of an artist's works," he required substantial "resources," and contracts required taking risks. Among the risks with the Rothko estate, he listed (as did Reis and Stamos) the following factors: the number of paintings and what their value might be over a long period of time; the number of years it would take to dispose of them, which was dependent on public whim and demand (among the artists whose popularity and prices declined after death, he cited Rosa Bonheur, Bonnat, Meissonier, Bouguereau, Puvis de Chavannes); the overhead expenses of running the business, which he claimed amounted to thirty to forty percent of his gross sales; the fact that the best works sold first, forcing him to carry the less desirable for years; and, finally, the economic condition in May 1970 when the stock market was at its lowest. These arguments had a familiar ring; Saidenberg had used them to support his bedrock bulk appraisal.

Lloyd defended the sales contract and found two dealers (Lawrence Fleischman and Klaus Perls) to back him with affidavits saying that the bulk purchase price discount is generally sixty to seventy-five percent of retail prices. No interest over many years, he pointed out, was

a feature of many of his purchases, such as the Feininger and Reinhardt estates, and his contracts with Still, Motherwell, and Gottlieb—as well as with Rothko and his estate. The consignment terms were fair as well as for the 698 paintings because the majority were in poor condition, rolled or unstretched or on makeshift stretchers, and needed restoration; only a minority of the paintings were from the salable mature period. Marlborough A.G. had already purchased the "best and most desirable" 105 Rothkos in 1969. He was "informed" that the executors did not want to be saddled with expenses of upkeep, which would cost "hundreds of thousands of dollars." He listed restoration costs at $1,000 a painting for oils and $500 each for papers. "Marlborough is not a charity," he added.

In retrospect, the affidavits of all three defendants—Reis, Stamos, and Lloyd—have curious holes. Lloyd explained that the "put" in the 1969 contract (whereby Marlborough was compelled to buy four paintings a year at ninety percent of prevailing market prices) was there in order to permit Rothko to share in the profits from merchandising and a rising market. Two years and two law firms later, his position would change. By then the "put" was only to let Rothko sell occasionally from the studio; perhaps for this reason Lloyd would renounce this entire affidavit saying that his lawyers had shown it to him late at night and he did not believe that he had actually signed the document.

Both Reis and Stamos repeated (in Reis's words) that "anyone who was really a friend of Mark and knew his feelings would never have sold one of his paintings. . . . Mark deeply resented the resale by any friend of any of his paintings. . . ." Reis had already put at least one of his own Rothkos up for sale, though it was later withdrawn. Stamos, at the time he signed this affidavit, had sold one painting and was negotiating the sale of both of the paintings that had been gifts from Rothko. One, a large multiform 1948 work, had been exhibited at MOMA in 1961 and hung in a place of honor over Stamos's bed; now, needing restoration, it was offered to a dealer for $61,000. Stamos later said he sold it for $43,000 to dealer Harold Diamond, who denies such a purchase. Three paintings Levine owned would also be sold the following year.

Several facts about Reis's sworn, self-important resumé did not check out. Reis claimed to have written a "Book-of-the-Month Club selection" titled *False Security, The Betrayal of the American Investor*. But

the Book-of-the-Month Club has no record of Reis's bestseller. The book, it appears, was printed in 1937 by Equinox Publications, a Canadian firm.

Among the clients Reis listed as those with whom he had "personal relationships" was Willem de Kooning. This relationship was almost the artist's undoing. According to de Kooning's lawyer, Lee Eastman, Reis advised the artist to hide some of his income. Reis later held this kitty over de Kooning's head, threatening to report the painter to the IRS. "I told him go ahead," says the artist, "and I would tell them who advised me to do it." Reis did tip off the IRS that de Kooning had been paid $15,000 by check from a Swiss bank and that it had not been reported on de Kooning's tax returns. But since de Kooning had been advised by his lawyer not to cash the check, and was able to produce it for the IRS, he paid no fine.

On his own lawyers' copy of the affidavit, where after describing his warm friendship with Rothko, Reis wrote, "My compensation in turn was not monetary," one of his lawyers had revealingly penciled "paintings" in the margin next to this sentence.

Judge Midonick was not convinced by the respondents' arguments. In September he handed down a preliminary injunction, explaining: "The conclusion is that the appearance of self-dealing is so strong in this case that the court could not permit performance under the contracts without judicial supervision and permission . . ." He ordered a trial so that the parties could be heard.

For some time Kate Rothko had not been satisfied with the legal advice of Stanley Geller. Thirteen months had elapsed before the contracts were turned over by Karelsen; then, when Geller finally filed suit six months later, he had not sought the necessary *ex parte* restraining order. Only through the efforts and determination of Assistant Attorney General Harrow had the injunction finally been ordered. Kate guessed that millions of dollars' worth of her father's paintings had been sold in the intervening seven months.

Though Kate had repeatedly stressed to Ferber and Geller that her father had not wanted his paintings disposed of, that the foundation was intended to hold on to his works so that they might gradually be given in groups to museums, Geller had not raised this issue. Therefore, the court had remained unaware of this central aspect of

the case. This omission had made the executors' arguments that it was their duty to liquidate the estate sound reasonable. Geller had also told Kate that she could not examine her family's papers while the executors' appointees were taking inventory; Kate had since discovered this was not true. And the lawyer had made another mistake which to her was unforgivable. The date on which her parents had separated was a vital point in the lawsuit brought by the executors against her and Christopher in an attempt to take the paintings from the house. She knew the exact day he had walked out, New Year's Day, 1969. Geller had not taken her word for it, but had asked another of his clients, Rita Reinhardt. When Mrs. Reinhardt told him that the separation had taken place in the fall of 1968, after the Rothkos' return from Provincetown, Geller used that date in his brief. As Kate put it, on this matter why should he trust a woman hostile to her mother?

Switching lawyers in mid-suit would be extremely awkward—particularly since Geller was a cousin of Herbert Ferber's wife, Edith, as well as Ferber's own lawyer and the lawyer of record in the settlement of Mell's estate. A further difficulty was that just before Kate turned twenty-one, Ferber had persuaded her to sign a contract saying she would continue to retain Geller. But she knew now that she must have her own lawyer.

In August, when she and Christopher visited their friends the Kravitch family in Savannah, she told attorney Phyllis Kravitch and her sister, Sally Scharf, about her disillusionment with Stanley Geller. The Kravitch sisters, daughters of a well-known civil rights activist and attorney, agreed to help her. Sally pored through the Martindale Hubbell Law Directory and telephoned trusted and eminent lawyer friends in other cities. They all agreed that whoever Kate chose must have nothing to do with the art world. He must also be a partner in a large and well-respected firm with a solid record in litigation and handling estates. Two firms met their specifications. Kate chose Breed Abbott and Morgan.

The firm agreed to take the suit despite its distorted history, and the chief litigating partner, Edward J. Ross, a brilliant if abrasively egocentric lawyer, took charge of the case. Stanley Geller sued Kate Rothko for $50,000 in fees he claimed were due him (the judge awarded him $32,800). He continued to represent Mell Rothko's estate, taking a defensive role in the proceedings to attach the paintings in the

brownstone. But Charles Gibbs of Breed Abbott would represent Kate in this suit.

Meanwhile, in the central lawsuit there was still no information about what had happened to the 798 estate paintings. Harrow had filed two sets of interrogatories on all the defendants, but Marlborough had refused to reveal the names of purchasers. Both customers and prices paid were, they claimed, trade secrets, confidential matters. But through pressure from his new lawyers, Levine had finally received his first accounting of paintings sold under the consignment contract, although the contract called for an accounting on January 1, 1971, and every six months thereafter. What it showed gave rise to more worried speculations. Seventy-three consigned paintings that Marlborough appeared to have sold had gone at distress prices in odd lots to what seemed to be business connections of Lloyd's outside the United States. The lawyers concluded that on the face of it, these sales looked more than suspicious—"non-bona fide" was the way Harrow put it. Two were to Liechtenstein corporations, one of which was called a "galleria," a third to a London gallery, William Hallsborough, Ltd., which did not deal in modern art. In all but one of the bulk sales, the deals had been made through Liechtenstein and the estate was charged a forty percent commission by Marlborough in addition to dealer sales discounts. The sales averaged $38,000 for an oil on canvas and $10,000 for an oil on paper. Of the total $1,319,000 listed as consigned sales, the estate apparently had received only $786,000. (Later both the number of sales and total prices would be amended.)

The preliminary injunction, of course, had been appealed. But in early December 1972, the five appeals court judges upheld Midonick's ruling, and at the same time directed "an early trial." His order forcing disclosure of purchasers of paintings from the 100 bought through Marlborough A.G. had also been appealed.

For some time, Harrow had been seeking to examine the non-executor trustees of the foundation, hoping to discover whether there was proof that the foundation had been used as a pawn by the executors and to gather testimony as to the foundation's purposes. It was Robert Goldwater who could shed most light on this. Harrow wanted to put into evidence the concealment of the contracts Goldwater had told him about in May, and the 1970 letter which Goldwater had written to Reis, querying the change in the foundation's purposes.

Perhaps Goldwater would have even more to tell about what had happened since.

By a barrage of legal ploys, Greenspoon blocked a Goldwater deposition. Not only had he filed a motion to dismiss the attorney general from the case, but he filed a second motion to prevent Harrow from examining Goldwater and Feldman. If information about the foundation was wanted, Clinton Wilder, as its president, was the only person who could give the facts. Greenspoon also moved to examine Harrow himself about his sources of information. Harrow was thus prevented by legalities from taking direct action.

But Robert Goldwater was increasingly disgusted with Bernard Reis and the way the foundation operated. On July 12, 1972, a day Reis knew Goldwater would be away, a meeting was held at Reis's town house, on three days' notice. Only officers Reis, Stamos, and Wilder were in attendance, with lawyer Greenspoon, who took the minutes of the meeting. According to these minutes, the foundation formally backed Wilder's retention of Greenspoon to represent them. That same day an affidavit was signed by Wilder for the foundation, officially supporting Marlborough and the contracts.

When he heard about this, Goldwater again told Reis that he did not think the foundation ought to take any position in the case and abstained from approving the minutes of that meeting. But whenever Goldwater raised serious questions such as these, he told his family, Bernard Reis would counter with "What you said doesn't count" or "I don't know what you are talking about" or "Put that in writing, I did not hear what you said." The professor had become a problem.

The situation became critical in August when Greenspoon sent Goldwater an affidavit to sign that endorsed the foundation's change in purposes. Not only did Goldwater twice refuse to sign Greenspoon's draft, he drew up his own rough revised version, asking Greenspoon to put this into legal form as an affidavit that he *could* sign. Goldwater stated the foundation had been formed primarily "to hold the bulk of Mark Rothko's pictures, and to exhibit and disperse many of them to museums and private collections in such ways, including sales and gifts to public institutions, as to protect Mark Rothko's achievement and reputation, being especially conscious of his wish to have his paintings seen in groups rather than singly."

Goldwater added Rothko's secondary intention: "From the proceeds of the sales of a portion of Mark Rothko's pictures to make grants to mature artists who, regardless of any judgement of their

talent had displayed life-long dedication to their art and were in need of financial assistance."

Goldwater said that after Rothko's death when he raised the question of the change in purposes he was told "informally, and formally by Messrs. Levine, Stamos and Reis at a meeting held late in 1970 at the home of Mr. Stamos that Mark Rothko had changed his mind about the dual purposes of the foundation and did not want the foundation to hold any pictures and that he wanted the foundation to make grants to help mature artists, painters, sculptors, writers and composers." On his part, Greenspoon merely ignored the professor's attempt to set the record straight. Goldwater's affidavit could have blown the lawsuit wide open.

In order to write his book, Goldwater was still in the unfortunate position of requiring a further extension of the exclusive rights to the Rothko estate papers. Several publishers had expressed an interest in the book, but Goldwater, ever the reasoning perfectionist, needed a guarantee that he would be allowed more time with the papers before he could commit himself to a contract. Still, Bernard Reis put him off.

At a foundation meeting on October 22, 1972, Goldwater introduced a mild statement urging that the foundation withdraw from the lawsuit and asked that the statement be placed in the minutes of the meeting:

> I recognize that the Mark Rothko Foundation stands to be deprived of principal and consequent income for a limited period of time by the granting of a temporary injunction in the matter of the "Application of Kate Rothko." In spite of that I believe that the Foundation cannot properly take a stand on the legal issues. Therefore I call upon the other Directors of the Foundation not to submit any more legal arguments in the case.

But no one would second Goldwater's motion. Of the directors, only Reis, Stamos, and Wilder were present, again with counsellor Greenspoon in attendance. Not one of them wanted Goldwater's statement recorded in the minutes. (Evidently Goldwater felt this statement to be of importance to posterity. He had it notarized and hand-delivered to his lawyer-executor to be placed in the file containing his will.) But none of the facts relating to the foundation's role in the lawsuit would become known for four more years—long after the court's decision in the "Matter of Rothko."

While the minutes do not disclose even the tenor of Goldwater's proposal, they do suggest how access to the Rothko papers was being held over his head. The final paragraph of the minutes states:

> Mr. Goldwater raised the question of his exclusive access to the papers of Mark Rothko in view of the fact that another had indicated the intent to write a book about Mark Rothko. It was pointed out that this was a matter for the Estate and not for the Foundation. Mr. Goldwater stated that anyone who desires may write a book about Mr. Rothko, and that he was interested only in preserving his exclusive right to Mark Rothko's papers until the expiry thereof.

The "another" who wanted to write a book, Goldwater was told, was in fact two people: Tom Hess and Dore Ashton. Goldwater was chided for being so slow.

In November 1972, Stanley Kunitz, an ardent supporter of Bernard Reis, was nominated by Reis and elected to the foundation's board. In December, Goldwater's apprehensions were confirmed. Thomas Hess attended a foundation meeting during which, as the minutes read, he was "voted in" as a director. The foundation was stacked against Goldwater, and the screws were tightened. Reis and Stamos wrote memos implying that the Rothko papers were going to the Archives of American Art and would be open to all. Of course, this turned out to be nothing but a ploy. When, in a letter to Reis, Goldwater repeated his request for an extension of exclusivity, he reminded the board that Rothko had selected him to write the book. Reis did not reply. The exclusivity lapsed. To his credit, Goldwater did not yield to the pressures, even at the expense of his precious book. He had been a victim of a not too unusual attempt at literary blackmail.

In December 1972, Judge Midonick upheld the right and obligation of the attorney general to appear in the case, as well as his right to examine Goldwater and Feldman. As his decision read:

> The special circumstances permitting the questioning of the directors of the Foundation who are not executors, lie at the very heart of the claims of self-dealing. The "duality" upon which the Appellate Division remarked in its affirmation [of the preliminary injunction] affects the Foundation in an alleged *interlocking triality* [emphasis added] in that two of the three executors

who are claimed to have conflicting ties with the purchasing and consignee galleries, are also directors of the charitable foundation.

Furthermore, stated the judge,

> If it can be established at the trial that the testator intended to preserve all of his paintings or some of them in public museums, without excessive dispersal, for the benefit of the general public and for charitable reasons of education and culture, the Attorney General has this burden by statute.

Immediately, the foundation appealed Midonick's decision, further postponing Goldwater's deposition.

On Monday, March 26, 1973, the Appellate Court handed down its affirmation of Midonick's decision. At last Harrow was able to begin his examinations. But that morning at the Goldwater home in the West Twenties, sculptor Louise Bourgeois discovered that her husband Robert Goldwater had died in his sleep. He was sixty-five years old and in apparent good health.

On Saturday, five days after Goldwater's death, the Mark Rothko Foundation met again at the Reis house. Only Reis, Stamos, Hess, and Kunitz were present. Their fellow director's untimely—or timely—death went unrecorded. The minutes do mention that "Thomas Hess was asked if he would be willing to undertake the writing of the book on Rothko. There was some discussion and Mr. Hess said he would let us know his decision." At the following meeting Hess agreed. "Bernard Reis talked about the possibility of having the Executors of the Estate of Mark Rothko meet to discuss ideas and possibilities for a Rothko book which Thomas Hess would like to write."

With Goldwater gone, there was no one left who would further enlighten Harrow about the foundation or about the three-way conflicts of interest—or, as the judge had written, the "interlocking triality" of Reis's and Stamos's positions. The court would exclude foundation matters as an issue in the trial. Harrow did not discover what had transpired until nearly four years later, far too late to influence the judge's deliberations in the "Matter of Rothko."

# 16 The Free-for-all and the Referee

(JANUARY 1973–FEBRUARY 1974)

> Why may not that be the skull of a lawyer? Where be his quiddities now, his quillets, his cases, his tenures, and his tricks?
>
> Shakespeare
> *Hamlet*

Nineteen seventy-three will be remembered as the year of the Watergate hearings. The attention of the nation and the world was riveted on the devastating disclosures emanating from Washington, D.C.

Naturally, compared to these momentous and historic events, there was little public interest in the tiny mare's nest of legalities taking place behind the scenes of a civil lawsuit against three executors and an art dealer in New York. But in the microcosm of power and money that is the art world, the Rothko lawsuit would assume enough importance by the summer to be dubbed "the art world's own little Watergate."

For the Rothko children's lawyers and the attorney general, the entire year was a seemingly endless series of frustrations and confusions devoted to an attempt to examine the defendants and other witnesses in preparation for the trial. Again and again, their efforts to pry key documents and information from the opposition were foiled—often with accompanying vitriolic epithets, disappearing-acts, and raucous filibustering from defense lawyers. From the eight sets of lawyers there were motions, countermotions, and four further appeals (making a pre-trial record of seven in all). The depositions would number 7,000 pages, the exhibits 500, but much vital information remained suppressed.

From the beginning, the actual whereabouts of the resold Rothko estate paintings was a mystery. Lloyd's lawyers still blocked all interrogations as to who had purchased them, when, and for how much. All that was known was that seventy-one paintings had been sold from the one hundred bought by Marlborough A.G. After the argument that the names of purchasers and prices paid for the sales contract paintings were "trade secrets" had failed to impress Judge Midonick, he held that "legitimate sales were an element of proof as to the value of the paintings executed by the testator." Then Lloyd's lawyers claimed that revealing the names of customers was a criminal act punishable by a fine under the laws of Liechtenstein. But early in 1973, Midonick rejected this ploy, saying the law they had presented in "unauthenticated translation" from the German did not apply. It apparently concerned "economic espionage" aimed at wartime disclosure of business secrets to foreign powers. Harrow, who had been attempting to examine Lloyd for months, only to be put off by Lloyd's lawyers, moved to cite the dealer for contempt if he did not appear. The deposition was scheduled for early April.

In late January, with disclosure still months away, the examinations finally began. The lawyers took the depositions at one of their offices with a court stenographer keeping the record. Stamos was followed by Reis and Wilder. But because of a continual barrage of noisy objections, asides, harangues, and even applause by counselor Greenspoon and nudgings of his witnesses by Richenthal (noted on the record), next to nothing was uncovered.

When they did answer, the witnesses were less than candid. At first, Stamos's version of the negotiations with Lloyd on May 19, 1970, included the fact that Lloyd had waved a copy of the Saidenberg ap-

praisal of the 100 paintings (at $750,000) and, pointing to it, had said, "I'm really buying only ninety pictures—the late black and grays are untried, you know." This corresponded to Levine's version. Then, in reply to another question, Stamos said he had watched Levine sign the contract and after that thought he had seen Reis sign. At this point, Richenthal abruptly interrupted him, and Stamos qualified his answer by saying he could not remember any details or where he had signed the document. The next day he retracted both statements. Lloyd had not had a copy of the Saidenberg appraisal, he remembered, and he, Stamos, had signed the contracts at home.

During the initial examinations, documents subpoenaed by the lawyers were not produced; incredibly, Richenthal declared them unnecessary. Stamos never alluded to his original contract, brought to his house in 1970 by McKinney on his birthday, New Year's Eve. Under the terms of that contract, Marlborough's commission was forty percent, ten percent lower than the Rothko estate contract. The earlier contract would be uncovered only after other records finally surfaced which referred to a Stamos contract of "1/1/71" and a forty-percent commission. During his examination, Stamos recited the details only of his contract dated January 5, 1971, with its fifty-percent commission. He added that Marlborough had offered him a monthly stipend of $1,000, but that he had taken only $700. Even these later terms, however, were far better than the Rothko consignment contract —Stamos had set his own minimum prices, received a stipend, and the four-year term was certainly preferable to the unheard of twelve.

When Reis was examined, Harrow requested a copy of the fall 1970 letter written to Reis by Goldwater questioning the foundation's change in purposes. But after Richenthal had promised to produce the letter, he asked if Harrow had seen it. When Harrow unwittingly disclosed that he had not, Richenthal claimed the letter had been lost. Most of Reis's papers having to do with the case, including the carbon of his original letter to Saidenberg asking him to appraise the 100 paintings, had also disappeared when he left his accounting firm. "All my files," Reis lamented, "my tremendous files . . . they were all dumped together and—ever so many files were lost and missing . . . in connection with this estate." His former partners dispute this, though their story never came out during the lawsuit. They had 262 cartons of Reis's papers delivered to him in June 1970. Restorer Allen Thielker's assistants remember that six months later an entire wall of cartons containing Reis's papers were stored at the Marlborough Studio. They

were directed by Reis to throw out four of these cartons, but the majority were kept there for an indefinite time.

In reply to the simplest questions, Reis would often hem and haw and mumble "Don't recollect." When he did remember, Richenthal had a way of leading him into recanting. Asked by Ross, for example, when the executors vacated the studio, Reis first responded, "In the very early part of March." To which Richenthal interjected: "Moved out in the early part of March? Do you know what you are saying? Do you understand his question?" Reis declared he did understand and repeated the question. Then Richenthal and Greenspoon ran interference for a bit, Richenthal repeating, "I don't think you understand." Finally after Ross showed Reis that the estate had only paid one month's rent, Reis said, "They [the executors] never gave up occupancy until May something, the latter part of May 1970." Months later, canceled checks and the lease showed that Reis had paid the March rent for the estate and the April rent in the name of the gallery and had also signed the new lease for Marlborough. When he signed his deposition a year after the examination, his final answer was corrected to read simply: "Yes, at the end of March, 1970."

Both Reis and Stamos claimed to have told Mell Rothko about the Marlborough deal in the summer, before she died. Stamos declared that he had told her in July 1970 after Barney Newman's funeral, as they were sitting in Stamos's own backyard. She had shown no surprise, he said, because Bernard Reis had already spoken to her about it at the Tate opening in May. No substantiation was ever offered, and neither had Mell ever mentioned it to Kate or to anyone else. "Had she known, my mother would have told me, I'm sure," says Kate Rothko.

Clinton Wilder's testimony reflected at best a studied naïveté. His support of Reis and Stamos and the Marlborough contracts was unwavering, even though the foundation stood to gain far more money if they were set aside. Wilder's ignorance of the issues was apparent; he had blindly relied on Greenspoon. Nor could the petitioners discover from him how Greenspoon had been retained. Each time the question came up, Greenspoon would cite the privileged nature of the attorney-client relationship, even though in this case the rule did not apply. The vituperations and legal fees were rapidly mounting and the examinations were very slowly getting nowhere. Nine days and 1700 pages of transcript had revealed next to nothing.

Indignantly, Edward Ross wrote a long and blistering affidavit de-

scribing the mockery of the judicial process and requesting a referee. Never in his twelve years as chief of litigation for a large law firm had he witnessed anything to resemble this "shambles." He cited some of the defense's shenanigans as well as some of Greenspoon's saltier epithets: Rothko's paintings were "crap"; Ross had "purloined documents"; "this is insanity multiplied running riot ad infinitum . . . to the eleventh power"; "Triple-distilled minutiae trivia" and "antediluvian trivia minutiae"; "it's irrelevant, immaterial and trivia to the thirteenth power." Other direct and relevant questions Greenspoon characterized as "just this line of grabage." Also, in his affidavit Ross termed the foundation "a cat's paw" for the executors. For using this analogy, Greenspoon repeatedly threatened a lawsuit against Ross.

When Judge Midonick had read Ross's brief, he agreed that a referee was necessary and appointed former Supreme Court Judge Bernard S. Meyer (who would later make headlines as New York Governor Carey's choice to head an inquiry into the Attica prosecutions). With Meyer overseeing the proceedings, the lawyers could reexamine witnesses and subpoena others. His presence lent the court's weight to the demands for documents. But his $42,700 fee, which Ross requested the defense pay, would come out of the estate's funds.

In mid-February, through Levine's lawyers, a document came to light that was to become central to the case. The lawyers had demanded that the estate's accountants, Kozak and Schwartz, send them copies of letters concerning the Rothko estate. At that time, in January 1973, the accountants were disturbed about discrepancies in the accountings for thirteen consigned Rothkos. Leery of the lawsuit, they clearly did not want any trouble and dispatched a letter to the Karelsen firm with a copy to Levine and his lawyers, querying the estate about several strange accountings for thirteen Rothkos. First, they wrote, the thirteen had come to their attention on a November 16, 1970, *Statement of Sale* as having been sold to Marlborough for $248,000; the estate had been paid in full seven months later. The transaction had been included with the 100 painting sale to Marlborough by the accountants on the estate's federal tax returns, bringing the total paintings sold to 113. Then in April 1972, five months after Kate filed suit, for some reason the estate was paid an extra $73,000 for these same paintings and the accountants received a new statement of sale dated January 2, 1971. And when Marlborough issued a *Statement of*

*Consigned Sales* on November 16, 1972, these very same paintings were listed as having been consigned and sold to various third parties.

The confused accountants begged to know what the new and inconsistent documents concerning this "sale" were about. How could the identical thirteen paintings already "sold" be relisted with the consigned sales? How to get around the fact that a "sale" was listed on tax returns already filed and that the checks received in payment specified a further "purchase of 13 Rothkos"?

Levine's lawyers then demanded that the accountants send them all the documents mentioned. These papers contained the seeds of Frank Lloyd's destruction. Many differing paper versions of this transaction were still to come. A sales invoice was clearly drawn up by Reis on stationery of "The Estate of Mark Rothko," and the address on the letterhead was that of the Reis town house. The invoice was addressed to Marlborough Gallery, Inc., and showed the sale of thirteen paintings (seven oils at $80,000 and six papers at $10,000) for a total of $620,000. From the total amount there were two commissions deducted —the first at "33⅓ percent for sale to European dealer," the second "40 percent to Marlborough Gallery, Inc." Marlborough was the "European dealer," which meant they had at first taken double commissions. From this sale the estate netted only $248,000. But later documents revealed that a year after the estate had been paid the full $248,000, and, significantly, after Kate's suit began, there was a further payment of $73,000. A second document, also on Reis's stationery, showed the sale had been made to "an affiliated gallery," which was later identified as Marlborough A.G. While there was no second commission or discount listed in this version, the price of the thirteen paintings was lowered to $535,000 (reduced by $85,000), and apparently only one commission was paid Marlborough; but the estate's share was raised by $73,000 to $321,000. What made the sale even more interesting was that when checks for the payments were introduced in evidence, Bernard J. Reis had both signed them (for the gallery) and deposited them into the estate's account (as treasurer). Ambidexterities such as these—not all that unusual in the art game— continued to arise throughout the Rothko affair.

What the Kozak and Schwartz memo meant, in short, was that in the glare of the lawsuit, there was no accounting for all these accountings. A year later, when numbers could be matched to paintings, twelve of these paintings proved to have been among those exhibited

in the Rothko European traveling show—with its fine museum pro-
motions for which Lloyd thought he deserved a lion's share of the
profits. Yet during these initial depositions both Reis and Stamos
repeatedly denied knowledge of the deal for the thirteen paintings.

Marlborough New York finally released the names and transactions
involved in seventeen of the seventy-one sales from among the one
hundred paintings that Lloyd had bought outright. All these had been
sold by Marlborough New York. These seventeen New York paint-
ings were sold to legitimate individual purchasers for a total of
$1,264,000. In November 1970, the lawyers now learned, Paul Mellon
had bought five, ranging from $55,000 to $180,000. *Homage to Matisse*,
a painting especially cherished by Rothko and the family, had been
sold at a discount to the art collection of the McCrory Corporation
for $67,500. Other purchasers and the amounts they paid included
publisher S. I. Newhouse, Jr. ($85,000), and philanthropist Barbara
Westcott ($75,000).

The pattern of Liechtenstein sales was also revealed, although the
names of purchasers remained secret while Marlborough appealed
Midonick's decision. Until Kate's suit began in November 1971, there
had been twenty-five Liechtenstein sales, all of them to individuals,
apparently averaging $73,000 each. (Later it was discovered that on
certain sales Marlborough had reported to the court prices tens of
thousands of dollars less than the actual figures.) After the lawsuit
commenced, sales were made quickly and in bulk, at "distress" prices
averaging $38,000 a painting. Marlborough's brief held that pub-
licity over Kate's lawsuit had lowered the demand, making it hard
to sell Rothkos for high prices. But already there was enough evidence
to make these later sales suspect.

With referee Meyer sworn in and presiding, Harrow finally was
able to elicit more key documents from Marlborough and the execu-
tors. On April 4, the lawyers had their first innings with Francis K.
Lloyd. Behind his battery of lawyers, impeccably dressed and per-
petually suntanned, Lloyd, full of smiles and Viennese charm, greeted
everyone. But his Austrian accent became noticeably stronger as the
questions were fired at him; many he could not understand, and these
had to be rephrased several times. He gave some idea of the extent of
his operations, but did not explain the interconnections of his com-
panies or where the money went. The "sale" of the thirteen paint-
ings was not really a sale, he declared; the $248,000 had been given

Bernard Reis as an "advance against future sales." Reis had told him that the estate needed more cash, so he had agreed to oblige. Twelve of the paintings had actually been sold to two Liechtenstein entities— seven to Allgemeine Europaische Kunstanstalt (AEK) and five to a Galleria Bernini. The thirteenth he had sold to Galerie Flinker in Paris. Lloyd testified that neither AEK, Bernini, or Flinker had any connection with him or any of his companies.

Gradually Lloyd's lawyers did produce a vast batch of invoices, catalogues, memoranda, and letters, but important documents sub-poenaed long ago were still withheld: the stock book, insurance documents, and, pending appeal, the names of the purchasers and prices paid for the fifty-four Rothkos Lloyd claimed to have sold through Liechtenstein. Lloyd maintained that since he had bought the one hundred outright, they were his and it was no one else's business where these paintings were.

The examinations continued. It was Bernard Reis, certainly, who as the estate's executor-in-chief and as an officer and director of the gal-lery was pivotal to the "Matter of Rothko," but after his halting winter deposition he would never appear again in the proceedings. In late April 1973, he suffered a stroke and was hospitalized for three weeks. Later, when the lawyers wanted to question him further, his physician wrote that it would be detrimental to his health. For the same reason, he would not testify in the trial. However, after he re-cuperated, he continued to work at Marlborough, and later, in the midst of an August heat wave, he would testify at some length as the sole witness against the Rothko children in the trial over the brown-stone paintings.

Levine's deposition was the most intense and extensive. As he put it during the trial, "They are all out to get *me*." And they were. He was questioned minutely by all the lawyers about what had happened before and after Rothko's death until May 21, 1970, the date on both contracts. He swore to the April 1970 acrimonious fight he had had with Reis and Stamos, during which he accused them both of having a "seeming conflict of interest" because of their relationships with Marlborough. He had had no idea that Reis was an officer and direc-tor, only that he did the accounting for the gallery. But Levine had no memory for dates and kept no engagement books, so he was unable to pin down many of the events he described.

Levine said he had never seen any of Rothko's previous contracts, that none had been sent him with Reis's memo urging a quick sale

to Marlborough. He had not heard of the "put" clause in the February 1969 contract until 1972, when his new lawyers pointed it out to him. He had suggested the alternative, he said, of consigning the 100 paintings if Lloyd would not pay $3 million for them. Therefore, Karelsen had drawn up a memorandum on that basis. He told of Lloyd's publishing propositions, "subventions" before the deals were made, and his refusal.

When Daniel Saidenberg arrived for his deposition, Harrow remembers, the elderly man was visibly shaking and he faltered as he testified about his appraisals. He was represented by Arnold Roth (of Ralph Colin's firm), who was also representing Marlborough Gallery. Just before the trial, with a new lawyer, Saidenberg would correct much of his testimony. But he could not remember how the appraisals and letters from him had been typed or why he had no proper file copies. In his amended deposition, he inserted figures showing that between 1968 and 1970 the Saidenberg Gallery had purchased $1,300,000 worth of art jointly with Marlborough. And this was the last the lawyers would see of Saidenberg, too. Though he was subpoenaed through his new lawyer to appear as a witness in the trial, he chose to take a year's sojourn with his wife in Europe.

At the time of Saidenberg's rattled examination, Frank Lloyd announced that he was switching law firms. Lloyd took the case to the flamboyant litigator Louis Nizer, and for several weeks there was a hiatus while Nizer studied the evidence. But he found that he had a conflict of interest, since oil tycoon Armand Hammer, chairman of Knoedler's board, was a client. Lloyd again went shopping.

All three executors had blamed Karelsen for their predicament, in particular the firm's judgment that even with conflict of interest the deal did not need the Surrogate's approval. And his legal advice had fully supported the secret contracts. But when Karelsen was questioned, the old man (now eighty-one) had so many different recollections and made so many asides that it proved hard to pin him down on any one issue. When his fat deposition—with many amended statements—was put in evidence later at the trial, Judge Midonick suggested that each of the seven sets of lawyers take a different colored pencil and circle the parts he felt supported his position.

In June 1973, *Time* mentioned the suit in passing, in an otherwise laudatory article about Frank Lloyd titled "Artfinger: Turning Pic-

tures into Gold." *Time* called Lloyd's military background "brave and aggressive" and commended his business genius during a rising art market. The occasion for the article was the opening of Marlborough's new satellite in Tokyo, Marlborough Torii Fine Art Ltd. *Time* dubbed Lloyd's international "empire" the "General Motors of the art world." After twenty-five years, *Time* added, it "exudes fiscal power like a dew." Lloyd had given *Time*'s reporter, Oliver Moore, an interview, during which he said that Marlborough's profits had increased from $11 million in 1969 to $25 million in 1973. Despite the taped record, he would later deny the accuracy of these figures under oath in Moore's presence. *Time* described Lloyd's showmanship and his connections with those among the powerful and wealthy such as Nelson Rockefeller and Pope Paul VI. Collectors and businessman-investors loved dealing with Lloyd, *Time* reported, and even artists in his stable, with a few minor exceptions, were generally content. The only real hostility against Lloyd came from other dealers who were jealous, particularly dealers from whom Lloyd had attracted artists.

Lloyd had told *Time* how his empire operated. Though the description was oversimplified and, under oath, Lloyd would later deny some of the details, this was the first glimpse the lawyers got of the Liechtenstein setup. But the article was inaccurate and misleading about the Rothko lawsuit. *Time* stated that Rothko left a will "directing that the bulk of his estate be used as a fund for struggling old artists." Therefore, the article concluded, "obviously it was Rothko's hope to raise as much money for the foundation as possible." That Rothko's will contained such directions had become another self-perpetuating myth of the art world.

In July 1973, another set of examinations was held to prepare for the trial of the executors' lawsuit against the children (to possess the brownstone paintings), scheduled to begin in August. Much of the questioning covered the breakup of the Rothko marriage and his relationship with Mell and his children in the last years of his life. Before the trial, Reis was not available for deposition due to his illness. Stamos and Levine gave opposing pictures of those years. Stamos contended that Mell hated her husband's later paintings and told Rothko so, and that Rothko was "very disturbed with Katie." Levine was more measured. Rothko, he said, had "mixed feelings toward Mell." He kept in "frequent contact—sometimes there were disputes, sometimes just communications." About Kate, he said Rothko "had concern for

his daughter" and would disagree or "worry about some aspects" of what she wanted to do. For example, taking an apartment in Brooklyn "overly concerned him." He wanted her within reach and worried about her living alone. Both agreed that he adored Topher. Stamos added that sons were particularly important to Jews, "at least boys can read the Kaddish."

In their lawyers' brief, Stamos and Reis contended that Rothko had not meant the family to have any of the forty-four paintings in the house. Levine said he thought that Rothko had wanted to leave Mell the art in the family quarters—some twelve Rothkos plus a Motherwell, a Ferber, and others—but that the rolls of canvas stored upstairs on the fourth-floor studio were supposed to be part of the estate. Marlborough's lawyers contended that the forty-four paintings were included under their aegis as "approximately 700" consigned paintings. The children's lawyers pointed out that the secondary suits, which had not been initiated until six months after Kate's suit against the executors, were clearly retaliatory: memos Levine had received from Karelsen indicated that the suits had been started to scare Kate into settlement.

Clinton Wilder was examined as to why the foundation was participating in this suit. At first he professed total ignorance. He had never authorized the suit, he said. But when it was pointed out to him that his signature appeared on the petition, he said he had merely signed it because Greenspoon had told him to.

It was a sweltering August day in Surrogate di Falco's un-air-conditioned courtroom when the case known in legalese as both the "construction" (of the will) or "contents" (of the house) suit finally came to trial. Despite his disability and his doctor's letter, the only witness for the petitioning side was Bernard J. Reis. Reis told Judge di Falco of his close friendship with Rothko. He was "especially his most intimate friend and confidant in the late spring of 1968—after that time I saw Mark particularly [sic] daily every day I was in New York."

The judge listened intently to Kate Rothko's lucid description of the works of art she had grown up with; one of the paintings the foundation was after, she testified, was inscribed to her from her father. However, it was Dan Rice's testimony as Rothko's friend of twenty years, apprentice intermittently over four, and disinterested inventory-taker that seemed to impress the judge. Rice told of the extensive inventory he had taken with Levine, in which the paintings

in the house were not listed. Since he was at the studio regularly during December 1968 and January 1969 he remembered exactly when Rothko moved out of his home. It was New Year's Day, and afterward, Rice remembered, though the artist was extremely emotional, he had said his decision was "irrevocable."

Six months later the judge handed down his decision in favor of the children. Greenspoon then appealed di Falco's decision, and not until the spring of 1975 was it rejected. It is still not clear when the children will be able to claim the brownstone paintings, the disposition of which depends on legal negotiations with the IRS over the disputed valuations of the Rothko estate paintings.

After that brief trial was over, the examinations continued in the central "Matter of Rothko." With Nizer out, in August 1973, Lloyd hired Sullivan and Cromwell, one of Wall Street's oldest and best-known law firms—also reportedly its most expensive. From this Brahmin partnership, both Allen and John Foster Dulles, among other statesmen, had emerged. Lloyd had been able to persuade senior partner David W. Peck to forsake partial retirement to head the new team of lawyers now defending both Marlborough New York and Marlborough A.G. A former presiding justice of the Appellate Division of the New York Supreme Court, Peck was known to pack a deal of clout in the bar as well as in the highest echelons of the Republican party. Since Marlborough and the executors had lost every appeal so far, and perhaps Lloyd thought for the ultimate appeals they might need some backstage finesse, the choice of "Judge" Peck was a natural.

In August, the Appellate Division upheld another Midonick decision: after nine months of motions and appeals Marlborough A.G. was again ordered to produce the secret records of purchasers of the fifty-four Rothkos sold through Lloyd's Liechtenstein companies. But still his lawyers procrastinated. Finally, after two moves to hold Marlborough in contempt, Sullivan and Cromwell turned the records over to the court. Like all the consigned sales, there was clearly something suspicious about the sales of thirty-five of these paintings. Marlborough A.G. claimed that these thirty-five valuable large oils were sold in bulk lots to individuals in Europe after Kate's suit began, at the incredibly low average price of $38,000 per painting. The lawyers suspected that the purchasers—who Marlborough claimed had bought nearly all of them within a month in January and February of 1972—were pals of Lloyd's who had agreed to front for him until the case

was settled. The suspect buyers and their addresses (at first) were listed as Count Paoli Marinotti of St. Moritz, Arturo Pires de Lima of Lisbon, Yoram Polany of Hong Kong, and Robin Ward of Cannes. (But these names remained sealed, as Marlborough requested, from public scrutiny.)

Lloyd was recalled for questioning about these sales. He could not remember exactly where and how he had contacted these "important" individuals. He said there had been no correspondence about the paintings, that it had all been done by word of mouth, on his say-so. He had no idea where the paintings were when he sold them. But it was too much for the petitioners to believe.

In November 1973, Donald McKinney, now $40,000-a-year president of Marlborough, was reexamined and the acknowledged "bible" of an art gallery, the stock book, finally was placed in evidence. It was a huge binder containing pasted slips, one for each painting, giving the cost, price, insurance, and a gallery-coded ownership reference. Next to the slips, the movements of the paintings in and out of the gallery were inked in. But it soon became clear that, contrary to Lloyd's reputation as a stickler for detail when it came to money matters, the condition of the stock book was anything but meticulous.

Hundreds of slips for Rothko paintings were missing. Whole pages had been "lost," the defense claimed, at the time of Frank Lloyd's first deposition six months earlier, when Donald McKinney had given orders to Xerox page after page of the stock book. For hundreds of other Rothkos new slips had recently been inserted which contained no information as to prices and values. This was done, McKinney testified, so that Marlborough salesmen would not attempt to sell Rothkos after the injunction.

At the time it was produced, the stock book was copied by the lawyers and returned to Marlborough. When it arrived back from the gallery, before the examinations of Marlborough's administrator and registrar, it was apparent that more alterations had been made. The administrator, Richard Plaut, could shed little light on what had happened, his failing memory at odds with his alert, youthful appearance. But he did admit that he had the slips torn out, had ordered the Xeroxing the previous spring during Lloyd's examination, and that the "loss" of the key pages had somehow occurred thereafter. He did not recall why his reports of sales of consignment paintings were at variance with each other. Then the pretty, wide-eyed young registrar, Marian Moffett, testified. It was her guileless testimony about the revi-

sions in the books that led Edward Ross to dub her "the Rose Mary Woods" of the Rothko affair.

Just as eighteen and a half minutes of crucial taped Nixon conversations had been mysteriously erased while Miss Woods transcribed them, so too had many key facts in Marlborough's books been recently blocked out and revised by Mrs. Moffett. She said that she had not erased but had merely "whited out" 1972 dates which had occurred "through an error on my part" and rewritten "1971." When? She did not remember. Why? "Because Xerox copy does not show changes" that way. She could not "recollect" when or who instructed her to make the alterations.

The trial would begin in mid-February 1974. There remained only six short weeks to prepare. But the judge bade both sides to settle and avoid a costly and protracted trial. The most Frank Lloyd would offer, however, was the return of the 658 unsold paintings to the estate and a million dollars. Kate's costs had already exceeded her share of that figure, and Lloyd's actual profits from the paintings sold appeared to be many times that amount ($2,474,250 for the 36 paintings actually sold to individual collectors from the 100 paintings group—plus the future profits on the 104 paintings Kate's lawyers believed Lloyd had "parked" until the lawsuit was over). Settlement was not at hand, but, at the judge's insistence, there was negotiating until the last minute.

Meantime the stock book required extensive study and comparison with invoices. Tracking the code number for each of the paintings through the avalanche of documents became the special task of Harrow and the youngest member of Kate Rothko's team of lawyers, twenty-nine-year-old James R. Peterson. Still there were no shipping papers or insurance records to check them against. What Peterson discovered, to his great surprise, was that some of the dates on which many of the paintings had left Marlborough Gallery in New York appeared to be in violation of Judge Midonick's injunction of June 26, 1972. He would check further.

Harrow moved to survey the condition of the 600-odd estate paintings still stored at the Marlborough Studio. His team of art experts, led by James Speyer, curator of twentieth-century paintings at the Art Institute of Chicago, spent two days examining what was there. Speyer wrote an affidavit stating that work of the middle and late years looked "well preserved and cared for." The larger canvases were "in excellent condition." He added that seeing the work as a whole "would in

itself establish the importance of Mark Rothko as an artist of the first quality and it most amply reinforces my convictions that he was one of the great American painters."

There was no time to lose. In hopes of tracking down some of the paintings Lloyd said he had sold abroad in bulk, Harrow flew to Europe. In London he found Yoram Polany, a young Israeli, whom Lloyd identified as having moved from Hong Kong after his purchase of four Rothkos. Polany told Harrow that he had not specifically purchased Rothkos from Lloyd, but merely invested $100,000 with him. In Rome, Count Marinotti (who had supposedly ordered twenty paintings sent to his lodge in St. Moritz) would not see Harrow, but his son referred him to the family lawyer, who told him he had no idea about Marinotti's alleged purchase of $780,000 worth of Rothko paintings. Playing the gumshoe in Liechtenstein proved unrewarding. Harrow located the low cinderblock building housing the offices of Presidial Anstalt, where both Marlborough A.G. and Galleria Bernini shared directorships, and saw a Mr. Merlin, one of the common directors, but all he could ascertain was that no Rothkos had ever been delivered to that address. He never found the actual offices of Marlborough A.G., which was using a post office box address. Harrow left Liechtenstein in the nick of time; someone had alerted the police, who wanted to arrest him. It is against the law of the principality to investigate business there if the matter is related to a criminal lawsuit. Even though the Rothko case was not criminal but civil, it might have taken him some time to prove this while languishing in prison.

In Zürich, he saw Gilbert de Botton, an officer of the Rothschild Bank and a former director of Marlborough's Zürich gallery. De Botton had allegedly bought and then canceled the purchase of five important Rothko paintings consigned to Marlborough. He told Harrow that when he had bought the paintings he had asked Lloyd about the lawsuit. Lloyd had reassured him that the case was of no importance. Later, when de Botton heard that "two orphans were involved" and that it was a "serious matter," he told Harrow that he had reneged on the purchase and had resigned the directorship of the gallery. Lloyd later claimed that he had forced de Botton to resign because de Botton had gone into the art investment business and, therefore, had a conflict of interest. He accused well-mannered, punctilious Harrow of harassing his important customers—Marinotti, Polany, and de Botton, and slandering him to them.

When Harrow returned to New York, he decided to play down his European discoveries, hoping to scare Sullivan and Cromwell's lawyers, who pelted him with questions, into thinking he had uncovered more than he actually had. It is likely that Harrow's strategy of mumchance was responsible for an immediate and startling admission on the eve of the trial. That day Sullivan and Cromwell amended their month-old brief to indicate that two of the thirteen estate paintings listed as having been sold to Bernini for $70,000 apiece from Marlborough A.G. on March 2, 1971, had been bought that very day by Paul Mellon of Upperville, Virginia, for $420,000. It was the first really solid indication that Lloyd was operating an art laundry.

Ten days before the trial commenced, while Harrow was still abroad, Kate Rothko married. Her husband, Ilya Prizel, a Russian-Jewish immigrant like Marcus Rothkovich was her fellow student at Brooklyn College. A reform rabbi officiated at the wedding, a traditional Jewish ceremony, which took place in a Brooklyn country club. Though neither bride nor groom nor their families were religious, both felt that centuries of tradition called for the ceremonial occasion. At the reception, ten-year-old Christopher, who had traveled from Columbus with his aunt and uncle, watched as the bride and groom recited medieval Hebrew poetry under an antique *choupah*. In the white velvet dress and train she had made with the help of friends, Kate, in the words of Katharine Kuh, had become "quite a beauty." The guests agreed that not only was Ilya a perfect mate for Kate, with his broad intellectual curiosity, warmth, and delightful sense of the ironic, but his family had embraced her as if she were their daughter. Kate had made plans to enter medical school in the fall. Her new family would provide support for the legal hurdles about to commence.

# 17 The Trial:
## Phase One—Self-dealing?

(FEBRUARY–MAY 1974)

Let's choose executors and talk of wills.

Shakespeare
*Richard II*

The trial began on St. Valentine's Day. The cast of characters and the setting were as remote as could be imagined from Rothko's spiritual and aesthetic aspirations. The splendidly ornate details of the courtroom—carvings of owls, eagles, Justice with her sword, gilded cupids—had nevertheless a dingy aspect. Three lavish chandeliers supplied the light, supplemented by electrified gas fixtures on the walls. The curved pink marble fireplaces and balustraded balcony—all long unused—added to the faded baronial atmosphere. The courtroom was uncomfortably rather than pleasantly out of date. Even with the windows open, it smelled of dust, death, and disputation.

On the first day of the trial, sixteen attorneys and three assistants sat at the thirty-foot table facing the bench. In front were the elder partners, gray or balding; a bit to the left of each of them and slightly behind, their juniors, generally longer- and darker-haired fellows, their

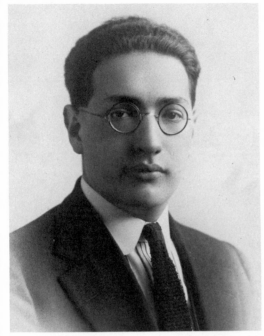

Seventeen-year-old Marcus Rothkowitz on his graduation from Lincoln High School, Portland, Oregon, 1921.

*Portrait of Mark Rothko* by Milton Avery (1933). *(Museum of Art, Rhode Island School of Design; Albert Pilavin Collection of Twentieth Century American Art)*

Mell and Mark Rothko with Clyfford Still, California, *c.* 1946.

Mark Rothko standing before one of the surrealistic seascapes characteristic of his work from 1944 until 1947.

Photograph of Rothko taken *c.* 1949. *(Consuela Kanaga)*

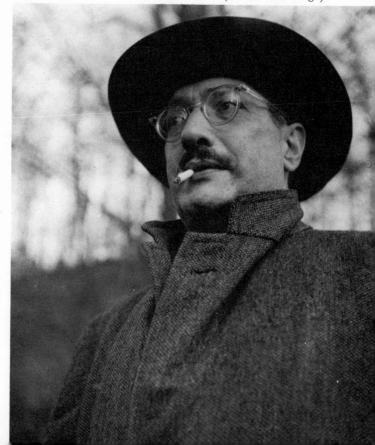

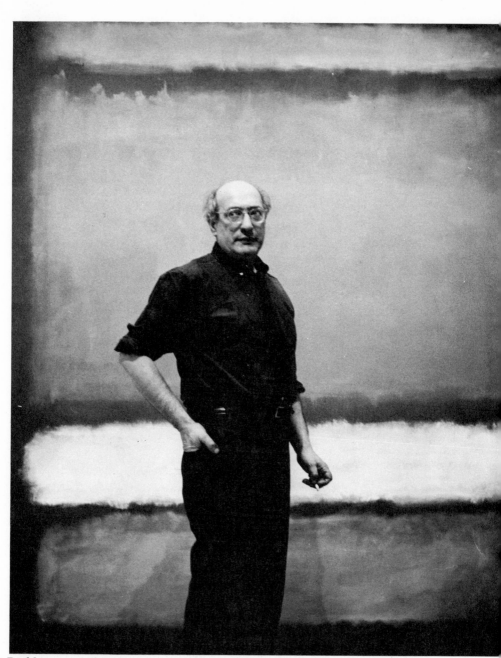

Rothko poses before *Painting Number 7*, 1960, about the time of the MOMA retrospective in 1961. He considered the painting one of his masterpieces and refused to part with it. After his death, it was consigned then sold with twelve other Rothkos to Marlborough Liechtenstein by Bernard Reis for a total of $248,000. Insured for $200,000 this painting then toured Europe with a lavish Rothko exhibit. Lloyd claimed to have sold the painting for $80,000 (of which Marlborough kept half) to a mysterious Liechtenstein corporation known as AEK. The trail of papers documenting the travels of the thirteen paintings led to Lloyd's undoing, but *Painting Number 7* has not yet reappeared. *(Photographer unknown)*

Mell, eight-year-old Kate, and Mark Rothko aboard the U.S.S. *Constitution* en route to Italy in 1959.

The Rothkos' airedale, Crispin, and new baby Christopher Hall, February 22, 1964, on the brownstone on Ninety-fifth Street. *(Hans Namuth)*

Rothko and Mell at the reopening of the Museum of Modern Art in the summer of 1964. *(Erich Hartmann, Magnum)*

The Rothko studio at 157 East Sixty-ninth Street, which immediately after the artist's death became the Marlborough Studio. *(Diana Michener)*

Rothko and Kate in Rome, 1966, during their last trip to Europe. *(Gianfranco Mantegna)*

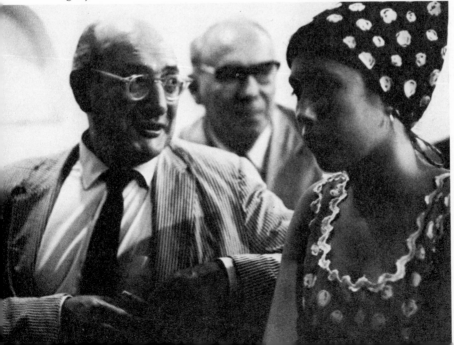

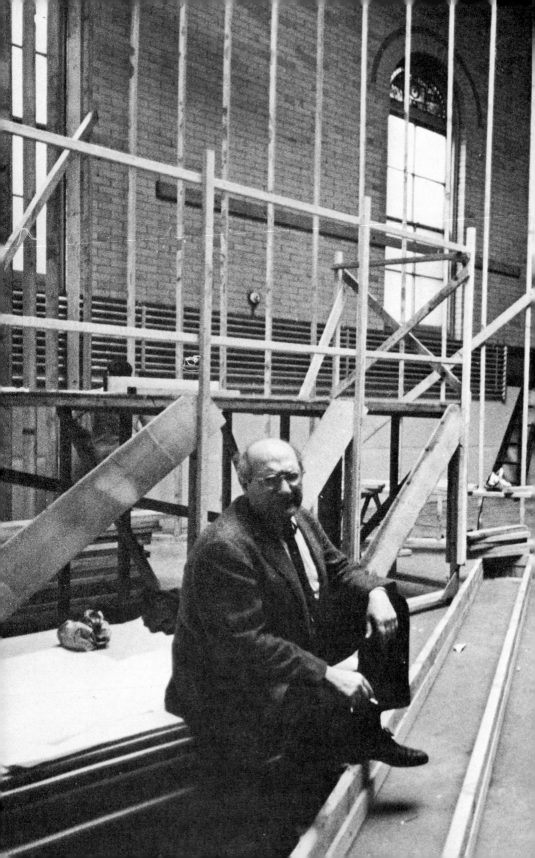

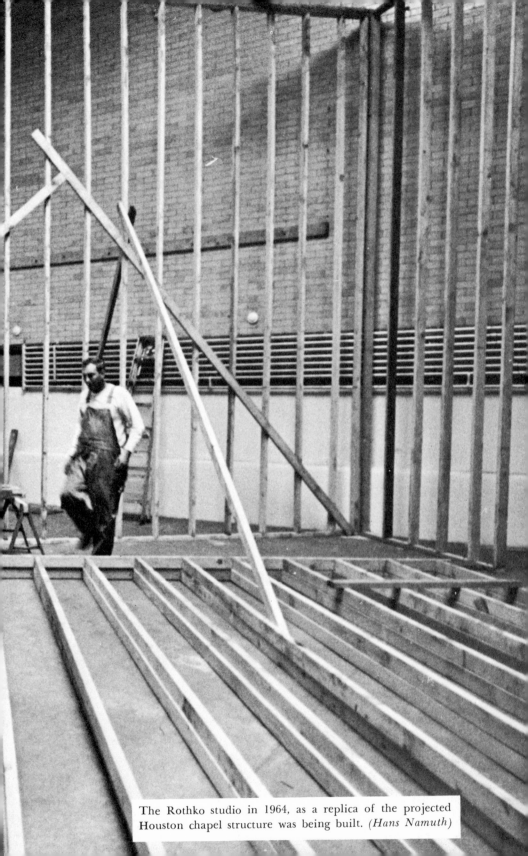

The Rothko studio in 1964, as a replica of the projected Houston chapel structure was being built. *(Hans Namuth)*

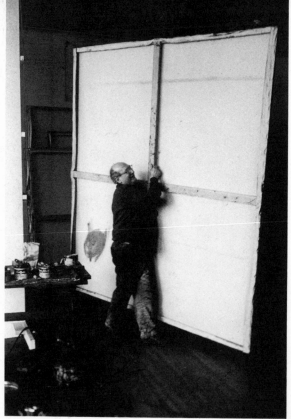

Rothko in his studio in the mid-sixties. *(Alexander Liberman)*

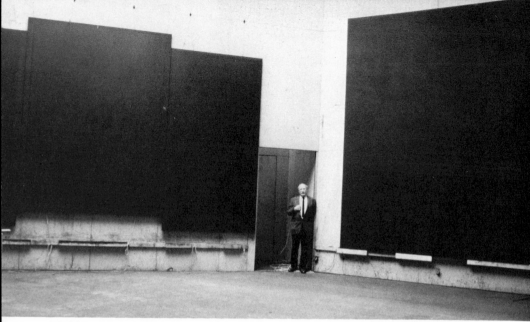

Rothko poses in his studio with the finished chapel murals, 1968. *(Alexander Liberman)*

The Rothko Chapel was finally dedicated in 1971, a year after Rothko's death. The lighting problems still have not been solved. *(Courtesy of the Rothko Chapel, Houston)*

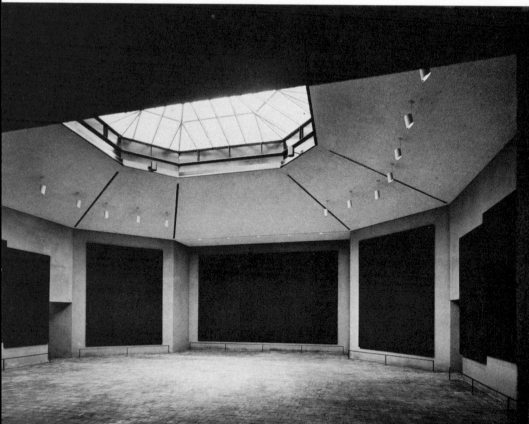

Stamos and Rothko at an artists'
party before the opening of the
Jackson Pollock exhibit at the
Museum of Modern Art, April
1967. *(George Cserna)*

Anthropologist and Rothko exe-
cutor Morton Levine photo-
graphed at his apartment during
the Rothko trial.*(Photograph ©
1977 Jill Krementz)*

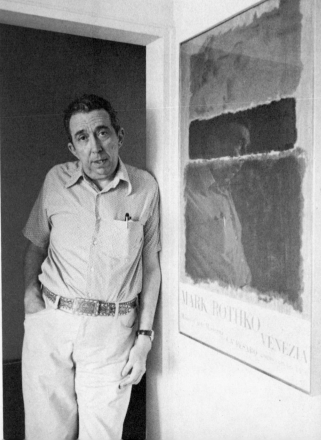

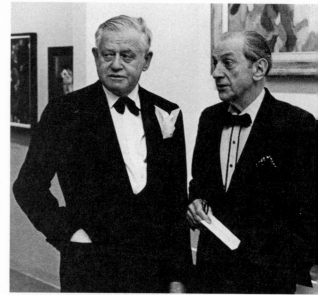

Bernard Reis and art dealer Sidney Janis confer at the opening party for a dada-surrealism exhibit at the Museum of Modern Art in late March 1968. *(George Cserna)*

Bernard and Becky Reis and Lee Krasner Pollock at the official museum opening of the Pollock exhibit. The man behind Lee Pollock is Donald McKinney, then a vice-president of Marlborough Gallery. *(George Cserna)*

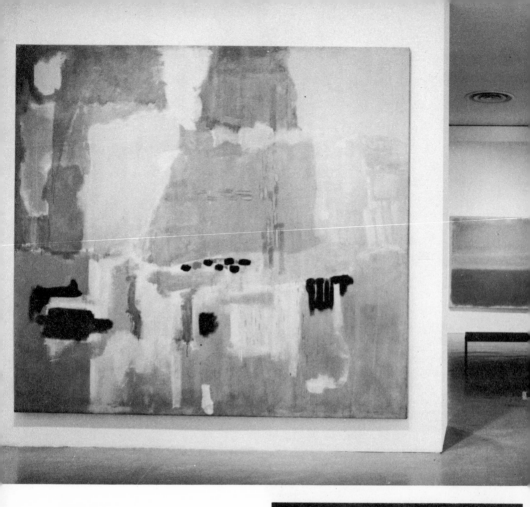

The late Robert Goldwater, the art historian whom Rothko entrusted to write his artistic biography. As a director of the Mark Rothko Foundation, he became a victim of the manipulations of Rothko's executors, who were also directors of the foundation. *(Maryette Charlton)*

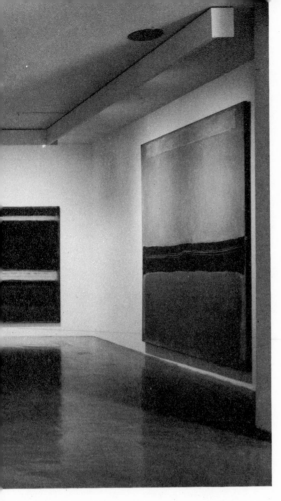

View of the Rothko room at the exhibit "The New American Painting and Sculpture: The First Generation," June 18–October 5, 1969, at the Museum of Modern Art. *(The Museum of Modern Art, New York)*

William Rubin, chief curator of the Painting and Sculpture Collection at the Museum of Modern Art, who had been dropped from the foundation before Rothko died, but challenged the directors' later restructuring of its purposes. *(Leonard Le Grand; used by permission of the Museum of Modern Art)*

A still from a film of the Scull auction at New York's Sotheby Parke Bernet in November 1971, "America's Pop Collector: Robert C. Scull —Contemporary Art at Auction." As Lloyd lifts his glasses to bid, he confers with Donald McKinney, then vice-president of Marlborough Gallery, on his left, and Gilbert Lloyd, his son, who runs Marlborough Fine Art in London. *(Filmed by Alan Raymond; originated and produced by E. J. Vaughn)*

Frank Lloyd arrives to testify in Surrogate's Court in the "Matter of Rothko." With him are his second wife, Susan, and Arthur Richenthal, lawyer for Bernard Reis and Theodoros Stamos. *(New York Times)*

In the corridor, Lloyd with *(left to right)* Susan Lloyd; Fred Rosen, Lloyd's public relations consultant; lawyer Richenthal; Charles G. Mills IV, representing the Rothko Foundation; and John Dickey of Sullivan and Cromwell. *(New York Times)*

Millard L. Midonick, the Surrogate. *(Katrina Thomas)*

New York State Assistant Attorney General Gustave Harrow standing in front of Surrogate's Court. *(Katrina Thomas)*

At the opening of the Metropolitan Museum's Francis Bacon exhibition in March 1975, Frank Lloyd chats with Henry Geldzahler, curator of Twentieth Century Art. The occasion marked Lloyd's last public appearance in the United States. *(Fred W. McDarrah)*

Bernard J. Reis taking a stroll with his longtime secretary Ruth Miller, during the fall of 1976. This photograph was one of a series shot by a detective hired by Kate Rothko's lawyers to prove that Reis was not too infirm to testify about matters relating to the Rothko case. On the basis of photographic evidence, the judge ruled that Reis must undergo an examination by an impartial physician.

business suits less expensive. Beside and behind each of the seven banks of attorneys were cartons, file cases, and file boxes of documents—records of many of the tangled events of the past six years.

Gus Harrow sat in the middle of the group looking tense, worrying about strategy. As the assistant attorney general, he and his colleague Laura Werner, among all the lawyers present, were the only ones who had no financial stake in the lawsuit. He had borne the brunt of the insults and unbridled hostility of the opposition over the past two and a half years. He was one of those only too rare individuals, a totally dedicated public servant. It was Harrow who had succeeded in amassing most of the evidence, demanded the stock book, forced disclosure, led the fight for the injunction against Marlborough's battalion of lawyers, and who, for all those months, had kept the lawsuit alive by attacking every motion and appeal. Without his persistence, there probably would have been no case. But during the trial, Kate's lawyer, Edward J. Ross, a shrewd litigator with long experience in multinational accounting battles, went first and assumed the role of chief interlocutor.

All rose as Surrogate Millard Lesser Midonick strode to the bench and, with a greeting to the court, seated himself. "At long last," he said gingerly, "we have come to trial in this many-sided case."

He explained that because of the complexities of the issues, the trial would be divided into two phases. First, the charge of "self-dealing" or conflict of interest against Reis and Stamos would be heard, and an examination made of the merits of the charges of "wasting the assets of the estate" and "conspiracy and fraud" in the making of the two estate contracts with Marlborough dated May 21, 1970. Phase two would cover the charges of fraudulent sales of paintings by Marlborough.

Then began a long series of captious objections and colloquies that would impede the progress of the trial, as they had the plodding pretrial proceedings; as the attorneys were aware, the game plan in such a lawsuit can be as important as the issues. And the judge's arbitrary division of the trial proved to be a mistake: the charges and the proof overlapped in such a way as to drag out the proceedings and cause unnecessary repetition and omission of evidence. When witnesses were questioned about events after May 1970, there was a storm of objections and repeated colloquies over whether such evidence should be heard later during phase two. The division would mean that defendants and major witnesses testifying about self-dealing

would never be required to answer key questions relating to alleged subsequent frauds.

Because Marlborough, Reis, and Stamos represented Rothko as a mediocre artist whose reputation might easily have declined but for Lloyd's fantastic merchandising, Harrow asked to call experts from the art world to attest to Rothko's stature and the value of his paintings. Over the objections of Marlborough's counsel, David Peck, Midonick allowed experts to testify throughout the trial.

Thomas Messer, the Guggenheim's director, was Harrow's first witness. Messer stressed the importance of the New York School's contribution to art history, and Rothko's prominence as an innovative member of the school. "The movement of abstract expressionism simply is meaningless without referring to the leadership positions of such artists as Pollock, de Kooning, Clifford [sic] Still, Mark Rothko, Barnett Newman, Robert Motherwell. . . . There is no question in my mind that among these Rothko assumed a primary level of importance." Messer had approached Lloyd to make arrangement for an exhibit of the late black-on-gray paintings, but Lloyd had put him off.

During Messer's testimony, Frank Lloyd crept silently into the courtroom, on tiptoe, as though pretending he was not there. Seated, his hands slightly fidgeting, he peered up from under his wide rounded brow and listened intently—particularly when his lawyer, David Peck, rose to object or insert some observation. Peck, in his steel-rimmed glasses, gray suit with waistcoat, and Phi Beta Kappa key chain, looked the epitome of the aging, stooped Ivy League headmaster. Nodding toward Messer, he said, "We can't just have some passerby coming off the street to testify." Paintings, he declared, were like IBM stocks— they fluctuated in value with the economy.

As Messer stepped down, Lloyd sprang from his seat, rushed over to the museum director and smiling broadly like the genial host at a reception warmly shook his hand. It was a performance Lloyd would repeat often throughout the trial with rival dealers and art critics, reporters, and almost anyone who caught his eye.

Morton Harold Levine, in his mid-fifties and head of the anthropology department at Fordham University, was sworn in next. Levine's graying crewcut and baggy brown tweed suit underscored his academic role and emphasized his candid manner. He had been divorced from his wife a year earlier and had moved to a small apartment in the Village. He spoke with an occasional jerkiness of head and body, as

though he had suffered some childhood nervous disorder. Day after day, through the direct, cross, redirect, and recross examination, Levine clung ferociously to his story, becoming belligerent when his motives and responses were questioned. He traced and retraced the details of the events after Rothko's death up to the May 21 date of the contracts. Again, he maintained that he had been misguided by Reis, had not been told of the "put" in the 1969 contract, had questioned the conflict of interest of both Reis and Stamos, and had been falsely reassured by Karelsen. Given Reis's premises that, because of the 1969 exclusivity agreement, the executives had to deal with Marlborough and that it was important to liquidate the estate, he had thought at the time that they had made a good deal. Did he now? "No, I'm not so sure," replied Levine. Succinctly, he reaffirmed that he had said in the fall of 1970 that Kate Rothko might receive "a judicious admixture" of paintings and money as her inheritance, but was evasive when asked, under the circumstances, what he had meant—since all the paintings had been turned over to Lloyd for twelve years, according to the consignment contract.

Levine had now refreshed his memory and could place the vituperative altercation with Reis and Stamos at the Reis town house on April 13, 1970.

After punchy verbal poundings by lawyers, particularly Messrs. Richenthal and Greenspoon (who called him "a kind of mental aberration"), Levine looked haggard. He requested frequent recesses. When Judge Midonick, worried about Levine's health, asked: "Don't you sleep well at night? Don't you rest at night?" Levine replied: "I have dreams."

When Ross sought to take Levine's testimony about the foundation's 1972 retention of Greenspoon, Richenthal and Greenspoon succeeded in blocking the inquiry. Judge Midonick ruled that the testimony should be part of phase two because it "sounds like a possible conspiratorial cover-up, but it doesn't sound like a self-dealing problem."

After two weeks of intensive questioning, Levine came off as a fairly credible witness but, at the least, a bad executor. He had made no outside queries as to the prices being received for Rothko's work or the ethics of the Marlborough deal. He had trusted Reis, even though he knew of his conflict of interest. As for borrowing $10,000 from the estate—"This is the first time I ever heard of an executor borrowing from his own estate," the judge commented—Levine said that

he had not been told by Reis and Karelsen that it was illegal, and when in December 1971 he had learned otherwise, he repaid the money with interest.

Stamos followed. With the help of lawyer Richenthal, he strove to prove that *he* had no reason for an uneasy conscience or sleepless nights. Wearing a series of bright orange, purple, and pink shirts and Shetland sweaters, tortoiseshell glasses, and minus the long bottom flourishes of his Fu Manchu mustache, he looked less dramatically fierce than he had four years earlier. His testimony was essentially unchanged except for a few new recollections. Now he placed Karelsen's partner, Ernest Bial, at all key meetings with Lloyd. He disputed Levine on almost every point, both small and large, aiming to destroy his credibility.

Unlike Levine, who said that the $3 million cash asking price for the 100 Rothkos was a fair figure based on what Rothko told him of sales, Stamos claimed that it was merely a starting point for negotiations. Why hadn't Reis, doubling as both Marlborough's and Rothko's accountant (and an officer and director of Marlborough at the time) turned over to Stamos and Levine a list that might have reflected the rising prices of Rothko's paintings sold through the gallery (to nearly $60,000 before the artist's death)? There was no way for Stamos to answer this.

Stamos maintained that the sale was a "good deal"; it was better than sitting "with unproductive assets," as he put it. He attempted to reinforce Marlborough's claim that Rothko had sold Lloyd his best paintings in 1969, and that the 100 Lloyd and McKinney had chosen from the estate's warehouses were the "second best." On questioning, however, he did agree that "sometimes an artist keeps his best paintings," and he could not account for the fact that Rothko had never let Marlborough into his warehouses to make a selection before he died and had only given them a preselected batch to choose from in his studio.

But, Stamos insisted, "I don't think we gave the pictures away. Mark Rothko would turn over in his grave if he knew what's going on here. He would be delighted if he knew what we've done." Turning to Midonick, he added pityingly, "That was a poor man, Mr. Judge."

Stamos placed himself in the same artistic class with Rothko. When Edward Ross characterized Rothko as one of the "foremost" abstract expressionists, Stamos interrupted: "Aw come on, that's just not true." No, he said, death did not enhance the prices of a great artist. Others

have "died and been forgotten," he said, "like Bradley Walker Tomlin, who was just as famous as all of us" and "a beautiful painter." Finally, backed against Ross's wall, he agreed that Rothko, too, was "a beautiful painter." His praise of Lloyd's selling practices was lavish in view of his failure to promote Stamos's own works:

> To increase or decrease [in value] depends on how an artist is handled. If you make the paintings scarce, promote the artist in the right way, such as the way in which Marlborough has done it with the most extraordinary beautiful catalogues and publicity and posters and traveling shows all over the world, you can create a market and get high prices for these things—but it doesn't happen just like that, Your Honor, you work on it, your salesmen work on it.

Stamos also explained why he had never mentioned at his deposition his first "birthday" contract with Marlborough, which featured the forty percent commission. He had simply forgotten it because it was of such a short duration. When Lloyd heard of it from McKinney, the dealer had become "absolutely furious" and had had McKinney draw up another immediately. Stamos had agreed to the new contract at fifty percent commission if they would raise his prices, which they did. (But he agreed to lower the prices later when the paintings were not selling.) Again, he was at a loss to explain why even the second contract was superior to the unprecedented Rothko consignment contract.

Stamos's violent temper, never far below the surface, surfaced often during the questioning. When Ross brought up the only Stamos painting that Marlborough had bought at auction for $1,200 during the period between negotiations with Lloyd, Stamos shouted: "That's a lot of nuts! Are you trying to tie me with an auction at Parke Bernet and the contract? . . . If I had known about it I would have brought it in at $4,000." Stamos maintained that it was a dealer's duty to bid up the prices of his artists, but almost in the same breath said that he only learned of the Marlborough purchase two years later by accident.

And finally during his testimony, as Kate Rothko sat quietly among the few onlookers, Stamos recalled something that he had never mentioned throughout his pretrial examinations. When asked why no one had ever suggested that the Rothko family or the foundation might

have had paintings "in kind" rather than money, he replied, "I think the topic of distribution in kind was brought up at the will-reading." Then he was definite: "Karelsen did bring this point up. . . ."

The judge asked, "In Kate's presence?"

"Yes," Stamos replied, "and Kate said not only didn't she want any pictures, if she got them she would give them to her friends and she didn't want any money, and Mr. Morton Levine got up and went over to her and said, 'Now, you keep quiet or I'll slap you.'"

"You are really telling me Mr. Levine said he would slap a nineteen-year-old girl?" Midonick asked.

Stamos: "On my honor."

The Surrogate was incredulous but Kate Rothko remained composed. Her only sign of anger or nerves was that she continued to bite her fingernails. Asked afterward if this incident had happened, she said that it "certainly had not." And Gerald Dickler, who had been at the will-reading as Mell's new lawyer, also said that Stamos had invented the scene. Stamos was later unable to explain why he had not remembered such a vivid scene before and why, subsequently, the three executors had gone to such lengths to keep the deals secret from Kate and the non-executor directors of the foundation. There was no answer.

During the questioning of witnesses, the lawyers interjected long colloquies as to the scope and limitations of the trial position papers, and motion after motion piled up on the judge's desk. While Harrow gained the point on expert testimony, he lost another to the defense at the heart of the "Matter of Rothko." As part of the charges of disloyal conspiracy and fraud against the executors and Marlborough, he requested latitude to show that the executors had betrayed Rothko's "stated specific objectives" and "lifelong intention" for the foundation—namely, that it was organized first to preserve and promulgate his paintings and only secondarily to distribute moneys to aging artists in need. Harrow wanted to present proof from "disinterested parties"— Heller and Rubin, among others—that the art world knew of Rothko's aspirations and that the executors could not have been unaware of them. He wanted to subpoena Mrs. Rita Reinhardt, who had indicated to him privately that she strongly supported this position. Quite understandably, Mrs. Reinhardt was less than eager to "get involved," but on one point she says she would not mind being quoted. "Regardless of everything that has happened," she said soon after the trial was over, "I am still convinced that Mark wanted his paintings kept, put

214

in the foundation for the purpose of showing his work in the best possible way. And he was not interested in selling off his paintings for anybody. That was furthest from his wishes."

Had Mrs. Reinhardt been subpoenaed and had she testified under oath about witnessing the later will Reis is said to have destroyed, perhaps the suit might have taken a dramatic turn. Though it seems unlikely, Rothko, at the time of the alleged later will, might have been more specific about his intentions for his paintings than he had been after the confused Provincetown summer. In any case, a later will could not have been more vague than the operable one. Of course, such evidence would have been circumstantial, but, as Harrow pointed out, in cases of conspiracy, the widest possible latitude is allowed. Since no participant willingly testifies against himself, such a broad set of circumstance becomes essential to proof.

But the judge, perhaps because he wanted to simplify the number of issues and lessen the amount of acrimonious arguments, refused to consider evidence on this facet of the case. Though a year earlier Midonick himself had noted the possibility of an "interlocking triality" of Reis's and Stamos's conflicts of interest as foundation directors, he now ruled out any aspect of evidence related to the activities and purposes of the Mark Rothko Foundation. He upheld Richenthal and Greenspoon's arguments that such testimony would be barred by the "parole evidence" rule and involve hearsay. Parole evidence, generally applied in contracts and will-construction cases, precludes oral testimony as to the meaning of the document when there is a written legal instrument. Midonick would not let Harrow go beyond what existed in writing—the will drawn up by Reis and the foundation's incorporation drawn up by Reis through Karelsen—with an assist from Dickler. Midonick explained: "I have excluded all remarks of Mark Rothko, the decedent, with respect of how he wanted his estate handled, for the simple reason that it interferes with the reading of his will as an integrated instrument as well as his contracts when he was alive, etc., and it has no place, it seems to me, in any court of law." He reiterated, "If he didn't put it in his will, too bad. That's what wills are for. The only thing I could hear is where a will has an ambiguity in it. There is nothing ambiguous in this will. It says 'all the rest, residue and remainder of my estate I give to the Mark Rothko Foundation.' "

The judge did not rule on Harrow's argument that it could be inferred that the executors had used the foundation and changed

its purposes in order to facilitate the sale to Marlborough. Midonick just did not see it that way. "The trouble is here, who is being defrauded by what? Now, I have racked my brains to discover how you can defraud a dead man by something that happened after he died."

In this way, money dominated the trial. This, at any rate, was what the lawyers and the dealers understood best. "His will," ruled Midonick, "isn't in terms of where he wants his paintings to end up. His will is in terms of money."

Triumphant, Greenspoon went so far as to say that he knew where the fraud in the case was. "There's something wrong when this *stuff* is palmed off as art. We will take the *money* when we can get it." At the judge's quizzical look, Greenspoon added with great jocularity that of course he did not know the difference between "a Rembrandt and a Rothko" and he would be happy to take a tour with the judge of the Metropolitan Museum.

After Stamos, there was a round of expert testimony. Arnold Glimcher, the president of Pace Gallery, gave a two-day lecture on Rothko's durability and importance. He spoke of art in terms of investment. When an artist dies, he said, this creates "a finite commodity, where there once existed an open-ended one." He affirmed the $500,000 cash offer Rothko had rejected in tears in the fall of 1968. Glimcher was followed by Beyeler himself, who flew over from Basel to testify. Beyeler affirmed Glimcher's story, but not before a smiling Frank Lloyd had darted over to clasp his hand. Beyeler had told of the enormous demand for Rothkos in Europe since 1960. Lloyd's lawyers tried to make hash of the sales listed by Beyeler, including a $124,000 sale a few months earlier. They demanded to know who his customers were, but he refused to tell them. Then the defense offered in evidence a letter from Beyeler to Lloyd which they contended showed that Beyeler was trying to double-cross both Lloyd and Glimcher, making a Rothko deal with each of them. Beyeler pointed out that the letter to Lloyd was sent in late February 1969, after Glimcher had told him there was no chance of a deal because of Bernard Reis's relationship to Marlborough. Until then, he had been bound by honor to the Glimcher participatory offer, he explained.

Harrow charged that the opposition was harassing the experts he had announced would testify by subpoenaing their books and records and some of their personal papers. And other tight little art world pressures were brought to bear. One of Harrow's key witnesses had been James Speyer, curator at the Art Institute of Chicago, who had

assessed the inventory of the 600-odd Rothko works at the Marlborough Studio. When the time came, however, Speyer refused to testify. Not only had he been served with improper out-of-state subpoenas by Marlborough, but some in the art world have suggested that he had been persuaded to decline by the museum's board of trustees. The chairman of that board was Leigh Block, brother of Daniel Saidenberg's wife, Eleanor, and close friend of Frank Lloyd.

And in the case of Ben Heller, the canny private dealer who was the next expert to take the stand, the defense almost succeeded in exposing his tax returns to public scrutiny. As requested, he brought them to court and was holding them in his hand when Arthur Richenthal maneuvered him into referring to them for information about a consultancy. Richenthal then moved to examine these confidential personal records, but the judge ruled against him.

Heller had gone to the trouble of doing a slide-by-slide appraisal of most of the estate paintings, so the defense lawyers fought hard to punch holes in his estimates. He called the 798 paintings in the estate "an incredible plum," "a beautiful number," since half of that figure were mature paintings (1947–70), more than 200 on canvas and another 200 on paper; potentially, these were extremely valuable. The pre-1947 paintings were of primary interest to historians and students of art. With an estate that size, he declared, "the matter of having control is essential" in order to arrange carefully orchestrated "exhibits, writings, and essays." Control must last from thirty to fifty years, said Heller, essentially agreeing with Beyeler and Glimcher. "The market value of an artist's paintings is determined by the halo around the artist," he said. Heller, who was also in the textile, computer, and wine businesses, stressed the necessity of "beautiful merchandising and marketing techniques." On that score Marlborough was an "excellent gallery," well-equipped to handle the Rothko estate.

Heller used a sliding scale to make estimates of the value of the estate before Rothko's death, at the time of the contracts in May 1970, two years later, and finally in 1974. (Paintings on paper, he said, doubled in value after death and then leveled off later, while oils increased at first by a third, but continued to appreciate.) In May 1970, he declared, the 100 paintings sold to Marlborough A.G. were worth $6,420,000; by 1974 they were worth $14,613,000. The 698 consigned paintings were worth $4,800,000 in May 1970, and by 1974, $17,527,000. The total estate was worth $32 million in 1974.

By selling the 100 to Lloyd, Heller pointed out, the executors were

"extraordinarily imprudent"; they had lost the control of the estate as well as some of its most valuable assets. For Lloyd, Heller said, it was "plundering" the estate and like "buying into the mint." If, as the executors claimed, they had wanted to raise money, why settle for $200,000 in cash? To raise more money than that, they could have exercised the "put" to force purchase of four paintings a year—twenty-eight paintings would have brought several million dollars by 1977.

But, interjected Peck, what if the executors had been bound by the exclusivity clause in the 1969 contract? "It is possible to question exclusivity," said Heller, to see whether it is legally binding, especially without any survival clause in the contract. But even if the exclusivity clause had been judged by a court to be binding, then it would have been "prudent" to negotiate to sell the four paintings a year under the "put" for seven years and to arrange shows with museums.

Heller refuted claims that an economic recession would have negatively affected the values of Rothko's paintings. He pointed out that it is precisely during downside money and stock periods that the wealthy, as a hedge, buy great art and gems. "In any slow movement, there are momentary fluctuations, but they are not of great import. It would be important to hold on to the paintings through temporary reverses rather than sell them" in order to maintain the price levels, then "slowly bit by bit" release them for sale. The prices would go "up, up, up." It would not be long before some huge Rothkos from his mature period would be worth a million dollars apiece, he predicted, and having recently sold Pollock's *Blue Poles* to the Australian government for $2 million, it sounded as if he was in a position to know.

Heller maintained his cool demeanor as the defense lawyers hacked away at him. Twice he would be requested to return with more of his appraisal notes so that again the defense could attempt to undermine his credibility.

A question of Richenthal's afforded Heller the opportunity he had been waiting for to let off steam. Richenthal asked: "Is it a fact that you have a personal antagonism against Mr. Reis because his advice to Mr. Rothko prevailed over yours?" Heller jumped at the chance to bring up the foundation:

> I would have to say that having seen the results of Mr. Reis's advice and execution, I feel totally miserable . . . that having seen the rape that I have been seeing of Mark's work and his

wishes, the foundation that he and I worked on for so long blown to smithereens and some of his closest friends disassociated from him through Mr. Reis, I would say yes, I feel a certain amount of—well, let's say more wry human condition [sic] than personal antagonism. Mr. Reis is too old by now. . . . Yes, rather than antagonism to Mr. Reis, right now I feel despondent about the human condition.

During some of the testimony of Ernest Bial, Karelsen's associate, the elder lawyer sat like Lloyd George, his hand cupped to his ear. "What a waste of time," he would murmur to anyone whose attention he caught. Bial made a weak witness. He had prepared for Bernard Reis the convoluted mid-May 1970 memorandum of law stating "notwithstanding the statute [to the contrary]" the Surrogate would decline to rule on the executors' sale to Marlborough. When confronted by his statement in the same memo that, because of his position with Marlborough, Bernard Reis had a "conflict of interest," Bial said he had made a mistake. He had meant to write *"seeming* conflict of interest." He could not say why, in the light of Reis's dual position, he had not advised Reis to resign from Marlborough or else consult the court, since even a hint of a conflict of interest on the part of a fiduciary makes the court's review mandatory. He admitted that his memorandum was faulty when it cited a case (in which the beneficiary of an estate had gone into the real-estate business) as a precedent for showing that the executors might be taxed as dealers if they kept the paintings over a period of time.

The notes of the meetings with the executors and Lloyd had been "discarded," as had the drafts of the contracts. "At least," noted the judge in a Watergate aside, "he didn't say shredded." Surprisingly, the law firm kept few records.

During Bial's testimony, Gerald Dickler, Christopher's lawyer, noted the inconsistencies between the two contracts both allegedly typed at the same time at Marlborough. Dates were written out on the sales contract, which was single-spaced, with the executors' signatures on the left. But on the consignment contract dates were in numerals, the contract itself was double-spaced, and the executors' signatures appeared on the right.

Then, from Edward Ross, Kate's lawyer, came a ringing conclusion: *the consignment contract had not come into existence until June 1971*—just before Ferber, Geller, and Dickler had received it in the

mail. Without a confession by some party to the agreement, the back-dating could only be proved circumstantially. Nevertheless, Ross wove an elaborate tapestry from the evidence. Each strand seemed to fit. Every credible contemporaneous document in the case had referred to the "contract" (singular). The back-dating theory would explain why the bottom prices of the consigned paintings were based on the estimates from the Saidenberg appraisal dated January 1971. It also explained why Reis had made a further "sale" of thirteen paintings to Lloyd in November 1970. And Bial's time sheets listed long hours, far longer than for May 1970, devoted to the Rothko estate in June 1971. (A Marlborough employee later suggested a possibly more conclusive point that never came out at the trial, and so remains unproven; Pierre Levai, who was a signatory to the contract for the gallery, and who did not testify, was nowhere near the gallery on May 21, 1970, the day the contract was purportedly signed.)

Ross's logical piece-by-piece presentation to the judge provoked in the defense a fit of apoplexy. Foundation lawyer Greenspoon called for a mistrial, again threatened suit against Ross, and said he would file bar association charges against him personally for "inserting shocking poison into the record." If Ross's thesis could be proved, and Karelsen or Bial were implicated, they could have faced possible disbarment and disgrace. "We have had Mr. Ross belittling small law firms," Greenspoon shouted, "one of which I have been a member of for over twenty-five years. We have taken on every single law giant on Wall Street, and we have rolled them in the dust every single time." He added, not a bit self-consciously, "Ross is attempting to divert this court into a three-ring circus with him as ringmaster."

Bial's explanation as to why, on the contemporaneous documents, the contracts had been referred to as an "agreement" or a "contract" in the singular was a feat of ingenuous induction: "If you take all the pages and you staple them together, and if you have so many pages and staple them together with one staple, it's one agreement, and if you have one agreement with two staples it makes two agreements." Were these agreements then "Siamese twins"—with one in New York and the other in Liechtenstein? the judge asked sharply.

The next day, Arthur Richenthal arrived in court with a large envelope that he declared contained "three silent witnesses" to the fact that the consignment contract was written at the same time as the sales contract. But, he said, only the judge could look at the contents. Midonick, however, did not deem that proper. Rather, he made a

point of sealing the envelope so that no one, "except possibly an international spy," could open it until Richenthal chose to make its contents known. He liked Ross's reconstruction of events even less and would hear no more such argument. Things were complicated enough.

In March, Harrow brought a petition asking that Lloyd and Reis and the two Marlboroughs be held in contempt of court for the "flagrant violation" of the injunction. The petition alleged that they had "willfully disposed of and/or maliciously removed" at least 112 paintings. New documents and invoices showed that Lloyd had shipped or air-freighted a majority of these Rothkos out of the country following the announcement of the temporary restraint in June 1972. Those too large to go by plane had gone by ship. All 69 consigned paintings had been laundered and 35 from the 100 sold were actually "parked," the motion charged, through fictitious sales. But the judge reserved decision on contempt, holding that during phase two of the trial, centering on fraud, both sides would give the questionable transactions a thorough airing. As the first and only time that Frank Lloyd himself had been cited officially in the case, the contempt motion would prove extremely important.

During the trial, there had been some of the same secrecy in open court about the transactions as there had been earlier in the whispery back rooms of the gallery. Judge Midonick had been prevailed upon by Sullivan and Cromwell to seal the lawyers' pretrial briefs from the press. Even the disclosure of the initial pleadings of all parties was forbidden until, at the request of *New York Times* reporter Edith Asbury, lawyers for that newspaper submitted a memorandum citing the law of Surrogate's Court which provides that "[a]ll books and records other than those sealed [be] open to inspection of any person at reasonable times." The memorandum went on to say that reporters were people too. "Not since the Middle Ages has there been a private court system. . . . Our courts are owned by the people of the state; they are open to the people's view and their comprehension." But this did not stop the defense. Foundation lawyer Greenspoon had stated flatly, "The Foundation objects to any disclosure of any court document to a reporter. We don't think this case should be tried by the press, and I think the press is too officious in most matters, in any event, and I think the time has come for this court and other courts to stop their officiousness, so we object." And he continued to object.

221

Marlborough also persisted. David Peck sought to seal from public view all the exhibits marked in evidence. Midonick, however, saw this as a violation of the First Amendment. But Peck argued again that disclosure of the names and addresses of Marlborough's customers would give competitors unfair business advantage and intrude on the privacy of these wealthy collectors. Midonick did agree to conceal the identities of purchasers from the press by the use of scissors or masking tape in every reference to them filed at the court. For the duration of the trial this cumbersome process made many documents almost incomprehensible. Yet Peck was not satisfied with the blacking-out of customers' names. Pursing his lips and peering around, "Judge" Peck stated dryly that he had "never been on a case which was accurately reported."

In both the Rothko trial and the Goldman Sachs trial in the federal courthouse around the corner, Sullivan and Cromwell's clients-defendants had hired the same PR firm: Fred Rosen Associates. Later it would develop that Rosen's mission was not just to enhance Lloyd's position, but to curtail accurate reportage in the press.

The mounting pressures of the case, on which Harrow had worked eighteen-hour days and weekends for two years, began to show on him. Now in the courtroom he looked haggard. Whereas in private conversation he was gentle, good-humored, and quick-witted, during interrogations he was not himself. His voice would rise an octave, his accents become mannered, and, out of intense conviction, he would sometimes overstate his case or overreact to the calculated confusion of the defense. Using such phrases as "flagrant abuse" and "contumaciously," he would concentrate so hard on his examinations that the back of his balding pate would furrow as deeply as another man's troubled forehead. Fueled by the opposing lawyers' deliberately condescending remarks, the judge would sometimes become impatient with Harrow's impassioned intensity. One night in mid-April, Harrow suffered a bleeding intestine and was rushed to the hospital for an operation. The case to which he had given so much time, care, and energy would continue without him. He would miss the arch-witness, Francis K. Lloyd, when he first took the stand to defend himself.

Of course none of the issues of self-dealing or conflict of interest or conspiracy could be attacked squarely in the continued absence of the central defendant, Bernard Reis. But seventy-nine-year-old Reis, though he continued to work at the gallery for several more years,

never appeared in court. The fact drove Judge Midonick to several moments of helpless exasperation. "Is Mr. Reis still being paid? Does he go to work three hours a day? Is he sick? What am I supposed to think?" Arthur Richenthal brought in a new note from Reis's doctor, Isadore Rosenfeld, a heart specialist and another of Mary Lasker's particular friends and medical protegés who had also treated Rothko for a while. Mr. Reis, wrote Dr. Rosenfeld, would be adversely affected by the strain of testifying. Besides, his stroke a year earlier had impaired his memory and left him with a halting gait. Yet Reis had been well enough to testify in New York Supreme Court in January, just before the Rothko trial opened, in a civil case brought by his old friend and client Clinton Wilder. And while the Rothko trial slogged on with a halting gait all its own through the scorching New York summer, Bernard and Becky Reis made their annual foray to Italy.

# 18 The Trial:
## Phase Two—the Master Dealer

(JUNE–AUGUST 1974)

> **P.** But you can say I don't remember. You can say I can't recall. I can't give any answer to that that I can recall.
>
> from the Watergate tapes, March 21, 1973

Liechtenstein, the tiny principality in the foothills of the Alps, sits peacefully on the bank of the Rhine. Wedged between Switzerland and Austria, its narrow boundaries contain sixty-two square miles—one more than Washington, D.C. The rolling countryside is lush-green and bucolic, dotted with red tile roofs and grazing cows. It is a tourist stopover only for those who travel by road, since there is no railroad terminal or airport—nor any radio or television station, hospital, postal or telegraph office, or separate currency. For all these services—and many more—the country depends on Switzerland. Liechtenstein remains one of Europe's last monarchies; the population of 24,000 pays fealty to Prince Franz Joseph II, whose handsome castle high on a cliff above Vaduz (the capital) contains an inherited art collection valued at $150 million.

In tangible goods the country is known for its output of fancy postage stamps and realistic false teeth. But the chief resource is intangible. Liechtenstein is a tax haven for countless dummy paper corporations and trusts. To establish a Liechtenstein concern, all that is required is a $100 registration fee and a citizen of Liechtenstein to serve as director. There are no taxes on assets, and, as in Swiss banks, secrecy in all business transactions is assured by law. Consequently, a handful of lawyers serve as the directors of thousands of companies and trusts which rarely have an existence outside the papers indexed in their file drawers. These corporations serve as convenient letter drops, coded telex chutes, and Laundromats for untaxed money being washed in and out of Swiss bank accounts.

From June, much of the time of Surrogate's Court would be spent trying to penetrate the labyrinthian dealings of Francis K. Lloyd, so well protected by the laws of Liechtenstein and Switzerland.

During the testimony of Donald McKinney, the Rothko trial shifted into high gear. On May 24, 1974, just before the appearance of Frank Lloyd, Midonick unexpectedly opened up the case so that the second phase, the fraud charges, could be heard. He said that he "tentatively" had agreed to the division, which had been made at the urging of the defense; but now "to expedite this trial," he told counsel to be "prepared to examine Mr. Lloyd . . . on every issue of this case, not just self-dealing. I have tried to separate the issues in this case but . . . self-dealing spills over into other areas, and other areas spill over into self-dealing." The remnants of the mutilated stock book with some of its Xeroxed pages, Mrs. Moffett's whiteouts, and newly typed slips went into evidence. McKinney claimed little knowledge of and a poor recollection about these details; of the gallery's workings he said Lloyd made all the decisions for Marlborough. Naturally McKinney was not disinterested. He played the rating game, demoting Rothko to the lesser ranks of the New York School—with Reinhardt, Gottlieb, and even Stamos, far below Pollock and Still, both of whom McKinney exalted. In May 1970, McKinney said, he had appraised the 100 Rothkos at a retail value of $3,200,000. But Edward Ross, Kate's lawyer, demolished his appraisal when McKinney was forced to admit, when confronted with annual sales figures, that Rothko had been the gallery's best seller, averaging consistently better prices than even Pollock and Still (discounting Lloyd's later suspect bargain-basement bulk sales abroad). At first McKinney claimed to have lost the insurance

evaluations on Rothko's work that he sent abroad to the museums for the traveling exhibit, but by luck, a copy had been obtained when a colleague of Harrow's dropped into the Berlin National Gallery. The insurance values on fifty-seven pictures unaccountably proved to be three times the values Lloyd claimed for them. Furthermore, the insurance estimates coincided with Marlborough's actual Rothko sales to individuals and corresponded to the asking prices in the few pages of the Xeroxed stock book which were left to cross-check.

Ross queried McKinney about the ringing tribute to Rothko's "genius" in the introduction to the traveling show. With a slight pause and a sideways glance, McKinney said he had written the article.

Finally Ross asked, "And is it still your opinion that the art which has resulted from Rothko 'has led the artist to ever increasing recognition and fame'?" McKinney replied, "Well, that was my hope and wish when I wrote this article, yes."

"And has your hope and wish been realized?"

"It has, I must say, more and more so, in recent times, yes."

After the trial ended, Ralph Pomeroy, Stamos's biographer, said he had actually ghost-written this monograph at McKinney's request. At the time, he had been working as an assistant restorer in the Marlborough Studio. In return for his writing, Pomeroy said, McKinney had arranged that he be granted taped interviews with Rita Reinhardt and the Reises for a possible book on Rothko.

After McKinney stepped down, Surrogate's Court was ready for the testimony of the elusive Francis Kenneth Lloyd. On that day the number of interested onlookers and reporters multiplied considerably. All spectators waited eagerly to catch a glimpse of the dynamic sixty-three-year-old entrepreneur billed by the *Times* as "the most powerful single self-made figure in the international art world" and later as the "Man the Art World Loves to Hate." On several occasions the *Times* noted that Marlborough had lately moved to an even larger, grander space with a sculpture terrace in the Squibb Building at 40 West 57th Street. The cost of the new gallery was given out as $2,500,000, but actually, according to the architect, it had cost, at most, around $320,000—the bulk of which had been paid by the landlord, Samuel Lefrak, to entice new tenants.

"I hate publicity," Lloyd said, ignoring his press agent seated in the back row, pausing to chat with reporters as he made his way to the stand. "But I can't get away from it. It's just like money—if you don't want it you become rich. When you want it, it isn't there."

Once in the witness chair, he beamed beatifically, his face a tiny suntanned man-in-the-moon above his well-tailored banker's suit. Over the next three months, as he parried questions from the lawyers, led by Edward Ross, he displayed his theatrical persona: alternately charming and playing the injured party, nervously giggling and indignantly frowning, offended, then audacious and feisty, impatient and then lecturing off the cuff for long intervals, cajoling and flattering, then insulting and disdainfully condescending. Lloyd had lived by his wits, and in court he demonstrated how. He invited Ross—for whose brain ("like a computer") he expressed admiration—to visit him in the south of France during the next recess. And one day he offered to show Kate photographs of the Rothko family taken during their 1966 visit to London. His wife, Susan, a slim and attractive manicured blonde in her mid-thirties, often sat in the rear of the courtroom taking notes during his performance. As she scribbled, in her expensive understated clothes and Italian couturier shoes, a ring that she had been wearing backward, frontside to her left palm, occasionally became visible. It was a diamond the size of a bicycle reflector. In jest, reporters dubbed it the "Rothko Rock."

As soon became apparent, in terms of accountability, the diminutive person of Francis Kenneth Lloyd actually was kind of a mirage. Like a magician introducing a disappearing act, Franz Kurt Levai went to great lengths to show that just as easily as he had invented Francis Kenneth Lloyd and "*the* Marlborough," as he called his empire, he could turn himself into the little-man-who-wasn't-there. He held no office in any of his myriad Marlborough galleries and shell companies, though he admitted that he had masterminded every facet of the complex interlocking multinational organization. "Somewhere at the top of the pyramid," said the judge, "we're bound to find Mr. Lloyd." Maybe, but it would be no easy task. Lloyd was a citizen of the United Kingdom, Bahamas branch. For income he depended on his fee as consultant to Marlborough New York, on which he paid no taxes since the money was channeled through his Nassau company. Marlborough A.G. paid all expenses for his travels and hotels, which he said "helps me out a little bit." He was "not familiar" with the gross turnover of the business. All the cash was funneled into two "irrevocable" family trusts. Later, papers showed the trusts were not irrevocable after all, and that Lloyd himself, as a lifetime beneficiary, could revise their terms at will. Other recipients were his wife, Susan, and their young children, Alexander Lloyd, then six, and Caroline

Lloyd, four, as well as his grown children, Gilbert, thirty-four and Barbara, twenty-eight, both living in London and working for Marlborough. His red-haired nephew, Pierre Levai, and Levai's young son also would inherit small percentages of the Nassau trust. Even so, Lloyd claimed to own nothing taxable or attachable.

Much of Lloyd's time was spent bringing deals together by jet and by telephone. He estimated privately that he was airborne for a total of one month each year. On land, he seldom lingered in one spot, though his younger family, Susan and their children, wintered on Paradise Island in Nassau and summered in the Riviera villa which Joseph Hirshhorn had traded for paintings. In a given year, his visits to the United States totaled less than six months to avoid resident taxes. He rented an apartment in Paris and another in the East Sixties in New York.

In court it became clear that his galleries, for all their impressive appointments and costly exhibits, were little more than rented showrooms, shop windows for wealthy patrons. The real business of Marlborough was handled in a tiny Liechtenstein office. There, a comptroller-accountant-bookkeeper named Franz Plutschow routed invoices for millions of dollars' worth of art in and out of a constantly enlarging interlocking pyramid of paper holding companies to and from the various Marlborough galleries around the world. From time to time, the companies' names, addresses, and ownerships changed. The oldest of Lloyd's Liechtenstein companies are Trafo (the traffic routing center) and Galerie des Arts Anciens et Modernes (a holding company), formed in the mid-fifties and partly owned by outside investors Gianni Agnelli (through his Shaefer and Company) and partly by Bruno Herlitzka, who also was half owner of the Marlborough Galleria d'Arte in Rome. But Lloyd managed all—including Agnelli's art investment company. These two companies were the holding companies for other shells with multilingual names, among them Marlborough A.G. (the contracts company); Société Anonyme pour les Beaux Arts; Stutz Pulver; Art Finance, Ltd. (formerly Bruha, Ltd.); Galerie Athénée A.G.; Bilder and Skulpturen A.G.; Kunst & Finanz; Art Holding A.G.; and Marlborough Fine Art (Nassau), Ltd.

Lloyd implied there might be more corporate changes, further additions, substractions, and multiplications. As he told Judge Midonick, "I can only assure you that most of these companies don't function anymore." Through telexes, invoices, and shipping documents, Plutschow kept track of exactly where each work of art was located. Often

Lloyd made deals by "a handshake on the telephone." "Our business is like the jewelry business," he testified, "we don't do anything in writing—there are very few written instructions." On his orders, sales deals were signed by one of his Liechtenstein directors. When there was an emergency, Lloyd said he would telephone or telex a director and order him to cable his formal permission so that Lloyd might sign.

Confronted by the chaotic changes in the stock book, the many conflicting invoices, the altered dates and prices of Rothko transactions, and such missing documents as insurance evaluations, price lists, and hundreds of Rothko slips, Lloyd was aghast. He called the records a "big scramble." "I couldn't believe it. . . . I never go into details like that myself. . . . Your honor, if I have so stupid people, I'm not responsible if they remove something. I mean, this can happen." More than once the judge became annoyed. "Everything you ask Mr. Lloyd about records, he says, 'It's a mistake,' or something, and he doesn't know."

Besides blaming his "stupid secretaries," registrars, and administrators, Lloyd said that missing documents were the fault of his three earlier sets of lawyers. David Peck, on the other hand, he said, told him to produce "every scratch of paper."

As for the thirteen ubiquitous paintings, the court was further deluged with documents relating to them. "It seems a mystic number, thirteen," Lloyd mused. "We have bad luck with thirteen." Coincidentally, Lloyd's birthdate is July 13, 1911. Asked in a recess whether this was why he so often chose lots of thirteen paintings, he replied with a touch of chagrin, "I suppose you are right." Lloyd now said that the numerous papers referring to the "sale" of thirteen Rothkos were all mistakes of underlings. But even Frank Lloyd had made a mistake; he had also signed a letter referring to the sale, when actually he had only meant to say "try to sell" or "guarantee a sale." Until he could sell the paintings, he was keeping them "in the Frigidaire." "On ice, you mean," corrected the judge. Lloyd could not explain why the checks from Marlborough all said "For Purchase of 13 Rothkos."

He maintained that he had sold five of the paintings from the fridge to Galleria Bernini. After the trial, it came out that four of these had been sold at highly inflated prices directly to collectors through his Liechtenstein companies. The seven that had gone to AEK, also of exceptional quality, have not yet reappeared, though all of the AEK Rothkos had circulated on the same traveling show route

as the four "Berninis." It is the "Bernini" Rothkos that best illustrate the intricacy of Lloyd's accountings. As shown in the invoices produced by Sullivan and Cromwell just before the trial, two Bernini Rothkos had not gone to Bernini at all, contrary to the estate's accountings, but had actually been sold to Mrs. Paul Mellon in March 1971 for $250,000 and $170,000.

By piecing together the testimony of Lloyd and McKinney, it becomes clear how Marlborough appeases the whims of "important collectors." For a reason still not publicly known, in 1970, while he was governor of New York, Nelson Rockefeller decided to sell his modern American art collection, which had been exhibited at MOMA the previous fall, undoubtedly to the enhancement of the collection's value. Lloyd was given first crack at the collection; those he didn't want, other dealers bought. In a global deal, Rockefeller sold Lloyd—with a twenty-five-percent backing from Saidenberg galleries—over a million dollars' worth of art including the beautiful Rothko *White and Greens in Blue*, 1957, the canvas which had won the 1958 Guggenheim prize that Rothko rejected. In 1974, Lloyd testified that he had bought "two million dollars' worth of Rockefeller's collection" (the retail value) and that he had the greatest respect for "Rockefeller as a businessman."

Mrs. Mellon had coveted the exciting "Rockefeller Rothko," and Lloyd agreed to sell it to her for $125,000. On the books, he assigned a cost figure of $100,000 to the painting, which meant that the taxable gain (which also could be called a commission) would be a minimum of $25,000. A multiple purchase such as the Rockefeller transaction represents for the dealer elastic opportunities for inventive accounting. To minimize taxes, the buyer can assign whatever likely cost he chooses to each work as he sells it. Since there was a quick turnover on the Rockefeller painting, the cost and price were kept to a minimum. After all, Mrs. Mellon was more than a favored customer, she had in the previous three months purchased five estate Rothkos—one at $180,000—for a total of $465,000 from Marlborough in New York.

Late in the fall of 1970, Mrs. Mellon went to the Rothko studio, by then the Marlborough Studio, to see her latest masterpiece. She brought her friend and Paris couturier, Hubert de Givenchy. Since Rothko was her favorite artist and Givenchy her designer, perhaps she wanted Givenchy to have a painting as a gift. Or at least that is the way it looked to the employees working in the studio at the time.

The salesman for the Mellon account, Donald McKinney, gave Mrs. Mellon a guided tour of the studio.

At that time there were fifty-seven other important Rothkos there waiting to be selected, stretched, and photographed for the traveling exhibit scheduled to begin in Zürich in March. Mrs. Mellon's acquisitive eye fell on two enormous canvases. She had to have them, too—especially the *Number 20, 1950*—one of the paintings that Rothko had refused to sell to MOMA in 1969, telling William Rubin that they were to be kept by the foundation with a special group of paintings.

McKinney took careful note of the paintings she wanted and told her he would telephone Lloyd in the Bahamas to see if they were "available." He had remembered, he testified, that earlier Lloyd had come to the studio and, from a distance of thirty or forty feet, had gestured vaguely toward "a pile" of paintings in one corner and said "those are sold." Now, said McKinney, when he telephoned Lloyd, Lloyd told him that the paintings on which Mrs. Mellon had her heart set were indeed sold to Galleria Bernini, but that he would try to buy them back. Later, Lloyd called McKinney from Nassau and told him that he had negotiated with Bernini long-distance in Liechtenstein and obtained "the best price he could get" for the two paintings: $420,000.

McKinney did not take it upon himself to tell Mrs. Mellon about the intermediary transaction, but merely telephoned her in Antigua, where she was vacationing, and reported the exorbitant price. Afterward, he wrote her a letter beginning "Dear Bunny," with transparencies of the paintings enclosed. The paintings were "purchased but on loan abroad," he related. *Number 20, 1950* cost $250,000; the second, *Red, Black, and White on Yellow*, 1955, $170,000. He continued:

As I am sure you know there are very few Rothko paintings of this scale and importance which are available to the public except, of course, when paintings such as the Governor's are released for sale.

All that I can really say is that there would be no other collection in the world of this magnitude. Even though the Tate Gallery in London honored Rothko—the only American ever—

by installing as part of their permanent collection eight major paintings, these are all on one tone and the works follow a particular sequence of related forms.

Incidentally, I don't think you have the invoice for the blue [Rockefeller] painting, that is in your home in New York. I will prepare this, addressed to Virginia, but I will send it to New York for you. [Thereby avoiding a $8,750 sales tax due New York.]

So on March 2, 1971, Lloyd "re-purchased" two of the five paintings he allegedly had sold to Bernini, and the same day Marlborough A.G. sold them to Mrs. Mellon for $420,000. But Bernini had never had the paintings, and in fact Lloyd denied knowing who the owners of Bernini were. He testified that he had dealt with their lawyer, a Mr. Dasser. And even though Bernini's Liechtenstein address and that of its two directors Merlin and Ritter were the same as Marlborough A.G.'s, Lloyd insisted that there was "absolutely" no connection. Lloyd maintained that the $70,000 Bernini had offered to pay for each painting was "an excellent price" (from this $140,000, minus forty percent commission to Marlborough, the estate had received $84,000). "If I'm happy," he said, "if I get a good price, an excellent price, who can criticize me?" And though the Mellons had paid promptly, Marlborough actually would not receive purported payment from Bernini for the $176,000 sale of five estate-owned (consigned) Rothkos until September 1972. And it was not until December 27, 1973, that Lloyd would write a $420,000 "promissory note" to Bernini. Yes, he had had the use of the Mellons' money for a year and a half, but why not? Lloyd maintained that he had made no profit on the Bernini-Mellon transaction. "Zero percentage?" queried the judge increduously.

The two paintings meanwhile remained in the show abroad, and Mrs. Mellon would not see them again until she attended the Paris opening in the spring of 1972. They would not grace her walls until the following June. Ultimately they may hang in the projected modern annex of the National Gallery as a bequest of the Mellons— with, of course, appropriate charitable tax benefits based on Lloyd's inflated Liechtenstein invoice.

If all eight important Rothkos Mrs. Mellon purchased from Marlborough are someday hung together in a room in the new East Building of the National Gallery, at least it is a fate that might not have displeased their creator.

All sixty-nine consigned paintings (including the original thirteen), which Lloyd now alleged he had sold appeared to have been laundered in various ways. Though, like the Bernini-Mellon Rothkos, they had all been consigned to Marlborough Gallery in New York, sales were made by Lloyd's Liechtenstein companies in bulk at wholesale discounts to dealers and Marlborough directors outside the U.S.—in Liechtenstein, Zürich, London, and Toronto—and each transaction had been washed through one of Lloyd's Liechtenstein holding companies. Marlborough naturally took its commission, a forty percent bite out of the total $1,194,000 discounted for dealers, leaving the estate with only a paltry portion of the pie: $711,600 in all. During the trial, it became clear that even more of those "sales" were nonexistent, that there had been "mistakes" and "exchanges" for other paintings, and that Lloyd had made profitable resales of at least eleven paintings at fair market prices—at double or triple (or six times in the case of the Mellons) the prices Marlborough had accounted for. Lloyd said he had made these bulk sales "to create secondary markets" abroad.

For example, twenty-nine consigned paintings Lloyd sold to William Hallsborough, Ltd., a neighbor of Marlborough's on New Bond Street. At least four of these sales turned out at the trial to have been "mistakes" or the paintings had later been "exchanged." Lloyd avowed he did not know who really owned Hallsborough. The gallery, advertised as a dealer in old masters and antiques, was partially run by a fellow Viennese émigré named Franz Shrecker. Lloyd said he had met Shrecker in 1950. Later it was revealed that Shrecker's daughter had worked in Marlborough's London gallery for a while. And the snob appeal of the two "boroughs," say cynics, could only have been concocted by a Viennese. Lloyd slipped into calling Shrecker "Mr. Hallsborough," just as Stamos and others referred to Lloyd as "Mr. Marlborough."

To "raise some cash" for legal fees, Lloyd said, he had been obliged to sell thirty-five important Rothkos from the 100 he had bought outright, for an average of only $38,000 each, to four of his "rich" customers in Europe. He claimed to have raised $1,320,000. Twenty of the thirty-five were billed to Count Paolo Marinotti, identified as an Italian textile tycoon; eight to Arturo Pires de Lima, the son of a Lisbon banker; four to Yoram Polany, a young Israeli who had moved from Hong Kong to London; and three to Robin Ward, an English solicitor, living near Cannes. "You really must think we are

an international Mafia," scoffed Lloyd. "The president of the biggest industry in Italy is collaborating with us, the biggest bank in Lisbon is collaborating with us. You see, I think it is sheer fantasy." Though it was not revealed at the trial, former Marlborough salesmen identified de Lima as a private dealer in Paris, Polany as a young "jet set" classmate and close friend of Gilbert Lloyd's, and Ward as the lawyer who arranged the deal whereby Lloyd took Joseph Hirshhorn's villa in return for paintings.

Though Lloyd claimed the sales had been negotiated earlier, at least twenty of these thirty-five paintings did not leave New York until after Midonick's injunction, when they were shipped to a Zürich warehouse. Some arrived in 1973. In fact, the thirty-five paintings could not be traced to their nominal purchasers, and there was no solid evidence that any money had changed hands. Again in affidavits, the lawyers for the children and the attorney general contended that these were part of a series of "fictitious sales," trumped up after the injunction to look like real sales so that Lloyd could "park" or "squirrel" the paintings "in friendly hands" outside the court's jurisdiction, awaiting his disposition after the lawsuit was over. And the maestro, though he tried his best, could not really explain certain incredible mix-ups.

Lloyd declared sixteen of these paintings had arrived in New York "by mistake" in June 1972 because the Paris Museum of Modern Art had confused his instructions: "They mixed up the whole sending back of the pictures," he recited with annoyance. "Instead of returning them to Switzerland, they sent them to America and made an enormous mess, as always these French museums are doing. It was all mixed up, the whole consignment. . . . They are very difficult in this way, the French. They don't let any people who is [sic] not employed by the State to interfere with their organizations." And, of course, this could not be considered his fault. "I am not responsible for the French government, if they make a mistake on their shipping arrangements."

But the Paris Museum of Modern Art, as was later proved, had followed precisely written orders from Marlborough as to how and where to ship the paintings. With great care the canvases were divided into lots, as directed. The twelve previously sold to such Europeans as Baron Leon Lambert in Brussels and Hubert Givenchy in Paris were routed to Marlborough A.G. through Crowe warehouse in Zürich. But forty-two were sent to New York in two clearly marked consignments—the first comprised of paintings already sold by Lloyd to

Americans, including the two Bernini-Mellon Rothkos, and the other of those allegedly laundered paintings. The second batch (of sixteen paintings) arriving in New York in June 1972 were designated on the invoice as belonging to Marlborough Gallery, Inc. It was this group of paintings that Marlborough secretary Alison Burnham had tried to expedite through customs, because the salesmen were "champing at the bit." The paintings were registered in the stock book as owned by the gallery. Then the alarming news came from the court that Midonick had decided to sign the temporary injunction. Hastily, shipping invoices show, eighty-three Rothkos, including these sixteen, were shipped out by costly air mail and freighter. Faced with these lading bills, Lloyd's voice rose: "We couldn't stop anything, we couldn't do anything. . . . They [the Paris Museum] refused to pay the shipping expenses. And we had at our cost to ship the things back to Europe, which was an enormous problem for us, cost us a lot of work, insurance, and so on."

And then magically his lawyers produced a copy of a recently discovered letter from Lloyd to the Paris Museum reinstructing them to send the paintings in question to Zürich. When museum officials denied receipt of the letter, Lloyd blamed the French mail system for losing it.

Then Lloyd took a new tack. The injunction had nothing to do with him "personally": "But, my dear, I, personally, was never served an injunction. I heard from hearsay that there's an injunction going, and that when the paintings were shipped out of the country, I wasn't aware of any injunction." He was reiterating this position when the incredulous judge intervened.

THE SURROGATE: You mean to tell me your lawyers don't tell you about a matter as important as an injunction on an important estate?

THE WITNESS: I wasn't in New York at the time. I was traveling in Europe, as far as I can recollect. I haven't got my schedule here of my trips in Europe. I cannot recollect when I was informed.

THE SURROGATE: Well, I am not asking you for the minute or the day, even, but I presume that shortly after such a thing happened, your lawyers would find you through Mr. McKinney or somebody. Mr. McKinney always finds you, unless you are in the Himalayas, no?

THE WITNESS: Yes, he could find me. Not always, but sometimes. I came back to New York, on the 24th or 25th of June, and then I knew of this effort. [The 24th was the day after the decision was announced, two days before the order was signed, and the day after his coup in the trade with the Metropolitan Museum. But he had said that he had earlier given instructions to ship paintings out of New York.]

It appeared that Lloyd's relations with big banks and bankers were good. With art an international currency, a new breed had been propagated: the banker–art-investor. In Europe, banks serve as backers and brokers for art investment syndicates as well as hedge funds. In the late sixties, Baron Leon Lambert of the Banque Lambert in Brussels masterminded Artemis, the private art investment fund and consortium whose shares are sold primarily in Europe, and whose dealer partners are situated in major cities throughout the world. In the early seventies, London banks had begun to buy into art and antique galleries and auction houses. As Lloyd testified in a spellbinding educational filibuster:

> . . . a great part of art buying is done by some—they are called Art Funds. Private collectors cannot afford anymore to buy expensive paintings, and it's usually banks which buy art portfolios and sell these art portfolios to their clients. There are many banks in Europe that have art funds, and I believe even in America they are starting doing it. If you go to a Swiss bank, let's say the Union Bank of Switzerland, and say, "I would like to invest some money," they would ask you, "Don't buy any miracle shares. Buy some gold and buy some bonds, and we have something very special for you, we have an art fund. These art funds outperform everything and buy also some art funds for your portfolio." So all the banks, the Rothschild bank, the Union Bank of Switzerland, the Banque des Pays Bas, the Allgemeine Bank, the Banque Lambert, the Bank Modaco—I don't know, I can count twenty banks which have funds, participation in funds.
> They also have funds in diamonds. They sell also diamonds. They don't buy anymore shares [stocks], so all the banks in Switzerland, and in Belgium and in Italy, are potential art buyers and if you go to the Union Bank of Switzerland, and in the basement there you will see 200 pictures on the walls. . . . This

is our problem in the art business, that there is too much spec-
ulation going on, and not enough collecting, but we can't change
that. If somebody pays cash, they are our clients, and we have
to deal with art funds and there are many art funds.

At that, Ross demanded to know why, if cash was a factor, Lloyd
had waited one, two, and even three years for cash payment for the
suspect sales to Marinotti, AEK, de Lima, Ward, Polany, and Bernini.
And why had he no knowledge of who the owners of Bernini and
AEK were, and if they were not to pay cash for several years, after
allegedly making bulk purchases, how could he be sure of their credit?

All other dealers had Liechtenstein connections, Lloyd declared,
affirming art world gossip. But, he added, Marlborough was the only
one honest enough to admit theirs.

We say it quite openly, you see. The others don't say it, be-
cause what we do is legal. What the others do is not legal. That's
the only difference, but you can go to any dealer here in New
York and you will find out he has a company in Liechtenstein,
but there's one difference, the Marlborough has not a company
and address in Liechtenstein, it maintains an office. It really
works in Liechtenstein.

It was a dizzying prospect Lloyd presented. Was this where all art
was headed? Had artists struggled over the centuries to have their
unique contributions to culture held in Swiss bank vaults until
anonymous Liechtenstein entrepreneurs determined the time was
ripe to pop them onto the market?

# 19 The Defense— 140 Different Trials

## (AUGUST–OCTOBER 1974)

> To quote Lewis Carroll, if you say it three times, then it's true.
>
> Millard L. Midonick, Surrogate

It was a typical hot, humid mid-August in New York, and Surrogate's Court was even more airless than usual as Marlborough prepared to defend itself. While the lawyers spent most of the month arguing in shirtsleeves, the judge, barely concealing his impatience, was sweating it out under his black robes. Of the lawyers, only Arthur Richenthal looked actually younger than he had at earlier sessions; his gray hair had become coal-black.

Richenthal's colleague Greenspoon had left the trial—after the foundation learned that its attorneys' fees might not be approved by the attorney general's charitable trust division. Afterward, the foundation was represented by only one lawyer, Greenspoon's younger associate, Charles G. Mills IV, who would provide staccato interruptions with trivial objections on the part of the foundation. Looking pale and thinner but just as intense, Assistant Attorney General Harrow

238

was back, having recuperated from the operation for his bleeding intestine.

That Harrow had been a constant irritation to Lloyd was apparent at every turn. Lloyd mocked him repeatedly—for example, deliberately mistaking his pronunciation of Givenchy for "di Vinci." Though he insisted that the other lawyers stand beside him to show him exactly what they were reading aloud, when Harrow stepped in his direction Lloyd would tremble with disdain. "Don't touch me," he screamed. "You're not supposed to approach me without asking my lawyers! . . . You go where you belong to. . . ."

It was to Harrow's secondary suit, charging Lloyd himself, Reis, and Marlborough Gallery and Marlborough A.G. with having violated the restraining order of the court, that Sullivan and Cromwell would primarily address its defensive maneuvers. In preparation for this, John Dickey and David Olasov, Peck's younger colleagues, had flown to Liechtenstein, Rome, Zürich, and London. In the files of Marlborough's minions (Crowe, Marlborough's Zürich warehouse, and Rea Brothers, their London insurance broker), Olasov had found such a wealth of new documents—carbons, Xeroxes, notes of phone conversations, telexes—some 400 in all, that court officer Jerry Sullivan now utilized a two-tiered steel cart to wheel the evidence in and out of chambers. With these newly introduced documents, Marlborough's lawyers attempted to bolster Lloyd's claims that all estate sales were legitimate arms-length transactions. Paintings shipped out after the restraint were now surprisingly covered by all sorts of written circumstantial "proof" that they had been merely deliveries. When Lloyd had previously testified that nothing existed in writing about the sales, again he had erred. As had Sullivan and Cromwell, who had claimed not once but several times that every shred of subpoenaed evidence relating to Rothko estate paintings had been produced.

Wearily, over the vehement protests of the petitioners, Judge Midonick decided to allow "this exhausting, interminable, and unending stream of documents" into evidence, "with all their infirmities." He pointed out that if one proved fraudulent, it cast doubt on all the others. Since there was no jury, he said, their admission was not worth all the argument; he would weigh their merits for himself. He added that the papers "are of dubious value to me anyway."

The lawyers had previously said that the defense's refutation would be limited to one or two witnesses, but now, in part to identify documents, they would call nine. Lloyd would serve as his own main wit-

ness, testifying again both as a party to the case and as his own "expert." He had some difficulty rounding up other experts in his support. Dealer Klaus Perls had refused to appear, it was announced; and, when Lawrence Fleischman of the Kennedy Galleries was subpoenaed by Marlborough, his lawyers were able to persuade the judge that he need not give expert testimony against his will.

To combat the expertise of Ben Heller, the first witness for the defense was Peter Selz. Then a professor at Berkeley and a tenured curator of contemporary art at the Berkeley Museum, Selz had produced an appraisal of the 100 paintings bought by Marlborough and of the sixty-nine consigned paintings resold. For his efforts, Lloyd had paid him a fee of $20,000, plus his expenses, including air fare for two trips from California and back. Unselfconsciously lounging in the witness chair, German-born Selz told the court the "one reason" he had come east to testify was his "intimate relationship and friendship with" Mark Rothko. He hotly denied reports in the *Berkeley Gazette* and *The New Yorker* that he had been recently forced to resign under a cloud as director of the Berkeley Museum. (But reportedly museum trustees *had* fired him as director; because he had tenure, he remained at Berkeley as a professor of art history and curator.) Selz's *curriculum vitae* listed, under "books" he had written, many short monographs used as prefaces in exhibit catalogues. Significantly omitted from the resumé was the Rothko essay which he had written for the 1961 MOMA show (though it was included in his entry in *Who's Who in American Art*). When his metaphors extolling Rothko were read back to him, he admitted that he still believed what he had written to be true. In his rumpled seersucker suit, Selz played with a battery-powered mini-fan, as Ross attempted to knock holes in both his credibility and his estimates.

At first Selz testified that Rothko was unknown in Europe, but after passages about Rothko's international acclaim were read to him from the late René d'Harnoncourt of MOMA, Selz's own monograph, Beyeler's testimony, and a letter from art historian Meyer Schapiro, Selz backed down. "*If* I said that [Rothko was unknown in Europe], I withdraw it" was his backhanded way of changing his testimony. Then, in an informal demonstration of his expertise, he ticked off various painters that had declined in popularity after their deaths. He listed the entire Barbizon School, Hans Hofmann, Monet, Rodin, Corot, and Whistler.

Selz said there was no reason to believe that the New York School

and Mark Rothko might not decline as well. Had he been an executor, he too might well have sold the 100 paintings to Marlborough for the sum of $1,800,000. He professed not to have heard of Beyeler; Marlborough was the only gallery that could afford to handle such an estate, he said. But he explained that he knew nothing of consignment terms, contracts, or estates.

Using the paintings Rothko had sold Marlborough in 1969 as a yardstick, and working from slides, Selz had appraised the 100 paintings and the sixty-nine consigned paintings sold. He ranked them in three categories of quality: superior, average, and poor. Selz estimated that in May 1970 the 100 were worth a cash retail figure of $4,046,000.

It came as no surprise that the Selz appraisal dovetailed with Marlborough's contention that on such bulk purchases Lloyd paid sixty to seventy-five percent less than the retail asking prices. But it did not tally with individual sales as reported by Marlborough for the next year and a half, during which Rothko's oils averaged $75,000, ranging from $58,500 to the $250,000 Mellon sale, which Selz dismissed as an "aberration."

After Klaus Perls refused to testify on his behalf, Lloyd found one other dealer willing to take the stand, and Selz's testimony was interrupted by the last-minute appearance of Spencer Samuels, an affable dealer, who was flying to Europe the following day. As Ross put it, Samuels was a "hit-and-run witness." But this did not appear to matter much: Samuels was generally vague and did not profess to know much about the sales of contemporary paintings. The judge remarked: "He has not said very much. He really has not. I am not terribly impressed with general opinions. They don't mean very much." Samuels supported Lloyd on two points: that the 1970 economic recession had affected the volume of art sales by dealers, and that if a dealer buys several paintings, there must be at least a fifty percent discount from retail prices. But in all his dealings he had made only one bulk purchase of fifty paintings by an obscure artist.

Under cross-examination, Samuels added some unexpected information to the record. He told of becoming treasurer of Marlborough in 1963 when Lloyd bought the Gerson gallery, and that it was Bernard Reis who had set up the complex accounting and financial procedures. He also acknowledged that Stamos was a friend of his.

Next came Marlborough's crucial witness, on whose credibility they rested their case. He was Gilbert Dix of Rea Brothers, Marlbor-

ough's London insurance broker, who would verify many of the recently introduced papers purporting to show that the AEK, Marinotti, Ward, Pires de Lima, and Polany bulk sales were legitimate. Since Dix sometimes bought premiums through Lloyd's of London, there was some confusion in court for a while about whether he actually represented Lloyd's. A neat small-boned businessman, Dix respectfully explained how syndicated underwritings work, on one occasion referring to the judge as "Milord." He attested to each of the questioned sales; every time Lloyd had made one of these sales, it appeared, he had written, telephoned or somehow communicated it to Dix. It appeared that Dix had been informed by Lloyd of the Paris Museum's "misshipment." And when Lloyd had phoned him about one of the disputed sales to AEK, Dix happened to jot down the information on a current (May 13, 1971) magazine lying on his desk. This piece of evidence seemed to refute all earlier documents—including Mrs. Moffett's "white outs"—and indicated that the paintings had been shipped in violation of the injunction. It seemed odd, as Ross pointed out, that the questioned sales were the only ones Lloyd had ever cleared with Dix. Especially when there was no reason to have done so. Normally, Marlborough did not advise Rea Brothers unless there was damage or loss.

Any movement of Lloyd's paintings was covered by several "block" insurance policies for $80 million to $100 million. Premiums for this super-insurance cost Lloyd $400,000 a year. And the coverage extended through delivery to the customer.

Since for twenty-three years Dix had had a close working relationship with Lloyd, who, he admitted, was his best customer, he could not be considered a disinterested witness. In the midst of Dix's testimony, Richenthal introduced the "three silent witnesses"—still sealed by the judge—which would offer "irrefutable proof" that the consignment contract had been made at the same time as the sales contract. When unsealed, the documents proved to be a letter from Marlborough administrator Plaut to Dix mentioning the consignment paintings, a carbon of a second letter, and a "honeycomb agreement" from Lloyd's of London underwriting insurance for "700 items to be taken into Marlborough stock." All were dated August and September 1970. Richenthal had discovered the agreement in an unusual manner for a lawyer. At first, he said he had had them in his files, but later he claimed to have *privately* "subpoenaed" them from Sullivan and Cromwell—so they were not available to other lawyers. The new letter

did not seem to be part of ordinary business for Richard Plaut and Gilbert Dix. For one thing, Dix's office had not dated Plaut's letter on receipt, as they usually did. Having examined the insurance policy, Ross maintained it did not refer specifically to a formal consignment agreement but to the handing over by the executors of the estate paintings to Marlborough for safekeeping. As convinced as he was of the backdating, and given the innumerable genuine documents confirming this thesis, Ross could not prove it without a confession; yet neither did the defense offer conclusive proof that the consignment agreement was not backdated. Again, perhaps to hasten the trial, the judge decided that the issue of the contract's backdating—with its serious overtones of conspiratorial fraud—was not relevant to the Surrogate's case at hand.

Judge Midonick had been pressing for a settlement for months—for years, in fact. Now he directed the parties to settle, but requested the lawyers to stipulate that his efforts with negotiations not compromise his position as judge if the trial necessarily continued. Behind closed doors he and his staff attempted to search for forms of restitution in monetary terms for the 140 paintings sold by Marlborough. But his efforts proved fruitless.

Frank Lloyd took the stand again. During his defense, his attitude toward the court became one of lordly condescension. And unfortunately, in terms of a new and obvious imbalance in the scales of U.S. justice, Lloyd had some reason for self-righteous hauteur. On August 7, as Lloyd was winding up previous testimony as a hostile witness, Nixon resigned. The court had adjourned to the judge's chambers to watch the swearing in of Gerald Ford on a tiny ten-inch television set. In September, during the next phase of Lloyd's defense, Ford pardoned Nixon. As the lawyers and judge discussed settlement, Lloyd chatted with a reporter about the shocking news. "I am a victim of American justice," he declared. "Look how this crook is pardoned and see how I am treated by this same system of so-called justice," he said angrily, echoing prisoners and civil libertarians all over America. "When I fly to Europe first of all I will call a press conference and tell the world about my experience with American justice," he promised, his voice filled with moral indignation. The frivolity of time and money spent on the trial compared to the deepening world economic crisis was also a favorite topic of Lloyd's. "While we're sitting here in court, the whole capitalistic system is in danger of collapse" was one Lloyd epigram.

As the defense continued, it became clear how Liechtenstein companies served as shells for nominal ownership, title, and price alterations to maximize profits and minimize taxes. A useful device employed by Marlborough in this sleight of hand was the invoice headed ON SALE OR RETURN. This is a legitimate operation in the dress or book business, whereby a mass of books or dresses are sent to a given store and the retailers only pay for the actual number of goods sold, returning the remainders to the manufacturers. But with the Marlborough operation, ON SALE OR RETURN was merely a paper switcheroo among Lloyd's companies to facilitate changes in the prices and ownership of paintings. Take the Sale or Return of June 12, 1970, three weeks after the executors had sold the 100 paintings to Marlborough Liechtenstein. Seventy-two Rothkos were listed as having been transferred from Beaux Arts, one of Lloyd's Liechtenstein entities, to Marlborough New York, "F.O.B. Toronto." None of the paintings had actually traveled overseas and back again. Sixty-one of them had just been purchased from the estate at a pro rata price of $12,000 apiece. So that for tax purposes his profits would appear less when he sold them from New York, Lloyd merely shipped the paintings across the Canadian border and upped the cost (to him) listed on the Beaux Arts invoice to $3,051,000 for the lot, suddenly converting individual prices to $90,000 and over. The invoice was stamped by the U.S. Customs at the border, making the apparent transfer look real.

The Sale or Return invoice implied that the ownership was foreign and the painting merely consigned to New York. Lloyd explained: "The pictures must have left New York, were shipped to Toronto, and were re-imported to New York, in accordance with our practice." Or a painting later could be said to have been returned and the sale made to seem a Liechtenstein transaction. "If we sell anything on consignment in New York, belonging to a foreign company . . . it would have been that the foreign companies doing business in the United States . . . would have to pay income tax. If something is sold outside New York, like in this case . . . the foreign company isn't trading in New York, the place of business is outside New York and that isn't trading in New York."

Another useful paper device is the global sale, such as Lloyd's Rockefeller purchase, or better still the global exchange, similar to the trade with the Met, in which individual prices can be juggled to suit either party's convenience. An example of a global exchange was the deal between Marlborough A.G. and Harry Anderson of Ather-

ton, California. Anderson exchanged a Renoir plus $25,000 in cash for two Rothkos and a small de Kooning (30″ × 40″). The two Rothkos were large and important estate paintings: a 1955 (102½″ × 66⅔″) in rainbow hues of blue and yellow, which had been exhibited in the Venice and New York shows and priced at $80,000; and a 1969 black-on-gray (93″ × 76″) consigned painting. Since there was no way of determining the price of the Renoir, and the two Rothkos and the de Kooning could be allocated values at will, untangling the deal was like fencing in the dark. In July, two months after the exchange, Anderson wrote Marlborough asking for an allocation of prices for the three paintings and Marlborough sent back an invoice listing each painting at $76,500; presumably the Renoir had cost something near $205,000.

But before the actual details of the exchange were known, Marlborough's sworn statement listed the 1955 Rothko as a sale to Anderson for $45,000. When the invoice appeared in evidence as a result of Harrow's eliciting it from Anderson, Sullivan and Cromwell grudgingly allowed that $76,500 might have been the price of the painting, but maintained in each written reference to it that its value was far lower. This painting would be sold by Anderson in 1975 to the Carnegie Institute in Pittsburgh for $155,000.

The tale of the consigned black-on-gray exchange is even more tangled. It had been listed on Marlborough's accounting to the estate as one of a group sold to Hallsborough Gallery for $24,000 each—of which the estate received $12,000. To confound matters more, in 1973 an invoice was produced—apparently inadvertently—which listed this painting as sold to Marlborough Zürich on the same date that it had been exchanged with Anderson. The petitioning lawyers found it impossible to track the painting further during the pretrial examinations because Marlborough's registrar, Mrs. Moffett, had whited out the information pertaining to it—not just once but a second time between the stock book's appearances in the proceedings.

Confronted by the Anderson invoice, Richenthal and Greenspoon had acted out a charade with Marlborough. The estate and the foundation intended to sue Marlborough after the trial ended for this false accounting, they repeatedly declared, and therefore they would not take the $25,000 compensation from Marlborough which was offered them. Lloyd blamed the "mistake" on his clerical staff; the numbers had gotten mixed up, actually this painting everybody knew had been sold to Anderson, while Hallsborough had bought a differ-

ent Rothko. The estate never sued Marlborough nor did it demand the $28,250 due under the consignment terms.

In the myriad new documents attesting to the allegedly "firm sales" of the paintings that had been sent out of the country, there was no solid evidence that the paintings had ever left the Crowe warehouse in Zürich. On the other hand, so far there was little proof available that the allegedly parked paintings had also been laundered.

Then, just as Lloyd was concluding his defense, Harrow received a phone call from the Australian Consulate General, who related the following tale: Representatives of the Australian National Museum who had bought Pollock's *Blue Poles* for $2 million and had recently acquired a de Kooning for $850,000 had also purchased a 1949 Rothko in 1972 for the relatively modest sum of $92,000 from Marlborough London. Originally the asking price had been $80,000, so they had put down an $8,000 hold on the painting. John Erle-Drax, a Marlborough salesman, and Lloyd's son Gilbert had negotiated the sale; it was represented to the museum as a painting belonging to "a Swiss owner" and consigned to Marlborough for a twenty percent commission. Marlborough later informed the Australians that the Swiss had raised the price to $92,000. After some deliberation, the museum's acquisitions committee agreed to pay the new price, adding that they would like to buy more Rothkos. In January 1974, just before the trial began, Marlborough refused to complete the sale, sent back the $8,000, and notified the museum that the customer had changed his mind and the painting was not for sale. Indignant, and considering their position legally tenable, the Australian government was threatening suit against Marlborough.

It was the needle in the haystack that Harrow had been hoping to find. He hurriedly matched the numbers identifying the canvas. Yes, no. 5069.49 was one of eight which innumerable documents said had been purchased by Arturo Pires de Lima of Lisbon. Though it had left New York by jet after the restraining order, Lloyd had recently produced a mass of correspondence with the scion of the Portuguese banking family—or so Lloyd presented Pires de Lima—to prove that the sale had actually been made in January 1972 and the delivery was merely delayed. Pires de Lima, though, like Marinotti, Ward, and Polany, had not paid for the paintings until 1973 (coincidentally they each appeared to have made payments on exactly the same dates in January and February 1973). How could the sale be genuine if the

same painting had almost been sold to the Australian Museum for $80,000 in the fall of 1972, four months before Pires de Lima paid $38,000 for it?

In court Harrow asked Lloyd whether any of these paintings had ever been offered for resale by Marlborough. "No," said Lloyd under oath. Then Harrow confronted him with the Australian Museum's information. Lloyd blanched noticeably, his gap-toothed smile tightened. It was news to him. But he said he was sure the painting was at present in Pires de Lima's collection in Paris. Although Lloyd had testified that he was in constant touch with each gallery by telephone and knew all about sales, on this one he drew a complete blank. "Someone must have made it by mistake" was his comment. His son had not confided in him, but he would find out what had happened and produce all the documents from the London gallery.

A recapitulation of this painting's peregrinations both physically and on paper illustrate what happened to the Rothko legacy. The canvas, 69″ × 54″, was painted by Rothko in 1949, the year of his triumphal transition into his mature sectional images. The soft horizontal rectangles were about to emerge from the multiforms; his palette was glorious: violet, black, orange, and yellow on red and white. That year he sold only three paintings at Betty Parsons for a total of $900, of which he netted $600. The price of this painting would have ranged between $500 and $600. It was not sold.

The painting was carefully rolled and stored with Rothko's collection in one of the warehouses for twenty years. Then, a month after Rothko's suicide, Donald McKinney was given the executors' letter describing him as "the official appraiser" of the estate, enabling him to choose paintings from all the warehouses. This was one of the earliest paintings McKinney chose and was included among the 100 Lloyd had trucked to the Marlborough Studio. On May 21, 1970, Lloyd bought it with the others from Reis, Stamos, and Levine for $2,000 down and an approximate discounted value of $12,000.

Title went to Marlborough A.G. in Liechtenstein. Whether, like many others, it was physically trucked to Toronto and back is not known, but, like the rest, it was listed on a Sale or Return invoice from Société Anonyme pour les Beaux Arts to Marlborough Gallery in New York. This paper then catapulted its cost price on the books to $39,000 so that Lloyd's taxable profits on its selling price would appear minimal in case it sold immediately. Most probably it remained in the studio until December, when the European museum directors and

McKinney selected fifty-seven paintings for the traveling show. Stretched, photographed, and insured for $65,000 by the museum pool, the painting was shipped in March 1971 to the Kunsthaus in Zürich and numbered *fourteen* in the handsome catalogue. From Switzerland, it was trucked to museums in Berlin, Düsseldorf, Rotterdam, London, and Paris. Its public appearance in Paris proved to be its last as part of what Lloyd termed "the enormous mess." On May 15 the painting was shipped to New York by the French government, along with the still unsold paintings as well as the two Mellons and the others purchased by Americans. Hurried through customs to appease the Marlborough salesmen who were "champing at the bit," it was reentered in the Marlborough stock book and its cost price to the gallery relisted at 215,000 Swiss francs ($53,900). When Judge Midonick announced the restraining order on June 23, 1972, the painting was noted as "returned to Beaux Arts." Actually, on July 1, 1972, it left JFK airport by a Swissair jet destined for the Crowe warehouse in Zürich. It was then that the painting disappeared. In a statement made in January 1973 by Lloyd's lawyers, the picture and seven others were identified as having been sold to an anonymous buyer in January 1972 by Marlborough A.G. through Beaux Arts for $36,000 apiece. Finally, in August 1973, after Marlborough had lost its appeal to keep secret the names of its Liechtenstein customers, the buyer was disclosed as Arturo Pires de Lima of Lisbon. By the fall of that year, when the Marlborough stock book was introduced, the slip for this painting, like countless others, had been destroyed and a new one typed. The new slip gave little information about the painting except its new cost price of $53,900 and that it had been returned to Beaux Arts on June 23, 1972. The selling price was left blank. During his second session of pretrial examinations, Lloyd stated under oath that there had been no correspondence relating to the Pires de Lima sale or the other bulk sales. An ostensible credit advice from Swiss banks showed that money for the paintings had not been deposited in Pires de Lima's name in Lloyd's account until January 1973 (on the same dates that other bulk purchasers apparently made payments).

Before the trial and several times during the trial, Lloyd's lawyers, Sullivan and Cromwell, had said that all of Marlborough's files had been combed and everything relating to the Rothko estate paintings had been produced in evidence. Then, during the preparation for Lloyd's trial defense, came another avalanche of "newly discovered" evidence relating to all the questioned bulk sales. Among these papers

was a Crowe warehouse invoice showing that all eight Pires de Lima paintings had been stored there in December 1972. This was most peculiar in view of the fact that this painting was also in London that December, where the Australians had seen it and believed they had purchased it for the initial figure of $80,000—more than twice the $36,000 Pires de Lima allegedly finally paid Lloyd's bankers for it *the following January.*

It was the first really hard evidence, as Harrow pointed out, indicating that not only had the bulk consigned paintings been laundered in self-dealing transactions by Lloyd, but so had at least one painting from among the 100 Lloyd had bought outright.

The new "researches" Lloyd now ordered in the files of the London gallery produced yet another mound of paper, some sixty new documents relating to the painting, which David Olasov of Sullivan and Cromwell offered in evidence. Some of the correspondence was obviously genuine, that among agents for the Australians, the acquisitions committee of the museum, and Gilbert Lloyd and John Erle-Drax for Marlborough, and it confirmed the museum's story. Other letters to and from Pires de Lima and David Somerset (now chairman of Marlborough London's board) were suspect; they even appeared to have been typed on the same typewriter. Their import was that Pires de Lima had purchased the Rothkos as an investment, then offered them for sale for from $70,000 to $80,000, but later changed his mind. This was incredible, since the correspondence was all dated months before he had *paid* for the paintings. It was not difficult to infer that the "Swiss owner" was in fact Frank Lloyd.

Lloyd had related an elaborate story about how Pires de Lima wanted the paintings stored in Zürich before deciding which would go to his father, "the president of the biggest bank in Lisbon," and which he would take for himself.

When Marlborough's contracts with other estates were finally put in evidence, the best and most advantageous, from the estate's point of view, was the Jackson Pollock contract. Lee Krasner Pollock, with Gerald Dickler as her lawyer, still had ironclad control over what Lloyd did with the 450 Pollocks consigned to Marlborough. No wonder she remained partial to the gallery's performance. The 450 works had been consigned to Marlborough for six years at one-third commission, but with cause she could cancel the contract at any time. Minimum prices could be adjusted yearly, and she had to authorize which paint-

ings were to be sold during each year. If Marlborough sold anything below her specified minimums, she could cancel the contract—thereby insuring herself against fictitious sales. Moreover, supposedly no other artists' works could be sold with Pollock's, to prevent use of the global sales device, and there could be no trades or exchanges without her written consent. Accountings were to be given every six months. The Rothko consignment contract contained none of these provisions, except for the six-month accountings—even so, there was no accounting for more than two years.

Though subpoenaed to do so, Marlborough did not produce the original contracts with the Feininger estate and its executor, Ralph Colin; the Kurt Schwitters estate; or the Lipchitz estate. But all of the New York School contracts produced—the Kline, the Pollock, the David Smith, the Baziotes, and the Reinhardt sale contract with its six-year exclusivity agreement—were in fact superior to that of the Rothko estate. None lasted for a term of twelve years or omitted control of minimum sales prices. While Bernard Reis had also advised the Kline estate in 1965, the contract was only for seven years at a commission of one-third, with a fifty-percent commission on restored drawings. The executor, Elizabeth Ross Zogbaum, could negotiate minimums, and there was a three-month accounting period. But though the agreement promised exhibits, Marlborough had only mounted one. In 1974, after the contract expired, Mrs. Zogbaum consigned what was left of the Kline estate to former Marlborough salesman David McKee at his new gallery. She had discovered disparities in the accountings from Marlborough, including a big bulk purchase made by the Hallsborough gallery at half the going rates.

Baziotes's widow, Ethel, was also guided by Reis, and by her lawyer, Dickler, who at the trial accused Marlborough of letting the Baziotes estate "dry on the vine." Lloyd had negotiated the Baziotes contract with a fifty percent commission for four years with a drawing account. Reportedly no appreciable efforts were made to sell the paintings over the four years, and when Mrs. Baziotes needed money for medical expenses, according to her friends, she had to borrow against future sales. When the amounts borrowed added up to half the minimum retail price she had prescribed for oil paintings, Marlborough bought a painting for itself. By 1975, according to Marlborough employees, there were few, if any, oils left in the Baziotes estate. That year Marlborough finally exhibited Baziotes's watercolors. By then it was time,

it would seem, from the point of view of Marlborough's pocketbook, for a rediscovery of Baziotes.

After Lloyd had completed his twenty-eight days of testimony in early October, the Rothko estate was presented with additional problems. The art advisory panel of the IRS had declared that the Rothko estate was worth $16.5 million in February 1970 and that $4.6 million more in taxes was due the government, three times what the executors had declared in 1971. This led Ross to bring another motion to remove the executors summarily so that the tax case could be negotiated on behalf of Kate and Christopher Rothko, the only beneficiaries who would have to pay the tax. But the judge denied Ross's motion, declaring that it was to the advantage of the executors to attempt to negotiate with the IRS for the estate and that Levine's lawyers, Paul Weiss Rifkind Wharton and Garrison, in particular, were noted for their tax department expertise.

It looked as though fate were trying the Rothko children for their dead parents' flaws in judgment. The Museum of Modern Art now filed suit against Mell Rothko's estate to claim the two paintings Mell had promised to leave the museum, the 1944 *Slow Swirl by the Edge of the Sea* and the later nineteen-forties multiform. The museum valued the paintings at more than $125,000. Under Rothko's will, they belonged to Mell as part of "all the contents" of the brownstone, and she had agreed in a letter to give them to the museum. But since she had not rewritten her will, the museum did not have a clear claim to them. The statute of limitations was running out, so the museum's lawyers had advised curator William Rubin that a suit to acquire them formally must be filed. Kate Rothko was incredulous, since she had agreed verbally that once legal difficulties were over, the gift would be arranged. At the time, the foundation was appealing Surrogate Judge di Falco's decision that the children should inherit the forty-four paintings. The estates of both parents were still in legal limbo.

After Lloyd finished his defense, the next witness was the vibrant and provocative Carla Panicalli, who had flown over from Rome to testify for her boss. In her mid-fifties, wearing a houndstooth tweed cape and matching hat, she looked handsome and intelligent. But she told her story haltingly in soft Italian accents, playing down her com-

prehension of the English language and her business acumen. "I am not a commercial person," she said; or "I'm really unpredictable." But she had done well enough running the Rome gallery for Lloyd and his silent partner, Bruno Herlitzka, to have earned $30,000 a year and become a limited partner (at twenty percent) in 1973. And yet she claimed her gallery was beset by typical Italian confusion—disappearing letters, records, an absentee bookkeeper. Naturally, it had recently taken all of lawyer Olasov's perspicacity to uncover the location of documents relating to Rothko.

One purpose of Carla's testimony was to strengthen the claim of Lloyd and the executors that Lloyd would have refused to organize the Venice show had he been unable to purchase the 100 Rothkos. Already in the record, however, was a set of letters between Carla and Donald McKinney showing that the exhibit had been "finalized" and was "definite" even before the first negotiations between Lloyd, Stamos, and Levine took place. But now there was newly discovered correspondence showing the opposite. Signora Panicalli said that her language difficulties lay at the root of the misunderstanding in the earlier letters. *Finalized*, she thought, meant "perhaps." Actually, she said, Lloyd had telephoned her in the middle of the night on May 19, after concluding the agreement, to tell her to go ahead with the exhibit.

She had loved Rothko and spent every visit to New York "passing all my free time with him." He was one of her "greatest and closest friends." She had always wanted to exhibit him, but in May 1970, "in Italy nobody knew the work of Rothko—only I knew the work of Rothko." When reviews were read to her of the 1958 Venice Biennale Rothko room and the 1962 raves comparing "maestro" Rothko to Matisse, Klee, and Mondrian (at the time of the MOMA traveling exhibit), she criticized the reviewers one by one. She said the show had "lasted in Rome so long because no other museum wanted it" and "to my great dishonor, I did not like it."

She was almost as close to "Paolo" (Marinotti) as she had been to "Marco" (her name for Rothko). Marinotti—who had bought those twenty Rothkos in bulk—trusted her to advise him on acquisitions for his immense collection of art. She spoke of Paolo's great wealth, his love of caviar, and big-game hunting. Besides his ski lodge in St. Moritz and the huge villas he owned in Paris, Rome, and Milan, he owned the Palazzo Grassi, an impressive showplace in Venice for art and antiques. Marinotti himself, she said, had organized many art exhibits and written monographs for catalogues. By late 1971, after

having told him for years about Rothko's greatness, she was able to interest him in the purchase of the twenty Rothkos for $780,000. No, it was not unusual for Marinotti, with his great wealth, to have made such a large purchase, and naturally he received a small discount for such a big sale. She added significantly, "If Paolo bought something, Frank would never never be able to get it back." (Note the conditional "if.") One newly found letter to Carla signed "Paolo" asked her to have the paintings held for him in the Zürich warehouse.

But Carla seemed candid and winning enough for the judge to say, "I think she is an honest and honorable witness. . . ."

Winding up the defense in mid-October were a handful of witnesses whose testimony was short and expert. Marlborough brought in two restorers who were paid for their time in court as well as the time they had spent examining the condition of the paintings left unsold in the studio. Four small Rothkos of various periods were exhibited to illustrate the condition of the unsold paintings.

Gustav Berger estimated that restoration of 342 oils on canvas that he had seen in the studio would cost from $259,000 to $290,000. But no one, least of all Rothko, would have wanted to restore more than a few of the paintings from his early period.

Mary Todd Glazer, a tall scholarly woman, was the expert on the Rothko papers. She testified that Rothko's flat matte surfaces were so delicate that they could not be cleaned with solvents, only by a brush. Since they could not be protected by framing under glass, there was no way to keep them from deteriorating. Her estimate for restoration was from $114,000 to $139,000.

Neither Berger nor Mrs. Glazer had ever actually restored a Rothko, and since there was no likelihood of restoring all 658 paintings, the witnesses' testimony seemed to have little relevance.

These two experts were followed by cabinetmaker James Lebron, who had made the special durable expandable stretchers that Marlborough used in the traveling exhibits. After testifying as to the costs of stretchers, he added valuable information about the timing of Marlborough's takeover of the Rothko estate paintings. His worksheets showed he had begun to stretch forty paintings for Marlborough in the studio in late April 1970 and had stretched twenty of them before Stamos and Levine first negotiated with Lloyd to sell the 100 paintings. Clearly, Lloyd knew they were his before the "negotiations."

The courtroom was suffused with a welcome hilarity during the testimony of Mrs. Rebecca Reis, who was called by Richenthal primarily

to refute Levine's account of the April 1970 argument during which Levine had accused the other two executors of conflicts of interest with Marlborough.

With her theatrical English accent and fluttery tea-party charm, Rebecca Reis was reminiscent of Spring Byington. Even when her lorgnette was not poised, she had the mannerisms of a tiny duchess. Heavy chunks of pre-Columbian jewelry dwarfed her petite figure. Gesturing coyly, eyebrows arched, she first misdated her marriage by ten years—then exclaimed, "Am *I* married fifty-three years?"

She had "never" heard Levine or Stamos raise his voice, and the argument could not have happened while she was not at home because she was "always at the house." "We don't keep a servant, you know," she went on conversationally. "I always answer the door. . . . I like to entertain people, so I'm there all the time." There was no possibility she had not been there within earshot. Impossible, she decreed, describing the layout of her house, "the large dining room and garden," the absence of doors. She invited the court to pay a visit to the Reis town house.

No one would have left her out of anything. "I consider myself a cozy congenial person . . . a very good cook." She told of the importance of the Reis art collection and of requests for loans from the Cleveland, Los Angeles, and Fogg museums. But as to its worth, she had no idea. "Oh, I'm not a very money-minded creature—if you asked me about money, I'm afraid I would never know."

Becky said that it was she who wrote the Rothko Foundation's letters by hand, because hiring someone to type was "a waste of money," as she had learned through "many years connected with an eleemosynary institution." The foundation was "luckily" composed of "a distinguished lot of people." She named Stanley Kunitz ("our poet laureate"), Mr. Stamos, Mr. Reis, critic Thomas Hess, Wilder ("a very rich man"), and Morton Feldman.

She informed the judge that Rothko had begged Reis to join Marlborough so he would "have a friend in court." Rothko's main concern, according to Becky, was "his relationship with Marlborough and my husband." When he joined Marlborough at Reis's behest, it was "the happiest thing for Mark."

She described the Reises' annual travels abroad. "Yes, we go every year," she said. Then she rhapsodized about the "delightful villa near Florence" where they had once stayed for two months and the visit to their "very good friend" Peggy Guggenheim in her palazzo in

Venice. Apparently it did not strike her as incongruous that while most of the people there that day had been sweltering through August in a New York City courtroom largely because of Bernard Reis, she and Bernard were having a holiday in Europe. She even offered to find the address of the delightful little Florentine pension on the hill for Edward Ross. But when Ross pointed out how little Reis's stroke seemed to have impeded their social activities or his working at Marlborough, Becky reproached him. The judge noted that "testifying here is no fun for anybody." Yet Becky seemed to enjoy the drama of her courtroom appearance.

Then Heller was recalled to the stand by Harrow to identify his preliminary estimates as they went into evidence over the objections of the defense lawyers. He also attested to a new sale of a Rothko. The most recent known sale had been at a Parke Bernet auction in May, when a medium-sized mature yellow on white Rothko went for $110,000 to Galerie Internationale of Milan. Heller's news was that the Robert Elkon Gallery had just sold a large 1955 painting for $142,000 to dealer John Herring, who bought it for a client, William Mazer, of the Hudson Paper Company. Knowing the Mazers wanted a Rothko, Heller had received a finder's fee of $7,000 from Herring, while Elkon was paid the balance.

The night before Heller appeared, there had been an auction of Impressionist paintings at Parke Bernet, at which only three art works had received their estimated values; but Heller maintained his stance. Auctions were only one barometer of the market, and that auction had offered only works of "mediocre quality," he said. When Lloyd was quoted as having said that "the bottom had fallen out of the art market and the stock market," Heller disagreed. The modern masters were holding up well, he argued, citing a 1943 Max Ernst recently sold for $150,000. A quote given by art dealer Stephen Hahn to the *New York Times* was read into the record: "In an economic recession, people will buy topnotch paintings and pay nothing for so-called merchandise."

The trial might have ended on a higher aesthetic note if the next witness had been the last. Meyer Schapiro, the distinguished Columbia professor of art history, was called by Harrow as his final expert. Professor Schapiro, whose authority in his field was unquestioned, exuded a dignity and an honesty that were refreshing after Professor Selz's mocking tones. Why had Schapiro agreed to testify when so many art world figures were reluctant to get involved? "I think it is a matter

of duty. If there is an issue of public importance pertaining to law and to right, any citizen whose views are regarded by the court or by the parties concerned as important should testify." Shapiro added, "Of course I have a general reluctance to appear in court."

The judge listened intently as Schapiro pinpointed Rothko's place in the history of art. More than anyone else during the eight-month trial, he was able to give a broad perspective to Rothko's accomplishment. In a letter to Harrow before the trial, he had summarized his estimation of Rothko:

> At the time of his death, Rothko was regarded by many artists and critics as an old master, a painter who had established himself firmly as one of the three or four outstanding American artists, and perhaps one of the half dozen greatest living artists anywhere in the world. The impact of his retrospective exhibitions, the deep interest they aroused, the high prices for his paintings demanded in the world market, are evidence of that recognition. His paintings were enjoyed and revered as a unique and deeply absorbing art, with rare qualities of conception, color and grandeur and solemnity of effect that invite comparison with great religious art of the past, though they present no imagery or symbolism. No account of American art for the period after World War II, published after the middle 1950s, ignored his name, and the space given to characterization and discussion of his work has increased steadily since that time.

Now in court, Schapiro described how he reached his conclusions:

> . . . we measure . . . importance in a practical sense by how an artist appears publicly in writing, exhibition, sales, zeal of collectors to find his work, response of dealers to his work. All that, taken together, makes up, you might say, the importance of the artist at that moment.

Schapiro was reluctant to play the rating game, but he did say, referring to the late fifties:

> I would hesitate to make a simple categorical statement, but I would incline to say that, without insisting on it, Rothko and

Pollock and de Kooning were not only the outstanding American painters but also in world painting at the moment. In Europe, those who were looking at American art regarded Rothko as a top painter. . . .

Schapiro affirmed Rothko's durability in the face of recent events and faddish trends:

I can't think offhand of a painter who had a sustained reputation, like Rothko's, over a period of twenty years, who then was forgotten. . . . Perhaps, after leaving this court, some name might occur to me, but that would not be an obvious or familiar phenomenon for a painter whose reputation lasted for twenty years and became international, and was evident in museums, and in criticisms, and in writings. I can't think offhand of an equivalent painter who then disappeared.

I believe that dealers were judging him in about the same way, dealers who would not have bought a Rothko in 1950 or 1960, who are all ready to buy works of his in the sixties and seventies, so there has been a growth, a movement in a certain direction.

During Richenthal's cross-examination of Schapiro, he asked the expert whether Bernard Reis and Stamos had a "good reputation." Before Schapiro could reply, Judge Midonick interjected: "Reputation has nothing to do with fraud." He was interested, he said, in "evidence not reputation, in integrity or lack thereof. Reputation and deeds are different."

As an addendum, Sullivan and Cromwell lawyer David Peck asked to be sworn in for the defense. He had been to the Parke Bernet auction the night before and wanted to read the low prices into the record. But since no Rothko had been on the block and one had recently been sold privately for $142,000, Peck's account merely emphasized the fact that during a general decline in the prices art was fetching, Rothko's prices were soaring (partially because of scarcity, to be sure).

Finally, eight months after it began, the Rothko trial ground to a halt. There were almost 15,000 pages of transcript and thousands more

pages in the 875 exhibits, many of which were suspect. Legal fees and court costs over the preceding two years and through the trial had probably risen to well over $2 million.

Now it was up to the seven sets of lawyers to produce more paper—lengthy summations of the positions of each side. Judge Midonick gave the petitioners three months to write their briefs, to be followed by three more months for the lawyers for Marlborough, for Reis and Stamos, for Levine, and for the Mark Rothko Foundation, to defend themselves, and another six weeks for the petitioners to counter with a set of reply briefs. As the judge had pointed out, accounting for the legal whereabouts of every painting Lloyd "sold" made it really 140 different trials—"each one following a painting." Thus the number of pages that the judge had to read would continue to mount into the hundreds of thousands, postponing the decision for some time. Midonick still hoped for a settlement, but like Morton Levine's dreams the judge's headache would not go away.

# 20 Press Clips from the Gallery:
## Aftermyths of the Trial and the Long Wait

(DECEMBER 1974–DECEMBER 1975)

> The art of publicity is a black art; but it has come to stay, and every year adds to its potency.
>
> Learned Hand,
> 1951 address to the Elizabethan Club, Yale University

In December 1974, as the lawyers were sifting through the mass of evidence, preparing their ponderous briefs, a handsome book on Theodoros Stamos was put into circulation. Priced at $32.50 and only available at larger bookstores, the rarefied book, like the artist himself, was not destined to be a best seller. But why had it been published at all? And why had its publication date coincided with the trial's end?

For a few years, the author, Ralph Pomeroy, had believed the book would never see the light of day. When he had written it during those critical days in May 1970, he had been unaware of the decisions that his friend and subject faced at the time. His publishers, Harry N. Abrams, Inc., had scheduled the book for publication in 1971, and Marlborough had announced the book when Stamos officially joined the gallery early that same year. But the project had been postponed.

259

When it was resurrected, Pomeroy's editor asked him to change the May 1970 date of his poetic monograph, but he refused.

Usually, art book publishing is so expensive, explains art historian Sam Hunter (who is also an editor at Abrams), that it is not unusual for dealers to underwrite these books. Lloyd himself had testified that Marlborough "contributed to books about its artists" and named Abrams, Viking, and Praeger as publishers the gallery had subsidized. Had the book possibly served as an additional enticement for Stamos to agree to the Rothko sale? When Harrow telephoned Pomeroy's editor, he was told that the book had been commissioned in December 1969, before Rothko's death. However, there was no satisfactory explanation of why it had come to be published immediately after the trial, too late for its origins to be discussed under oath. Clearly, Lloyd had contributed some of the unattributed color plates, but what else? Reportedly, Stamos had bought $17,000 worth of copies of his book and, with the help of a woman friend, had set up a private mail-order house.

In January 1975, Lloyd made a slip. A thirteen-page defense of Marlborough's position was photocopied on the gallery's letterhead and sent out to important clients, to some artists still with the gallery, and to lawyers for other estates under contract to Marlborough. Titled "Unpublished Aspects of the Rothko Lawsuit," it was unsigned but presumably had been prepared (as Ross later charged) by Lloyd's lawyers and polished by Fred Rosen's writing staff. The unsigned white paper, carefully worded and couched in simplistic legalisms, cited "Anglo-Saxon law" to show that the Rothko executors and Frank Lloyd were above reproach and that the deals had been valid arms-length transactions in line with Rothko's 1969 contract. The document was replete with such statements as "Evidence at the trial appeared to establish without doubt that the contracts were fair" and "Regarding the allegation that sales made by Marlborough to European collectors and dealers were not legitimate or real sales, the petitioners offered no factual evidence to this effect. This claim was based merely on innuendo." The paper was purely self-serving, of course, but it was only circulated privately, and there was no pretense that it was anything but Marlborough's version of the facts.

Astonishingly, when the January 20, 1975, issue of *Art International* appeared, there was the Marlborough white paper, word for word, in print. Now, however, "Unpublished Aspects of the Rothko Lawsuit"

had an author, the mysterious "Augusta Dike." A footnote from the magazine's editor, James Fitzsimmons, explained:

> After many garbled and incomplete press accounts based for the most part on sheer hearsay, we think our readers will welcome an objective and comprehensive presentation of the facts, set down by a venerable authority.

Xeroxes of the article were eagerly distributed by Bernard Reis and Karelsen to friends and acquaintances.

As to the identity of the "venerable" Augusta Dike, there was no Dike at the Rothko trial—unless she came dressed in Fred Rosen's clothing.

It should not have been surprising that the article appeared in *Art International*. In August, Lloyd, as his own expert witness on his own expertise, had asserted that "*Art International* is the leading international art publication in the world." Referring to the October 20, 1970, issue, with a Rothko ad on the back cover and two mighty articles on Rothko inside, he had said, "Only through our contributions was it possible to write this article." After a motion from petitioning lawyers had been made to strike his answer from the record, the judge ruled, "No, he is an expert on how you can write articles about Rothko and he said that without his cooperation these articles could not have been written."

"Would never have existed," said Lloyd, interrupting.

"I think he's an expert on that problem of how to write articles on Rothko, yes," concluded Midonick.

What else had Rosen done to earn his reported $60,000? Actually, his job of enhancing Lloyd's image during and after the trial had not been easy. He had scoured the city for free-lance writers, editors, and critics to represent the account, but even for substantial fees during a time of unemployment, Rosen had difficulties finding and keeping good people. Lloyd's was an unpopular cause, and Rosen's methods and personality made life difficult for his employees. When articles about the trial were written for *Time* and *Esquire*, Rosen attempted to know and influence the contents. Fortunately, Rosen's pressures backfired. The editors of both magazines disliked high-handed interference. But at the *New York Times* Rosen had excellent relationships with Abe Rosenthal and Arthur Gelb, then the news-

paper's managing editor and metropolitan editor respectively. The Gelbs and the Rosenthals often visited Rosen and his wife, Jane, a former *Times* editorial writer, at the Rosen home in Westport, Connecticut.

The *Times* had covered the trial through "phase one," the complicated and repetitive issue of self-dealing. But in May, when the first Marlborough witness, Donald McKinney, took the stand and Midonick opened up inquiry into fraud as well, the *Times* ceased coverage. *Times* reporter Edith Evans Asbury filed stories for three consecutive days, but each day they were killed by the editors. As it was explained to her there was not enough space, because of the state political campaigns. Just as the Rothko trial was livening up, it suddenly was not interesting enough to warrant space. On the fourth day of McKinney's testimony, Edith Asbury was assigned to another story, and the *Times* was unrepresented. But after *New York* magazine printed an item linking Rosen's representation of Marlborough to cessation of coverage by the *Times*, Edith Asbury was reassigned to the trial.

Later, Rosen suffered another setback when his new account executive, Mimi Kazan, quit in disgust after six weeks. Rosen's strategies, she revealed, were not entirely aboveboard. He instructed her on how to divert the press from the facts emerging in the trial. He told her ugly, elaborate tales about Harrow's expert witness and appraiser Ben Heller. Shocked, she asked if these things were really true. Rosen replied with an order: "You document it." At another point he told her, "The question is, if Asbury is taken off the story, who do *we* want on it." Rosen also employed former *Times* writer Howard Katzander as part of his P.R. interference. Katzander would arrive at the trial just before lunch-breaks. As the owner of an art auction newsletter, *International Art Market*, it seemed logical that he might be there. But Katzander's mission also was to distract reporters—especially Edith Asbury. He repeatedly invited her to lunch, but she, by chance, was busy. When she discovered later that he had been on Rosen's payroll, she was greatly relieved that she had not been available. Katzander's view of the trial, as expressed to reporters, was that it was "boring" and a waste of time and money, and that Frank Lloyd was no worse than other art dealers.

Late in the trial, lawyer Richenthal had attempted to read a quotation from Howard Katzander into the record, but, pressed by the other lawyers to place the publication in evidence, Richenthal

then had refused. In the case of the *Times,* Rosen's attempted interference seemed to have backfired again, but it was impossible to tell whether he succeeded elsewhere.

In March 1975, the Francis Bacon exhibit opened at the Metropolitan Museum. On hand for the long-planned event was the English artist himself, with Frank and Susan Lloyd sharing his limelight. The critics noted Bacon's supreme importance, attested to by the fact that his large canvases now sold for $200,000. What they did not note was that the exhibit was another example of Lloyd using a museum's prestige to peddle his high-priced and unique wares. Only three of the Bacons seemed to be owned by authentic collectors. The attributions on paintings were "private collection, Zürich," Milan, or London; one blandly read "Marlborough collection"; some were said to be owned by the artist. The vast and chillingly beautiful exhibit— demonstrating Bacon's mastery, as well as his terrifying vision of mankind—was said in the catalogue and museum press release to have been made possible by the Treadwell Corporation. A telephone call to the corporation's offices elicited the information that the actual sponsor of the exhibit was the engineering company's president, Robert Spitzer. Former Marlborough employees describe Spitzer as "an intimate friend of Frank Lloyd" dating back to the friendship of their families in prewar Vienna. The yachts of Spitzer and Lloyd were often seen anchored next to each other at Paradise Island. Lloyd had asserted that, "I made possible museum exhibits by giving money— often sizable—and personnel." Small wonder that at the gala opening Lloyd's expert-witness dealer Spencer Samuels turned to Lloyd with eyebrows arched and—as he tells it—whispered, "Your gallery has never looked better."

But the magnificently mounted show was Lloyd's final grandstand play, or at least the last over which he would preside in person in the United States. Whether from caution or fear of further investigations, or for another reason, he is not known to have set foot again in America.

By 1975, since the inception of the lawsuit four years earlier, Marlborough had suffered some reversals. With the departure of Motherwell and Guston, the Kline and Smith estates, and Michael Steiner and other younger artists, the stable was fairly depleted. Only one important artist had signed. Master of wit and invention, Red Grooms had been delivered to Lloyd by dealer John Myers when his gallery

folded. Reportedly, Myers retained a share in Marlborough's profits on Grooms.

Just how many big collectors closed their Marlborough accounts is not known. Those who know about such things in the art world say that Marlborough often offered collectors as well as artists kickbacks deposited in numbered Swiss bank accounts. If so, these arrangements might have made severing one's ties with Marlborough—to say nothing of testifying about relations with the gallery—quite difficult.

All spring, rumors flew throughout the art world that Lloyd was selling or removing his art assets and that Marlborough was leaving town. Other dealers and auction house personnel said that not only was Lloyd moving out of New York because of the Rothko case, but would close down the London gallery as well.

In response to a query about the rumors of Marlborough's departure, Lloyd's lawyer, David Peck, denied them with qualifying generalizations. "I am not in touch with my principals," he said, "but if other dealers are spreading the story, you can be sure it is not true." Ensconced in the Bahamas, Lloyd told Grace Glueck of the *Times* the same thing on the telephone. "Wishful thinking on the part of my competitors" was his nimble reply. "Tell them I'm not considering it." He claimed that "a very powerful clique" in the art world had a vendetta against him. Naming as "the art mafia" critic "Clem Greenberg and [dealers] Larry Rubin and Ben Heller," he theorized: "The only thing that blocks them from complete control of the art world is Marlborough. We are the biggest handicap to that clique." He then said that he had little interest in the Rothko case, had tried to settle the suit, and adopted an optimistic approach to Midonick's decision, predicting that he would win, "and the art mafia will have gained nothing."

But in late June, after Lloyd had made these denials, a doctor and his family who lived near the Marlborough Studio on Sixty-ninth Street noticed some unusual nightly occurrences taking place on the street. For several consecutive nights these neighbors watched spellbound as a ghostly band of young men hoisted giant canvases out of the studio and into a "strange-looking" anonymous caravan. When news of the undertaking reached Edward Ross, he demanded to know what was going on. Harrow wrote a letter to the judge apprising him of rumors that Marlborough was taking the 658 unsold Rothkos out of the studio. David Peck of Sullivan and Cromwell explained that

this was a cost-cutting move by Lloyd, who had rented a new, larger warehouse in Queens where the paintings would be safely stored with the rest of Marlborough's art until the judgment. "Marlborough," he wrote, "had decided to expand and consolidate its warehouse and facilities. . . ." Ross had little choice but to take Peck at his word. What actually was taking place was a warehouse version of the paper shell game at which Lloyd already had proven his mastery. As Rothkos were moved from the studio and into the new warehouse, the Marlborough floor at the commercial warehouse was emptied of Marlborough stock, as was another, private warehouse Marlborough rented in Queens. As he relocated the Rothkos, he was simultaneously sweeping clean his other valuables outside U.S. borders. He probably would have explained it as he explained other transactions at the trial; this also was "nobody's business except mine."

The petitioners' last reply briefs were submitted in June. The judge now faced a 3,000-page typescript. The peregrinations of 140 different paintings sold had to be untangled, the value of each pondered, and their whereabouts after the temporary injunction determined. After every page had been received in court, Midonick agreed to a reporter's request that legal briefs be opened to public scrutiny. It was one way, perhaps, of sharing the burden of having to read through much of the nonsense, but Midonick looked drawn and haggard as he faced the dismal prospect.

The Appellate Division denied the foundation's appeal of Judge di Falco's decision on the forty-four paintings left Mell as "all the contents" of the brownstone. But the paintings were held in storage until the taxes were settled. Then Stanley Geller, still the lawyer for Mell's executor, Herbert Ferber, presented Kate with a bill for a whopping $150,000 for his services in the "contents" case. Later, all the other lawyers on this secondary case brought by the executors— Dickler; Gibbs of Breed Abbott; surprisingly, too, the lawyers for the executors and the foundation, Richenthal and Greenspoon; and finally Levine's law firm—would apply to the Surrogate for their fees to be paid out of the Mark Rothko estate. It is not unusual for lawyers suing over the construction of a will to demand a big fee for the action that they initiate even when they lose. But in addition to the fees in the construction case, millions of additional dollars in lawyers' fees would almost certainly be charged against the estate in the central case. It was an added irony, considering Rothko's antipathy for

lawyers, that some of these fees might possibly be paid in kind—in art rather than dollars. Perhaps many of his paintings ultimately would adorn New York law offices and not the museums for which they were intended.

By 1975 Kate Rothko was low on cash. "My bank accounts [established by her father in December 1969] have almost evaporated," she related, "and there's nothing left." About $1,000 had been spent on her wedding, but the rest had gone toward legal costs. She had had to post a bond of $50,000 for the suit and to pay Breed Abbott's out-of-pocket expenses. Her debts in deferred legal fees were already into seven figures, and still rising. All that, with the costs of the 20,000 pages of trial and pretrial transcripts at a dollar a page, amounted to what she had in the bank.

While the lawyers were worrying over the decision and their fees, Kate and Ilya Prizel were living quietly in Baltimore where they had moved in 1974 during Lloyd's defense proceedings. Both were attending graduate school on student loans. In many ways, Baltimore was ideal for Kate. She had chosen not to go to the Cornell University Medical School in Manhattan, because the day she went for an interview she had run into Becky Reis. Now chance encounters with the Reises, with Stamos, Levine, or anyone in their circles were most unlikely. The bitterness and pain they had caused could not be forgotten, but there were few reminders in Baltimore. "Of course, being only a teenager when my parents died," she said, "I did not know many of their friends really well. But I believed then that my father had some true friends who would not betray him." Kate now was in her second year of medical school at Johns Hopkins University, and her husband, whose interest was prison reform, was attending the School of Social Work at the University of Maryland. Chistopher, now twelve, was at a boarding school nearby and spent weekends with the Prizels. At twenty-five, Kate was a perceptive, unaffectedly polite, capable young woman. She valued her privacy and worried about how the publicity over the lawsuit might affect Christopher. Not unaffected by the sudden traumas of his childhood, he had grown into a gentle and cautious twelve-year-old with his father's physique and (like Kate) his mother's facial characteristics. The details of the lawsuit had been kept from him while he was living with his aunt and uncle in Columbus, but now, since it had become a topic among his schoolmates, Kate and Ilya explained it as best they could. Christopher was

able to grasp the essentials. In 1975, he announced the composition of his first opera, "The Mal Practice."

What was hard to accept was that even the brownstone paintings, which were the ones the Rothko children loved and knew best, remained tied up in tax litigation. Though the foundation had lost its appeal, the Museum of Modern Art was suing for two of them, and many of the rest would probably disappear in taxes and bills. MOMA was claiming *Slow Swirl by the Edge of the Sea*, the only painting Christopher really remembered as part of his childhood. Had the museum not sued, Kate Rothko said, she would have felt obliged to honor her parents' wishes and donate the two paintings; but after the suit, she did not feel friendly toward the museum. Later, negotiations would mollify her, especially William Rubin's suggestion that Christopher might have *Slow Swirl* when it was not on exhibit. But the Rothko children would not possess any of their father's paintings until more than seven years after his death.

The judge's procrastination gave Kate pause. "Of course from time to time, even Kate has had her doubts about the wisdom of pursuing the case," said her husband, "but she never wavers for very long." Part of the secret of her strength lay in the fact that money did not matter to her. "What has upset me most," she said, "is that because of the case, the only thing considered is the monetary value of my father's work rather than the artistic value. Maybe certain people felt that way all along, but that was not apparent to me because that wasn't my father's way of looking at things."

If Kate won, the victory probably would be only a moral one, her friends predicted pessimistically. The case had dragged on too long. Was there any proof the paintings were in the warehouse? And, if they were, in what condition? Besides, as these same people pointed out, to use Gustave Harrow's analogy, Lloyd had "skimmed the cream" from the top of the estate: many of the finest paintings had been sold or had disappeared into the Marlborough maze.

As months passed and still the judge had come to no conclusions, the petitioners' hopes for a favorable decision waned. Overseas, rumor circulated as fact: Lloyd and the executors had won. One of these stories emanated from Bernard Reis himself, who apparently had told Mary Lasker and other friends that the judge had exonerated him.

Meanwhile, the Mark Rothko Foundation continued to dole out grants to a few artists, poets, writers, composers, photographers and

musicians. Clinton Wilder was still its president, Stamos its secretary, and Bernard Reis remained treasurer. Thomas Hess had replaced Levine as vice-president. Hess, Stanley Kunitz, and Morton Feldman lent their prestige to the cause and never seriously questioned the merits of the foundation's position in the lawsuit. Some of the issues had been explained to them by lawyer Greenspoon. When Kunitz was asked by a reporter why he had not attended the trial to see what was really happening and hear what Greenspoon was saying, he said, "Oh, I couldn't—it would offend Bernard." Reis maintained his posture as a noble soul intent on helping gifted individuals less fortunate than himself.

In the four years since its rechartering after Rothko's death, the foundation had given out some $245,000 in ninety-nine grants. Most gifts were around $2,000, but they ranged from $800 to $5,000, and many of the recipients were relatively unknown. A few, however, were famous. Writers included James T. Farrell, Nelson Algren, Tillie Olsen, Laura Jackson, and Susan Sontag. Poets included Allen Tate and Jean Garrigue. Two photographers were helped out, the late Walker Evans and W. Eugene Smith, and musician Stephan Volpe. Rothko would have approved of several of the grants given artists— particularly those to George Constant, Maurice Sievan, Aristodimos Kaldis, Joseph Solman, Gwen Davies, and Loren McIvor. Others, neither elderly nor needy nor particularly "serious," no doubt would have caused him great indignation.

What would have most angered him, however, was the enormous sum his foundation had spent in legal and court fees in the suits against his children. Greenspoon's bills for $90,000 had been paid and another $50,000 was outstanding. In addition, approximately $30,000 had been spent on court costs, including printing and numerous appeals from the Surrogate's decisions. And Greenspoon's brief continued to support the executors and the contracts with Marlborough, despite the fact that the foundation had lost vast sums of money in sales on which Lloyd had made millions of dollars. The foundation's only concession was that Marlborough's accounting for some of the consigned sales was "spotty"; but surely after the lawsuit Lloyd could be required to pay up on wrong accountings. Greenspoon put the blame on the petitioners' "wild claims of value" for the paintings that had been sold. Because of this: "The IRS stands like the Sword of Damocles over the hapless body of the Estate . . . ready to gobble up

all funds that might become available through the sales of paintings." Yet the foundation paid no taxes.

Reis continued to sit on the dais at the annual awards-giving luncheons of the Albert and Mary Lasker Foundation. He and Becky Reis made the usual round of chic art world openings and loaned works of art—including several Rothkos—to museum exhibitions.

Stamos had sold his country house on the north fork of Long Island near the cemetery where Rothko was buried. He continued to speak of moving to a house he owned in Greece, but remained in New York, living in his house in the West Eighties, painting and teaching at the Art Students League. When his contract with Marlborough expired, he sold paintings through Spencer Samuels and later signed with a small Soho gallery.

Nothing was heard from Morton Levine, who continued to teach the anthropology of the Basques at Fordham. His lawyers, Paul Weiss Rifkind Wharton and Garrison, reportedly had taken his case on a contingency basis, and their fees depended on his exoneration for having cooperated; now, after three years, the amount was not insubstantial. One day during that fall of 1975, a friend of Kate Rothko's ran into Levine in a restaurant. He did not look well. He mumbled something self-pitying about Kate Rothko ruining his life.

In the fall, Harrow moved to reopen the case. The judge flinched when the eager attorney arrived with an armload of "newly discovered evidence." Harrow had received official copies from the French government of the correspondence with Marlborough about the Paris exhibit. It turned out there had been no enormous mistake made by museum officials; they had followed Marlborough's instructions to the letter. What had taken Harrow so much time was dealing long-distance with the French government's legal bureaucracy; all the documents had to be translated, certified, witnessed, and embossed with the official seal of state. Marlborough responded by submitting new documents to show that the museum's files were not complete. The argument was not convincing; but Judge Midonick refused to consider Harrow's motion. The case was cumbersome enough.

Meanwhile, the Rothko affair was being studied with quiet deliberation in another quarter. Witnesses were being examined by the New York district attorney's office to determine whether criminal laws had been violated and, if so, whether this could be proved to the

extent that a grand jury would bring indictments. Were there specific cases in which perjury could be proved, or had the phrases "to the best of my recollection" and "I cannot recollect" successfully served to frustrate prosecution? Was a conspiracy provable? What about forgery?

New York's district attorney, Robert Morgenthau, had made his name fighting white collar crime during his years as U.S. attorney. On occasion, he had even been able to penetrate the secrecy of Swiss banks. But as district attorney, his powers abroad were more limited. And in Switzerland and Liechtenstein, where tax evasion is not criminal (in fact it is a basic source of income for both countries), it seemed as though some very important people were protecting Frank Lloyd. Heretofore, the white-collar crimes had involved brokers, bankers, businessmen, lawyers, and accountants. Could Morgenthau extend his reach into the far-flung and unregulated world of art dealings? In particular, could he pin down an apparition, a Panama hat shading an impudent grin, lounging on a Bahamian yacht or a Riviera beach— or jetting, in banker's gray, to and from London, Zürich, Tokyo, Rome, and Vaduz—and always skipping New York?

# 21 The Decision

(DECEMBER 18, 1975)

> Where unique works of art are wrongfully sold, there is
> no market where they can be recovered.
>
> Surrogate Millard Lesser Midonick
> "Matter of Rothko"

At 10 A.M., December 18, 1975, Judge Midonick handed down
the eighty-seven page decision that electrified the international art
world. Kate Rothko had won. Judge Midonick decided to remove the
three executors and cancel the contracts with Marlborough. He
ordered the return of the 658 unsold estate paintings and assessed the
defendants jointly and severally a total of $9,252,000 in damages and
fines. Included in this figure was a $3,300,000 fine against Lloyd and
Marlborough for violating the court's restraining order by shipping
fifty-seven paintings out of the country after June 26, 1972. This
penalty was later increased to $3,800,000 after a recount showed that
five more paintings—making sixty-two in all—had been shipped in
violation of the temporary injunction. And after deducting the pay-
ments that Marlborough had already made to Rothko's estate since

271

May 1970 from the $9,252,000, the final award to the estate was reduced to $7,339,000. Of this amount, Levine's liability was $6,200,000, although some or all of that amount could be paid by the other defendants. For example, if Marlborough chose to pay the entire $7,300,000 amount, none of the others would have to pay anything. But it was up to the defendants to work out the liabilities among themselves.

If Marlborough returned the paintings Lloyd had claimed were sold, and if the estate chose to accept them rather than money, the damages would be decreased, to $90,000 for each oil on canvas and $28,000 for each painting on paper returned. The judge suggested this alternative means of payment not only out of "a sense of equity" but as "an attempt to resolve the conflicting views of both parties as to the present marketability of the paintings." Since Marlborough contended that the art market had become depressed, perhaps they might recover the paintings at lower prices. "On the other hand, if the values of Rothko paintings have increased, as contended by the petitioners, they should be pleased to receive the paintings in lieu of cash." Midonick's valuations were based on his determination of the average value of the paintings at the time of the trial. He attributed part of the increase in value since 1970 to Marlborough's merchandising. Heller's 1974 estimates he found "too optimistic" and Midonick based his valuations largely on those of Peter Selz. Since these valuations were supposedly based on May 1970 prices, Midonick raised them to 1974 levels.

To the uninitiated, the penalties sounded startlingly high, but were actually modest. No one expected Lloyd to return individual canvases for $90,000 when most of the fine oils he had sold in bulk were worth upward of $150,000 in 1975. A dealer pictured Lloyd as "laughing up his sleeve at such an option." That year, the Carnegie Institute had paid $155,000 for the large 1955 estate painting Marlborough A.G. had exchanged with collector Harry Anderson. The Des Moines Art Center also bought a medium-sized Rothko for $150,000 from a private collector who in 1972 had paid Sidney Janis $50,000 for the work. These works were comparable in size and quality to those the judge had valued at $90,000.

The decision was sweeping in regard to the executors' breach of trust and duty. Midonick did not address himself to the charge of

conspiracy and fraud in Marlborough's subsequent sales, though laced through the legal prose were phrases indicating that he believed both charges were not unfounded.

On the fiduciary duty of an executor under law, Midonick was stern:

> He cannot serve two masters, and if he has a conflict between his duty to his estate and his duty to his corporation, he must resign or seek the direction of the court in advance. The use of his fiduciary position to gain a benefit for a third person also constitutes an act of disloyalty.

Midonick found "beyond doubt" that Reis had a "serious conflict of interest" and "divided loyalty."

> Reis was squarely faced on and after the death of Mark Rothko on February 25, 1970, with his dual status. . . . Nevertheless, Reis qualified as an executor and has continued to serve in that capacity. At no time has he resigned as director or secretary or treasurer of MNY [Marlborough New York], nor has he declined his salary as an officer of MNY. . . . He contends that as a person of substantial independent wealth and income his status as a director and officer to MNY was of little significance. Such protestation is not persuasive in view of the prestige of MNY and its directorships and officerships and in view of Reis' tenacious continuation in this position at all times after the testator's death and currently. Despite Reis' contention that the MNY association was inconsequential to him, the dual status he has clung to imposed upon him an extraordinary head-on conflict. His primary duty as an estate fiduciary was to obtain terms the most advantageous for the estate in its dealings and negotiations with MNY and its affiliate Marlborough A.G. . . . His conflicting duty as a director of MNY was to bargain precisely in opposition. . . .

The judge quoted Reis's memorandum to Stamos and Levine as proof that the accountant knew he had a conflict of interest. He found the Karelsen firm's legal advice clearly incorrect and lawyer Ernest Bial's testimony incredible. However, he held that the executors were not exonerated by this.

Trial counsel for Reis [Richenthal] urges that personal "aggrandizement" is prerequisite to a finding of a breach of duty of loyalty. But Reis' aggrandizement or self-interest, weighty enough to cause him in these transactions to favor the corporation of which he was a director, was palpable enough. . . . The stakes were obviously millions of dollars of potential profits for the respondents Marlboroughs. What part of these profits would flow to the estate was a matter of crucial interest both to Reis as a fiduciary estate executor and to Reis as a director and therefore fiduciary to the conflicting Lloyd interests. If Reis were to exercise an interfering, restraining, enhancing or opposing influence on the part of the estate, contrary to Lloyd's wishes, Reis' future with MNY, Lloyd's company, was hostage. . . . This court finds that the prestige and status of Reis as a director, secretary and treasurer of MNY, apart from his salary as secretary-treasurer provided by Lloyd's MNY, and his fringe benefits and perquisites, were quite important to Reis' life style. The court infers and finds that Reis was concerned and insistent on the continuation of this prestigious status. He was known and wanted to be known as a collector of valuable masterworks of many artists. He continued to sell some of his and his family's private collection for substantial sums through MNY before, during, and after the critical periods of these estate negotiations. Reis' and his immediate family's share of such sales by Marlborough as part of their private collections for about eight years before through two years after the May 21, 1970 estate contracts here complained of, aggregated for Reis and his family almost $1,000,000. . . .

In sum, the substantial private wealth of Reis, his retirement from his accounting partnership, and his advanced age, all point to his shift of primary motivation of financial aggrandizement in favor of his aggrandizement of status as well as his financial aggrandizement through sales of his own and his family's art collections through his association with the cultural business of the Marlborough interests. Had he served the single interests of his fiduciary duty to the Rothko estate, he would have increased his commissions as an executor by enhancing the value of the estate (whether by sales or distributions in kind), but he would have risked the loss of his status with the Marlborough interests as well as their world-wide galleries and expertise in liquidating for his enormous financial stake in his own and his family's ex-

tensive private art collection. His conduct does not amount to self-dealing in the sense of buying or selling assets directly to or from the estate for his own personal account, but the court deems this breach of loyalty, where a fiduciary benefits himself indirectly at the expense of the estate, to be the equivalent of self-dealing.

As for Stamos, whom he described as a "not too successful artist," Midonick found that while he was "clearly" improvident and "grossly" negligent, his disloyalty and conflict of interest were "not as certain." The Stamos contracts were "more advantageous" than the Rothko consignment contract in three ways: first, the initial commission at forty percent versus fifty percent for Rothko; second, the duration of four years versus twelve for the estate; and third, Stamos could fix minimum sales prices, while the estate contract required only that sales be made at "the best prices obtainable but not less than the appraised value of the estate"—besides, he could borrow against "potential sales which proved to exceed substantially the eventual sales of his work."

The judge believed Levine's testimony about the April 1970 meeting at the Reis town house, during which the anthropologist had confronted his co-executors and what the judge called "angry exchanges" had ensued. Because the description was an admission on Levine's part of his foreknowledge of the other executors' conflicts and therefore damaging to Levine, it was credible to the court.

And after Stamos signed with Marlborough, he was "certainly in conflict with the interests of the estate, especially leading to lax estate contract enforcement efforts by Stamos." He had a personal interest "in the enhancement of his artistic career," and it served his interest "financially, to curry favor with Marlborough."

Although Stamos's self-serving was not "as clearly proved as that of Reis," Midonick believed there was a "self-serving breach of loyalty" on his part. Besides that, Stamos acted "improvidently and negligently in view of his own knowledge of Reis' self-serving and the entire course of events."

Levine, found not guilty of self-serving disloyalty, got off more lightly than the others, but not much. Aware of the others' self-interests, "he followed their leadership." He did not investigate such essential facts as prior sales of Rothkos, expert art merchandising opinion, and dis-

interested appraisals. He believed that the 100 paintings were worth $3 million in cash and that the Saidenberg appraisal was absurd, yet he docilely loaned his approval to a deal of which he was distrustful. "Surely Lloyd's expertise was not to be relied upon as disinterested advice. . . . [Levine] also joined with his co-executors in opposing the elections of the children, although it was not the duty of a fiduciary to take a partisan attitude as between the children and the charitable foundation. It was not until later in the litigation that he altered his position in an attempt to shed himself of personal liability." He "failed to exercise ordinary prudence. . . . In short, his performance as an executor has demonstrated his inability to continue in that position."

But the judge left the way open for Levine to appeal personal liability by stating that while he had to oust Levine, he would prefer not to fine him at all, "because of his candor during the trial by giving evidence of the internal deliberations of the executors," his "verbal protests," and the "absence of bad faith motives" on his part.

None of the three "acted innocently and without knowledge of entanglements" during the negotiations and by their failure to enforce the consignment contract. Midonick cited the travels of the thirteen paintings as a clear example of what he meant by the executors' laxity about consigned sales.

It is disheartening . . . to find Reis, whose duties for MNY were largely focused on accounting, not actually helping to make or insisting on semi-annual accountings to the estate as the consignment contract required. No proceeding by Reis or the other executors was commenced against Marlborough for breach of contract or for breach of any other duty. Only after the commencement of this proceeding did Marlborough New York pay over $73,000 to the estate which it had overcharged by giving a dealer's discount to its affiliate Marlborough A.G. and taking a consignment commission as well. Only after the commencement of this proceeding, one year and a half after the making of the contracts, did the trial counsel for Reis and Stamos, both still allied with Marlborough interests, threaten, when the facts disclosed in this proceeding became too plain to avoid acknowledging, to sue Marlborough at long last, in behalf of the estate at the conclusion of this proceeding.

Further proof of Reis's bad faith and self-interest was his initialing of a later change in the consignment contract—without informing Stamos, Levine, or Reis's attorneys—that enabled Marlborough to sell more paintings. Moreover, Reis was disloyal in his selection of Saidenberg as the appraiser. The judge noted that the appraisal was typed on Reis's typewriter, that either Reis, Saidenberg, or both had disloyally given Lloyd a copy of the appraisal before the negotiations began, and that Reis failed to tell the others that Saidenberg also had a conflict of interest "after years of joint dealing with Marlborough."

The decision then listed further "suspicious circumstances," among them: "The haste in negotiating the agreements during a few days" within three months of Rothko's death, the failure of any of the three men to query independent art merchandising experts as to "whether 100 canvases should have been sold at all, and what better method of merchandising could have been insisted upon, including efforts at initial sales to museums"; the failure to ask Lloyd for Rothko prices "despite the decline in the stock market which Lloyd used as his repeated argument during negotiations"; "the failure to demand not only the strong prices Rothko's work was fetching" but also the card-index prices of unsold Rothkos to which "all Lloyd's salesmen had to adhere and to which Reis had access"; and, finally, their failure "to test the market themselves as an alternative to losing control of the estate paintings forthwith by compelling Marlborough to sell four paintings at retail for at least one year (90% for the estate)" under the "put" in the 1969 contract, which both Karelsen and Lloyd and his lawyers had insisted was binding and prevented competition.

> All these circumstances reinforce the curious atmosphere involving absence of hard bargaining, arms-length negotiations, deliberate consideration, and the presence of improvidence and waste verging upon gross negligence on the part of all the executors. . . .

As for terms of the contracts, he wrote,

> serious deficiences in the benefits to the estate establish a half-concealed bias on the part of Reis and Stamos to favor Lloyd's Marlborough interests over that of the estate.

It had been proved, the judge noted, that the paintings among the 100 canvases were resold by Marlborough at "6 to 10 times" the $12,000 discounted average Lloyd paid for them. And Marlborough's average sale of $80,000 in 1970 was but the "beginning" of the escalation in value to Marlborough's benefit. The estate price accordingly was "unconscionably low" and the payout term "unreasonably long." The terms of the consignment contract were not only unfair to the estate, Midonick noted, and to an artist of Rothko's preeminent marketability ("second to no artist represented by Marlborough with the possible exception of Jackson Pollock"), they also lacked provisions to protect the estate and gave Marlborough a chance to defraud it. The judge hinted strongly at foul play, mentioning Marlborough's "opportunity to sell at prices fixed only by itself with consequent danger of collusion, misrepresentation, favoritism, secrecy and outright fraud—all difficult and some impossible to detect."

The judge estimated a commission ranging from twenty percent to one-third would have been fair to the estate of an artist of Rothko's stature and five or six years a reasonable length of time for such a contract.

Midonick described Marlborough's set-up:

> The Marlborough organization is a maze of 21 legal entities. Except for nonmajority participations in three galleries, the ultimate interests in the organization, as well as the three mentioned galleries which are not the respondents here, rest in a foreign *inter vivos* trust and a "stiftung [Swiss trust]." The beneficiaries of these holdings are respondent Frank Lloyd (Francis K. Lloyd) and members of his family alone. At the time of the negotiations with the estate, Frank Lloyd was the life beneficiary of these trusts with rights to revise their beneficial terms. The "stiftung" held all stock in 16 Marlborough companies including the respondents Marlborough Galleries, Inc. (MNY) and Marlborough A.G. (MAG). Lloyd authoritatively asserted at the trial that he alone dominated and controlled all Marlborough operations. All consequential decisions were made by Lloyd and all employees acted pursuant to his instructions. The finances of the various Lloyd-controlled companies were intermingled and paintings were invoiced to and from those companies as convenience served.

The conclusion must be that Lloyd is Marlborough. No distinction can be drawn for purposes of liability between the respondent MNY and respondent MAG since, for such purpose, any gossamer corporate veil can be pierced.

In the numerous invoices adding up to the same figures in quadrangular deals among Marlborough Rome, Marlborough New York, and two Liechtenstein corporations, Midonick found particularly conclusive evidence of Lloyd's internal manipulations. As the judge put it, "this disregard of corporate entities and the interrelation of financial transactions is particularly apparent in the sale of 22 consigned paintings, purportedly to Allgemeine Europaische Kunstanstalt (AEK) on June 28, 1971." (This sale was in addition to the original sale of thirteen paintings to Bernini and AEK.) But that is as far as he went down those labyrinthine paths.

He also refused to venture far into the area of the charges of Marlborough's fraudulent resales.

Major portions of the petitioners' unnecessarily voluminous briefs . . . are devoted to charges that many sales invoiced by Marlborough were fictitious transactions with two objectives, namely, (1) to avoid the injunction, and, (2) to place paintings in the names of purported buyers who were friendly to Marlborough and would make such paintings available to Marlborough for covert resale at higher prices or for some indirect benefit, during or after this litigation. These transactions are described by the petitioners as "parking" or "squirreling" of the paintings in bad faith.

Hundreds of documents have been received in evidence either to substantiate these charges or to refute them. The petitioners' accusations impute a conspiracy involving purchasers, shippers, warehousemen, and insurers even to the extent of characterizing this far-reaching plot as another Watergate. The allegations include the concealment of documents and perjury at the trial. These sweeping accusations have not been ruled upon because they are unnecessary to this decision.

Despite his ostensible failure to rule on the merits of the proof of these alleged frauds, Midonick did find Lloyd's excuses incredible:

Lloyd testified that sales were induced by a need to provide money for the defense of this litigation. However, it is devastatingly plain. . . . In selling estate Rothkos in bulk at distress prices, while carefully marketing pre-estate Rothkos, Lloyd has undermined his credibility as to . . . the reason for distress bulk sales at improvident prices. The court is constrained to find that the respondent-galleries, at the direction of Lloyd, wilfully disposed of estate paintings in bulk resulting in falsely low prices at the time of such sales.

The judge rejected as untimely Harrow's late documentary proof about the Paris Museum because it constituted "immaterial evidence in view of the disposition of this issue favorable to the petitioners on other grounds." Because he decided in favor of the petitioners he reasoned, he did not have to go into more deliberations.

Nevertheless, the Surrogate came down on Lloyd himself for violating the injunction:

The court finds that Lloyd had actual knowledge of the issuance of the temporary restraining order as of the date of its issuance and that in any event such knowledge is imputed to him by virtue of his acknowledgement that he controls the entire Marlborough complex. The court further finds that Lloyd acted in collusion and in combination with the restrained Marlborough parties in bringing about the sales and dispositions of many paintings in violation of the orders of this court.

Had Harrow not moved to hold Lloyd personally in contempt for violating the injunction, no doubt, with the help of his lawyers, Lloyd would have wriggled through that hole in the net of evidence.

The judge's reasoning concerning damages was lengthy and heavily documented, but confusing and almost impossible to follow. Having credited Lloyd's outstanding merchandising ability for part of the rise in Rothko prices, the judge noted that "where unique works of art are wrongfully sold, there is no market where they can be recovered." Because of their disloyal and self-interested acts, Reis and Stamos, with Marlborough, were declared "liable for the present [1974 trial] value of paintings" sold at Midonick's $90,000–$28,000 formula (plus interest). Levine, with a more limited guilt of negligence, was made liable for the actual value (plus interest) of the paintings on the dates

Marlborough sold them. But the judge found that the resale prices of paintings Marlborough had claimed to have already sold in bulk (and later admitted to having repurchased or exchanged and resold) were "significant indicators of the true value of such paintings." Of the paintings sold in bulk, the judge said the prices were "falsely low." How the defendants would apportion the $7,300,000 was left to them. The petitioners would have to collect from whomever they could— except that Lloyd personally owed the contempt fine of $3,875,000 included in the total. It was a complicated formula Midonick had used in assessment, and $6,200,000 seemed an unduly high liability for Levine, who, after all, had not gained much more than bad dreams and ignominy from the entire scheme.

Rothko's stature as an artist passed all the examinations of the court with highest marks. Four pages of the decision were devoted to the experts' testimony. Clearly Midonick was most impressed by Meyer Schapiro's evaluation of Rothko's continued preeminence. He noted that even Marlborough's witness Peter Selz had thirteen years earlier compared Rothko to Michelangelo and likened his paintings to "annunciations." Quoting Glimcher, Beyeler, and Heller, he said: "All of the experts who appeared at the trial were in agreement that Rothko was a great master."

The collective judgment as to his stature had been borne out by the genuine prices Rothko commanded before the lawsuit as well as the genuine sales put into evidence during the trial proceedings.

> While the criterion of taste which thus exacts Rothko as an artist may not be universally accepted, the respondent parties here have not substantially shaken this extraordinary praise, and the enormous prices fetched for individual sales, through to October 1974 [the $142,000 Elkon-Mazer Rothko] when the art market was said to be soft and spotty, corroborate commercially what was proved aesthetically.

The executors were denied fees and could not charge their legal costs against the estate. The judge reserved decision on whether the children's legal fees might be paid by Reis and Stamos or from estate funds.

Disinterested lawyers, noting the strange methodology and the unusual organization of the opinion, said that Surrogate's Court was not

suitable—either procedurally or through experience—for such an extended and complex trial. But they conceded that the complexities of the "Matter of Rothko" were such that it is difficult to imagine a state court disposing of it without similar problems.

On the day of judgment, Midonick looked relaxed; he had rid his chambers of the poltergeist. At last he could turn his attentions back to the human problems that really interested him. The decision, of course, was hailed by the children's lawyers and the attorney general. No one doubted that the opposition would appeal, but it was a victory against powerful odds.

When Kate Rothko heard the news that afternoon, she told the *Times* (long-distance), "I am relieved and happy." For the moment at least, it seemed a happy ending. What was left of Rothko's legacy would return to the estate.

But in Paradise Island, the Bahamas, the master dealer, gambling on every possible turn of fortune's wheel, had a few more surprises up his sleeve.

# 22 The Toronto Caper

(DECEMBER 19–24, 1975)

"Come, Watson, come! The game is afoot."

Arthur Conan Doyle
"The Adventure of the Abbey Grange"

On the day following the victory, Edward Ross suddenly realized that in his jubilation he had almost overlooked an important precaution. Hastily he drew up an affidavit and a restraining order for the Surrogate's signature stating that none of the defendants could divest themselves of their assets or transfer them out of the country until the judgment was paid or a bond for the $7,300,000 was posted. The restraint was signed, but again Frank Lloyd had anticipated the short arm of New York Surrogate's Court's jurisdiction.

On December 20, the Saturday before Christmas, at 7:30 P.M., the telephone rang in the office of Attorney General Lefkowitz. The call was from criminal lawyer Howard Eisenberg, who said he had important information about the Rothko case. When Gus Harrow called him back, Eisenberg explained that, through a client in Europe, he

283

had been informed that Lloyd was about to remove his assets from Toronto to avoid payment of the Rothko judgment. Furthermore, Eisenberg stated exactly how, where, and when this was scheduled to take place. A Mr. Plutschow was to arrive in Toronto at 5:15 P.M. the next day, Sunday, on Swissair flight 170 from Zürich. He was to arrange immediate shipment of art from Toronto to Zürich. Mention of Plutschow to Harrow was like a red flag to a bull. As the controller of Lloyd's Liechtenstein complex, Franz Plutschow kept track of all Marlborough art and was the author of masses of documents in evidence that Harrow had challenged as fictitious. Harrow asked Eisenberg who his informant was, but Eisenberg cited confidentiality. He did feel, however, that as a member of the bar for twenty years, it was his duty to report the tip.

There was no way to confirm that Plutschow was on the plane until its departure from Zürich, scheduled for Sunday morning New York time. Harrow waited restlessly. Then Swissair called to confirm that Plutschow was indeed on his way to Toronto.

After midnight, Harrow notified Edward Ross, who contacted a Toronto law firm, Weir and Foulds, to represent Kate there, and Harrow and Jim Peterson, Ross's young associate, booked passage on a night flight to Canada. But a new, stronger court order was needed, specifically directed against transfers between all known Marlborough entities and shipping agents, warehouses, truckers, and airlines, particularly those in Canada. After spending the day in their offices preparing new affidavits and the order, Ross, Peterson, and Harrow brought them to Judge Midonick, who was dining with friends on Park Avenue. After the lawyers explained about Eisenberg's tip and their own suspicions and presented him with sworn affidavits, the judge signed the new order. Ross remained in New York to argue the matter in Surrogate's Court.

With the new order and the Midonick decision in a briefcase, Harrow and Peterson left for Toronto at 2 A.M., in the midst of a snowstorm. On their arrival, they were faced with several complex problems: They had no idea where the art was stored, what Plutschow looked like, or where he was staying. During the trial evidence had pointed to a Toronto warehouse, Tippit-Richardson, Ltd., as the place where Marlborough stored artworks. But even if they were lucky enough to find both Plutschow and the warehouse, how could the assets legally be kept in Toronto until Lloyd posted bond against the

judgment in New York? Would Canada honor the Surrogate's restraints? Weir and Foulds had already begun research into these questions. And, although private detectives were on the lookout for Plutschow, his plane had already landed and he had disappeared.

The first thing Harrow and Peterson did on that snowy Monday was to meet the Canadian lawyer and plot a strategy. Lloyd W. Perry, the Official Guardian of the Province of Ontario, an American-born attorney, offered to represent Christopher Rothko. He explained that in Ontario there was a precedent for obtaining a restraint and simultaneously placing the goods in receivership. That afternoon the Toronto barristers, Harrow, and Peterson appeared at the Supreme Court of Ontario before Mr. Justice Weatherston. After they presented the order and affidavits, he issued a temporary restraint and appointed the National Trust Company Ltd., as the receiver of the goods until a hearing could be held in Toronto to determine the merits of the case.

But they still had found no trace of Plutschow or where the art was hidden. One of the detectives, a former Scotland Yard inspector, had cased Tippet-Richardson and called in to say that the art wasn't there. Since Plutschow was scheduled to leave the following day, another detective was posted at the airport. Luckily, no freight planes were scheduled to depart before then. Toronto, however, has several hundred warehouses, in any one of which Marlborough's goods might have been secreted. One of the Canadian lawyers telephoned the Marlborough-Godard Gallery, said that a client was looking for a warehouse for his collection, and asked which Marlborough would recommend. The answer was almost automatic: Deakin Fine Art.

Back in their hotel Monday night, their clothing soggy from snow and slush, the two lawyers were exhausted but exhilarated by the cops-and-robbers investigation and the Ontario court's alert response. They agreed to split up in the morning to cover as many bases as possible. Harrow would go to customs and the airport, and Peterson, with the Canadian lawyers, would serve the order on Marlborough-Godard. A detective was posted at the gallery that night and another was sent out to investigate Deakin's warehouse.

Marlborough-Godard is situated in a four-story town house with garden in the chic, newly redeveloped Yorktown section of Toronto. For the Christmas holidays a Botero exhibit, which had recently traveled from the Marlborough in New York was on display. Early Tuesday morning, a neighbor called to report that a suspicious-looking

man had been lurking or snooping outside the gallery during the night. But since nothing was missing and there were no signs of disturbance, the staff went about its business. So it came as a complete surprise when Peterson and a National Trust representative, armed with the court order, arrived before the gallery opened. Casually Peterson asked: "Oh, by the way, is Mr. Plutschow here?"

"Ah," responded a man rising from a chair in the corner. Of medium height and in his mid-thirties, he had a pale round face, black slicked-back hair and thick black-rimmed spectacles. He was wearing a double-breasted mouse-gray suit. In heavy Germanic accents he introduced himself as Plutschow. Peterson presented both himself and his court order. As it dawned on him just who Peterson was, Plutschow blanched.

Chris Birt, the salesman in charge of the gallery, put in a call to Mira Godard, Lloyd's Canadian partner, in Montreal and passed the phone to Peterson. Mira Godard told Peterson that she did not know what assets Lloyd had in Canada, but that Godard had some art stored at Deakin's warehouse located on the other side of town near the docks of Lake Ontario. She had not known and expressed some surprise that Plutschow was in Toronto. While the lawyers began taking an inventory of the gallery, Plutschow, on another telephone, was talking rapidly in German. After several heated exchanges he approached Peterson, held out the phone, and said, "You talk?" The man on the other end of the telephone identified himself as Fraser Elliott, a Montreal attorney acting for Mira Godard. He said that Plutschow was too upset to understand that the lawyers were not going to incarcerate him—just the art he had been arranging to ship to Zürich on Lloyd's instructions. Peterson mentally noted this unexpected admission (later confirmed by Elliott in a sworn deposition). When Peterson asked Elliott how he knew of the court order, the Godard representative replied that Irving Moskovitz, Lloyd's New York attorney, had telephoned him from Paradise Island. Moskovitz explained to Elliott that he had flown to Nassau right after the decision to "commiserate with" Lloyd. On the phone Moskovitz had asked Elliott if Elliott would "mind" if Marlborough took its consigned art from Marlborough-Godard. Now Elliott asked Peterson to try to calm down Plutschow who clearly thought he was going to jail by assuring him that he was free to catch his plane back to Liechtenstein for Christmas "as long as he took nothing with him." At this, Plutschow stopped

twitching and with great relief departed. Peterson continued to check the stock book and the inventory.

The high point of the saga took place that chilly afternoon at Deakin's warehouse. Peterson, with a posse of officers from National Trust, the court-appointed receiver, rode out in search of the booty. Not knowing what, if anything, they would find, they headed toward the large, low, cinderblock building. After they had walked through the huge double-hung doors, it took some moments for their eyes to adjust to the light inside. Before them was a giant collection of huge bronze sculptures by Lipchitz. There were eleven Henry Moores. In one corner, what appeared to be a flock of white marble penguins gathering together were works by Barbara Hepworth. Around the walls, enormous paintings were packaged and lined up five and six deep. There were twelve paintings by Clyfford Still, including two immense triptychs. There was a Kline, a Pollock, eight Gottliebs, and nineteen Reinhardts. Altogether, there were 1,490 Lipchitz sculptures, five Chadwicks, seventeen Hepworths, four David Smiths, five Gabos, one Gauguin sculpture, two Nicholsons, two Calders, four paintings by Mark Tobey, two Klees, two Kandinskys, four Massons, a Rivers, three Signacs, fifteen large works by Schwitters, thirty-four Feiningers, and still other less valuable works.

"The sight was enough to leave you slack-jawed," Peterson says. "It was like the giant storeroom of a large modern museum."

There were in Toronto a total of twenty-four Rothkos—in addition to twenty-two discovered at Deakin's warehouse, two were later found at Tippit-Richardson, after all. Twelve were among the twenty-nine left unsold from the 100 paintings Lloyd had bought from the executors and that five days earlier the judge had ordered Lloyd to return to the estate. The other twelve were part of the 1969 purchase.

As the lawyers and bankers surveyed the booty, someone spied stapled sheets of paper on top of a crate. It was an inventory left by Plutschow the day before in expectation that he would return to finish his job. It was another coup, thought Peterson, but he later discovered that the coded number system would not match any placed in evidence at the trial. Also, Lloyd apparently had invented another corporate entity since then: Marlborough International Fine Arts of Vaduz was listed on shipping documents as the owner of many of the works. (A later check of Liechtenstein registrations would reveal that,

until Lloyd's 1973 deposition, MIFA had been known as Cloud End Investment Corporation, another heretofore unknown entity. After the deposition, it became Fine Arts Marlborough A.G., until two months before the trial, when MIFA was born in secrecy.) It was in the name of MIFA that the space at Deakin's warehouse had been rented.

Lloyd had been cagy about this new Canadian hideaway. He had made sure that if he lost the decision, the assets could be removed surreptitiously to Switzerland. By checking customs and shipping records, Harrow was able to ascertain that Marlborough had been quietly shipping truckloads of art out of the United States during three periods: just before the trial, after the trial, and again at the time of the judge's decision. One shipment had left the country on the day of the decision. Hundreds of works of art had been shipped, the first batch to the usual warehouse, Tippit-Richardson, Ltd. Then, after the trial, there were shipments in May and July 1975 (while the Rothkos and the rest of Marlborough's stock supposedly was being "consolidated" in the new warehouse in Queens), two vanloads containing cargoes valued at $8,200,000 were sent to another Toronto warehouse, Borisko Bros., Ltd. Most of the declarations were signed for the gallery by Pierre Levai. Meanwhile, the contents of the Tippit warehouse were quietly moved to Deakin's warehouse where the contents of Borisko later joined them. Two more vanloads from New York arrived directly at Deakin's warehouse in December. Mr. Len Deakin, an unprepossessing former nightwatchman, said he had no idea why his warehouse had been set up to store Lloyd's treasure. Whether he actually owned the warehouse is not known.

When the art was counted at Deakin's warehouse, there were 1,750 works which had come from New York in seven vanloads. Their declared value for customs was $12,469,464. Estimates of their actual retail value range from $25 million to $30 million.

Also under receivership were 323 works from the Marlborough-Godard gallery (including thirteen Stamos paintings) valued at $7,278,777.

On Christmas Eve, two tired but elated lawyers flew back to New York to recount their cloak-and-dagger adventures. Luck had been on their side, and they had outmaneuvered Lloyd at last. The National Trust of Canada now had control of everything until a hearing was held—unless, of course, Lloyd chose to put up a bond for the $7,300,000 Rothko judgment in New York. They envisioned Lloyd

when he first received the news from Toronto: jumping up and down with rage—like Rumpelstiltskin—having been outwitted just as he was about to claim his prize.

Eisenberg's tip had come not a moment too soon. Had they delayed at all before embarking for Toronto, Plutschow might have accomplished his mission, made shipping arrangements, and flown back home for Christmas. And who was Eisenberg's source? That remains a mystery. It had to be someone within the Marlborough complex. And who there had most to lose if Lloyd's assets were spirited out of reach? Some speculated that it might have been Bernard Reis.

# 23 Kate Rothko and the Notion of the "Double Whammy"

## (DECEMBER 26, 1975–OCTOBER 1976)

> They have no lawyers among them, for they consider them as a sort of people whose profession it is to disguise matters.
>
> Sir Thomas More
> *Utopia*

In New York, the Christmas holidays were filled with further confusion. The multimillion-dollar question was who the Surrogate would appoint to replace the executors.

The position was powerful, the stakes very high. With the $7,300,000 in fines and damages and the return of the 658 paintings, the estate was now estimated at more than $30 million. The administrators' fees, under state law, were approximately two percent each—possibly up to $700,000—and a good chunk would go to lawyers. Who would reign over the Rothko kingdom, dispensing its favors to which law firms, which banks and accountants, what galleries, restorers, warehouses? Would there be a single monarch or a triumvirate? Many wanted a

290

piece of the action. The unresolved issue of control would cause more squabbles (this time among lawyers formerly allied), misunderstandings, and obfuscations—some deliberate, some perhaps innocent— and resulted in further ugly skirmishes by lawyers in Surrogate's Court. These in turn caused a new rift in the family.

Important decisions had to be made. A hearing about the receivership was set for December 30 in Toronto. As a twenty-five percent beneficiary of a rudderless estate, Kate was powerless to take action, her lawyers explained. The rule of law, as Edward Ross pointed out, was that the administration must go to the beneficiaries first, then, if none is eligible, to "one or more persons interested in the estate."

Since Kate and Christopher, aside from the foundation (which was discredited over its untenable position in the lawsuit and might be reconstituted by the attorney general), were the only beneficiaries of the estate, it was up to her aunt, as Topher's guardian, to decide what her role would be. Kate telephoned Barbara Northrup in Columbus to explain the Canadian escapade and ask her opinion about control of the estate. First her aunt had to decide whether to accept the offer of the Official Guardian of the Province of Ontario to represent Christopher as a public service in the Toronto proceedings. Barbara Northrup assented readily. Then Kate asked her aunt if she wanted to be an administrator of the estate. Mrs. Northrup declined; she wanted no responsibilities that might entail traveling to New York. Kate said that Gustave Harrow had backed Kate herself as sole administrator. In this way the estate would save money in executors' commissions and eliminate unnecessary duplication of legal fees. Would her aunt back her too? Yes, was the unequivocal answer.

Barbara Northrup agreed to wire both permissions to her lawyer, Gerald Dickler, in New York. Later Ilya, Kate's husband, telephoned with a tentative draft of the necessary Northrup telegram to Dickler:

> Kate tells me her lawyers have initiated a suit in Canada to reach Frank Lloyd's assets, and that the official guardian in Ontario is willing to appear for Christopher. I request you to sign a consent for me in this procedure.
>
> Kate and I also agreed that it would be best for her to serve as sole administrator to save further expense for the estate. I understand Gustave Harrow has also agreed to her appointment. Please join in the application to appoint Kate Rothko sole administrator.

Though they did not know one another well, Harrow and Kate had developed a mutual respect during the course of the lawsuit. Their objectives had been the same: the return and preservation of the paintings. Now he supported her completely. As Kate said of her intentions: "I hope to distribute the paintings themselves rather than having to sell too many. Of course, some will have to be sold to pay the estate's expenses. And then we will need art experts to advise about the value and importance of the paintings and which ones should be kept in groups. As for my own share, I hope to keep some, loan most of the others with careful consideration of how they will be exhibited. I will sell only gradually and only when I have to—for upkeep, insurance, restoration or anything unforeseen that might happen. I hope my brother and the foundation will have similar goals but, as administrator, I would not have control over that."

On December 29, the eve of Kate's twenty-fifth birthday, the petition was submitted, asking that the Surrogate appoint her sole administrator.

On New Year's Day, Kate and Ilya left his parents' house in Brooklyn, where they had spent most of the holidays working out these problems with the lawyers; Kate's end-term examinations were scheduled to begin the following week at Johns Hopkins, and she had some serious studying to do. Christopher would return soon, after having spent the holidays with the Northrups in Ohio.

Then began certain crucial family misunderstandings. From the start, Gerald Dickler's position in the Rothko affair had been filled with contradictions and ambiguity. His midtown firm, Hall Dickler Lawler Kent and Howley had a number of important clients and solid Republican connections. Self-made, a maverick with charm and seeming candor, Dickler represented, among others, Lowell Thomas and the late showman, Billy Rose; his clients in the art world, besides Lee Krasner and the Pollock estate, included the late Adolph Gottlieb, the estates of Baziotes, Marin, and Ann Ryan, all of whom were with Marlborough. In addition to acting first for Mell, and then for her sister, Barbara Northrup, he had also been retained by Bernard Reis in mid-1970 to rewrite the purposes of the Mark Rothko Foundation.

During and after the trial, Dickler had privately expressed his affection for Frank Lloyd, whom he said had sought to retain him as Marlborough-Gerson's counsel in 1963 before Colin was hired. He likened Lloyd to Billy Rose, saying that "scoundrels" rather appealed

to him. Before the decision, Dickler had predicted that the judge, a fraternity brother of his at Columbia Law School, would remove the executors and fine them, but not invalidate the contracts with Marlborough. He explained that it was for the good of the New York art world that Marlborough remain in business. If Marlborough had been constrained to live up to its obligations to the Pollock estate, he saw no reason why the terms of the Rothko consignment contract could not be similarly amended through negotiations to ensure further benefits and safeguards to the estate. This had been the argument for settlement that he had been pushing from the very start of the suit. The day after Midonick's decision Dickler had told the New York *Post* that while he was "naturally delighted," he predicted that "we may encounter considerable difficulty collecting the amounts assessed." He added "delicately," that the lawsuit had dragged on so long that Frank Lloyd "was in a position to fortify himself against collection."

Immediately after Kate's petition was submitted, jockeying for power began. On January 6, as the lawyers again filed into the courtroom, only Gerald Dickler expressed some chagrin at the presence of the press. Then he shrugged, mumbling something to the effect that it would soon come out into the open anyway. He was about to act out what he called "the principle of the Double Whammy," a notion that he had tried to explain to the judge during the trial when he objected to Marlborough's dubious documents being placed in evidence. Dickler's whammy went this way: When a situation demands deliberate deception, it is all the more believable if the trail contains a red herring—an outwardly innocent error that by its unintentional-seeming nature tends to reinforce the honesty of the rest of the argument. Now, as he praised Kate's abilities and then proceeded to demolish her credibility and maturity, it became clear how Dickler's "double whammy" worked.

But first, it was Ross's turn. He summed up the estate's legal complexities. Then he described Kate's decisiveness and dedication to her father's wishes: how as a minor she had assumed the responsibility for removing Christopher from his unhappy days at the Levines' to her aunt's custody; how when she saw the contracts and realized their import, she had pressed for suit; how she had switched lawyers when the pace of the case seemed too slow; how she had depleted her personal funds as the expenses of the suit mounted and boldly backed the Canadian investigation and proceeding. She had also agreed in writing to take half the commission due an executor. Then, circuit-

ously Dickler began his multipronged but soft-spoken offense. "If your honor please, this is no time, after the prolonged road that we have traveled together, for me to have personal differences or even differences of credibility with Mr. Ross." He said that he did not question Ross's word, nor did he "attempt to lay any blame at the feet of Kate Rothko for misunderstanding her aunt's position." He called her "a very bright girl" and praised her "devotion" to and "great love" for her father's works.

He chastised Ross for implying criticism of his close friend and colleague Stanley Geller, on whom he then heaped praises for legal acumen. He mentioned that Geller had "pried out" the contracts from the executors and noted his diligence in the handling of Mell's estate and in instituting the lawsuit and his defense in the suit over the contents of the house. (Dickler made it sound as though Geller's bill for $182,800—$32,800 already paid him for the original suit and his latest bill of $150,000—was worth it.)

As for the representation of the Official Guardian in Toronto, Dickler said, "I got wind of the matter first on December 29th"— even though his office had received a copy of the consent form five days earlier. And when he had read it, he signed it, but instead of posting it hastily to Toronto, he filed it until he could ascertain more about what was going on in Canada. (The letter of consent would remain in his file indefinitely.) Dickler said that Mr. Ross and Mr. Harrow had proceeded in Canada without "inviting" him to join them, so he had felt it unnecessary for his client to enter into the suit until something "constructive" happened. He had been concerned about what "financial responsibilities" the suit might entail.

Mrs. Northrup and her husband had told him by telephone that Kate and Ilya wanted them to back Kate as sole administrator. Dickler had pointed out to them that being a "beneficiary does not give you the same kind of muscle as being a co-executor or a co-administrator does in protecting the interests of your ward." Mrs. Northrup was in an ideal position to be an administrator, he now told the judge, because her husband was "quite savvy" with respect to tax matters, being a "certified public accountant who was available to her at any time."

Then Dickler brought out the point of the verbal blade. "Kate has been banging away at this thing with a persistency that disturbs me," he said. He claimed that, to persuade her aunt to decline, Kate had told her that the Surrogate wanted Kate to be the sole administrator.

He added, "Why Kate . . . is prepared to make up stories like this in order to get her aunt's consent, I don't know."

Dickler said he had explained to his client that Christopher's share of the estate must go through an orderly process of liquidation. In other words, the paintings were to be gradually placed on the market and sold for income—exactly what Kate had been trying to prevent. Dickler had also advised Mrs. Northrup that if Christopher's share of the estate were not liquidated, she faced a "surcharge" when Christopher came of age if the paintings had gone down in value. Dickler argued that "Mrs. Northrup not only has a right but an obligation to see this estate is liquidated to the extent that represents prudent investment from the standpoint of an infant."

He declared that the Northrups had sent him "no telegram," though they had called him a number of times. What Kate discovered later was that the Northrups had sent a *registered letter* in which both permissions were given. When Dickler received it, he telephoned them and told them he would not place it in his file—in other words, he would pay no attention to this communication of their wishes in writing—and proceeded to advise them against this position, using the argument of surcharge he related in the court.

Now before the judge Dickler thrust deeper. "I do not believe that an estate of this size should be administered by a youngster, however precocious, who at this juncture is still in the process of obtaining an education, whose relationship to the assets of this estate bears more than a tinge of emotionality, and who does not relate to her brother's problems—in terms of not what her brother needs but what obligation her brother's guardian has toward this infant."

In the interest of harmony, he strongly suggested a "double harness." But, at whammy's end, Dickler backed off a bit: "Now Mrs. Northrup did tell me yesterday that she said to Kate that 'if the Surrogate should decide that you will be the sole administratrix, that's all right with me. I will not appeal, I will not protest the decision, I will not move to have it set aside. I will do nothing. But that is a matter for the Surrogate to decide. In the absence of a decision by the Surrogate to that effect, I would like to be co-administrator.' "

That same day, Kate's aunt was entering the hospital in Columbus for a serious operation, Dickler allowed, and would not be able to travel for "approximately six weeks."

Time and the loss of the lawsuit had done nothing to subdue the sharp-tongued legal spokesman for the Mark Rothko Foundation. Now

it was the turn of Greenspoon's associate, Charles G. Mills IV. He declared that Kate Rothko had exhibited "such venom and hatred of the foundation" that she was "incapable of administering an estate in which the foundation is the overwhelming beneficiary without running into conflict between her emotions and duties." Mills added that the foundation would insist that Kate post a bond for $12 million.

Both Dickler and the foundation had filed affidavits suggesting that the estate would best be run by a triumvirate. Dickler wrote that "Mrs. Northrup did not consent to Mrs. Prizel's appointment as a sole administrator" and that she had "conveyed to Mrs. Prizel that she should likewise serve as administratrix." Though Dickler in court talked of a "double harness," in his affidavit he said that two executors might be "at loggerheads with each other," and therefore a threesome was preferable. "Three fiduciaries would permit the affairs of the estate to be governed by majority rule and obstructive efforts on behalf of the foundation could, therefore, be minimized." The idea of a triumvirate also (coincidentally?) dovetailed nicely with the foundation's own position. In its affidavit the foundation had reserved a right to name the third entity, but in court Mills sought an impartial third party selected by the court. Thus Midonick was faced with discerning the facts in these odd and changing shifts of political allegiance.

Ross pointed out that there was no conflict between Kate and her brother. If there were a distribution in kind (of the paintings) the guardian could either sell or retain the paintings until Christopher was of age and could choose his own. Kate was a mature woman, not a child. Ross asked if Mrs. Northrup would be willing to waive her executor's commission. Neither in his affidavit nor in court did Dickler ever respond directly to the question.

Harrow, who had already spoken strongly in favor of Kate as eminently "prudent" and capable of sole administration, spoke last. Kate was neither emotional nor vindictive and throughout had proved herself "level-headed and objective." This "attempt to brand her with that type of temperament" was "both false and most unbecoming."

Waiting in the wings was another with designs on the job as administrator—and a piece of the fee. It was Herbert Ferber, who had lawyer Stanley Geller write a four-page letter to the judge presenting him as

not only the executor of the estate of one [Mell] of the two named beneficiaries in Mark Rothko's will [but also], as the former

guardian of Kate Rothko Prizel, the individual who single-handedly started the removal proceeding that ended recently with your decision to oust the "old" executors of the Mark Rothko estate. He is indeed the "forgotten" man of the removal proceeding, although it was through his efforts that Barbara Northrup, the guardian of Christopher Rothko, was persuaded to support the proceeding and that the office of the Attorney General was encouraged to do the same.

Geller wrote that Ferber was "vitally interested in" who would run the estate and mentioned that both Mell and Mark Rothko's estates faced Tax Court proceedings concerning the value of the Rothko paintings—and the $4,300,000 the IRS claimed as their due.

Ferber would "deem it an honor" to serve as a third administrator-mediator, and like the others, no doubt, "at less than a full commission." Geller's own "urgent recommendation" to the judge was that he appoint Ferber to this position. Geller repeated Ferber's qualifications, adding:

He was a close friend during their lifetimes of both Mark and Mary Alice Rothko. He is a fine artist in his own right, and is recognized as one of the leading sculptors in this country. He is, therefore, very knowledgeable in matters relating to the art world, and is well known to leading figures in that world. He is at the same time a successful practicing dentist and an investor, and thus a man with some substantial business experience.

He repeated that it had been Ferber who had initiated the suit, "pitting himself against strong forces within the art world. He has established himself as a man of courage, independence, intelligence, and integrity."

As Geller saw it, because the children had not been named in their father's will but had inherited as a result of their mother's elections, they did not qualify as the beneficiaries; they were merely qualified under the more remote category of "persons interested in the estate." As fiduciaries, Mrs. Northrup and Ferber were more qualified than Kate for the role of administrator. It was a curious bit of roundabout reasoning, especially since Ferber's interest, the $250,000 legacy under Rothko's will, had already been paid to Mell's estate.

Geller wound up by requesting that the judge "give serious con-

sideration to his suggestion that the new executors . . . should be Kate Prizel, Barbara Northrup, and a third person, preferably Mr. Ferber himself, on condition that each agrees to share equally a single full executor's commission." This was in line with the Dickler affidavit. It was left to Gustave Harrow to put these new claims in perspective:

> Because of its long, significant, and tormented history, this estate demands a special scrutiny of the characters of those who will be entrusted with the destinies of its beneficiaries.
>
> I have had numerous discussions with Kate Rothko Prizel, and have watched her reactions to the long course of these proceedings. There is no question that Mrs. Prizel has been highly motivated by a desire for justice, possesses a resilient independence of mind, and has intelligence combined with common sense seldom found in persons of far more advanced age.
>
> What has been clear throughout is that Mrs. Prizel has been motivated by a desire to bring honor to her father's memory, to respect his wishes, and to cleanse the stench of injustice which marked the events following his tragic death and which so callously disregarded his treasured works of art. At the same time, Mrs. Prizel has exhibited a sense of realism and a grasp of practicalities.
>
> Nothing less than an enormous expenditure of time, energy, and determination could have resulted in overcoming the powerful forces arrayed against the beneficiaries of this estate. . . .

Point by point, Harrow challenged Geller's statements about the case, saying that Geller had had nothing to do with the attorney general's initiative; on the contrary he had "reluctantly provided little information and persistently avoided any meaningful cooperation" with Harrow. Geller had "stalled" Harrow's moves for the injunction, and "put off making the motion" until it was clear that the attorney general would move independently if not joined. Nor had Geller helped obtain any of the experts' affidavits. If Geller had sought an injunction at the beginning of the lawsuit, it might have saved eighty-two valuable paintings Lloyd claimed to have sold in the eight-month period before the injunction. Both Geller and Dickler had played passive roles throughout, Harrow pointed out, and this had had important negative consequences.

Harrow declared that he would set about reconstituting the Mark

Rothko Foundation. Until this was accomplished, the foundation, with Reis and Stamos as officers, had no rights or say in estate matters.

To clear things up, Kate sent her aunt and uncle a copy of the affidavits and the transcript of the hearing. Annoyed, when they learned of Dickler's misrepresentation of their position and the anguish it had caused, the Northrups hired a Columbus attorney to draw up a letter of withdrawal for Mrs. Northrup, which she signed and the lawyer sent to Dickler. With Dickler reportedly on vacation, it was the ignominious job of his associate Paul Sarno to present Mrs. Northrup's formal letter of withdrawal to the judge.

Though he had intended to appoint Kate and her aunt joint administrators, Judge Midonick, on receiving the letter, appointed Kate Rothko Prizel sole administrator of her father's estate, replacing the three executors. He then signed the decree (or judgment) granting "her prayers."

Again, Kate's victory hit the front pages of the *New York Times*. The press, which before the decision had focused on Lloyd and his mighty empire, swarmed about for interviews. When it became clear where the power now lay, Kate was besieged by dealers, museum directors, and curators, who began to pay court. It was ironic considering that some of those who now stepped forward were those who might have helped her during the lawsuit but had told Harrow and others they had not wanted to "get involved." Those who had helped hoped to be rewarded for their trouble. Old friends of her father's around the world sought her out.

After reading the news about Kate's struggle to become sole administrator of the estate, vice-president Thomas Hess resigned from the Mark Rothko Foundation. As he told the *Washington Post*, in his own version of a double whammy: "Our trustees and our lawyers fought Kate in the courts. They called her 'venomous.' Isn't it awful? Bernie Reis and Stamos think Kate is a monster." Hess had consulted his lawyer about Harrow's threat of restructuring the foundation through the courts. But he maintained his certainty that the foundation's purposes were valid, that Rothko had spelled them out in his will.

The Canadian hearing had been postponed several times pending Marlborough's posting of a bond to cover the $7,300,000 judgment in New York. (Under New York law a litigant who appeals a judgment is normally required to post bond securing payment in order to avoid

attachment of his assets pending appeal.) If the bond was posted, the proceeding in Toronto would be dropped and Lloyd would be free to transfer the art to Zürich as planned before the embarrassing interruption. But in New York, first Midonick and then the Appellate Division repeatedly granted Marlborough stays on the monetary judgment, so that for three months no bond was forthcoming.

Gustave Harrow, worried that Marlborough was altering its books to show that the art in the Canadian warehouse did not belong to Lloyd, repeatedly requested Marlborough's records. Churning out motion after motion, Harrow cited the endless transfers of ownership brought out in the trial as well as the many fabrications of documentary evidence. Through various maneuvers, his requests were frustrated each time.

In February 1976, Sullivan and Cromwell moved to cite Harrow for contempt. Lloyd was furious because, immediately after the decision, Harrow had letters from Attorney General Lefkowitz sent to Lloyd's "important" clients—Count Marinotti, Yoram Polany, Arturo Pires de Lima—asking the return of the paintings whose sale, the judge ruled, had violated the injunction. Harrow's letters suggested that if the paintings were returned, the possibility of further litigation might be avoided.

David Olasov of Sullivan and Cromwell called the letter to Polany, which Lloyd had forwarded to the law firm, "coercive" and "threatening," and a hearing was held on whether Harrow should be cited for contempt. It was another time-wasting legal ploy, but one that indicated Lloyd's displeasure. At the hearing, Ross suggested that Sullivan and Cromwell pay double costs to "deter frivolous motions." During the course of the hearings, David Olasov said that the bulk of the property held in Deakin's warehouse had not been sent by Marlborough Gallery but by Aqueduct Lane Corporation, formed by Lipchitz, which held title to his sculpture. All the art was sent, he said, in 1973 and, he believed, in 1974 (despite the 1975 dates on the shipping and customs documents), and the warehouse property was bought by Société Anonyme pour les Beaux Arts (a Marlborough Liechtenstein shell). He did not admit to any shipments in 1975 and specifically denied that of December 18, 1975, the day of the decision.

The appeals called for a new strategy. Arthur Richenthal filed a motion in the Appellate Division of the New York State Supreme Court to stop the enforcement of Midonick's monetary judgment with-

out posting a bond pending Reis's and Stamos's appeal. They now pleaded hardship. Throughout the lawsuit, Reis had proclaimed himself and had been characterized by lawyers and witnesses for the defense as "independently wealthy," the owner of a vast investment portfolio and an important art collection; he now represented himself as impoverished, with only his town house to his name. The art collection was jointly owned with Becky and was "kept in the home and maintained as part of its decor." The house and its "furnishings" were his major asset, and as Richenthal presented it, "the emotional strain of being uprooted from his home . . . would have incalculable adverse effects upon his health and life." Richenthal argued that the court should not remove Reis and Stamos as executors. Their removal would cause "unnecessary disruption and costs" and, at the same time, "real and irreparable personal harm to them, not recoupable in money, by sanctioning the tarnishing of the reputations and casting obloquy prior to the determination of the appeal." It would help with the IRS negotiations, Richenthal claimed, if they were kept in office.

Stamos's only assets were his New York house and his paintings. Besides, said Richenthal, there were "other sources [i.e. Lloyd]" from which to obtain the judgment. Marlborough had been fined $3,800,-000, was liable with Reis and Stamos for a total $7,300,000, and could afford to post a bond. If all of the 140 Rothkos that Lloyd had sold were returned, it should satisfy the liability of Reis and Stamos, except for the amount of interest that had accrued since December 1975.

Richenthal gave a preview of the basis for an appeal. He mentioned the "Surrogate's conduct of the trial" and cited "errors" in Midonick's decision, such as voiding the 1969 contract when $640,000 was still owed by Marlborough to the estate (Midonick had rectified this in his decree). Richenthal's most pointed attack was aimed at what he termed Midonick's "pseudo-Freudian analysis" of Reis's motives (gain of "prestige and status"), for which he claimed there was no evidence. Midonick had neither seen nor heard Reis during the trial. The damages the judge had awarded were not realistic, Richenthal protested, and should have been based on the fair market value of the paintings at the time of the contracts; Midonick had no business updating or "appreciating" their value to the time of the trial.

He enclosed a new letter from Reis's doctor, in which he wrote that Reis's condition had further deteriorated and noted that Reis's "in-

stability of gait had increased." "His condition was aggravated by the recent emotional impact of the court's decision, and is such that the stress of testifying may result in grave consequences endangering his life."

Richenthal summed up, all stops pulled out. If Reis and Stamos had to post bond, they would be "destroyed . . . not only economically but emotionally and uprooted with their homes and their contents sold out from under them, it will do Reis little good [sic]. His precarious health and even his life are shattered by the enforcement of the decree."

It worked. With more than due speed, the Appellate Division granted a stay until October, eight months away. Levine's lawyers also won the right to appeal in October without a bond, also basing their petition on hardship. This opened the way for Marlborough's motion for a stay, though how Lloyd could plead hardship and postpone posting a bond was beyond anyone's ken. Ross believed that the motion would present his lawyer, David Peck, the former presiding justice of the Appellate Division, with a chance to show just how much prestige he still commanded among his former benchmates and still deferential clerks.

In early March, Sullivan and Cromwell filed their motion accompanied by a thirty-seven-page affidavit by Peck. He denounced the Midonick decision as "patently erroneous and infirm" and predicted that it would be the basis for a "complete reversal or at the very least drastic modification . . . both on the merits and the gross excessiveness of the damages awarded." There was "no element of self-dealing on the part of any of the executors," since none of them "had any financial interest in any Marlborough company. . . ." In contrast to Richenthal's new portrayal of Reis as lacking assets, Peck still described Reis as an aged and wealthy man who only wanted "something to do" when he went to work for Marlborough.

"Certainly manifest injustice," Peck wrote, "would result in staying the enforcement against three persons held primarily liable but allowing enforcement of the money judgment against third parties before the appeal can be heard."

The contempt findings against Lloyd were "gratuitously erroneous," since, after the injunction, Marlborough had only delivered goods previously sold, said Peck, and the injunction was unspecific about this.

Peck suggested that if the court would not grant the same stay as it had to the executors, the bond should be greatly reduced. The fines, he reasoned, should not exceed $600,000 or, if figured at the most excessive formula, $1,700,000.

When Ross read Peck's affidavit, he was outraged by its imperious tone and cavalier treatment of fact and worried enough about Peck's status as perpetual "judge" of the higher court to take drastic action. Why had Peck not mentioned the attempt to transfer Lloyd's assets out of reach of the judgment? There had been no reference to the Canadian receivership or the nabbing of Plutschow in Toronto as he was about to violate Midonick's order. Why had he so totally ignored Midonick's extensive reasoning concerning the amounts of the fines? If Peck won his stay against bonding, the Canadian proceeding was "in jeopardy." Why, he reasoned, should an Ontario court continue to hold Marlborough assets to assure the judgment of a New York State court, when a higher New York State court would not require a bond for the same purpose? And, obviously, the only weapon that might compel Frank Lloyd to pay up was the threat posed by the Toronto affair.

So Ross filed an opposing affidavit, which led to the disclosure of entirely new and sensational behind-the-scenes activities—of Peck pulling strings to stop the district attorney's criminal investigation of Marlborough's activities in the Rothko case.

It was alleged that for more than two months some heavy political maneuvering had been going on. It had started on December 29, 1975, when the district attorney's office served a subpoena on Marlborough commanding the appearance of "any officer of Marlborough Galleries" before the grand jury on January 13 with "all records and documents" pertaining to the galleries' purchase of "the works of art of Mark Rothko from the Executors of the Estate." Morgenthau's office, which had been studying the case for some months, evidently had made progress. Ross charged that, on the day after the subpoena was served, "Mr. Peck came to my office" and said that "Lloyd and Marlborough would not bond the judgment unless the District Attorney discontinued his criminal investigation. . . . If the investigation went forward . . . then Lloyd would give up his New York business and would have no reason to bond the judgment. Mr. Peck then asked if I would speak to the District Attorney. . . . Mr. Peck explained that where a party who had been wronged by a person who was under criminal in-

vestigation requests the District Attorney not to bring criminal pro-
ceedings against the wrongdoer, the District Attorney would give
great weight to such request."

Then came disclosure of more backstage pressures. In the affidavit
rebutting Ross, Peck wrote: "The conversations were in the nature of
settlement discussions," and "there is no excuse for Mr. Ross's excur-
sion into our conversations." About stopping the "threatened criminal
proceeding," Peck revealed that he had also discussed heading off
the D.A. with Judge Midonick and the other petitioning lawyers as
well as Attorney General Louis Lefkowitz.

> The Surrogate looked with favor upon the effort and said that
> if the District Attorney would make inquiry of him, he would
> say that he thought that it was in the public interest to secure
> the Rothko estate with respect to what it was entitled to recover,
> rather than have another round of the same case with its vicissi-
> tudes in the criminal forum.

Earlier, Peck said, he had gone directly to Attorney General Louis
Lefkowitz (a fellow Republican) and said that if a bond were put up,
he hoped that Lefkowitz as well as Midonick and the other lawyers
"would speak to the District Attorney so that he might know that the
Attorney General was not pressing him. . . ." Lefkowitz later told Peck
that his office had merely supplied information to the D.A.'s office and
now "would interpose no objection to dropping any further investiga-
tion or proceeding." Peck added that despite the fact that Ross was
now "donning shining armor" he went along with Peck and the judge
and the attorney general for a while on the matter. Ross denies this.

Peck's affidavit reaffirmed that Harrow had some reason to worry
about switches in Marlborough's books over the ownership of art held
in Deakin's warehouse in Toronto: "I will say further . . . only that
there has been no violation of any order of Judge Midonick, and
neither Mr. Ross nor Mr. Harrow has shown any, and that the receiver-
ship in Canada has nothing to do with the proper exercise of this
Court's office. There is a lot of property tied up in Canada but accord-
ing to my information there is little, if any, of it belonging to these
appellants and, besides what may belong to other Marlborough com-
panies not party to this proceeding, there are others claiming owner-
ship who have *no connection whatever with Marlborough*." (Emphasis
added.)

When news of the attempt to stop the D.A.'s investigation hit the pages of the *New York Times,* it had the shock effect that Ross wanted. Now there was evidence in the public record of Peck's attempts to deter a criminal investigation by enlisting the aid of the judge and the attorney general (neither of whom had been mentioned in Ross's affidavit), as well as of Marlborough's threats to refuse to post bond if the D.A.'s case were not dropped. Thereafter the Appellate Division denied Marlborough's request for a stay of monetary enforcement.

David Peck had earlier indicated to Ross that, rather than pay the fine, Lloyd might prefer to return some of the paintings allegedly sold and to deduct the $90,000 per oil on canvas or $28,000 credit per painting on paper for which the decision had provided. Since Judge Midonick had left it up to the estate to decide whether it would accept the paintings in lieu of cash, Kate, as administrator, could choose the paintings she wanted returned. She called together three experts: William Scharf, Dorothy Miller, and Katharine Kuh.

On a Saturday in March, at Miss Kuh's apartment, Kate showed slides of the paintings Lloyd had sold. The slides were copies of those Morton Levine had taken in December 1968–January 1969, so some paintings were not represented, and some of the transparencies were not of good quality. But the three found themselves in accord on almost every oil on canvas. Kate decided to accept all oils offered— because she was persuaded that her father had cared most about these being exhibited together—but selected only a few of the paintings on paper.

As it turned out, Ross's calculated strategy with the Appellate Court affidavit then turned out to be worthwhile in another way. Just after he lost the motion for a stay, Peck came up with a new and surprising concession. He wrote Ross a letter offering to return nineteen of the paintings that Lloyd had sworn were sold to Count Marinotti. Would the estate accept them, so that Lloyd could take a cash credit of $1,710,000 (at the $90,000 per picture the judge had designated) against the judgment? Secrecy, of course, must be guaranteed, but it was a coup and at least an apparent admission of "parking." Lloyd then offered to ship the paintings back to New York, where they could be examined more closely. Later, more of the supposedly "sold" paintings were added to the returns. It was an unhoped-for bonanza—especially after all the testimony and countless documents devoted to proving that the sales had been genuine and not self-dealing transactions.

It was tantamount to an admission that might seriously undermine any appeal of Midonick's decision.

Why was Frank Lloyd, who had fought so long and hard to prove that the sales of these paintings were genuine, now prepared to return many of them? It was extraordinary, particularly in view of the fact that these canvases were of top quality, some of the best in the estate, worth far more on the market than the $90,000 credit from the court. Lloyd suddenly must have been hard put to raise cash and desperate to have his salable assets released from the Toronto warehouse. Also, perhaps, the supposed buyers—Marinotti, Pires de Lima, and Polany—were distressed to receive the letter from the attorney general implying further litigation, and pressured Lloyd to reinstate the paintings they had allegedly purchased. In any case, the returns could scarcely be regarded as anything but incriminating.

In the third week of April, Marlborough posted bond for $3,897,-474.72, plus $3,400,000 in credit for the forty-one paintings to be returned from Europe. Nevertheless the legal hostilities were far from over.

Four months after the decision, Ross instituted suit in Kate's name in federal court charging Karelsen and Saidenberg with complicity in the conspiracy to defraud the estate. The suit, brought partly so that the estate would remain intact, asked for $6 million in damages—$5 million from Karelsen and $1 million more from Saidenberg. It seemed clear that the issues might result in a settlement out of court to cover all or part of the millions of dollars in legal charges. If it was not settled, Ross would attempt to prove, with new witnesses and testimony, the back-dating of the consignment contract.

Levine's lawyers also sought payment of $100,000 for the tax work the judge had directed them to undertake for the estate. Later when Levine's lawyers read Ross's brief against Karelsen and Saidenberg, which cited the attempts to delude Levine with appraisals and legal advisements, they seized the chance to take action against Kate. They filed a motion in Surrogate's Court, based on what they called "newly discovered evidence" from Ross's brief, seeking to have Levine reinstated as an executor of the estate.

Levine now was portrayed by his lawyers as "the innocent and helpless victim of a consummate professional fraud cunningly contrived and perfectly executed." He was "the loyal gallant protagonist of propriety" against whom "an outrageous conspiracy which generated

pressure, coercion, fraud and deceit" was perpetrated. Actually, it was only Levine's position that was new; Ross had cited no further evidence. In Harrow's brief against Levine, he pointed out that never once during the four years of litigation had Levine accused the other two executors of conspiracy or fraud, and it was a strange reversal of his position to begin now.

After the posting of the bond and the negotiations over the return of the paintings had been resolved, Edward Ross instituted another suit, over the Toronto affair. He charged Frank Lloyd, his legal adviser, Irving Moskovitz, and Franz Plutschow with contempt of court for attempting to move Lloyd's assets out of the court's jurisdiction. Ross hoped to regain from Marlborough the estimated $200,000 it had cost to halt the shipment and to hold the art in the Toronto receivership. Later Moskovitz was dropped from the suit.

In the fall of 1976, Judge Midonick ruled that Levine's new challenge did not warrant further consideration. The appeals were postponed until February 1977, when the Appellate Division would give the lawyers a day of further impassioned legal arguments in court, before studying the merits of their new briefs. The appeal, as we shall see, would result in further revelations about the Mark Rothko Foundation, bearing directly on Rothko's hopes for the fate of his creations.

# 24 At the Coroner's Office

(FEBRUARY 25, 1970–JULY 1976)

To fear the worst oft cures the worse.

Shakespeare
*Troilus and Cressida*

Since the opening of the court case, speculations about Rothko's death have multiplied. Was it actually self-administered? Or had something more sinister occurred on that chill February night in his studio—a murder tailored to look conclusively like suicide? *Almost* certainly it was a suicide; but *almost* leaves the question finally unresolved. Investigation of the circumstances so long after the event have proven inconclusive.

Had investigators from the police department and the medical examiner's office been aware that morning of who Rothko was, how many millions he was worth alive and how much more dead, and how much others stood to gain by his death, surely there would have been a more thorough analysis of what had happened. There were an unusual number of slipups in the handling of the case—partly bureaucratic, partly due to ignorance. At that time, no one saw any reason

to question a suicide that looked so obvious. Certainly, little motive for foul play was apparent.

But years afterward, the possibility of foul play occurred not only to the conspiracy-minded, but some of those who had known Rothko well and thought him incapable of suicide. Finally the speculation was voiced publicly in a 1976 *Art News* interview by painter Agnes Martin: "I wish you could publish that I don't believe for a minute that Rothko committed suicide. Nobody in that state of mind could. He was done in, obviously . . . by the people who have profited or have *tried* to profit."

Perplexed by uncertainty and seemingly inexplicable incongruities surrounding her father's death, Kate Rothko had early confided her fears to Edward Ross. She wished to be "certain" that it had been suicide, to be relieved of any hideous doubt. A man who tends to take conspiracy theories seriously, Ross concocted several scenarios from the facts. He says he believes Rothko, from all he has learned about him, did not commit suicide.

But there were compelling reasons for believing that Rothko had killed himself. Yet, did the fact that the world was ready to accept him as "suicidal"—that his motives certainly existed—preclude the possibility that someone used these motives as a screen behind which to kill him, or perhaps to help him kill himself? To stage the death so obviously, so dramatically, so sanguinely as suicide that in all probability it would never be questioned?

Particular circumstances of his death that had been troubling family friends included the following:

Why had Mell not been notified until late in the morning? Why had Rothko, an extremely "oral" Freudian type, constantly needing to make contact, apparently neither telephoned nor left a note? Why the totally uncharacteristic (if explicable) violence? Why had he chosen to bleed to death when he was fearful at the sight of a drop of blood? And, given Rothko's slovenly personal habits, how to account for the neatly folded suit placed over a chair? Further investigation would turn up more discrepancies—even though the trail was by then quite cold.

In July 1973, Breed Abbott and Morgan had requested a copy of the medical examiner's report and the police department's Aided/ Accident report of the suicide. Studying them, the lawyers decided that they did not make sense. The Notice of Death was terse: "Suicide, he cut his arms. Wife present." But Mell Rothko had not

arrived until noon; who did they mean? The information was stamped as received at 10:18 A.M. by the clerk, presumably from the young intern from Lenox Hill Hospital who had pronounced Rothko dead. There was an explanation. When Rita arrived at the studio, no doubt the intern believed her to be Rothko's wife.

Stamos's various statements were generally contradictory. During his deposition, he testified that Oliver Steindecker had called him between 8:30 and 9:00 in the morning and that he had arrived at the studio about 9:30. How could Oliver have telephoned Stamos before he had discovered the body? Why did Stamos say that he could not recall whether anyone had called Mell? He also said that when he arrived, Oliver was there with Mrs. Levine and Donald McKinney. But Stamos, according to Lidov, had arrived before the others. And how could Stamos have confused Mrs. Levine with Rita Reinhardt? It was Rita who had arrived on the doorstep with Donald McKinney, and, on hearing the news, had broken down in hysterics—and had been forcibly detained from entering Rothko's studio by Lidov because Stamos told him Mell was either on her way or already in the studio. Mrs. Levine did not arrive until much later, and then she and Oliver had left to inform Mell and help her back to the studio.

When Ross examined Stamos in 1973, Stamos equivocated. At first he replied definitely that Rita had not been there. Then he amended this to "She wasn't in the studio." When Ross asked if she had been elsewhere on the premises, Stamos replied, "I don't recall." All this was especially odd since it was no secret to the art world, or to Mrs. Reinhardt herself, that Stamos disliked her. He had told Rothko how "depressing" he found her and often wondered aloud why she always wore black. Why had he gone to such lengths three years later to deny her presence at the scene? Was this his misguided way of somehow protecting Rothko's reputation—or was there a deliberate cover-up?

It was Stamos who had telephoned most people to tell them the tragic news before they read it in the newspapers. But many of those he telephoned give divergent accounts of what happened. Perhaps some of the discrepancies can be accounted for by the passing of time or the shock of the moment, but many recollections are so at variance with fact that they are worth noting. Philip Guston, who believes Stamos called him about noon, says he thinks Stamos told him that he found the body, and that Rothko had slashed his armpits. Perhaps out of his own sense of drama, Stamos reportedly told several others

that Rothko must have been in a frenzy: the studio and particularly
the bed were a "wreck," and Rothko had clearly struggled with the
sheets, which were "all churned up as though a cyclone had struck."
This varies with Lidov's memory and with the reports of the police
and medical investigators. When they arrived, there was no sign of
disarray; had someone cleaned up earlier? To some Stamos recounted
a conversation he had had when Rothko called him on the night of
February 24:

> ROTHKO: I'm cold.
> STAMOS: Have you got your socks on?
> ROTHKO: Yes, two pairs.
> STAMOS: Well, put your shoes on then.
> ROTHKO: I have them on, too.

Later, at his deposition, Stamos denied that he had spoken to
Rothko either that night or for several days preceding the artist's
death.

Though Guston says he thought Stamos had told him he had found
the body, to most others, Stamos later said that he was second on the
scene after Oliver Steindecker—apparently forgetting or choosing to
overlook Lidov and his assistant.

But the most puzzling aspect of Stamos's stories concerns the tim-
ing of his phone calls. One artist says she is certain that he called her
at 9 A.M. sharp—before Oliver discovered Rothko's body. Stamos told
her, she believes, that Rothko had cut his wrists and that Mell had
been sent for. On later occasions, Stamos described to others how he,
not Lidov, had forcibly restrained Rita Reinhardt from entering the
studio.

Katharine Kuh also remembers Stamos calling her very early, and
she believes that he said that Rothko had died of an overdose. Since
Rothko had talked of suicide to her six weeks earlier, she registered
little surprise, just a numbing sadness and concern for the family and
Rita Reinhardt. She asked about Mell's whereabouts. Mell, Stamos
told her, was still in Washington visiting Rothko's nephew and would
be back that afternoon.

Whether Stamos had been in a state of shock or people had been
confused by their emotions at the time, or whether the obfuscation
was something more serious is unclear.

# THE LEGACY OF MARK ROTHKO

On that Wednesday morning, Mrs. Reinhardt told Lidov and others there that she had come to the studio that morning because she had promised to go to the warehouses with Rothko and McKinney. Afterward, Rita's explanation was that she was there because she had become alarmed when she telephoned Rothko and received no answer. Her arrival with McKinney was coincidental, she maintains.

The time of death, listed on the forms as 9:35 A.M., was merely an official register of the time that Oliver had called the police. The coroner's office says that they could not determine when death had occurred—except to say that it must have taken place between four hours after Rothko had eaten (before he had fully digested his meal) and the time Oliver had found the body. Digestion, they pointed out, can be slowed abnormally, depending on the amount and type of drugs taken and on an individual's tolerance of these drugs.

The following day, Mrs. Reinhardt told Lidov that she had talked with Rothko at midnight or thereabouts. And Stamos had told Ralph Pomeroy that he had talked with Rothko sometime in the early hours of the morning. He had repeated Rothko's complaints about the cold, leading Pomeroy to believe that Rothko must have been taking drugs.

The detailed notes that had been dictated by pathologist Judith Lehotay as she performed the autopsy tended to confirm the suspicion of the medical investigator on the scene—that Rothko had taken a big overdose of drugs. But what had happened to the missing medicine and their vials? Where was the Sinequan Dr. Kline had recently prescribed for his terrified patient? Why had no one but Dr. Allen Mead seen the empty vials on the floor, which had looked to him as though they had contained chloral hydrate? Where was the medicine for gout, hypertension, and all the rest? Had Rothko or someone else cleaned up all the medications and disposed of everything except the two empty vials found by Dr. Mead and the bottle half full of phenobarbital that Dr. Strega had found?

Signs of gastritis due to acute drug poisoning were found in Rothko's stomach and pylorus (the entrance from stomach to duodenum), according to Dr. Lehotay's report. In the stomach was "a large amount of undigested food particles and a cake-shaped, slightly firm chunk composed of greenish gelatinous material in which particles of undigested meat are imbedded. This cake measures 3″ × 2½″ in thickness. The fundus [base] of the stomach shows a round area

312

measuring roughly 2½ inches in diameter which shows a very severe acute gastritis and [sic] somewhat greenish in color. Similar greenish area is located at the pylorus where the mucosa also somewhat thickened and firm." His eyes were "dilated," his small intestines "very distinctly dilated." All of this was what led Dr. Lehotay (and the four pathologists who had witnessed the autopsy) to conclude that there were two probable causes of death, loss of blood from the slashed brachial artery and acute "barbiturate poisoning." Which was the actual cause was left to the laboratory to uncover. The suicide did not seem unusual enough to any of the coroners to investigate further; as they point out, people often try to anesthetize themselves against further pain by an overdose and/or ensure death by using two weapons.

But when Dr. Lehotay sent the contents of the stomach and samples of the tissues from the brain and liver with blood and urine to the toxicological lab, the lab found no trace of barbiturates. The tests had taken place the two days after Rothko's death, the day of the funeral. According to the report by Dr. Charles Ungerberger, the chief of the laboratory at the time, there was no alcohol in Rothko's blood, no "basic drugs" in the stomach, no traces of barbiturates in the brain tissue, and no acidic drugs in his stomach. His findings completely contradicted the autopsy and what was known of Rothko's habits and final hours. But no one was to become aware of these findings for several years.

As a rule, in the medical examiner's office no autopsies other than homicides are transcribed until there is an outside request for the records. The "Rothknow" Dictabelt was filed until December 26, 1972, when a request for information about the manner of Rothko's death was made. But the medical examiner's office did not record who made that request, so this too remains a mystery. Three days later, however, the tape was transcribed. The next request to be placed in the file next to the transcribed autopsy was Breed Abbott's letter of July 1973. But before the copy of the autopsy was sent to Ross, Dr. Milton Helpern, then New York's chief medical examiner, added his own notation to the two-and-a-half-year-old autopsy:

> Anatomical findings in stomach strongly suggest ingestion of a large amount of barbiturate but chemical laboratory reports negative findings!!

In view of lack of corroboration by incomplete laboratory

report, cause of death is amended to exclude barbiturate poisoning and listed as:

"Self-inflicted incised wounds of the antecubital fossae with exsanguination. Suicidal."

The autopsy revealed more about the manner in which Rothko's arms were slashed. There was only one cut which could be called a "hesitation mark"—not several, as the detectives had reported in the *New York Times Magazine* story. Rothko was right-handed, though he sometimes painted with his left as well. Putting together all of the evidence, the following scenario of Rothko's final moments can be constructed. Sometime during the night, he swallowed an enormous number of capsules in the kitchen. In the early hours of the morning he took a double-edged razor blade, wrapped one edge carefully with Kleenex, and with his right hand lightly scored the skin along the crook of his left arm—a cut 2½ inches long and ½ inch deep—the hesitation mark. Then, rather than making the second killing slash immediately on the same arm, he shifted the razor blade to his left hand and with a thrust almost powerful enough to sever his brachial artery, cut deeply into his right arm. The surface wound on this arm was 2" × 1". Somehow, before he keeled over he carefully put the blade on a nearby shelf. Was this physically possible? Although it would have required great strength, he might have managed it— unless the dose of drugs had put him under and someone else had made the gashes in his arms.

But at the time of his death, according to Lidov and Oliver Steindecker, Rothko was not wearing his glasses. Without his glasses he was so myopic that he could only stumble about feeling with his hands for familiar objects. In order to read he had to hold the print a few inches from his eyes. Could he possibly have made his way into the kitchen, found the razor blade, wrapped it carefully, and committed the violence to himself without his glasses? It is extremely unlikely. Where the glasses were found is not known, but somebody, presumably Mell, discovered them somewhere in the studio in time to put them on the body for the funeral-home viewing the following day.

Another element that leads to doubt about the positive finding of suicide is, of course, the absence of all the medicines. Who cleaned them up and why? Roy Edwards, who afterwards cleaned up the kitchen, might have been able to shed some light on this, but he has

moved to the Hare Krishna mission in South Africa. Oliver Stein-
decker, after answering some of Kate Rothko's questions about her
father's death, did not permit further interviews.

Shown a copy of the autopsy in 1974, Dr. John Devlin, one of the
deputy medical examiners who had witnessed the autopsy, said that
clearly the laboratory had "goofed." Reached at her new office in Buf-
falo as chief medical examiner of Erie County, Dr. Judith Lehotay
said that despite the fact that five years had elapsed since she had
performed the autopsy, she remembered that suicide victim well. But
she had never seen a copy of her autopsy or known what the lab's
findings were.

After Breed Abbott sent her a Xerox of the autopsy she said that
she was sure the laboratory had made a mistake. She was certain about
the drug poisoning, and further, she said, because of the greenish
color, she thought that he must have taken either green-colored cap-
sules or blue ones that the stomach secretions had turned green. Both
chloral hydrate and certain dosages of Sinequan come in blue capsules,
so either was a possibility.

Dr. Lehotay was angry that her findings had been challenged after
the fact and that Helpern had amended the cause of death to exclude
drug poisoning. At the same time, she had no reason to believe that
"Rothknow" was anyone more exceptional than a white male, sixty-
six years old, who the medical investigator had listed as an artist and
Morton Levine had identified as a painter. The fact that he was a
millionaire and that persons might have had motivation to murder
him was not known to her, nor had the police made it their business
to ascertain this.

In view of the circumstances and the challenge to her findings, she
suggested a possible course of action. Long after an autopsy is per-
formed, she said, the medical examiner keeps samples of tissues from
the corpse's brain and stomach. Probably Rothko's were still stowed
somewhere in formaldehyde in the lab in New York. To prove that
her findings were correct, she wanted to have two microtoxological
analyses performed on these tissues. The first should be done by the
lab in New York, which she said had improved since 1970, and the
second at her new toxicology lab in Buffalo. It was just a chance, she
emphasized, but if the tests showed that the drug had entered Rothko's
bloodstream, the dose was so enormous that he would have quickly

become unconscious and probably could not have done further violence to himself. Dr. Lehotay thought that such new tests would require a court order.

At Kate Rothko's request, Breed Abbott and Morgan immediately wrote Acting Chief Medical Examiner Dominick J. di Maio requesting such a test in early 1975. There was no response.

Sometime after Breed Abbott had received its copy of the autopsy with the Helpern amendment, a further mystery developed—or at least so it seemed for more than a year. The Rothko folder disappeared from the medical examiner's files with no clue as to its whereabouts. It was missing through the 1974 trial.

But the manner in which it reappeared in 1975 disposed of conspiratorial conjectures connecting the peculiar loss with Rothko's death and added a bizarre comic subplot to the macabre mystery.

In December 1973, after twenty years in office, Dr. Helpern resigned as chief medical examiner. After the newspapers uncovered several scandals in the coroner's office, he accused his ambitious deputies of leaking the stories. Two years later he would say, "I don't trust any of them," calling them "snakes." This self-protective reaction led Dr. Helpern to appoint as acting medical examiner a man whom he scarcely knew, Dominick di Maio, medical examiner in Brooklyn at the time. Di Maio was also to hamper, for no apparent reason, further tests to determine whether Mark Rothko had been murdered.

Evidently to avoid further embarrassment, in an act of self-preservation, Helpern, when he resigned, either saw to it that certain botched-up cases were put in some separate file or actually took the folders with him. Since the lab had mishandled the Rothko test and Helpern had amended the cause of death, the Rothko case could have caused him further embarrassment. At least this was the way that his former deputies perceived the results of the "old man's paranoia." One pathologist guessed what must have happened, and his guess was what led to a telephone call to Helpern. The folder immediately reappeared at the office.

After the Rothko autopsy resurfaced, a request was made to interview the new head of the toxicology lab, Dr. Milton Bastos, to go over the laboratory's notes on the case. But di Maio refused. The office's notes were "nobody's business," he said, and besides, he had read the autopsy and there was a simple explanation. "The man had been eating green

Jello." The toxicology notes could only be examined with a court order.

His opinion was denounced as absurd by Drs. Lehotay, John Devlin, and, even from his retirement, Milton Helpern. (Both Devlin and Helpern have since died.)

Eventually, a backstairs source did examine the lab notes and found that there was nothing in them to indicate more than what had been reported. But someone had erred. Further, Dr. Bastos, reached by telephone despite di Maio's edict, said that there were increasing numbers of suicides and deaths reported from antidepressant drugs— including Valium and doxepins (Sinequan is a doxepin). Moreover, he stated that the lab test given for barbiturates was entirely different from the kind given to uncover chloral hydrate and Sinequan. This kind of test had not been sought by Dr. Lehotay in Rothko's case, partially, perhaps, because Sinequan was a new and relatively un-known drug in 1970. If, as Dr. Mead concluded, the empty vials he discovered had contained chloral hydrate and Rothko had taken mas-sive sleeping drafts, there should have been a distinctive odor and other symptoms that an experienced investigator like Dr. Strega would have noted. Since she, instead, had deduced "barbiturate poison-ing," it is more likely that Sinequan was the agent that led to Rothko's death.

The only real hope of assuaging doubts about Rothko's suicide rests with the district attorney's office. If their investigation goes further than the "white-collar crime" aspects of the Rothko matter, perhaps they can gain the cooperation of Dominick di Maio, the police depart-ment, and the witnesses whose stories have altered so greatly since February 25, 1970. If the body tissue has not been thrown out, Dr. Lehotay can still analyze it for its drug content.

If Rothko was not murdered, he was pressured into taking his own life. The circumstances—including the medication, the forced selec-tion and sale of his paintings to Marlborough, the hypocrisy of his friends—ensnared him like a noose pulled taut by others. It was at best a kind of remote-control killing.

If it was murder, whoever did the unlikely deed need have contained his impatience for only a short while. The autopsy showed that Mark Rothko did not have long to live. Within the year it was likely that he would have died of any number of causes. What Dr. Lehotay found in her anatomical diagnosis—besides the acute gastritis in the stomach

due to poisoning—was: "marked senile emphysema . . . marked calcific and ulcerated atherosclerosis of the aorta and the coronaries with an aneurysm of the descending position of the aorta . . . occlusion of the left circumflex branch of the coronary artery"—all of which spelled imminent death.

The doctor's optimistic findings only hours before his death about the condition of his heart from his blood pressure tests at the medical checkup had proved as delusory as the outside of Pandora's box.

# 25 Questions of Perspective

Early in May 1976, Frank Lloyd ordered the shipment of those forty-one canvases which during the trial he had gone to such lengths to prove had been sold. To obtain the release of the several million dollars' worth of art impounded in Toronto, Lloyd decided to post bond. He put up $3,900,000 in cash and promised the return of the forty-one paintings for a credit of $3,400,000. At Lloyd's expense, the paintings were loaded aboard the S.S. *Dart Atlantic* at Antwerp for the eleven-day voyage to New York harbor.

On May 13, the mammoth packing cases were unloaded at the Morgan Manhattan warehouse to be placed in the care of Kate Rothko. Kate asked two trusted artist friends to accompany lawyer James Peterson to the warehouse. William Scharf and Daniel Rice

checked the condition of each painting and supervised the uncrating and storing. Since, according to Judge Midonick's decree, Lloyd was responsible for returning the paintings, if he chose that option, in the "best possible condition," the Marlborough registrar was there to take notes.

It was a dramatic morning. As one by one the brilliant canvases of the late forties, fifties, and early sixties were stood on end and examined, the dingy loading area of the warehouse lit up. Such dazzling canvases as the 1949 *Violet, Black, Orange, Yellow on White and Red* —on which the Australian government in 1972 had made a downpayment to Marlborough London—were home again. The handsome, subtle *Yellow, Pink, Yellow on Light Pink* that Katharine Ordway had coveted in the fall of 1970 and believed she had bought, had traveled far and returned. At last it was possible to see what the hotly contested battle had been about. There were the eight canvases Lloyd claimed had been sold to Arturo Pires de Lima, the four sold to Yoram Polany, eighteen of the twenty giants purchased by Count Marinotti, and eleven of a second batch of twenty-two paintings that had gone to the mysterious AEK in Liechtenstein.

Considering the amount of handling and touring the paintings had undergone over the past six years, they were in good condition. A few had been carelessly packed, superfluous nails and screws had ruptured some edges, and there were scuff marks and an occasional scratch. The stretchers told parts of the paintings' pasts. A couple with crazy-quilt patterns of staples and primitive knotted crossbars indicated that the artist had stretched those canvases himself in the days before he could afford to hire a professional cabinetmaker to do it. There were labels left from some museums that had mounted the traveling show— Rotterdam, Paris, Zürich. One had been shown in the Rosc Museum in Dublin. Marlborough Zürich and Marlborough-Godard Canada had affixed labels to the back of some, as had Italian customs officials to those paintings that had been part of the Venice exhibit. There was no sign of the supposed purchasers, Marinotti, Pires de Lima, Polany, or AEK, nor was there any indication that these paintings, since their hasty departure from the United States after the injunction, had left the Zürich warehouse.

As they worked, Scharf and Rice recalled helping Rothko prepare canvases and told each other stories about his way of working and his perfectionism. To an onlooker who marveled at the brilliance as well

as the soft subtlety of the color contrasts, Scharf explained: "You have to remember that Mark did not want to be a great colorist. He wanted to be a visionary."

After inspection, the paintings were stacked carefully in a special room on the top floor of the warehouse, where red velvet covered the walls and floor. There was a high vaulted ceiling with papered-over clerestory windows. It was like the inside of a large jewelry case or a specially outfitted mausoleum.

Meanwhile the bulk of the estate's paintings—some 600—were waiting in the new Marlborough warehouse in Queens to be catalogued, insured, and removed to new warehouses. It was to be a time-consuming job for Scharf and Rice, since the insurers specified that only $1 million dollars' worth of canvases could be removed in each vanload. The twenty-nine paintings left unsold from Lloyd's purchase of the 100 were shipped from abroad and trucked from Toronto to the warehouse.

On the first trip to the warehouse, Scharf and Rice were presented with a confusing sight. Canvases were stored every which way, some stretched and covered with plastic sheeting in racks or stored in bins and cardboard boxes. Visible, were several huge studies for the Seagram murals—the plum-wine vertical rectangles inspired by the trompe l'oeil windows of Michelangelo in the Medici library.

Most of the unstretched paintings lay flat on or rolled up at the head of a huge pallet about fifteen by twenty feet under a plastic tarpaulin. When Scharf later examined what was underneath, he discovered some "really fine" unknown oils and watercolors from Rothko's earlier periods—tall subway figures from the thirties, mythological studies from the early forties, and many superior surrealistic works from the midforties. In a nearby rack, Scharf found the red on red canvas that Rothko was painting just before his death. Unfinished and undated, this macabre final echo of his earlier, more colorful period was listed and appraised on the copy of the inventory he was using. Someone, Ben Heller perhaps, had scribbled in the margin next to it: $200,000. For its value as a curiosity, Scharf supposes.

Filled with paintings, the warehouse recalled Rothko's studio as it once had been and the grandeur of the artist's daring. And there, to put all in perspective, in a cardboard trough lay a smallish painting—about three by five feet—of brilliantly hued floating abstract shapes. It was mounted with a crude pitted crossbar stretcher, obviously

knocked together by the artist. A small yellowed, half-unstuck label contained the following handwritten legend in faded ink: *Mark Rothko, 1948, Betty Parsons Gallery, $500.*

On the evening of May 27, 1976, Sotheby Parke Bernet in New York held a sale of "Important Post War and Contemporary Art." The auction, it was predicted, would reverse the general flabby state of the art market that had prevailed for the preceeding two years. Though dealers from around the world were present and diamonds flashed on the nervous fingers of well-known collectors, the atmosphere was far from the frenzy of the late sixties and early seventies. Only three paintings were considered to be of sufficient importance to possibly break previous auction records for their creators: Francis Bacon's *Reclining Man with Sculpture,* valued at $150,000 to $200,000; an Arshile Gorky, *Soft Night,* executed in 1947, just before the artist's suicide, estimated to bring in between $120,000 and $150,000; and a large Rothko painted in 1962, misty floating rectangles of *Sienna, Orange and Black on Dark Brown,* appraised at from $180,000 to $200,000.

The painting was not one of Rothko's finest, not nearly so delicately contrasted or so dramatic as the paintings Lloyd had recently returned to the estate. But Kate's lawyers and dealers in contemporary art waited in suspense to see what it would bring. The bottom estimate was double the $90,000 credit valuation the judge had fined Lloyd for similar but superior oils. If the painting came close to its estimate, Ben Heller's projections, which the judge had dismissed as "too optimistic," would be supported and any appeal by Marlborough of Midonick's decision could be further jeopardized. Parke Bernet, secretive as usual, refused to divulge the seller's name. The provenance listed was misleading: "Marlborough Gallery, New York; Marlborough A.G., Zürich" (Marlborough A.G. is in Liechtenstein). The painting was also said to have been exhibited in the Gallery Beyeler in Basel in 1971. By comparing inventories and slides, lawyer James Peterson discovered that the painting was one sold by Rothko to Lloyd in February 1969. Rothko had received $19,000 from a retail price of $32,000. Marlborough's brief identified this oil as having been sold to Leonides Goulandris that same December for $40,000. (This is disputed by a former officer of Marlborough who says that no oil this size was sold for as little as $40,000.) In 1972, it was reconsigned to Marlborough by Goulandris and sold to Count Marinotti for $70,000.

There Peterson's paper trail ended. A New York dealer, however, is positive that in 1974 he was offered this same painting for $150,000 by Ernest Beyeler in his Basel gallery.

The canvas was carried on stage by two uniformed attendants. The bidding was swift and sure. Rapidly the price rose to $190,000, where it was knocked down. Exactly midway in the house estimate. Auction insiders speculated that it was all too pat.

Parke Bernet remained mum about the buyer. The public relations department identified him as a "European collector," but good customers were told a "European dealer." Rumors were fanned that it had been purchased by the wife of the Shah of Iran, who reportedly had developed a passion for Rothkos equal to Bunny Mellon's. But streetwise dealers speculated that the purchase was made by Beyeler himself, who, they thought, had put the painting up through a friendly dealer, in order, possibly, to establish a new plateau for Rothkos. After all, Beyeler had been buying Rothkos assiduously over the years and still owned a good number. Perhaps, they guessed, Beyeler now had hopes of handling the estate as well.

As in other art dealings, there is no way of checking Parke Bernet's records. The way Lloyd had explained auction practices: "There's so much monkey business going on in auction sales that nobody knows what has been sold, what are the reserves, what are the conditions. . . . One has to check every sale, because in order to get high prices . . . they [dealers] create an artificial market, and dealers are putting up paintings for sale to establish high prices, which they buy back themselves."

Also, the record price—the highest ever paid at auction for an abstract expressionist painting—demolished Lloyd's contention that Midonick's estimates were too high and that Lloyd alone had been able to cause Rothko's prices to skyrocket.

The ramifications of the Rothko decision had not been lost on other art dealers. Long an outspoken critic of Reis and Marlborough, Richard Feigen, who had offered to testify against them, later commented: "The whole case is bad for the art business and for the reputation of art dealers in general. Marlborough has besmirched us." Grace Borgenicht agreed, adding that the verdict "might shake people's confidence in the art world," but also noting that it would be wrong to judge other dealers by Marlborough's standards.

After the decision, pressures from member dealers finally forced the Art Dealers Association from its ostrichlike position. Ralph Colin,

323

still spokesman, mainstay, and administrative vice-president of the ADAA at a feisty seventy-five years of age, issued a public statement. It was his first about the lawsuit since late 1972, after the injunction, when, speaking for the ADAA, he had publicly supported Marlborough (also his client) and said that there was "no merit to the case." He reported that discussion of the case at meetings of the association had been banned by ADAA directors "so long as litigation was pending in the courts." Now Colin stated that the board was "following the developments and frequent discussions of the developing situation have occurred at board meetings. . . . Now that the court has rendered an opinion containing findings and views which are most disturbing," there would be an emergency meeting of the board.

But Frank Lloyd scooped his old friend Ralph Colin. Lloyd had Marlborough vice-president and administrator Richard Plaut write a letter of resignation to the ADAA and release it to the *Times*. Plaut charged Colin with "obvious impropriety" in issuing the statement "prejudicial to the interests of Marlborough," since the case remained "in active litigation." He added pointedly that Colin formerly had been Marlborough's "general counsel and trial counsel during the early stages of litigation."

After Colin had received the letter, ADAA directors were polled by telephone. The resignation was not accepted; two days later Marlborough was formally expelled. As Clyde Newhouse, the ADAA's president, announced, "The board decided that Marlborough, having been publicly declared by a court of justice guilty of misconduct and having been penalized accordingly, no longer met the standards required for membership in the association."

The dealers closed ranks. In his statement, Newhouse went on to say that the Rothko case would *not* set a standard for future conduct of dealers. The ADAA, he said, did "not agree" with Edward Ross's published statement that art dealers "should be at least as honest as the people who deal in stocks." Newhouse then made an unfortunate comparison: "The behavior of Marlborough as a dealer and of the three Rothko executors as executors is no more typical of the behavior of art dealers and executors generally than was the behavior of Mr. Ross's fellow lawyer John Mitchell typical of the behavior of lawyers." He continued: "No change in the legal ethics of responsible lawyers was brought about by the Mitchell case and no change in the ethics of art dealers is required now." So much for the post-Watergate art world mentality and hopes for reform. Later, after heated delibera-

tion and some high-handed politicking, the board determined that Daniel Saidenberg's complicity in signing the false appraisals was not unethical enough to merit expulsion from the association.

From the outside the proceedings of the Art Dealers Association seemed farcical, but seen from the cockeyed gossipy inner circles of the art world, the events were far more comic: Marlborough-watchers knew that Richard Plaut had been hired by Frank Lloyd because he was Ralph Colin's nephew.

Before the Toronto escapade, many in the art world were prepared to forgive and forget Marlborough's transgressions in the Rothko matter. That all dealers take liberties when they can get away with it, was the typical attitude expressed at social gatherings. New York needed the glamour and fiscal power still associated with Marlborough, people said; in the Rothko affair, Lloyd had merely gone too far—his profit margin was too high, the collusion too clear, and so he had gotten what he deserved. With his purse about to be depleted, he would be compelled to behave. But after news of the Toronto art cache hit the front pages, this laissez-faire attitude was noticeably altered. Now it was obvious that had Lloyd's attempt at removing his assets proved successful, not just the Rothko heirs, but many others, would have been affected.

After Toronto many of Marlborough's stars left the gallery. Lee Krasner Pollock, for sixteen years Lloyd's staunchest defender, deserted, taking the remains of the Jackson Pollock estate with her. She settled on Arnold Glimcher of Pace; Rita Reinhardt also went with Pace. The widow of Adolph Gottlieb took his estate to André Emmerich and Richard Diebenkorn went to Knoedler.

At first it was hard to tell whether adverse publicity had damaged business at the Marlborough Gallery. For several months, its many opening parties were jampacked with celebrities; nearly all the exhibits received extensive coverage in both the society columns and the art press. Following a trend, in the fall of 1975, the gallery ventured into photography, signing on Richard Avedon and Berenice Abbott among others. Artists whose contracts with Marlborough had not expired included Red Grooms, Alex Katz, and Botero. And then, surprisingly, in the spring of 1976 the gallery tried on a new image: Marlborough the charitable. When it mounted Red Grooms's *Ruckus Manhattan*, a wildly imaginative caricature in sculpture of the city, its architecture, inhabitants, and way of life, the admission charge of

a dollar per person was said to be a contribution to the Citizens Committee for New York City, a new non-profit, volunteer agency established to raise funds and help organize vital services for the near-bankrupt metropolis in its hour of need. But the use of the committee was another ingenious Marlborough scheme. Not only was the gallery hailed and publicized locally for its public spirit, but the Grooms show was featured on the "Today" program and throughout the national media. Sixty-six thousand visitors poured into the gallery. Corporations were asked to buy Grooms's *Brooklyn Bridge*, his hilarious *Pimpmobile*, and other pieces from the mammoth show and donate them in the name of the committee to museums and public institutions. The tax write-off was stressed. Naturally, the gallery's commissions, overhead costs, and other outlays would be deducted from the profits. When asked by a reporter who the show would benefit, Grooms replied: "Me mostly, in a way. The money [from admissions] will be used to buy one of the pieces for a museum here, I think." But after realizing how the non-profit committee had been manipulated, its chairman, Osborn Elliott, then *Newsweek* editor-in-chief, ordered that the arrangements be renegotiated so that at least some of the funds raised could be used for more sorely needed municipal services.

The godfather of Grooms's brainchild was not present for the christening of his new and short-lived charity. Still smarting from the Toronto fiasco, the posting of the $3,500,000 bond, and the return of the Rothko paintings to the estate, Lloyd had not been seen in New York since the Francis Bacon exhibit at the Metropolitan a year earlier. Perhaps another reason for his absence was that the grand jury continued to sift evidence and interrogate witnesses from Marlborough's present and former staff to determine whether criminal charges were in order. To represent him in these proceedings Lloyd had hired yet another defense team headed by Peter Fleming, the defender of former Attorney General John Mitchell in the Watergate trials.

In August 1976, there were further invisible changes in the Marlborough setup. In the Bahamas, Lloyd's name was deleted from ownership and his nephew, Pierre Levai, became sole owner of the gallery. This became known when Levai privately initiated a plan to expand Marlborough's operations into another highly competitive field, the discotheque bar business. A former CBS studio was to be converted into a huge swinging jetset disco, called Studio 54. An application filed with the New York Alcoholic Beverage Commission in August

1976 stated that the chief stockholder of this enterprise was to be Yoram Polany, the international playboy friend of Gilbert Lloyd who, using what proved to be a false address in Hong Kong, had purchased four of the "parked" Rothkos from Lloyd. These four paintings happened to be among those Lloyd claimed to have bought back from the "purchasers" and returned to the estate. Polany's application named as a partner in the venture a German male model, Uwe Harden, and stated that financial backing was to come from one of Frank Lloyd's banks, Chase Manhattan of the Bahamas. But when New York State liquor license investigators questioned the source of the collateral, new papers were hastily filed stating that Marlborough Gallery, Inc., owned ninety-three percent of the stock. To investigators and the petitioning lawyers in the Rothko case, it seemed clear that Lloyd was repaying Polany for past favors. After a *New York Times* story exposed the background of this new venture, Marlborough dropped out of the project.

The New York gallery was reduced to an even emptier façade as its staff dwindled. Richard Plaut, the administrator, left, taking with him at least partial knowledge of how during the Rothko lawsuit Marlborough's books were doctored to camouflage the gallery's culpability.

Then, on Tuesday, March 8, 1977, District Attorney Robert M. Morgenthau announced that the New York grand jury had indicted Francis K. Lloyd on February 24 on two counts of tampering with physical evidence, and a warrant had been issued for his arrest. If convicted of both counts, Lloyd would face a possible eight years in jail. Lloyd was charged with "acting in concert with others" to suppress or destroy entries in the Marlborough stock book and to cause false entries to be substituted when the ledger was subpoenaed during the Rothko pretrial examinations in 1973. Morgenthau added that the grand jury was still holding hearings on the case. Further indictments might follow. Thus, it was the cover-up of the paper trail left from the travels of Rothko's paintings that finally ensnared the master dealer, despite all his high-priced lawyers. It remained to be seen whether the grand jury could pursue the travels of the thirteen paintings with the questioning of witnesses to prove "beyond a reasonable doubt" the alleged complicity of Bernard Reis.

In the indictment, Lloyd was declared a fugitive from United States justice. Morgenthau announced that he had alerted Interpol and expected that whatever country sheltered Lloyd would proceed with his extradition. But *Times* reporter Edith Asbury dialed Lloyd's

Bahamas number and found him installed with his family on Paradise Island. He was not, however, his usual voluble self: his only reply to her was "no comment."

With the reported backing of Gianni Agnelli, Lloyd was now investing heavily in the expansion into the Bahamas of the international chain of resorts, Club Méditerranée. Having purchased the estate of the late Lady Bailey on Paradise beach, he was now bulldozing forests and hunting preserves into tennis courts to entice the international jetset to his new resort and to the banks and casinos of the Bahamas. The courts of New York, it seemed, were a long way from delving further into the activities of their elusive quarry.

The lawyers involved with the "Matter of Rothko" and all its numerous derivative lawsuits, the appeals, and the tax negotiations continued to bill millions more dollars in legal fees and expenses. By 1977, Kate Rothko's legal fees and indebtedness had mounted into the several millions. Asked how it felt to be such a grand debtor, her husband Ilya Prizel replied for her: "We decided long ago that the first ten thousand dollars was overwhelming: after that it doesn't seem like money anymore."

Although Kate had won the initial victory—the paintings had been returned to the estate and she, as administrator, was officially their overseer—she still was unable to take charge. Pending the appeals, it was necessary to apply to the court for important decisions about displaying the paintings. Even more ignominious, it was necessary to obtain Frank Lloyd's permission to display them. Consequently, in October 1976, when the Guggenheim Museum selected for a major exhibit two estate paintings that Lloyd had returned, Marlborough's lawyers refused to give permission (going so far as to threaten legal action) unless both attributions read: "The Estate of Mark Rothko, *courtesy of Marlborough Galleries*," a final, ironic show of Marlborough's power.

And what of Rothko's legacy and his hopes for the life his paintings would lead in posterity? Many of those sold had vanished, but the paintings that had been returned to the estate would be exhibited. (A Rothko retrospective will be mounted at the Guggenheim late in 1978 and will later travel across the country.) And the future safety of his work was newly assured. Though Judge Midonick had banned evidence and testimony about the Mark Rothko Foundation from the

trial record, his decision in favor of the heirs did serve to benefit both the memory of Mark Rothko and the public interest in his paintings. True to his promise during the administrator hearings in court, Gustave Harrow had set about the restructuring of the Mark Rothko Foundation. Reis and Stamos had resigned as officers and directors in January 1976, writing Wilder that pending appeal they did not intend to participate in the affairs of the foundation. Without judicial mandate but with the persuasive power of his position, Harrow interviewed president Clinton Wilder and directors Stanley Kunitz and Morton Feldman who agreed to resign when their terms expired in May 1976, and vote in a new slate of directors that would meet both their and the attorney general's approval.

In the spring of 1976, Harrow consulted dozens of prominent art world personages about recommendations for new directors. There was a notable lack of consensus on most individuals proposed, and Harrow was repeatedly surprised by the misconception, distortion, and myth that still surrounded the lawsuit. He discovered that those who had taken a position or had offered to testify in the suit were considered "too controversial." On the other hand, persons who had taken no position or had decided early not to become involved were safe bets. A long list of people were rejected because of conflicts of interest: though some associations were public knowledge, many more were hidden beneath layers of past relationships and alliances.

Harrow settled on seven highly motivated individuals who met his standards and those of most of the people he had consulted. At the foundation's annual May meeting, after some stalling, Wilder, Feldman, and Kunitz agreed to resign and elect the new slate. The new directors of the Rothko foundation were: retired MOMA curator Dorothy C. Miller; Guggenheim director Thomas Messer, who had been the first expert to testify in support of Rothko's stature; MOMA trustee and collector Gifford Phillips, nephew of the late Duncan Phillips of the Phillips Collection in Washington, D.C.; Emily Rauh Pulitzer, wife of collector Joseph Pulitzer, Jr., and a former curator of the St. Louis Museum; Donald M. Blinken, whose parlor had remained a sanctuary for some of Rothko's paintings since he had acquired them from the artist twenty years earlier. There were also two artists: Jack Tworkov, a contemporary of Rothko's and William Scharf, the artist's one-time assistant and with his wife Sally a devoted friend of the family for many years.

It was only when Harrow set about collecting basic documents

pertinent to the foundation's history that he was able to discover what had happened behind the charity's outward benevolence. There existed little evidence in writing of Rothko's intentions for his artistic legacy beyond a newly found letter that the painter had written to Herbert Ferber and Bernard Reis as an adjunct to the first vague will Reis had drawn up in 1959. But there were many in the art world who attested to Rothko's passionate concern for his creations and their grouping and display. The letter that William Rubin had written Reis in 1970 challenged the change in the foundation's purposes after Rothko's death.

When Harrow demanded copies of the foundation's minutes, what he received proved scanty and incomplete; key minutes had disappeared and some of the papers looked like thank-you notes written in the large spidery hand of Becky Reis. But even with the omissions, the minutes were revealing. They showed how Reis and Stamos had used the charity to further their own ends and how the attempt was made to manipulate Goldwater, using the promise of exclusive access to the Rothko papers.

A dossier of even more damaging documents came to light in a curious fashion. At the outset of the trial, lawyer Gerald Dickler, acting for Christopher Rothko, had subpoenaed relevant papers from Robert Goldwater's estate. But Dickler had not shown the papers to his fellow petitioners, depositing them instead in his firm's files for two years. Harrow now discovered the draft of the August 1972 affidavit Goldwater had sent Greenspoon, in which Goldwater stated that Rothko had told him that the foundation was primarily meant to hold the artist's paintings for exhibition and promulgation in museums. Another document that Goldwater evidently considered of supreme importance was his statement challenging the foundation's appearance in the lawsuit, which in November 1972 the other directors had refused to let him read into the minutes of the meeting. Had Harrow been apprised of the contents of these records, he might have been able to convince Judge Midonick that, at the very least, the role of the foundation bore investigation by the court.

And so from a surprising source a further instance of concealment was uncovered—too late, of course, to change the Rothko lawsuit. But there would be one lasting gain from Goldwater's testament: a new direction to the foundation and new directors receptive to his beliefs.

But, again, Reis and Stamos, seeing the new foundation as a threat to their appeal, determined to dominate matters or at least delay the

pending appeal. Although they had resigned as officers and directors early in 1976, nine months later, as the fledgling foundation was about to meet for the third time, Reis and Stamos challenged its legality. Arthur Richenthal wrote acting president Donald Blinken charging that Harrow had illegally wrested control from "all persons named by Mark Rothko." The letter also charged Harrow with illegally altering the purpose of the foundation, stating that "all surviving directors named by Rothko are unanimous in their understanding that the primary objective . . . is the sale of Rothko paintings and the use of the funds for the aid of mature creative artists, musicians, composers, and writers." They threatened suit if the foundation took any action or spent any money before the appeal was decided.

In late November, Richenthal made good these threats, filing suit in New York Supreme Court for Reis and Stamos against Harrow personally and each of the new directors of the new foundation that he charged was "illegal," being the result of a "rump" meeting in May, before which Harrow had resorted to "coercion and duress," and "overt and inherent threats" to force the resignations of Kunitz, Wilder, and Feldman and to have them elect his own "handpicked slate" of directors. Harrow's actions, Reis and Stamos claimed, were "perverting Rothko's intentions for the Foundation"; his purpose was to block "any further support by the foundation of the estate contracts made with Marlborough," and to reverse the "position of the foundation on the appeal." The technical basis for the suit seemed to be that Reis and Stamos said they had not received notice of the May meeting. At first Clinton Wilder backed this position with a sworn statement but later reversed his position in a sworn deposition taken by Harrow. It appeared that Richenthal's latest strategy was another calculated bluff to scare the foundation out of supporting Kate and Christopher Rothko in the appeal.

Armed with his new documents, Harrow welcomed the opportunity to fight back. The new information about the foundation, including the minutes of its meetings and Goldwater's challenges, would be on the public record for the first time. Harrow took more depositions from Morton Levine and Clinton Wilder that clearly attested to the maneuverings of Richenthal and Karelsen that had led to the retention of Greenspoon as lawyer for the foundation. Rita Reinhardt now gave Harrow an affidavit stating that Rothko's "overriding concern" up until his death had been for the future of his paintings. They often had discussed this and the fact that the foundation was primar-

ily to be devoted to carefully holding the paintings in groups to be properly displayed in museums and special environments. Only secondarily, and only because Bernard Reis had told him it was necessary for the IRS, had Rothko agreed to give grants to elderly artists. Kate Rothko submitted a similar affidavit. By the time of the hearing in late December 1976, Richenthal had retreated. Two weeks later, New York Supreme Court Justice Sidney Asche dismissed the suit.

When a hearing was held on the appeals, in February 1977, and the old troupe of lawyers reassembled to argue again, this time in the Appellate Division, the reconstituted foundation was newly represented and reversed the position of the old foundation, filing an uncontested brief against the defendants' appeals for the side of Harrow and the heirs of Mark Rothko.

A month later, the five-judge panel handed down its opinion affirming Midonick's decision—with one small modification. Kate's option to choose which paintings the estate would take back from Lloyd was deleted from the decree; the estate had to accept any paintings Lloyd chose to return. Two judges dissented on Midonick's pro rata assessment of damages, which they believed ought to have been based on the value of the paintings in May 1970.

No time was lost in the next and possibly final round of appeals. By August 1977, all the printed shortened briefs with fat appendices full of selected evidence had been presented to the New York State Court of Appeals in Albany. Oral arguments were scheduled for October 4, 1977.

But at the last minute, Richenthal decided to play one last trump card. Gerald Dickler had recently been examined in the federal case by the lawyers for defendants Karelsen and Saidenberg. For the first time, Dickler admitted that he had been informed by Reis in the spring of 1970 that the executors were contemplating a sale to Marlborough, and that he had been given a copy of both the Saidenberg appraisal and the Karelsen opinion letter in May 1970. Dickler, in fact, had warned Reis about his conflict of interest and Reis had assured him that he would submit any deal to the Surrogate for approval. There was no evidence that Dickler had shared his knowledge with Mell Rothko, but the inference was there. What Dickler's testimony also revealed publicly was that he and Reis were old friends and had worked closely together on various artists' and widows' business affairs.

Richenthal, however, using Dickler's deposition, persuaded Bernard

Greene, Levine's lawyer, to join him in a motion in the Court of Appeals, charging this new and "uncontrovertible evidence" showed that Ross, Harrow, Dickler, and the foundation had perpetrated "willful and fraudulent misrepresentations" on the court when they claimed in their briefs that the executors had deliberately concealed the Marlborough contracts from the beneficiaries. Both Dickler and Mell Rothko, the motion claimed, had been informed of the deals by Reis in the spring of 1970. The executors' lawyers heard about Dickler's testimony from none other than David Peck, who, they added, backed them to the hilt on this motion.

In his reply, Dickler stated that he had been told by Reis that the executors planned a sale to Marlborough and had warned Reis about conflict of interest; Reis had promised to keep him posted and send him a copy of the contract, neither of which he had done. Dickler claimed that he was unable to pry out any facts about the sale until the June 1971 confrontation in Karelsen's office. To support his position, he cited letters, office memoranda, and the fact that neither Reis in his pre-trial examination, nor his lawyers, had ever previously made use of this "new evidence" or had attempted to call Dickler as a witness in the trial.

Ross and Harrow were surprised to learn from his deposition that Dickler had in his files a contemporaneous copy of the Saidenberg appraisal and the Karelsen opinion letter. Harrow was particularly angry to discover that Dickler also possessed the 1970 letter Robert Goldwater had written Bernard Reis, the letter for which Harrow had been searching since Goldwater's death. This was not introduced in evidence at the examination, however, and when Harrow demanded it, Dickler refused to turn it over to him, citing attorney-client privilege (in his role as the foundation's recharterer).

Both Harrow and Ross scoffed at the legal merits of the new motion. In their replies, they pointed out that Reis himself had concealed these facts and alleged conversations and that the alleged evidence had been available to the defense through Reis throughout the trial. Although Ross and Harrow had introduced in their arguments the executors' concealment of the contracts from Kate and the non-executor directors of the foundation, Judge Midonick's decision had not dealt with the question of concealment.

But the Richenthal-Greene motion opened the way for both Ross and Harrow to bring up new evidence of a far more damaging nature to the other side. Harrow produced the facts and testimony he had

amassed in the Reis-Stamos suit against the new foundation. The record now showed how the foundation was subverted to serve Reis's purposes and how Greenspoon was improperly retained.

Ross outlined Lloyd's criminal indictment and recent testimony by Richard Plaut in the same federal suit. Plaut had recanted the story he told in his 1973 pre-trial deposition; now he specified that it was Frank Lloyd who had ordered him to destroy the Rothko slips and type new ones omitting prices. And, in the same federal case, the Xeroxed pages of the old stock book that Lloyd had claimed was lost, were found by Sullivan and Cromwell and put into evidence (but temporarily sealed by the federal judge). Finally, Ross had incontrovertible evidence that the asking prices and certain sales for the Rothko estate paintings were much higher than Marlborough had ever admitted.

Eight years have passed since the death of Mark Rothko. The major questions about what happened to his paintings have been answered. Justice has prevailed; the wrongdoers have been punished. Or have they?

Judge Midonick singled out Reis and Stamos for having betrayed their dead friend for their own betterment. Yet it is highly likely that neither they nor Levine, aside from a possible social stigma, will suffer much in terms of the fines and damages meted out by the court. Lloyd's bond will pay those charges, if further appeals are lost. Except for dismissal from their lucrative executors' posts and the fat legal fees, they have lost little. It was Lloyd who seems to have reaped the profits, so perhaps it is fitting that he be the one to pay. But was it not Bernard Reis who played the most duplicitous role in the affair?

After the decision, Reis continued to live in his fine Manhattan town house surrounded by masterpieces. He and Becky regularly attended museum and gallery openings and he still sat on the dais of the annual Lasker foundation awards luncheon. An octogenarian, he occasionally was pushed about in a wheelchair by his live-in secretary Ruth Miller. He still managed to avoid giving testimony in the legal offshoots of the Rothko trial. At every turn his lawyers would produce new letters from his doctors attesting to his infirmities, including a "severe depression" suffered as a result of the decision. A protracted holiday in the summer of 1976 was urged by his psychiatrist, Dr. Nathan Kline, in a note to Becky Reis, in order that Reis might be "temporarily relieved as far as possible of all harassing situations

which are so detrimental to his chances of recovery." Again and again, his lawyers stated that testifying would endanger his health and his life. Reis himself would cite ill health when he finally sent in his letter of resignation as an officer and director of Marlborough after Lloyd gave the gallery to Pierre Levai.

Despite Richenthal's continuing protestations that depriving Reis of his art ("the decor of his home") to pay the judgement would endanger his life and cause him great emotional strain, Reis began surreptitiously selling his collection. By the fall of 1976, visitors to the town house were struck by the fact that where original works of art once hung, there now were prints and lithographs. One collector told of offering Reis a good price for two pre-Columbian masks only to discover that Reis had sold them for half that price to private dealers. Evidently at considerable financial loss—but hoping to keep his transactions confidential—Reis was converting his art into cash.

Frustrated that Reis's frailty had blocked his testimony for three and a half years, Kate's lawyers decided in late September 1976 to put it to the test. Breed Abbott hired a private detective to shadow Reis for a week and to snap photographs of him as he went about his daily business. In these pictures, Reis appears exceptionally keen and spry for his age and is seen walking without a cane, usually arm-in-arm with Ruth Miller or Becky. With these illustrations the lawyers were able to persuade the judge that an outside doctor be appointed to examine Reis. But for months Reis never appeared for the scheduled examination. Finally, in late June 1977, Reis was examined at his doctor's office by two outside physicians. Within seconds of the doctors' first question, Reis burst into tears. He was "being persecuted," he cried, being accused of "murdering" his best friend—"and all the people who want make a lot of money." It was the "bastard lawyers" who were doing this to him. But, the doctors found, even during several such emotional outbursts, Reis's blood pressure did not change nor were there any other debilitating physical effects. After a thorough checkup, they concluded that considering his age and previous stroke Reis was in pretty good shape. Since his doctor had ruled out any court deposition, they recommended that if he were to be examined, the deposition take place at his home. On reading their reports, however, Judge Midonick ruled that Reis was too ill to testify, adding that, in any case, Kate's lawyers had not presented a strong enough argument to compel Reis's testimony about the estate's accountings.

The friends who still attend the Reises' small dinner parties say

that, despite his infirmities, his mind is as sharp as ever. Some of his friends maintain that it was Reis's goodness and protectiveness toward Rothko that brought on the tragedy. Becky quotes sculptress Beverly Pepper who once said, "For God's sake, *stop*, Bernard. He'll kill you." Becky adds, "Who was it who said, I believe it was Andrew Mellon, 'No good deed goes unpunished'?" The view of the Reises' circle is expressed by their friend Stanley Kunitz: "It was Mark's paranoia those final years that destroyed him, and everyone he knew and everything he touched."

But it was not Rothko's paranoia that caused his death, nor did paranoia destroy his ambitions for his creations. Indeed, his deepest suspicions about the art world were warranted, although they may have been fatally misdirected. What finally destroyed him—whether by suicide, murder, or a remotely controlled death—was the greed of others for the profit from the merchandising of his immensely valuable paintings. There were very real pressures on him early that February morning. Marlborough was about to violate the sanctuary of the storage places containing his masterpieces and force a further sale. The realization that he had misplaced his trust, that he had been seduced by Swiss bank accounts, that Reis was working on Marlborough's behalf, must have deepened his anguish and helpless despair. The knowledge that he allowed sycophancy and the apparent concern of others to flaw his judgement could only have added to the torture. In his drugged and weakened state, he could have seen no way to protect either himself or his work. What the entrepreneurs aimed to wrest from him when he was alive became an easy plunder after his death.

The intricacies of art dealings were revealed for the first time in the Rothko proceedings—as were the specific dangers and temptations inherent in today's art scene. It is a small, incestuous world where vast sums of money frequently change hands. Secrecy or "discretion" are the hallmarks of each and every deal—even sales at public auction —so that rigging is not only expected but silently condoned. The mere fact that it took a costly civil court battle with armies of attorneys to expose these scandalous transactions indicates how immune the art world is to normal business ethics. Commerce in art is unregulated: there is no watchdog agency equivalent to the SEC monitoring private art trading even though many of the same manipulations occur on upper Madison Avenue and Wall Street. Because of its unique nature,

it would be difficult to apply to art the general commercial code regulating the trading of most other goods.

As with so many investments tailored for the rich and powerful, art buying, selling, and collecting, contain built-in gimmicks to conceal and inflate income and to avoid taxes. The IRS, the only agency with power to scrutinize these dealings, informally admits bafflement about how to unscramble dealers' books and how to enforce tax laws on sales that, at least outwardly, seem to take place in remote havens outside the United States. One veteran of thirty years with the IRS says: "Of course we are aware that these things go on; on occasion we have even tried to investigate them. But we do not have the men, the money, or the expertise to follow through." Inevitably such investigations are defeated by the banking secrecy laws of Switzerland, Liechtenstein, Bermuda, the Caymans, the New Hebrides, and the Bahama Islands, and all the other tax havens. The financial advantages to the governments of these places under the present system would seem to preclude any reform.

Not only is supervision of art dealings unenforceable abroad, but in the U.S. tax officials depend on the art world to regulate itself. The Art Advisory Panel of the IRS is comprised of a handful of interested parties: dealers who are members of Ralph Colin's ADAA, and museum directors and curators. Since 1968 when it was created, the panel has confidentially reviewed declarations of appraised art by estates as well as the charitable gift deductions by collectors and other donors of art. By its very composition and the secrecy surrounding its deliberations, the panel cannot help but foster some favoritism, inside tips, and conflict of interest.

As a result of this lack of public scrutiny and regulation, the art marketplace remains almost as wide open for ill-gotten gains as the old West during the days of the railroad barons a century ago. And with the murky inequities in our tax structure—the laws are as unfair to artists as they are advantageous to art entrepreneurs—a whole new breed of accountants and lawyers has been spawned, fattened, and over-rewarded.

Some mysteries concerning the legacy of Mark Rothko remain; some answers, such as the whereabouts of the numbered Swiss accounts may one day be forthcoming. The paradoxes surrounding Rothko's death and other fascinating questions (Who stole the three paintings from the studio and arranged for their return by an anonymous dentist?

337

# THE LEGACY OF MARK ROTHKO

What happened to the hundreds of paintings on paper said to be missing from Santini Brothers warehouse?) will probably have to be left to conjecture. The tracks were well covered long ago.

On the surface, at least, the art world seems to have knit together again. The old façades are refurbished, the old alliances of money and power still reign. There continues to be a general disinclination to face what the Rothko trial revealed to the art world about itself and some of its prominent members. Eyes are averted at its mention. It came close to tarring too many.

But the ghost of Mark Rothko continues to haunt the international art world. As an artist, his longings for immortality seem to be on the way to fulfillment. Almost as surely, through the strength and perseverance of his daughter and an assistant attorney general, he will achieve lasting fame on another level: as the hero and the victim of a modern morality tale. It is a role Rothko would have welcomed in the time before his principles were compromised by success, Francis K. Lloyd, and numbered Swiss accounts.

*On November 22, 1977, after six tortuous years of litigation, the New York State Court of Appeals handed down the landmark decision that finally and resoundingly marked the end of the "Matter of Rothko." Describing the conduct of the artist's executors as "manifestly wrong and indeed shocking," the court's seven judges unanimously upheld the Surrogate's decision imposing fines and damages totaling nearly $9.3 million on the executors and Francis K. Lloyd of the Marlborough galleries.*

# Notes

The primary sources for this book were, of course, the myriad court records in the "Matter of Rothko," and the numerous proceedings emanating from the central case. Particularly useful were the exhibits, pretrial depositions, affidavits, and lawyers' briefs. I attended the eighty-nine day trial throughout the eight months it lasted, and have used the 14,501-page transcript to double-check my copious notes and impressions. When I have made use of witnesses' statements to describe events that occurred anytime before the inception of the lawsuit in November 1971, I have identified the source in the notes. Also included in the notes are significant inconsistencies in testimony, and supplementary facts directly related to the narrative.

I wish here to reemphasize that the theme of the book is Rothko's paintings, his relationship to them, their bizarre peregrinations, both on paper and geographically after his death, in the international art marketplace and through the courts of justice. To tell their story, unfortunately, it was necessary to condense the life of their creator. I hope that someday Rothko's biographer will fill in the many intriguing gaps that I perforce have left.

Much of the early biographical material on Rothko comes from

conversations with his brother Albert Roth, who died last spring. Rothko's classmates in high school and college provided glimpses of his youth, specifically the years from 1915 to 1923. I am indebted to other artists and to Sally Avery for describing some of Rothko's early struggles in New York. (I was unable to locate Rothko's first wife, the former Edith Sacher, who has remarried.)

To some extent the material about his middle years comes from books and articles and news stories. Unpublished letters Rothko wrote to Betty Parsons, to museum directors, and to fellow artists—particularly those to Herbert Ferber and Robert Motherwell and Helen Frankenthaler—as well as letters written by these and other artists to or about Rothko were also helpful. For access to many of these letters I am grateful to the excellent library on microfilm at the Archives of American Art in New York. Others were collected for, but not necessarily put into, evidence in the lawsuit.

While I was gathering biographical material, a coincidence occurred that made me realize how large a part luck can play in uncovering pertinent details. Through a friend I met Diana Geary Michener, who purchased the Rothko house in 1971 from Mell's estate. After moving into her new home, she discovered an object that both sets of executors and their inventory-takers had overlooked (see chapter 10). It was a small portable metal filing cabinet containing many of the family's personal papers dating from 1944 to about 1957. Among the documents were letters from Clyfford Still written in the fifties, a note from the artist Joseph Cornell, cards containing Rothko's speaking notes for Brooklyn College faculty meetings, his reconstruction of the meeting about his tenure, and the letter from the president of Brooklyn College, in which Rothko was refused tenure. Also in the box were copies of income tax returns which proved invaluable in contrasting his years of absymal poverty with his eventual success.

Information about the last years of Rothko's life came mostly from interviews and court records. Notes taken by doctors Grokest and Mead, recording Rothko's physical and mental condition at that time, made it possible to understand what he must have been enduring.

<div align="center">FOREWORD</div>

<div align="center">1. THREE DAYS THAT ROCKED THE ART WORLD<br>(FEBRUARY 25–27, 1970)</div>

<div align="center">2. THE STRUGGLE (1903–45)</div>

<div align="center">3. THE TRIUMPH (1945–55)</div>

<div align="center">341</div>

# NOTES

Papers of the Whitney Museum of Art, Archives of American Art, New York.

28  still hope to paint.": Rothko to Goodrich, April 9, 1957, Papers of the Whitney Museum of Art.

29  like a million bucks.": Rothko to Ferber, August 19, 1952, Papers of Herbert Ferber, Archives of American Art, New York.

29  "a traveling design salesman" . . . "avant-garde huckster.": Ad Reinhardt, "The Artist in Search of an Academy: Who Are the Artists," *College Art Journal*, Vol. XIII, No. 4 (Summer 1954), pp. 314–15.

## 4. RECOGNITIONS (1955–63)

32  sensitive people recognize it.": Expert testimony of Meyer Schapiro in the "Matter of Rothko," October 1974.

33  "Yankee Doodles.": Cited in Patrick, Heron, "Americans at the Tate Gallery," *Arts Magazine*, March 1956, p. 15.

33  own dead subjectivity.": Cited in Heron, "Americans at the Tate," p. 15.

34  postwar modern art": T.B.H., *Art News*, June 1955, p. 54.

34–35  of Titian this is true.": Rothko to the Motherwells and Ferbers, July 11, 1955, Papers of Herbert Ferber, Archives of American Art, New York.

35  must destroy themselves": Rothko to Ferber, March 18, 1957, Papers of Herbert Ferber.

35–36  series of articles in *Fortune*: Eric Hodgins and Parker Leslie, "The Great International Art Market," *Fortune*, December 1955, pp. 118 ff., and January 1956, pp. 122–36.

36  subjective artistic visions.: "The Wild Ones," *Time*, February 20, 1956, p. 75.

38  except by mutilation": Mark Rothko, letter to the editor, *Art News*, December 1957, p. 8.

38  then you miss the point.": Selden Rodman, *Conversations with Artists* (Old Greenwich Conn.: Devin-Adair, 1957), p. 92.

38  desperately controlled by shrieks": Dore Ashton, "Art: Mark Rothko," *Arts and Architecture*, August 1957, p. 8.

38  "walls of light": Herbert Crehan, "Rothko's Walls of Light," *Art Digest*, November 1954, p. 19.

38  "vast smothering embrace . . . glowing caverns" Elaine de Kooning, "Two Americans in Action: Franz Kline, Mark Rothko," *Art News Annual*, 1957–58, p. 46.

39  from every ccuntry.": Yvonne Hagen, *Herald Tribune* (Paris), June 18, 1958.

39  the competitive arena.": Rothko to Sweeney, August 28, 1958.

41  their late husbands' estates.: After artist René Bouché died in 1963, his young widow, Denise, found herself in need of money. Since Bouché had been a client of Bernard Reis, Denise asked his advice. Reis suggested that she might raise $3,500 if she sold her husband's Lipchitz sculpture to Frank Lloyd. Reis telephoned Lloyd, who said he would

come right over. When Lloyd arrived, as Denise Bouché remembers, he offered her $4,000—$500 more than Reis had told her to expect. Lloyd had the sculpture out of the house that afternoon. Immediately afterward she had second thoughts. Checking with friends, she was told that the sculpture was worth far more than $4,000. When she went to Marlborough to repurchase the sculpture, she thought she spotted it in another of the gallery's rooms, but Donald McKinney refused to let her near it. Neither would Lloyd let her repurchase it. With some bitterness, she refused to take further advice from Bernard Reis.

42  to feed and show off.":    John Fischer, "Mark Rothko: Portrait of the Artist as an Angry Man," *Harper's*, July 1970, p. 16.

43  letters to Reis and the Ferbers:    Papers of Herbert Ferber.

44–45  strong motivating force.":    John Fischer, "Mark Rothko," pp. 16–23.

47–48  in search of his muse.":    Peter Selz, in *Mark Rothko*, catalogue, Museum of Modern Art (New York, 1961) , p. 14.

48  akin to violent self-control.":    Robert Goldwater, "Reflections on the Rothko Exhibit," *Arts*, March 1961, p. 42.

48  more so than any living artist's.":    Selden Rodman, *Conversations with Artists*, p. 94.

48  at the very moment it occurs.":    Elizabeth Till, "Mark Rothko," *Northwest Magazine*, March 29, 1970, p. 5.

49  to abide by them.":    Rothko to Panza di Biumo, September 12, 1962.

49  intact as a group.":    Rothko to Panza di Biumo, March 12, 1964.

49–50  my brother and other things":    Rothko to Ferber, 1962, Papers of Herbert Ferber.

50  they never ask us out.":    "Certain Spell," *Time*, May 18, 1962, p. 19.

50–51  their work on show.":    *New York Times*, May 14, 1962.

## 5. DOLLAR SIGNS AND QUESTION MARKS (1963–68)

53  "I was in oil.":    Quoted by David Shirey, *New York Times*, May 21, 1973.

53  "all his possessions":    *Francis Kenneth Lloyd*, a biography, Marlborough Gallery, May 28, 1974.

55  David gave it to us.":    Quoted by David Shirey, *New York Times*, May 21, 1973.

56  like stealing a patent":    *Time*, June 25, 1973, p. 65.

57  built Marlborough Fine Art":    Ralph Colin, "Art and Maecenas," Marlborough-Gerson catalogue, November–December, 1963.

61  or it doesn't.":    Fred Feretti, *New York Times*, November 13, 1963.

61  closing his doors.":    David Shirey, *New York Times*, May 21, 1973.

61  general's spiked helmet.":    David Shirey, *New York Times*.

61  a hundred race horses":    Stamos's deposition before trial, 1973.

64  with the other courtiers.":    Brian O'Doherty, "The Rothko Chapel," *Art in America*, January–February 1973, p. 15.

66  is as illuminating.":    Rothko to Ferber, July 19, 1967, Papers of Herbert Ferber, Archives of American Art, New York.

67  his twenty-eight sculptures.:    Marlborough's attempted seizure of Gabo's

works led the New York State legislature, at the instigation of the attorney general, to pass a law in 1968 making such seizures illegal while art was being exhibited by museums in New York State. See Sophy Burnham, *The Art Crowd* (New York: David McKay, 1973) , p. 99.

## 6. THE PRICE (APRIL 1968–FEBRUARY 1969)

70  my paintings are capable.":    Rothko to Reid, September 4, 1966.

72  contaminating for some of us.":    Frankenthaler to Ferbes, September 9, 1968, Papers of Herbert Ferber, Archives of American Art, New York.

75  Dr. Nathan Kline:    Kline's theory of treatment is described in his book *From Sad to Glad* (New York: Putnam, 1975) , and in an op. ed. page article he wrote for the *New York Times* that year titled "Feelin' Mighty Low": "Even the truly pathological depressions, once recognized, can often be treated quite rapidly (improvement sometimes begins in about three weeks) and often successfully with anti-depressant medications (a relatively inexpensive procedure since as a rule few visits are required) . There is even medicine which sometimes prevents reoccurrence. . . . The present state of therapy and the prospects for improved techniques of diagnosis and treatment are something about which to be cheerful." (January 11, 1975.) Advertisements for Kline's book claimed an "85% total cure." Several other clients of Bernard Reis were under Kline's care, and in the summer of 1976, Reis himself, and his lawyers, used a letter addressed "Dear Becky" from Kline to avoid testimony in the Rothko case (see chapter 25) .

79  "put one over on":    Bernard J. Reis's affidavit, July 1972.

79  "gotten the better of":    Theodoros Stamos's deposition before trial, 1973.

79  his own risks.":    Reis's affidavit, July 1972.

## 7. THE LAST YEAR (FEBRUARY–OCTOBER 1969)

84–85  Beethoven's last quartets.:    See Roy Edwards and Ralph Pomeroy, "Working With Rothko," *New American Review No. 12* (New York: Simon & Schuster, 1971) , p. 120.

87  everybody won.:    In 1973, during his deposition before the Rothko trial, Stamos described such a deal. A wealthy friend of his, James Loring Johnson, who was heir to the Johnson & Johnson medical supply company, wanted to donate Stamos's *Cheops Cheops Sunbox* to the Metropolitan. Johnson & Johnson donated to the museum stock worth $10,000 to $12,000 on condition that the Met buy the painting. In the Met's 1969–70 annual report, Henry Geldzahler announced the acquisition of the Stamos painting, donated by James Loring Johnson. Johnson was also listed as a donor of "money and securities" that year. Other museums report outright gifts of paintings by Stamos from Johnson.

90  two and three times a day":    Bernard J. Reis, deposition before trial, 1973.

90 "hovered over":     Morton Levine, testimony, Rothko trial, 1974.

90 "Siamese twins.":     Francis K. Lloyd, testimony, Rothko trial, 1974.

90 married people in *every* respect.":     Theodore Stamos, testimony, Rothko trial, 1974.

92 antidepressants.:     The composition and effects of these drugs were important enough to Rothko's health to be worth noting. They are defined as follows in *The New Handbook of Prescription Drugs* (New York: Ballantine Books, 1975), pp. 201, 236, 311, by Doctors Richard Burack and Fred J. Fox:

> Tofranil belongs to the class of drugs known as tricyclic antidepressants. These drugs (including Elavil) have a three-ringed chemical structure and are useful in the treatment of depression not directly associated with "tough" circumstances in life. When antidepressant medications are indicated Tofranil or Elavil may be effective . . . they are usually given in several doses a day and require a week or more before their effects on behavior and depression are noted. Side effects when they occur are serious with these drugs, with some reactions in 15 percent of all users and severe reactions in 5 percent: dry mouth, palpitations, constipation, blurred vision, precipitation of glaucoma, sweating, dizziness, weight gain, urinary retention, nausea, vomiting, tremors, confusion, agitation, hallucinations, seizures, low blood pressure when standing up, bleeding into the skin, jaundice, blood disorders, rashes, photosensitization, decreased libido, and impotence. . . .
>
> Mellaril is a phenothiazine drug that is often used for treating psychosis. Psychosis might be defined here as an illness in which there is altered emotion, confusion about sexual identity, altered thought processes, interfering with normal logic and thinking and inappropriate mood. . . . The drug should not be used for minor or self-limited illnesses, neuroses, or nervousness not associated with severe mental derangement because it is a drug with an extraordinarily large list of possible toxic side effects, including sudden death. Mellaril was among the 50 most prescribed drugs of 1973. Are there really so many psychotic people in this country?
>
> Valium is a benzodiazepine sedative best known as a tranquilizer and is the most prescribed drug in the U.S. . . . Valium and Librium . . . are useful mild sedatives. . . . While the side effects from Valium are usually less severe than with barbiturates, overdoses are not uncommon and have led to death. Drowsiness, nausea, blurred vision, and excitement, while unusual, do occur. Side effects are more common among the elderly.

## 8. THE LAST MONTHS—THE FINAL PRESSURES (OCTOBER 1969–FEBRUARY 24, 1970)

93–94 Metropolitan decorum.":     Calvin Tomkins, "Moving With the Flow: Henry Geldzahler," *New Yorker*, November 6, 1971, p. 58.

# NOTES

94 Museum's Achilles heel": John Canaday, *New York Times*, October 12, 1969 (section 2).

94 monograph for the exhibit.: Henry Geldzahler, *New York Painting and Sculpture, 1940–1970* (New York: E. P. Dutton, 1969), pp. 15–38.

94–95 share it with others.": Henry Geldzahler, *New York Painting*, p. 33.

96 "bordello.": Quoted by Grace Glueck, *New York Times*, October 17, 1974. The occasion was the opening of the Met exhibit, "The Grand Gallery," a show of art dealers' wares, most of which were quite frankly for sale, though no price tags were displayed on the objects at the time.

96 *Reds Number 16*, 1960: In November 1970, a year after the Met exhibit, the Sculls put their Rothko up for auction at Parke Bernet. Bidding reached $85,000, but Scull had placed a higher reserve price on the painting and it was not sold. In early 1971, Geldzahler bought it directly from the Sculls, reportedly paying the couple $125,000 from the Met's acquisition funds endowed by Arthur Hoppock Hearn, Hugo Kastor, and George A. Hearn. But, later, explaining his pride in the acquisition (*Notable Acquisitions, 1965–1975*, Metropolitan Museum of Art, 1976), Geldzahler omitted these details. All he wrote was: "This work traveled from New York to a collector in Brussels and back to New York where I saw it in the mid-sixties. I long wanted it for the collection and it was prominently displayed in 'New York Painting and Sculpture, 1940–1970.'"

97 Sinequan, had frightened him.: "Sinequan, doxepin hydrochloride, is a tryicyclic antidepressant drug very close to Tofrinal and Elavil chemically but advertised as a sedative and antidepressant. While as effective as the other tricyclics, its advantages over them are unclear. Side effects with doxepin are similar to those with imipramine (Tofrinal) and amitriptyline (Elavil), including heart rhythm changes, confusion or disturbed thinking processes, allergic rashes, dryness of the mouth, nausea, and some gastrointestinal upset, and, rarely, blood disorders. Overdose with doxepin and other tricyclic antidepressants is dangerous because of the possibility of death caused by sudden onset of very rapid and/or irregular heartbeat. A normally beating heart is a *sine qua non* for staying alive." Richard Burack and Fred J. Fox, *The New Handbook of Prescription Drugs* (New York: Ballantine Books, 1975), p. 300.

101 autumnal paintings.": Expert testimony, Thomas Messer, Rothko trial, February 1974.

## 9. FEBRUARY 25, 1970

107 Ad Reinhardt in 1967.: Both Kline and Reinhardt had been referred to Mead's office by another of Bernard Reis's clients, the Albert and Mary Lasker Foundation for Medical Research. Mead shares an office with Irving Wright, M.D., the cardiologist, who is a friend of Mary Lasker. Kline died in the hospital after severe heart problems; Reinhardt, having been ill a year earlier, died suddenly in his studio of heart failure.

346

109  24 hours a day.": Paul Wilkes, "Real-life Detective Stories," *New York Times Magazine*, April 19, 1970, pp. 32–33 ff.

111  was concerned about.": Motherwell as quoted by Alice Look, *Art Workers News*, April 1974.

## 10. ODDS OUT ... (FEBRUARY–OCTOBER 1970)

116  I was dying.": Theodoros Stamos, deposition before trial, 1973.

120  performed no autopsy.: The medical examiner's records show that Dr. Michael Baden made a small, quick incision in Mell's body and sent a sample of her blood to the lab. Only a trace of coffee was discovered in her bloodstream, no alcohol or sedatives. Coincidentally, Dr. Helen Strega, who had investigated Rothko's death, also investigated Mell's. A call was made to Mell's doctor, who confirmed the fact that she suffered from high blood pressure. The cause of her death was not explored further.

121  sought control of them.: Sometime in the fifties—perhaps when he was bedridden for several months with undiagnosed gout—Rothko jotted down his view of Western art from ancient Egypt to the present. About a hundred pages long, the manuscript was intensely subjective. In it, Rothko showed a clear preoccupation with form.

122  "judicious admixture": Testimony of Morton H. Levine, Rothko trial, February 1974.

## 11. DEALER'S CHOICE (FEBRUARY–JUNE 1970)

124  in our minds at all.": Deposition of Donald McKinney before trial, 1973.

124  "Yes, I will take that," . . . "No, pass,": Testimony of Morton H. Levine, Rothko trial, 1974.

125  a son of a bitch.: Testimony of Morton H. Levine, Rothko trial, 1974.

125  high-handed, and intolerable.": Deposition of Morton Levine before trial, 1973.

126  to write a book for us.": Testimony of Francis K. Lloyd, Rothko trial, 1974.

126  still owed him $2,500: Levine submitted his bill to the estate between the two negotiating sessions with Frank Lloyd in mid-May.

127  "philosophy meeting": Deposition of Theodoros Stamos, 1973.

128  even in the ball park": Deposition of Frank E. Karelsen, 1973.

128  "conflict of interest": Trial exhibit, Ernest Bial, legal memorandum to Bernard J. Reis, May 1970.

129  a copy of the Saidenberg appraisal: In his examination before the trial, Stamos first described the paper Lloyd held as the Saidenberg appraisal. Afterward, he denied that it was. See pp. 177–78.

129  "final offer" . . . "huddle": Deposition of Theodoros Stamos, 1973.

129  Stamos and Levine were "jubilant": Deposition of Bernard J. Reis, 1973.

# NOTES

129 "an excellent deal" . . . "marvelous job": Deposition of Morton H. Levine, 1973.

130 on everything.": Deposition of Frank E. Karelsen, 1973.

130 "Everyone was elated": Deposition of Bernard J. Reis, 1973.

130 buy it as cheap.": Testimony of Francis K. Lloyd.

## 12. MUCH FANFARE AND SOME SUSPICIONS (OCTOBER 1970–MAY 1971)

131–32 throughout the world.": The press release was not available to the petitioners at the trial, though it would have been useful "expert" evidence. It turned up in 1975 in the files of the Guggenheim Library, New York, N.Y.

133 a stinging letter: Rubin to Reis, October 19, 1970.

135–36 if the murals were touched.: The minutes of the foundation for April 4, 1971, reveal how the murals might be reclaimed. "Mr. Reis invited Alan [sic] Thielker, conservator of Marlborough, to the meeting to discuss the condition of the Rothko murals at Harvard.

"Mr. Thielker also discussed the possibility of having paint samples of the Rothko murals taken and with the NYU Fine Arts Institute conservation program, having an analysis done, which would cost about $50,000. Discussion followed as to who would bear the cost—the Rothko estate or the Marlborough Gallery. Mr. Reis said he thought the Gallery is morally obligated."

136 "estate business": Deposition of Clinton Wilder, 1973. Levine testimony, Rothko trial, 1974.

136 "It beared fruit": Lloyd testimony, Rothko trial, 1974.

140 mysteriously from within.": Barbara Rose, "Environment of Faith: Rothko Chapel," *Vogue*, December 1973, p. 134.

140 unbearable nothingness.": Quoted by David Snell in "The Rothko Chapel," Smithsonian, August 1971.

140 the harsh glare of Houston.: Brian O'Doherty, "The Rothko Chapel," *Art in America*, January–February 1973, pp. 14–16.

141 what Rothko had in mind.": Roy Edwards and Ralph Pomeroy, "Working with Rothko," *New American Review 12*, (New York: Simon & Schuster, 1971) , p. 118.

142 hospital sterilization.": Dominique and John de Menil, "Rothko Chapel," *Art Journal*, Spring 1971.

143 the National Gallery in Berlin: Parts of the text of the handsome accompanying catalogue were notably misleading, others ironic: Dr. Felix Bauman of the Zurich Kunsthaus expressed his thanks for the "friendly cooperation" and "generous support" of "Mark Rothko's heirs and the Marlborough Gallery in New York." A second monograph by Professor Werner Haftmann of Berlin's National Gallery described his conversation with Rothko about his participation in an important Berlin exhibition in 1959. Rothko "resolutely refused . . . as a Jew, he had no intention of exhibiting his works in Germany, a country that had com-

mitted so many crimes against Jewry. . . . He added that if I could manage to have even a very small chapel of expiation erected in memory of Jewish victims, he would paint this without any fee—even in Germany, which he had hated so much. He then said it need only be a tent." Again Rothko's wishes had been posthumously violated.

## 13. AN UNVEILING: THE DUMMY UNCOVERED
## (JUNE–NOVEMBER 1971)

147 "kept in the dark" . . . "further concealment":     Gerald Dickler affidavit, August 1972.
147 "odious and difficult" decision.:     Quoted by Leah Gordon, "The Rothko Estate in Marlborough Country," *New York*, August 20, 1973, p. 49.

## 14. MANEUVERS (NOVEMBER 1971–JUNE 1972)

152 got into Marlborough.":     Deposition before trial of Morton Feldman, 1973.
157 important museums were paying off.     In 1973, Maurice Tuchman, curator of the Los Angeles County Museum, accepted a $5,000 honorarium from Marlborough for a monograph on Soutine and later recommended that the museum purchase several Marlborough-owned works. When this became known there was a public outcry and Tuchman was reprimanded but not dismissed by the museum's trustees. (See Clark Polak's series in the Los Angeles *Free Press*, January 17, 1974–January 3, 1975.) A 1973 invoice in exhibit 235B in the Rothko trial shows Tuchman also was paid a $1,500 commission by Marlborough on the $43,000 1969 Rothko oil on paper which was sold to John W. Kluge of Waterford, Va.
157 Lichtenstein headquarters for $600,000.:     See Appendix III, *Report on Art Transactions, The Metropolitan Museum of Art, 1971–1973*, Metropolitan Museum Archives, June 20, 1973.
157 disposals from his collection.:     See *Guidelines for Sale of De-accessioned Objects*, November 23, 1971, and March 1972, Archives of the Metropolitan Museum of Art, New York.
158 *New York Times* reporter John Hess:     John L. Hess, *The Grand Acquisitors* (Boston: Houghton Mifflin, 1974) , p. 85.
158 paintings of equivalent value.":     *Report on Art Transactions*, p. 16.
158 of the Modigliani.:     Rousseau explained it officially. He "felt it only proper that in its agreement with Marlborough, the Museum provide either for the return of the painting and its replacement with another work or works valued at $60,000 or a refund of $60,000, the value assigned to the Modigliani in the exchange, should the Modigliani prove not to be authentic." *Report on Art Transactions*, p. 16.
159 champing at the bit.":     Exhibit in Rothko trial.

## 15. MISALLIANCES (MAY 1972–MARCH 1973)

161 lawyers in the case.":    Evidence in Special Proceeding, New York Supreme Court, November 1976. Reis and Stamos versus Harrow and new directors of the Mark Rothko Foundation.

162 "categorically refused." . . . "over my dead body.":    Deposition of Morton Levine in Special Proceeding, 1976.

162 wearing that crazy hat.":    Levine to Frederick Morgan, August 18, 1972.

172–73 financial assistance.":    Goldwater to Greenspoon, August 19, 1972, evidence in Reis and Stamos vs. Harrow and directors of the Rothko foundation, 1976.

173 arguments in the case.":    Robert Goldwater papers; evidence in Reis and Stamos vs. Harrow and directors of the Rothko foundation, 1976.

175 Thomas Hess would like to write.":    Minutes of Rothko Foundation meetings on March 31, 1973 and June 11, 1973, Harrow brief in Special Proceeding, 1976. When asked in the spring of 1976 about the Rothko book, Hess denied that he had ever intended to write it. He maintained that he had joined the foundation's board at the instigation of Robert Goldwater, whose family denies this.

After Adolph Gottlieb's death in early 1974, Hess, Gerald Dickler, and Bernard Reis were among the trustees who set up the Adolph Gottlieb Foundation. Its purposes, giving grants to artists, were similar to the amended purposes of the Rothko Foundation. Rothko Foundation minutes show that as a director of both foundations, Hess would serve as liaison for their "cooperation."

## 16. THE FREE-FOR-ALL AND THE REFEREE (JANUARY 1973–FEBRUARY 1974)

182 deal for the thirteen paintings.:    After many denials, Reis vaguely recalled seeing some sort of invoice for thirteen paintings sold in New York. Stamos, after denying any knowledge of the sale, when he was reexamined in November 1973, claimed he now recalled the sale. His memory was refreshed, he said, when he discovered an invoice in an old shoebox. He claimed all three executors decided that the estate needed more cash for some reason and had delegated Reis to make the sale to Lloyd. His new recall tallied with Lloyd's testimony. But Levine steadfastly denied any knowledge of the deal for the thirteen paintings or any discussions concerning the need for more money. It should be noted that it is against New York State law to allow estate property to leave the state without court approval.

184–85 "Artfinger: Turning Pictures into Gold.":    Time, June 25, 1973, pp. 65–67.

185 myth of the art world.:    Time's misinformation about Rothko's will specifying the foundation's purposes was compounded in various published accounts, among them: John Russell, New York Times, June 21,

1974; Alice Look, "Court Battle Rages over Rothko Estate," *Art Workers News*, April 1974; and *Time*, itself, again on December 29, 1975.

187  the Republican Party.:   Six months earlier, David Peck had persuaded President Nixon to grant full and unconditional pardons to three of Peck's clients convicted of criminal conspiracy and fraud. They were a general partner, a partner, and the chief accountant of Lybrand Ross Bros. & Montgomery, who had been convicted of falsely auditing and distributing financial statements for the Continental Vending Corp. Nixon's pardon of the three men was remarkably premature; just a few months earlier the Supreme Court had refused to hear an appeal of the case.

## 17. THE TRIAL: PHASE ONE—SELF-DEALING?
### (FEBRUARY–MAY 1974)

217  returns to public scrutiny.:   To demolish Heller's expertise, Sullivan and Cromwell's final brief would call him "only a megalomaniac—a part-time and a sideline private dealer, primarily in ancient art." Heller's "unbounded ego responded with delight to the dual purpose of head-lining himself and settling an old score with Marlborough for spurning him." Heller had said that Lloyd had offered him the job of running the New York gallery in the mid-sixties, but Lloyd testified later that it was Heller who had asked for the job and Lloyd who had refused his advances. Heller, the brief continued, through his appraisal had perpetrated a "fraud upon the court" and a "swindle." To further discredit him they cited the sale he had made in the early sixties to the Whitney of Rothko's *Four Darks in Red* for $45,000. The museum had paid $45,000 on the condition that he give them a $5,000 contri-bution. Heller had testified that this was okayed by his tax adviser. Marlborough's brief zeroed in on this "circular transfer of funds by which Heller got a $5,000 charitable deduction from ordinary income rates. . . . If Heller's capital gains rate was sixty percent or more, Heller received the benefit of the difference between the value of the (charitable) gift for tax purposes (sixty percent of $5,000; or $3,000) and reported capital gains tax (twenty-five percent of $5,000; or $1,250) for a profit of $1,750 for petty theft." Besides, they noted, he was not a member of the Art Dealers Association of America, and therefore not qualified to make appraisals.

## 18. THE TRIAL: PHASE TWO—THE MASTER DEALER
### (JUNE–AUGUST 1974)

226  international art world":   Edith Evans Asbury, *New York Times*, May 29, 1974.

226  Loves to Hate.":   Grace Glueck, *New York Times Magazine*, June 15, 1975, p. 12.

# NOTES

228 Galerie des Arts Anciens et Modernes:    On Armistice Day 1966, Frederick
A. Lambert, like Lloyd a Viennese-born refugee from the Nazis, was
browsing in the Marlborough Gallery in New York, which was exhibit-
ing a Kokoschka retrospective. He stopped before one painting. "I was
flabbergasted," he remembers. "It was my portrait of my uncle Emile,
*The Blind Man.*" When Lambert had fled Vienna in 1939, the painting
had been left rolled up in the attic of his house. (Kokoschka had been
designated "decadent" by Hitler, and Lambert saw no point in further
endangering his life by carrying the painting with him in his flight.)
He had never been able to retrieve it. In the Marlborough exhibit, the
subject was called *Emile Ludwig,* but there was no doubt that it was
Lambert's painting. The price was $60,000. Lambert asked to see the
owner of the gallery, and Mrs. Ilse Gerson listened to his story,
telling him to return the next day. When he did, he was told that the
painting did not belong to Marlborough but was on consignment from
another dealer. Since he had questioned its ownership, Marlborough
had returned it to the European dealer.

Lambert hired a lawyer and instituted suit against Marlborough. In
1971, after a long and costly delay during which Lloyd hired at least
two sets of lawyers, Mr. Lambert settled out of court for a substantial
check (co-signed by Bernard J. Reis). During a pretrial hearing, evi-
dence was produced showing that the painting was on consignment
from a "Galerie des Arts Anciens et Modernes" in Liechtenstein and
listed on a "sale or return invoice." During examination, on December
3, 1969, Frank Lloyd testified that he had no idea how the Kokoschka
came into Marlborough's possession. He also said that he had absolutely
no connection with Galerie des Arts Anciens et Modernes or with
M. Meyer, who was its listed director.

By the time of the Rothko examinations before trial in 1973, Lloyd
included the same Galerie des Arts Anciens et Modernes as one of his
Liechtenstein paper corporations. Had the petitioners known of the
Lambert-Kokoschka case, it would have helped them in their attempts
to cross-examine Lloyd about Bernini, AEK, and other Liechtenstein
corporations with which Lloyd claimed to have no connections. It also
would have illustrated the inaccuracy of Lloyd's testimony that "This
is the first time that I have a lawsuit, my first true experience in the
United States courts."

229 'It's a mistake':    In his pretrial examination, Lloyd said that Reis told
him the estate was hard-pressed for cash and Lloyd had bought the
thirteen paintings. Now he retracted that statement and said the "sale"
had been an advance. He also retracted his entire lengthy affidavit signed
two years earlier (which had stated that the "put" clause was intended
to enable Rothko to share in the rising market for his work). He later
said that he had been up all night and had not realized what his
lawyers (then Colin's firm) had given him to sign. He even claimed
he had not signed it, until Judge Midonick pinned him down.

231–32 to New York for you.":    McKinney to Mellon, February 17, 1971.

352

## 19. THE DEFENSE—140 DIFFERENT TRIALS
## (AUGUST–OCTOBER 1974)

240  Berkeley Museum.:     Paul Altman, *Berkeley Daily Gazette,* June 1, 1974; Harold Rosenberg, "The Art World," *New Yorker,* August 5, 1974, p. 71.

244  global sale:     Another excellent illustration of how the global sale works was a group purchase by Algur Meadows of Dallas in June 1971, in which a 1952 consigned Rothko was included, with works of Still, Pollock, and Motherwell. Marlborough repeatedly insisted on listing this Rothko sale as $48,000, despite the fact that it was known to be higher. A first invoice showed a total price of $135,000 to Meadows, omitted the Pollock, and gave no breakdown for the Rothko, Motherwell, or Still. Then a Xerox of a page from Mr. Meadows' Marlborough account was put in evidence, but the prices appeared to be altered. Two months later after the original finally was produced, the erasures and changes were easy to see. Lloyd claimed he had not been told of the transaction. The actual facts were revealed in a letter from Pierre Levai to Meadows explaining all (but not produced until the tail end of the trial) :

The Rothko painting "Yellow, red, violet, black, green with brown" (No. 5068.49) which you returned arrived in the gallery in perfect condition and we will now send you the Rothko "Untitled" 1952, oil on canvas, 97½ × 67½ in., Rothko #5143.52 which you selected in replacement. . . . As far as the accounting is concerned, there will be an additional amount of $4,000 due on the overall purchase which you made in April.—Due to the fact that the Rothko which you are getting is $85,000 and the previous one was $80,000. In order to have no misunderstanding, I should like to set out the following calculation:

PURCHASE OF 27TH APRIL, 1971

| Still | $80,000 | |
|---|---|---|
| Motherwell | $12,000 | |
| Jackson Pollock | $55,000 | |
| Rothko | $80,000 | = $227,000 |
| Less 20% discount | | |
| making final total: | | $181,600 |

AMENDED PURCHASE AS OF TODAY:

| Still | $80,000 | |
|---|---|---|
| Motherwell | $12,000 | |
| Pollock | $55,000 | |
| Rothko [5143.52] | $85,000 | = $232,000 |
| Less 20% discount | | |
| making final total: | | $185,600 |

250  half the going rates.:    An invoice showed that in May 1972, twenty-four Franz Klines had been sold to the Hallsborough gallery. When Kline's executor, Elizabeth Zogbaum, went to London and inquired whether she could see some Franz Klines, impatience registered on the salesman's face. "But madame," he responded, "we deal only in old masters."

255  so-called merchandise.":    *New York Times*, October 18, 1974.

255  Meyer Schapiro:    Professor Schapiro had been asked to join the board of the Mark Rothko Foundation in late 1973, having been nominated by Thomas Hess. Just before the Rothko trial began, Harrow had interviewed him as a possible expert witness about Rothko's stature. During this interview Schapiro inquired as to the nature of the lawsuit, and, after the facts were related to him, declined to serve on the board.

## 20. PRESS CLIPS FROM THE GALLERY: AFTERMYTHS OF THE TRIAL AND THE LONG WAIT· (DECEMBER 1974–DECEMBER 1975)

262  reassigned to the trial.:    Intelligencer, *New York*, May 27, 1974, p. 76.

264  will have gained nothing.":    Grace Glueck, "The Man the Art World Loves to Hate," *New York Times Magazine*, June 15, 1975, p. 12.

## 22. THE TORONTO CAPER (DECEMBER 19–24, 1975)

286  "commiserate" . . . "nothing with him.":    Deposition of Fraser Elliott, March 17, 1976; Ross affidavit in U.S. suit, K. Rothko Prizel versus Karelsen and Saidenberg.

287  four David Smiths:    As a result of the Toronto caper, some unusual dealings between Marlborough and the David Smith estate were revealed. When asked whether the fact that four Smith sculptures were among Marlborough's stock meant that the Smith estate had made outright sales to Lloyd, executor Clement Greenberg said yes, and that somehow the estate had not yet been paid for these works. Greenberg said that the estate had always been paid "cold cash" by Lloyd, so that he had trusted Lloyd when the dealer said he was purchasing seven Smith sculptures for his own collection at the low price of $130,000. Greenberg said they were not important works and that Lloyd had promised that he would not put them on the market but would keep them on Paradise Island. For some reason, Greenberg did not insist on a guarantee of this in writing. It is astonishing that Greenberg agreed to this deal, since, as the art world's longtime "kingmaker," he must have been aware of Lloyd's motto: "I collect money, not art."

## 23. KATE ROTHKO AND THE NOTION OF THE "DOUBLE WHAMMY" (DECEMBER 26, 1975–OCTOBER 1976)

293  New York *Post*:    Helen Dudar, New York *Post*, December 19, 1975.

299 Kate is a monster.": Quoted by Paul Richard, *Washington Post*, February 9, 1976.

306 returned from Europe.: Later, Lloyd returned another oil and another painting on paper, bringing the total to forty-three, and gaining credit of another $90,000 and $29,000 respectively against the judgment.

## 24. AT THE CORONER'S OFFICE (FEBRUARY 25, 1970–JULY 1976)

309 *tried* to profit.": John Gruen, "Agnes Martin: Everything, Everything is About Feeling . . . ," *Art News*, September 1976, p. 93.

316 in Brooklyn at the time.: Di Maio was named Chief Medical Examiner of New York by Mayor Beame in August 1976.

317 agent that led to Rothko's death.: Dr. Nathan Kline, who prescribed Sinequan for Rothko, refused to be interviewed or to answer written questions about Rothko's treatment during the last months of his life. Each time Kate Rothko made appointments to see Dr. Kline about her father's condition, he canceled the date.

## 25. QUESTIONS OF PERSPECTIVE

322–23 prices to skyrocket.: A second Rothko, a small paper, was also sold at the auction. It went for $28,000—$1,000 less than Midonick would credit Lloyd for the return of the paintings on paper (of any size) . Like the oil, neither its provenance nor its buyer was disclosed by Parke Bernet.

323 has besmirched us.": Quoted by Grace Glueck, *New York Times*, December 19, 1975.

323 by Marlborough's standards.: Glueck, *New York Times*.

324 "no merit to the case.": Quoted by John L. Hess, "The Rothko Donnybrook," *Art News*, November 1972, pp. 24–25.

324 pending in the courts.": Ralph Colin, letter to *Art News*, December 1972, p. 7.

324 meeting of the board.: Grace Glueck, *New York Times*, December 19, 1975.

324 early stages of litigation.": Plaut to Colin, December 20, 1975.

324 in the association.": Press release, ADAA, December 22, 1975.

326 here, I think.": Quoted by Tom Buckley, *New York Times*, June 7, 1976.

329 The new directors: In November 1976, Thomas Messer, the director of the Guggenheim Museum, resigned as a director of the Mark Rothko Foundation. He hoped that the Guggenheim would be selected over the competing Whitney Museum by Kate to mount a large-scale Rothko retrospective in 1978, and felt that there might be a seeming conflict of interest if he remained on the foundation. Kate chose the Guggenheim.

331–32 special environments.: In December 1976, as a result of the suit brought by Reis and Stamos against Harrow and the new directors of

the foundation (see chapter 25) , Mrs. Rita Reinhardt did submit an affidavit about the foundation's purposes. Significant segments of this document follow:

> The subject of Mark Rothko's plans for a foundation . . . came up in our conversations very frequently . . . and they were discussed both before and after mid-1969, the time when the foundation was organized and until his death. . . .
>
> During the course of these conversations Mark Rothko spoke of his overriding concern to have the foundation serve as a vehicle which would enable him to effect his intentions as to the proper placement of and proper situations and environments for his art. . . .
>
> Rothko also wanted to be certain that the foundation serve as a proper vehicle for tax exemptions both during his life and for his estate. During the period referred to above, Mark Rothko told me that Bernard Reis, his advisor and accountant, had advised him that in order for the foundation to be legally effective in this respect it had to include a more direct charitable purpose, e.g., making of grants to artists. Mark Rothko then told me that if the foundation needed to include such a purpose, he wanted the grants to be to older artists.
>
> However Mark Rothko's overriding concern, to have the foundation serve as a vehicle with which to effect his overall intentions as to the proper placement of his art, remained unchanged. He referred to the aspect concerning grants by the foundation as a way of making it legally viable, tax exempt and necessary if his abiding concern with the placement and proper showing of his art was to be carried out.
>
> Beyond these specific facts it would have been completely out of character for Rothko to have changed his basic, long lasting concern to have a foundation serve as a vehicle for the proper placement and exhibition of his art, and such a change would have constituted a complete reversal in his approach to the foundation. Also, it would have been out of character for him not to have disclosed any such change to me during this period since he spoke constantly of his financial concerns, his objectives for his art and any specific substantial facts affecting these matters.
>
> . . . until his death I am certain that Mark Rothko retained his long standing aspirations for his art and wished the foundation to be used primarily for that purpose.

# Selected Bibliography

BOOKS

Adams, Laurie. *Art on Trial: From Whistler to Rothko.* New York: Walker, 1976.
Arneson, H. Harvard. *History of Modern Art.* New York: Harry N. Abrams, 1968.
Ashton, Dore. *The New York School: A Cultural Reckoning.* New York: Viking Press, 1973.
————. *A Reading of Modern Art.* Rev. ed. New York: Harper & Row, 1971.
Associated Counsels of the Arts for the Association of the Bar of the City of New York. *The Visual Artist and the Law.* Rev. ed. New York: Praeger, 1974.
Burnham, Sophy. *The Art Crowd.* New York: David McKay, 1973.
Choron, Jacques. *Suicide.* New York: Charles Scribner's Sons, 1972.
Durkheim, Emile. *Suicide.* New York: The Free Press, 1951.
Geldzahler, Henry. *New York Painting and Sculpture: 1940–1970.* New York: E. P. Dutton, 1969.
Greenberg, Clement. *Art and Culture: Critical Essays.* Boston: Beacon Press, 1961.
Guggenheim, Peggy. *Confessions of an Art Addict.* New York: Macmillan, 1960.
Hess, John L. *The Grand Acquisitors.* Boston: Houghton Mifflin, 1974.
Hess, Thomas B. *Abstract Painting: Background and American Phase.* New York: Viking Press, 1951.
Hoving, Thomas, et al. *The Chase, the Capture: Collecting at the Metropolitan.* New York: The Metropolitan Museum of Art, 1976.
Howe, Irving. *World of Our Fathers.* New York: Harcourt Brace Jovanovich, 1976.

357

# SELECTED BIBLIOGRAPHY

Hunter, Sam, et al. *Art Since 1945.* New York: Harry N. Abrams, 1958.

McCabe, Cynthia Jaffee. *The Golden Door: Artist-Immigrants of America, 1876–1976.* Washington, D.C.: Hirshhorn Museum of Art, Smithsonian Press, 1976.

McDarrah, Fred W. *The Artist's World in Pictures.* New York: E. P. Dutton, 1961.

Martin, Gilbert. *Jewish Historical Atlas.* New York: Macmillan, 1969.

Menninger, Karl. *Man Against Himself.* Rev. ed. New York: Harcourt Brace & World, 1961.

O'Doherty, Brian. *American Masters.* New York: Random House, 1974.

Rodman, Selden. *Conversations with Artists.* Old Greenwich, Conn.: Devin-Adair, 1957.

Rose, Barbara. *American Art Since 1900: A Critical History.* Rev. exp. ed. New York: Praeger, 1975.

Rosenblum, Robert. *Modern Painting and the Northern Romantic Tradition: Friedrich to Rothko.* New York: Harper & Row, 1975.

Rothko, Mark. *Milton Avery.* New York: New York Graphic Society, 1969.

Sandler, Irving. *The Triumph of American Painting: A History of Abstract Expressionism.* New York: Harper & Row, 1970.

Selz, Peter. *Mark Rothko.* New York: Museum of Modern Art, 1961.

Vicker, Ray. *Those Swiss Money Men.* New York: Charles Scribner's Sons, 1973.

Wilke, Ulfert. *An Artist Collects: Journals.* Iowa City: University of Iowa Museum of Modern Art, 1975.

Wolfe, Tom. *The Painted Word.* New York: Farrar, Straus & Giroux, 1975.

## ARTICLES

"Aggressive Giant." *Time,* July 17, 1963, p. 34.

Alloway, Lawrence. "Notes on Rothko." *Art International,* Summer 1962, pp. 90–94.

———. "The Rothko Chapel." *Nation,* March 15, 1971, pp. 49–50.

"Artfinger: Turning Pictures into Gold." *Time,* June 25, 1973, pp. 65–67.

Asbury, Edith Evans. "The Rothko Trial." *Art News,* April 1974, pp. 72–73.

———. "Rothko, cont'd." *Art News,* May 1974, pp. 46–47.

———. "The Rothko Decision." *Art News,* February 1976, pp. 42–45.

Ashton, Dore. "Art: Mark Rothko." *Arts and Architecture,* April 1957, pp. 8 ff.

Deeley, Peter. "The Million-Dollar Art Wrangle." *Observer Review* (London), December 30, 1975, p. 17.

de Kooning, Elaine. "Two Americans in Action: Kline and Rothko." *Art News Annual, 1957–58,* pp. 86–97.

Edwards, Roy, and Pomeroy, Ralph. "Working with Rothko." *New American Review 12,* Simon & Schuster, 1971, pp. 109–121.

Feldman, Frank. "The Rothko Estate: The Case of the Beleaguered Executor." *Trusts and Estates,* April 1976, pp. 236–61.

Fischer, John. "Mark Rothko, Portrait of the Artist as an Angry Man." *Harper's Magazine,* July 1970, pp. 16–23.

Geist, Sydney. "Moodily Dare, IFP." *Scrap,* February 16, 1961.

Getlein, Frank. "The Ordeal of Mark Rothko." *New Republic,* February 6, 1961, pp. 28–30.

# Selected Bibliography

Glueck, Grace. "The Man the Art World Loves to Hate." *New York Times Magazine,* June 15, 1975, pp. 12–13 ff.

Goldwater, Robert. "Reflections on the Rothko Exhibit." *Arts,* March 1961, pp. 42–45.

———. "Rothko's Black Paintings." *Art in America,* March–April 1971, pp. 58–63.

Gollen, Jane. "The Metropolitan Museum: It's Worse Than You Think." *New York,* January 15, 1973, pp. 54–60.

Goossen, Eugene. "Rothko: The Omnibus Image." *Art News,* January 1961, pp. 38–40, 60–61.

Gordon, Leah. "The Rothko Estate in Marlborough Country." *New York,* August 20, 1973, pp. 43–51.

Hess, John L. "The Rothko Donnybrook." *Art News,* November 1972, pp. 24–25.

Hess, Thomas B. "Rothko: A Venetian Souvenir." *Art News,* November 1970, pp. 40 ff.

Hodgins, Eric, and Parker, Leslie. "The Great International Art Market." *Fortune,* December 1955, pp. 118–20 ff; January 1956, pp. 122–36.

Holmes, Ann. "The Rothko Chapel Six Years Later." *Art News,* December 1976, pp. 35–36.

Kenedy, R. C. "Mark Rothko." *Art International,* October 20, 1970, pp. 45–49.

Kozloff, Max. "Mark Rothko's New Retrospective." *Art Journal,* Spring 1961, pp. 148–49.

———. "The Problem of Color-Light in Rothko." *Artforum,* September 1965, pp. 39–44.

Kuh, Katharine. "Maximum of Poignancy." *Saturday Review,* April 17, 1971, pp. 52 ff.

MacAgy, Douglas. "Mark Rothko." *Magazine of Art,* January 1949, pp. 20–21.

"Mark Rothko." *Life,* November 16, 1959, pp. 82–83.

Merryman, John H. "The 'Straw Man' in the Rothko Case." *Art News,* December 1976, pp. 32–34.

O'Doherty, Brian. "Rothko." *Art International,* October 20, 1970, pp. 30–44.

———. "The Rothko Chapel." *Art in America,* January–February 1973, pp. 14–20.

Olmos, Robert. "Mrs. Allen Talks About Her Brother." *Northwest Magazine,* March 29, 1970, p. 17.

Putnam, Wallace. "Mark Rothko Told Me." *Arts,* April 1974, pp. 44–45.

Rexroth, Kenneth. "Americans Seen Abroad." *Art News,* June 1959, pp. 30–33.

Rosenberg, Harold. "Rothko." *New Yorker,* March 28, 1970, pp. 90–95.

———. "Death and the Artist." *New Yorker,* March 24, 1975, pp. 69–75.

Rothko, Mark. A statement in "Ides of Art." *Tiger's Eye,* December 1947, p. 44.

———. "A Statement on His Attitude of Painting." *Tiger's Eye,* October 1949, pp. 109–114.

———. "The Romantics Were Prompted." *Possibilities 1,* Winter 1947–48, p. 84.

———. "How to Combine Architecture, Painting and Sculpture." *Interiors,* May 1951, p. 104.

Rubin, William. Mark Rothko obituary. *New York Times,* March 8, 1970.

Russell, John. "Swinging Art Dealers: The Marlborough Boys in New York." *Vogue,* January 1964, pp. 102–105 ff.

Seldes, Lee. "The Trusting Trustees." *Village Voice,* April 19, 1973; April 26, 1973.

# SELECTED BIBLIOGRAPHY

Singer, Mark. "God and Mensch at Yale." *Moment,* July–August 1975, pp. 27–31.

Snell, David. "The Rothko Chapel: the Painter's Final Testament." *Smithsonian,* August 1971, pp. 48–55.

Till, Elizabeth. "Mark Rothko." *Northwest Magazine,* March 29, 1970, p. 5.

Tomkins, Calvin. "Moving with the Flow: Henry Geldzahler." *New Yorker,* November 6, 1971, pp. 58–110.

"Wild Ones." *Time,* February 20, 1956, pp. 74–75.

# Index

# INDEX

# INDEX

# INDEX

# INDEX